002-005 CURIOUSLY SERIOUS MARTÍ GUIXÉ
006-0[...] [...]SS
016-025 CLOSELY OBSERVED BIRD OBSERV[...] [...]CH
026-029 I WISH I W[...] [...]LE
030-033 PARTY ANIMA[...] [...]US
034-035 POST[...] [...]BERNAU
036-041 IT'S RAINING LINUS BILL
042-045 LA MORT ALINE BOUVY + JOHN GILLIS
046-047 FOUR LETTER WORDS DAVID CLAVEDETCHER
048-051 FREEDOM IN THE WORLD MARK DELONG
052-057 UNCENSORED ANDREA DEZSÖ
058-059 ROOM 404 E-TYPES
060-063 JUGS DOMINIC EARLY
064-069 IDYLLIC ANDRÉ ETHIER
070-075 BAD HAIR DAY EVAH FAN
076-079 PAPER INVASION FULGURU
080-083 SEND IN THE CLOWNS STEVEN GUARNACCIA
084-087 HIDING CHRIS HAUGHTON
088-093 OOOOOOOOH ANDREW JAMES JONES
094-099 THIS IS THERAPY ADRIAN JOHNSON
100-105 HEY BOBBY KESSELSKRAMER
106-111 WHUZZUP LES KRIMS
112-117 ANIMAL NEEDS SHIZUKA KUSAYANAGI
118-123 GTA ALL DAY TAYLOR MCKIMENS
124-129 YOU SHOULD STOP THIS NICHOLAS MAHLER
130-133 BAG OF INSPIRATION OGILVY
134-137 THE CAR CRASH LEIF PARSONS
138-145 INCL. © FREE IMAGES ANDREW RAE
146-147 INFLATABLES ALEJANDRO SARMIENTO
148-153 PORTRAIT OF THE ARTIST LIEVEN SEGERS
154-159 FISHERMAN MATT STUART
160-165 TOUPÉE GARY TAXALI
166-169 ART SCHOOL DROP-OUTS VÄNSKAP
170-173 THIS FEELS AWESOME POROUS WALKER
174-181 DEAD BIRD BALINT ZSAKO
182-191 42 QUESTION MARKS BY MARC VALLI
128 FULL STOPS BY DAN EATOCK DAN EATOCK
192 SORRY WE'RE DEAD ADAM MCEWAN

CU RIO SE

For an ex-designer, Martí Guixé is rather active. In fact, while dividing his time between Barcelona, Berlin and the internet, he can't stop reinventing what used to be known as design. If you are a designer and are thinking about retiring, well, this should make you think again.

USLY

Martí Guixé: I did interior design in Barcelona in the early 80s. Design was not very well known or popular at the time, and by the end of my Barcelona school time, the Memphis movement was starting to explode. After that I moved to Milan, where I studied product design for two years, in a very academic school, that followed the parameters of Ulm and the modern movement. Maybe it is also relevant the fact that I was always fan of comics and that, in the 80s, Barcelona had a great comics culture, underground and no. In general I enjoyed studying design and I liked being a designer.

What would you say was your lucky break?

In the mid-90s, I stopped all my design activities, and sold part of my company and went to Berlin to live and change my life.

What made you do that?

I thought I was becoming too accommodated (already by the age of 28) and I did not like the post-Olympic Barcelona. I wanted to stay with the action. Berlin is a great city and in those years so much was changing. There was plenty of energy around. Berlin was like a crossing point with the East of Europe.

What was wrong with post-Olympic Barcelona?

Post-Olympic Barcelona for me was like a city trying to emulate a shopping mall. Now it is much better. It is mostly a shopping mall.

You call yourself an 'ex-designer', why?

It was very complicated to get other designers and the media to understand my work. I was labelled an artist by the design community, but I do design projects mostly. The only difference was that the quality of the content was better, or that there was content, and not just a nice form.

Somehow, I was frustrated by the borders, or the frontiers, of the discipline, and I decided to define myself as an ex-designer so I could break away from the limits of design practice.

What changes once you become an ex-designer?

An ex-designer is someone who designs without rules, and with only a peripheral view of what design is.

You said somewhere that, as an ex-designer, you were interested in systems. What systems were you referring to?

Infrastructures, protocols, instructions, attitudes, social mechanisms...

You say your work is dedicated to 'brilliantly simple ideas of a curious seriousness'. How do you come to 'brilliantly simple ideas'?

It's a question of thinking in order to get an idea, and not to come to this idea just by getting inspired.

Could you tell us a bit about your work with food and your own relationship to it?

I have no idea about cooking. I believe that to be a food designer you do NOT need to know how to cook. If you know how to cook, then you are a craftsman (an artisan), but not a designer. I have started being interested in food, because I thought of it as a mass-consumption product. If you consider food as an object, a product, and not as a necessity, then it can be subjected to design.

I have no special fascination with eating. Food is for me just an academic interest, and an important part of my theoretical work.

Food Facility has not much to do with food itself. It refers to the design of infrastructures, or platforms. It is about the re-design of the business of a restaurant, using outsourcing, making its model in this way more economically effective, and more contemporary.

Could you tell us a bit about your work with Camper?

It started in '98 with a shop in London. I did several systems and shops in the last few years. Most relevant, I think, is the 'Walk in Progress' system. It is a temporary shop (the first shop was in Milan in 99) where the people can leave a graffiti on the wall. It allows the brand to form a close complicity with the customer.

Your work seems endlessly varied. What do you most enjoy working with?

My work is varied because I work with ideas, and these can take any shape, any material, in any context.

What's your favourite material?

Information.

You are hugely prolific. Do you have a particular work ethic?

I think this is also due to the fact that I do ideas, and that they have no body. They are faster, lighter, easier to manage.

What about a design philosophy?

I try to be radically contemporary.

What's your definition of 'originality'?

I don't like to be original. I try to fit into the present and be contemporary. There are a lot of wrong attitudes in our world, if you think about it, and you want to make sure your lifestyle is contemporary. You have to enter into a completely new perception of reality.

What about 'beauty'?

Beauty, speaking about it in terms of form, is limited by context, or social environment, or geographical or cultural conditions. I prefer the beauty of ideas.

Is there such a thing as a Spanish way of doing design?

Don't misunderstand me: I am Catalan.

You once said that you 'hated products'. Is that right?

It is not really like that. I need products, but I hate possessing them. I don't like to own products. They make me feel heavy. As a contemporary man I like moving, changing, mutating, travelling... Being heavy makes you solid, fixed. To collect and keep physical possessions is not, in my view, the right attitude.

I live in Barcelona and Berlin, and I develop ideas, concepts, shapes. Materials are a detail in my work. All my products tend to veer towards being immaterial, but are at the same time extremely functional.

But you do seem to have a fondness for designing multi-purpose object-pets.

The basic idea is to design objects that can communicate or be friendly with the user or the buyer. That is why pets are close to an object, ready to communicate or to interact with someone.

And what about the Flamp lamp?

Flamp is a luminous object in the shape of a lamp. It is painted with phosphor paint and it continues to glow for 20 minutes after being turned off. It was commissioned by Galeria H2O in Barcelona after my first exhibit there. They wanted me to design a Lamp, as in the first exhibit I did in the gallery we had an electricity blackout in the area and had to stop the performance for 15 minutes. That's the reason I designed it: to avoid interruptions in performances.

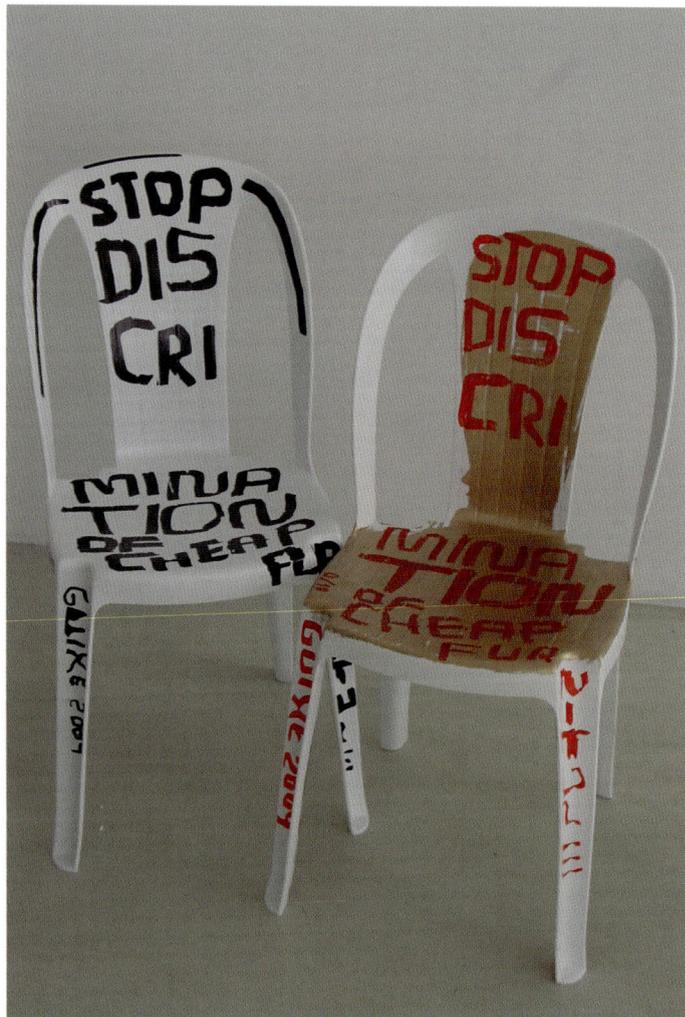

In Martí Guixé's world, how does form feel about function?
I think there is an aesthetic of the function. But it is not related to form. I see form as very local. That's why I don't think form is a good player in the global world. A phosphor object as an idea can go everywhere, with any form, but a real form can exist only in a certain social, cultural, or geographical context. It needs that in order to be properly appreciated.

Can you explain what you mean by 'local' form?
Yes, a shape has the limits of its form. It can be nice in one place and ugly in another. A concept can take any shape. That makes concepts more global.

Take, for instance, Flamp. The main point is that it's a luminous object in the shape of a lamp and that when the light is turned off, it continues to glow for 20 minutes. This is the concept. The form does not matter. This means that it could be square and big in the US and round and small in Japan. It can adapt itself to market conditions. If the lamp design were based, for example, on a square shape (form) out of dark wood (material), it would be much more delimitated.

In your work the line between art and design seems to grow thinner and thinner. Can you still tell the difference?
Yes, I can. An artist is free from commerce or commercial purposes, while design IS for commerce and commercial purposes only. I do concepts and ideas for commercial purposes. It is just design, but with complexity and content.

How often is work fun, how often is it hard work?
It depends on the client. Some projects go wrong when the client is afraid of taking the non-conventional route. Or when the process is too logical – then it's hard work.

Do you work with other people?
Yes, usually I need a lot of consultants, designers, architects, graphic designers, and good specialists. The work is arranged through projects, and depending on the project I put together groups of external collaborators. That is the only way to do it. I work with

the best people and it does not matter the city or the place where they live.

How do you go about selling your work?
There is an interface problem here, as culture and commerce (generally speaking) do not speak the same language. My work is very complex (I don't want to make it complex, but it is like that) and sometimes it is difficult to explain it to somebody that's not aware of it. It is difficult to explain concepts with a high cultural level to brands or board of directors, especially when I am not a communication company, but an ex-designer. This can be, on the other hand, a way of filtering, so that you only have the most interesting projects left. It doesn't depend on the brand so much, but on the people from that brand who commission me for a project.

Who do you most enjoy working with?
I like working (and work) with people who have a criteria and an attitude. These are the best people.

What was the easiest money you ever happened earn?
I don't think there is an easy way to earn money. For a lot of people, an idea is the consequence of inspiration. I don't believe in inspiration. In my case it is all about managing information at an abstract level. That's what allows you to develop good and 'brilliantly simple' ideas for any situation – with a work process.

What is the role of the internet in your life and work?
My work grew in parallel with the internet (r)evolution. I make the most out of the internet as a communication tool, or an information resource. But the internet also changed the way we perceive reality, so that reality could be designed in a different way, to fit in better with our lifestyle.

Who do you look up to in the humour/wit department?
Michel Houellebecq?

Do you see humour a challenge?
Not really, but humour allows you to remain critical in a commercial context.

So is it a way of coping with an increasingly mercantile and corporate world?
I don't see it like that. For me, it is more like having friendly surrounding.

What makes you laugh?
Surprising manoeuvres.

Did anyone ever take any of your jokes the wrong way?
I don't do jokes. But the products often have various layers of information, and people usually read only the easy one.

Do you come across people who take themselves a bit too seriously?
Designers!

If you were to place yourself in a novel, how would you describe your character?
Someone doing a lot of things while trying not to waste too much energy.

What are you good at, what are you bad at?
I am good at crossing contexts. Bad at mathematics.

Do you carry any crosses?
Not one, but the question is out of context. My work is not vital at all. It's mostly theoretical, based on thinking about design as a discipline in a more contemporary and holistic way.

Do life and work fit into each other neatly?
You mean, my life? It is all very, maybe too much, mixed.

What are your politics?
Mediocrity should be repudiated.

Do you have any addictions?
Yes, I have. They have changed continuously during the years. But I am not so addicted that I need medication. It's just that sometimes I'm so fascinated by something I cannot stop.

In your opinion, is there such a thing as intelligent or stupid humour?
Yes, intelligent humour makes you want to laugh and think, while stupid humour makes you laugh and forget.

●

www.guixe.com

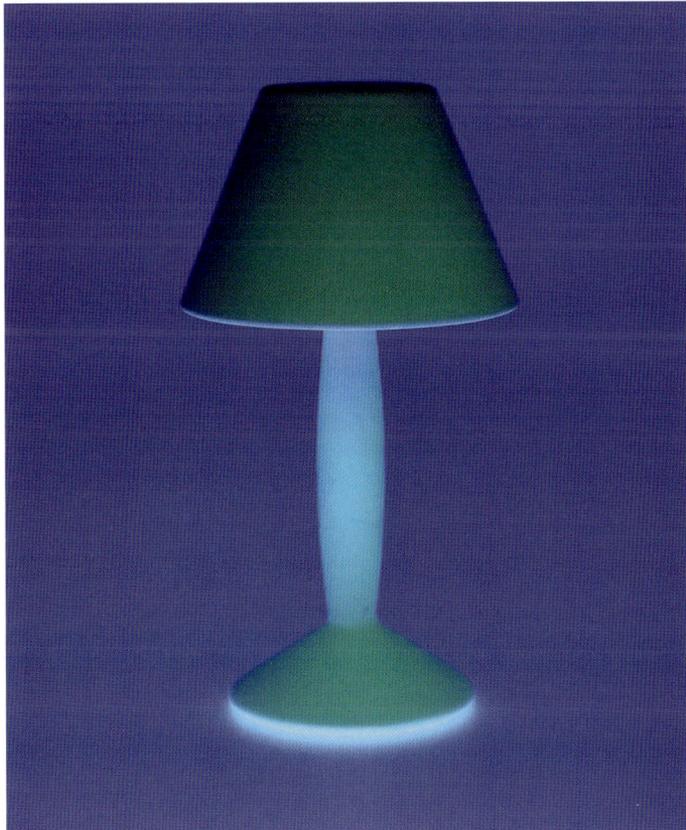

Left
Statement Chairs. First exhibited in Spazio Lima, Milano 2004

Above
Flamp. Produced by Galeria H2O, Barcelona 1998

©All images copyright of Imagekontainer

CR

AP

A tethered yapping sausage dog was piercing the alfresco calm of the Lido café terrace. "Shut up" I shouted as I walked by and a spontaneous applause erupted from the two tables sitting near by. Letting it out is why I love Modern Toss...

DRIVE-BY ABUSER

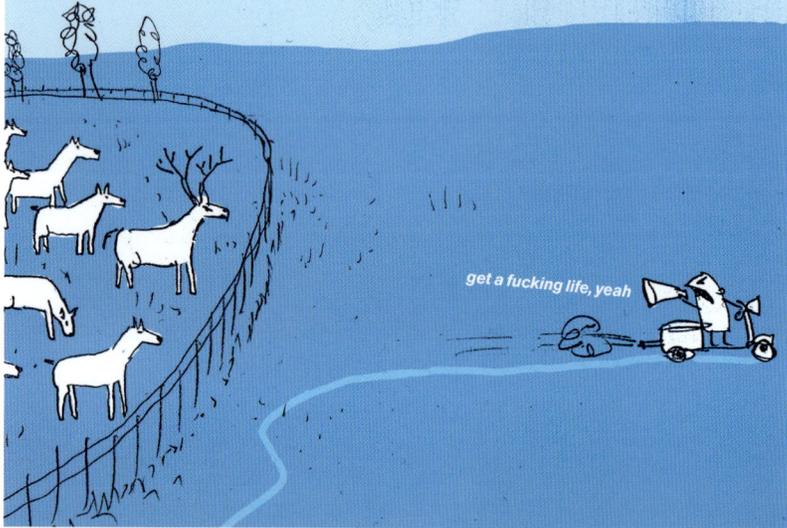

get a fucking life, yeah

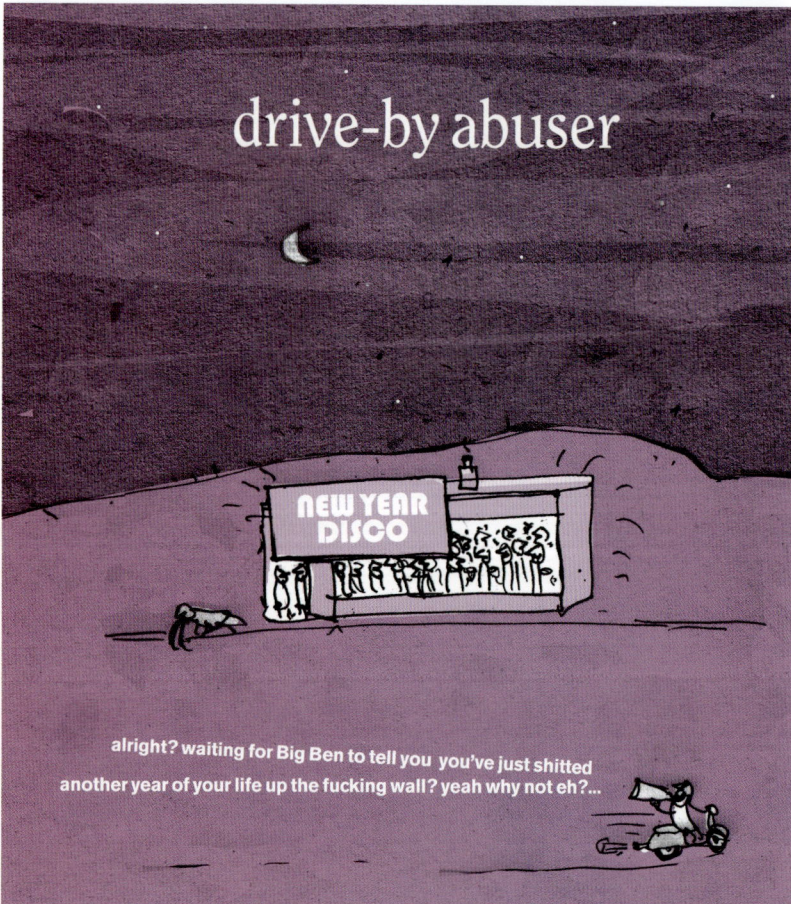

drive-by abuser

NEW YEAR DISCO

alright? waiting for Big Ben to tell you you've just shitted another year of your life up the fucking wall? yeah why not eh?...

Richard: One of my favourite characters drive by abuser who says "Fucking looks like it an' all". I've always read that in a northern accent, are you northen?

Mick: We're from Essex, don't mention that to Jon.

What's wrong with being Northern?

I don't think Jon would be offended. I just think he'd think it was quite funny that you would think we were from the North. Actually, "an' all" sounds cockney to me. My granddad used to say it all the time. It took me ages to figure what he was saying, he'd stick 'an' all' on the end of everything he said.

We'd use "an' all" in Stoke all the time, as our local vernacular for "as well".

Nowadays people say "like" which I think sounds really funny. Drive-By Abuser is cheeky, full-on and unstable. He often sounds like he's running out of things to say. He comes on with the heavy abuse, then starts loosing his way and becomes quite fragile. By the end of it he's quite friendly.

A lot of your humour comes over as very working class.

What do you mean?

What do you think I mean?

I don't know. It doesn't mean anything these days!

I know what I am. I'm from a working class city. (Three-bedroom semi with a fibreglass cartwheel out front and a sunken-speedboat fish pond out back) I'm very familiar with all things working class. My extended family are all working class – in their eyes the fish pond means we're fancy. I imagine you're middle class?

No! You couldn't be more wrong.

Well, what are ya then?

A couple of ordinary blokes from Essex.

What's ordinary?

I don't know.

Semi-(detached) or council?

Essex hasn't really got a middle class. Just a big swathe of people who are getting by. Everyone's pretty much the same. Just with varying degrees of money.

I suppose that's the same as Stoke. It doesn't matter if you drive a Volvo or catch a bus, you all identify yourself as working class. So how come Essex has got so much money?

Your average Essex man is quite entrepreneurial. They wouldn't think of themselves as either working or middle class – that's for other people to worry about. They just get on with it. I don't think someone from Romford would say they're working class. They would just say they are working people. In terms of the humour, we just find the way ordinary people talk funny. We like the way people talk. The way they get angry with each other for no reason. We just boil it down to the basics, I suppose that is a working class thing.

A directness?

Yeah. Although I think we used a middle class type to set up the Mr Tourette character. Often the people who commission his work are worthy and slightly pretentious, and Mr Tourette simply undercuts them with his bluntness. Too much humour is middle class. Everything on the TV is quite sensitive and wordy. We go for the opposite: precision and bluntness. You have to work really hard to get that, it's difficult to be scalpel-sharp. It is not a class war, just what we think is funny.

What a shame, I quite like the idea of a class war.

A comedy class war?

Yeah, a comedy class war would be funny.

Sorry to disappoint you.

It's ok. Your character Alan appears to detest the blandness of his suburban, sweater-wearing middle class brother?

That's what Alan is about really. A bloke who's had a nervous breakdown, who could be from any sort of background. He's just a bloke who's a bit blunt, a bit socially awkward. I think our cartoons appeal to a great a mass of people who haven't got any type of comedy that works for

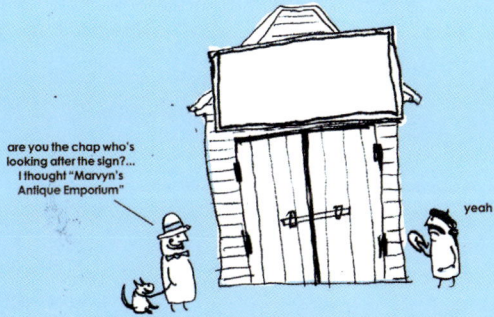

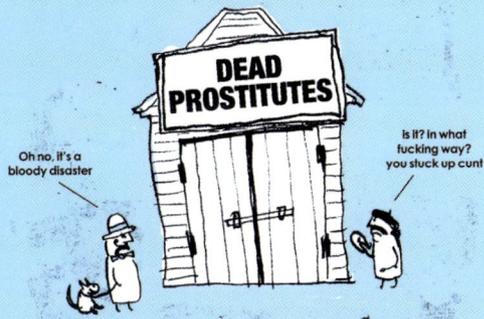

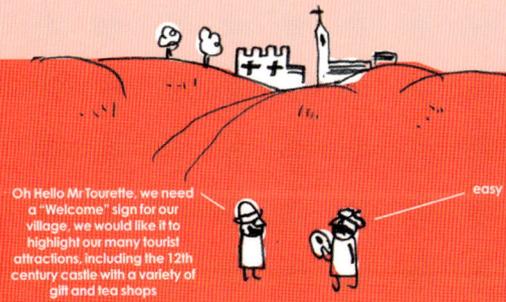

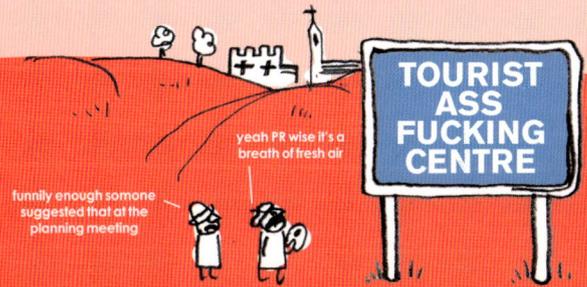

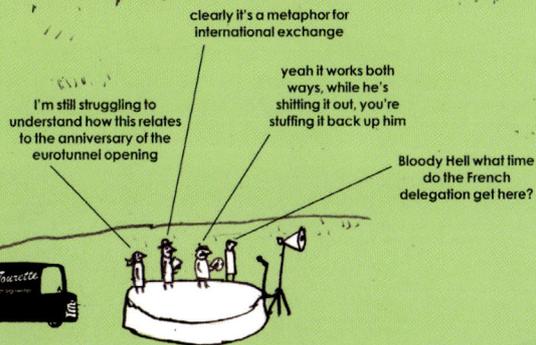

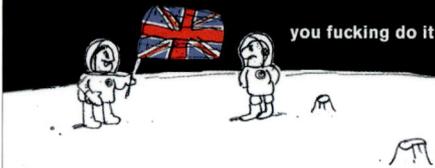

stick this flag in over there

you fucking do it

SPACE ARGUMENT #1

them. A lot of comedy is too sophisticated. Too Oxford-orientated. Too clever. We go in the opposite direction.

You mention nervous breakdown...
For Alan! Not for us. For Alan.
... is that something you've ever experienced personally?
No.
In others?
No. Not really. We just think it's funny that he is unstable and unpredictable. Why has he got this family who are obviously completely different to him? We have to have a little bit of backstory to make it work. We thought it might be funny if he was an ex-advertising man who'd had a bit of breakdown. Now it's all coming to the surface. In the next TV series we are doing we are going to develop him further. We're going to get him involved in proper relationships with people, so there's more interaction. We like the fact that he's so blunt and everyone else is so 'dinner party'.

I like that too. There is a resentment in many of your characters. A resentment I appreciate, I identify with. Is that resentment your own, or is it observed?
Resentment? Do you mean that they're all quite stroppy?
Yeah.
Well, they are quite confrontational. It's not really resentment. It's just getting back to straight talking. We find it funny when people are really rude and they don't need to be.
Me too. But were you resentful at one point?
No, I don't think so. We just write what we think is funny.
You're better adjusted than I.
Hoped!

When a child is born

heelloooo

isn't it beautiful

where's my fucking presents?

weekend

yeah, having a beer, watching a Hitler documentary

Pardon?
Better adjusted than you hoped!

Yeah alright, than I hoped. Your characters put their noses against the glass.
Yeah, that is what we find funny. There are a lot of things we don't like and I guess we use our characters to rub up against others. If something interests us and we think it worth looking into, we push it right to the edge. We make a little joke about it, a small joke. I think sometimes people think we haven't put a lot of thought into our jokes, but we have.

Some people are a bit thick – myself included – but I see your work as quality one-liners.
It's funny, when we started out we got a quite lot of emails from people who thought we were a bunch of kids, and we sort of encouraged that idea. We liked the idea of a bunch of kids doing some poor drawings and coming up with really sharp blunt jokes. It's funny.

So how was school?
Great. I loved it.

Oh, you sound so… Well, was there any bullying?
No. No more than usual. The occasional punch-up in the playground.

Did you fight?
No. I'm just a bloke who makes jokes. You don't get involved in anything, and that way everything just slides by.

Was humour your way of navigating past the hard nuts?
Probably.

My school was quite mixed, there was a sprinkling of tough guys, and because we had a fibreglass cartwheel out front and sunken-speedboat fish pond out back, we were seen as comparatively privileged. Humour was a way of diluting those differences.
Humour is just a natural thing anyway. If you think about it too much it falls a part. Humour starts at school, you learn not to take anything too seriously, and if you're lucky you can extend it into for the rest of your life. That's what we do.

Bastards. So when did find your creative voice, your cartoons?
About three years ago. Me and Jon had been working at *Loaded*. We'd been there for about five years. Jon was the art man, I was the journalist. We'd get an idea and knock it together. At the beginning *Loaded* was a whole new thing. We'd take the piss out of things other people took seriously. When it became more serious, it was time to leave. There are too many serious magazines around.

So how old are you now?
Forty-seven.

Christ!
Yeah, ancient.

D'ya drink?
Do I drink? Yeah, everyone does, don't they?

No, but what's your tipple?
A nice pint of Guinness.

I must say I'm slightly disappointed that you're not more combative, like your characters.
We get that out of our system through the jokes. That's why we have a nice life. There's this thing about comedians being really miserable. I think it's because they take themselves a bit too seriously. We just get on with it really. I think people are a bit surprised we're not surly. Most of the time we're pretty easygoing, except when we're getting stressed-out making TV programs. Even putting a magazine together once a month isn't as bad as making as making a TV show. We did everything, the artwork, the writing, the directing and the producing. And having never done television before we were sort of thrown in at the deep end. We were both on the verge of it every week.

Did you make the series through Channel 4 or through an independent production company?
We had a production company called Channel X. They did the Vic (Reeves) and Bob (Mortimer) stuff. They pretty

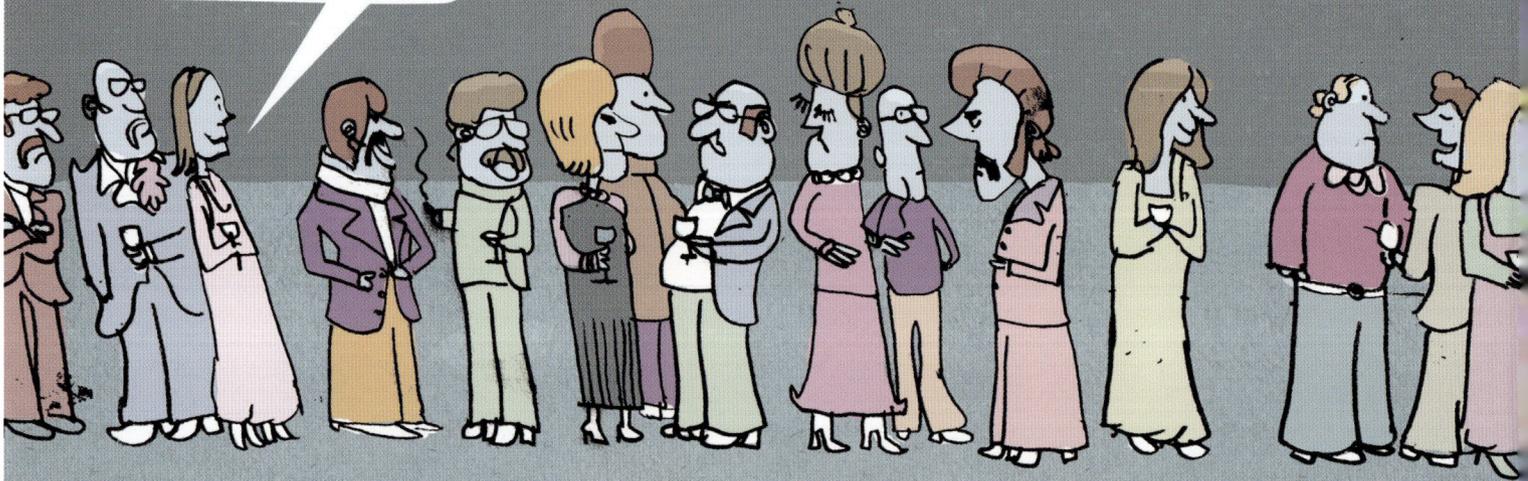

cheese&wine

has anyone seen Gerry?

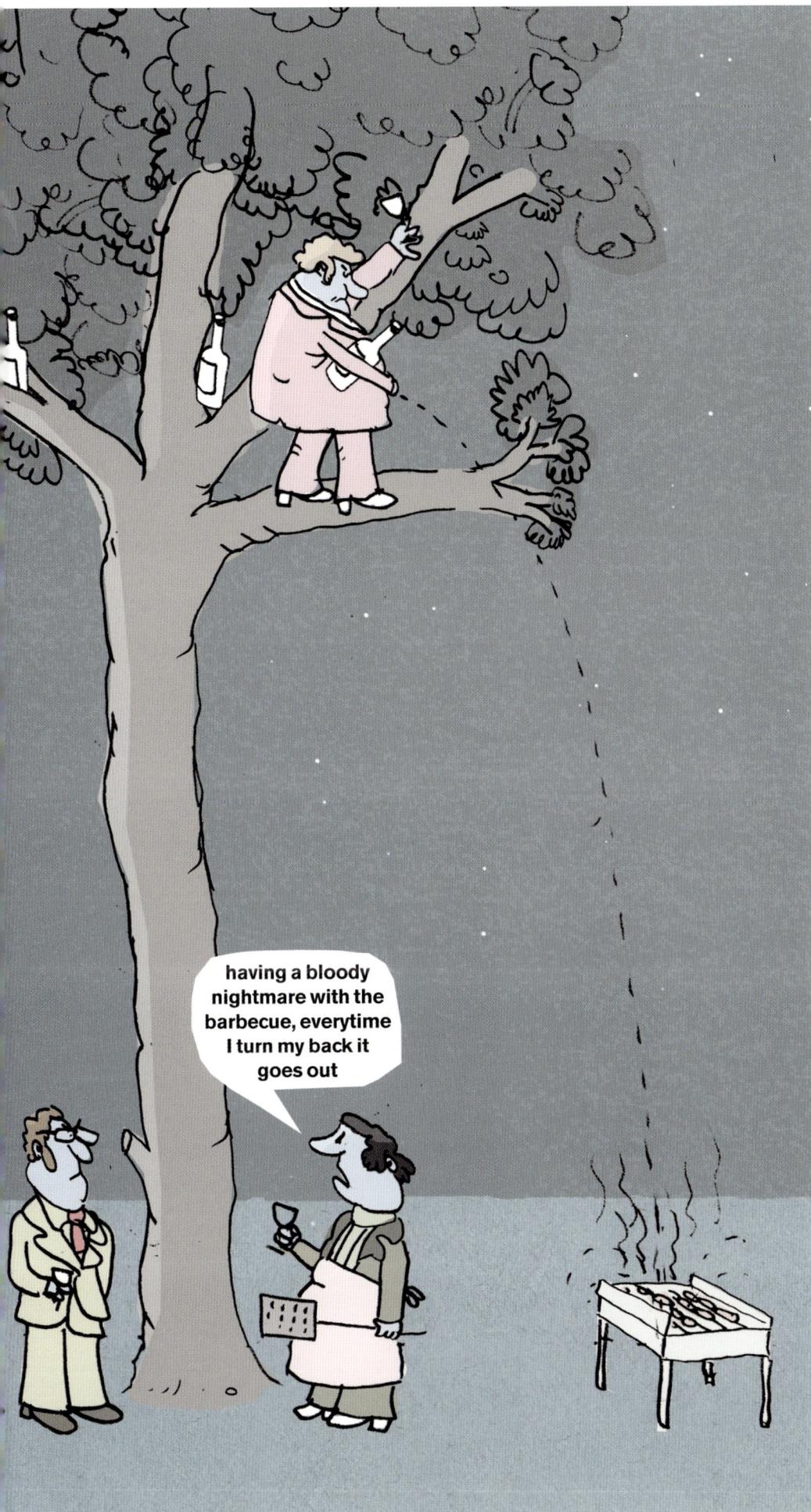

having a bloody nightmare with the barbecue, everytime I turn my back it goes out

much gave us free reign. The TV show is a lot more surreal than the comics, and it was hard for us to explain our ideas and feelings. Thankfully they allowed us to experiment. I just didn't expect it to be such a fucking headache.

In what way?

Producing is harder than anything else. Lots of sitting in meetings talking money, about how you're going to get things done. Not really our forte. We'd rather write down a load of shitty jokes and go out and film it. Comic cartoons are just an extension of journalism, just slightly more visual. Animation is a whole different ball game. It's about getting the timing right, the movements. An animator can spend a whole day making a character walk across a screen. You look at it and say "He should stop there and look around" or "He should walk like this" – it just takes forever, and it's very boring.

So you are going to do another television series, right?

Six episodes. We'll probably move it on quite a bit. Turn up the heat. Harry Hill liked it!

Is that a good thing?

Yeah. Harry Hill's brilliant.

Why do you say that?

I think he's the only one doing anything original on TV. He's the only one who is brave enough to do slapstick and general stupidness. Everyone else is trying to be too clever. There's a lot of pseudo-sensitive political satire. I'd rather just see a bloke get hit on the head with a pan. Harry Hill's really good, you should watch *TV Burp*. Do you watch TV? I watch it all the time. What do you do in your spare time?

Yeah I watch TV. I'm not very discerning though. I prefer painting.

A proper, serious painter? Landscapes?

Crucifixes.

Why? Are you Catholic?

No... I do enjoy fluff TV. When I'm down in Cornwall I watch QVC.

It's probably big in Cornwall!

It does tend to rain a lot.

You can sit in and buy a kettle!

Yeah, I can sit in a buy a kettle or an ab roller. When the kids get too annoying, I can go into the snug, turn on QVC and drift off into Neverland, listening to insincere sales pitches and gushing testimonials. I love it. Fluff and current affairs is what I like, and The Royle Family. Do you like American TV?

Curb Your Enthusiasm is brilliant. I think it's coming from the same sort of place as we do: everyday things, embarrassment, rudeness, awkwardness.

Your characters being cartoons means they are slightly less uncomfortable to watch than Larry David in Curb Your Enthusiasm. I notice you don't 'do' politics?

No, we don't do any political satire. Clip shows where you put funny voices into Tony Blair's mouth aren't really funny to me. I don't get political satire, I don't know why people find it funny.

Well, perhaps we shouldn't digress. So where do your characters come from?

Croydon.

I imagine there are a quite a lot malcontents in Croydon.

No... Croydon is just a stock answer.

SPACE ARGUMENT #2

you sound like a fucking
pig when you eat that

work

so if i keep not coming in, you're going to start not paying me?

Maybe. Don't forget it's not just me. It's me and Jon, and when we're writing together it gets a bit weirder. It's like the way any team of writers work. Once they get together they invent things and it becomes a separate world. People have said our work a bit like Pete and Dud. It's like when you get together with your best mates. You go into a different place. We only use things we observe as a fuel. As a starting point.

So what else do you like?

Old 1960's animation films. The early Pink Panther films. People think our style is childish, but it's not: it's quite stylistic in fact. There are a lot of influences in there: the simplicity of the 1960s, for example. Most of that has gone now: animation has become Americanized, a bit dull. We've gone back to basics – we like the simplicity of Road Runner. Strip it back, keep it stylish.

And what's next?

We've got to do the TV series and we've been selling posters through Banksy's art gallery. The prints go for about £75 and the original posters for about £600. It's nice to get back in where we started.

What do you mean? Started?

When we began doing Modern Toss we walked into the ICA (Institute of Contemporary Art), punk-rock-style, with a shopping basket full of comics, and said "Do you want to buy some of these?". They said yes. So in some way the art thing feels familiar. We own the copyright to everything, we've got a DVD coming out this summer. The Modern Toss book is now out in the States, and I think we'll do another book this year. I'm looking forward to the Japanese version, and there's a Dutch version coming too.

Sounds like money. Tell me, can you swear in front of your family?

Sometimes.

Not using extremities, of course.

Well no. I'm not going to call my sister a cunt, I don't think she'd appreciate that.

No... quite.

She'd probably call me one...

Richard: Mick suggested I should keep it brief. What's you star sign?

Jon:Pisces

Thanks

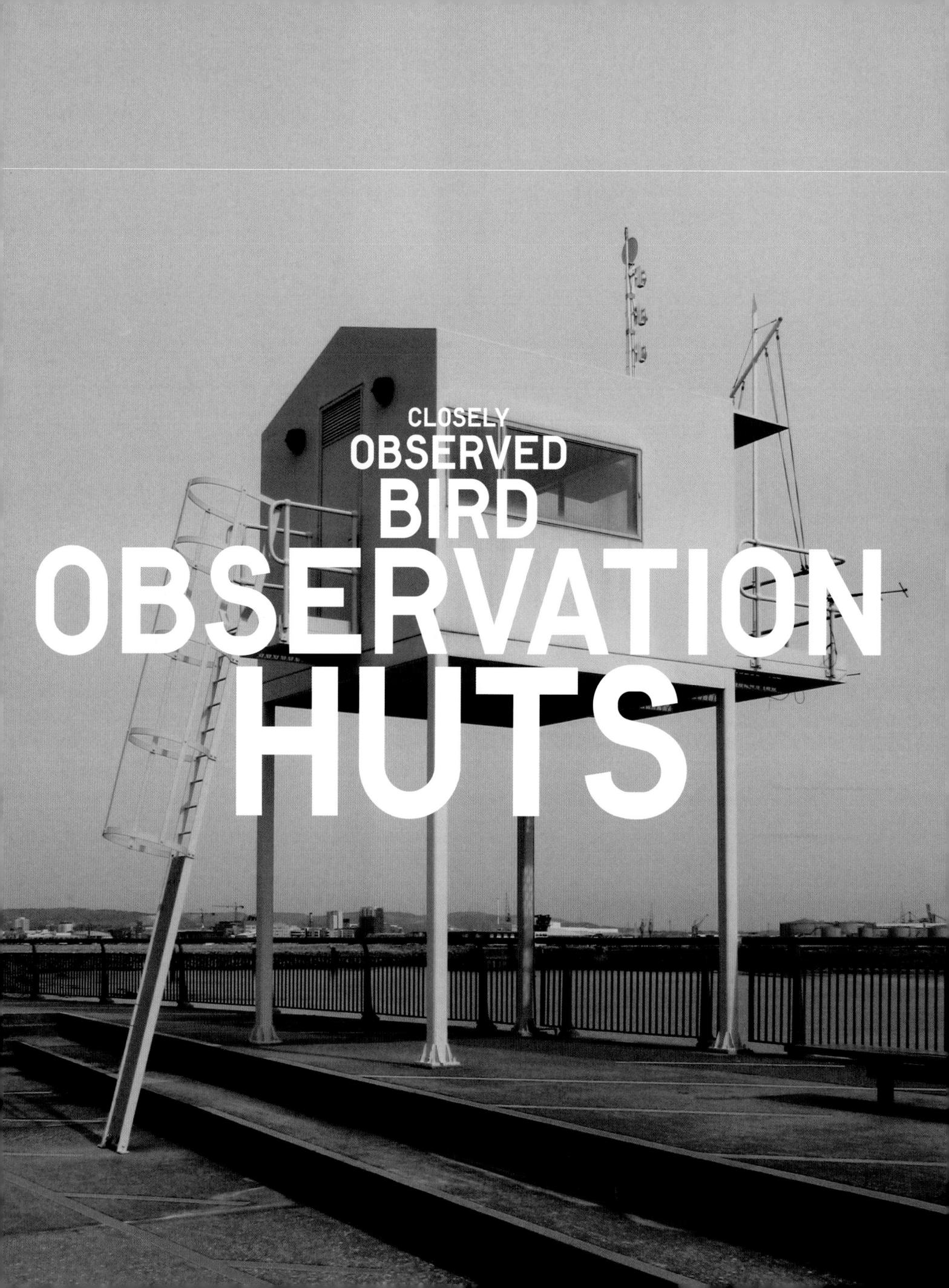

CLOSELY
OBSERVED
BIRD
OBSERVATION
HUTS

Marc Valli speaks to Alex Rich

Born in Caerphilly, Wales, Alex Rich studied Visual Communication at Ravensbourne. He has lived in Switzerland and Japan, but he will soon return to the UK (South Wales) with his family. Alex Rich is an unusual designer. Rather than trying to hide the world behind his own visions and creations, he would rather use what is out there already, playing with codes of communication, reinterpreting them, occasionally perverting them, making us think again, think harder, look again, look harder.

What can you remember from your childhood?
We always seemed to be busy either going off walking in the mountains or to the seaside.

Can you remember something that really made you laugh?
My brother pretending to speak a foreign language whenever we went on holiday abroad.

Can you remember a dream you had?
I remember having the idea to live in a very small house in order to own a fast car. In a way, I have the same dream of a modest dwelling, maybe a bit bigger, but without the fast car.

What kind of student were you?
After changing primary school twice, then secondary school twice, I always felt like the new one. At university there was yet again the same scenario. It made me realise that it is acceptable to savour change.

Design education is a weird one, as often it is very subjective as to what works and what does not. I eventually became interested in non-visual communication and the parallels to the problems of a visually dominant culture. It helped me define a way of working.

What do you mean by non-visual culture? What parallels are you referring to?
I spent some time visiting the Royal National College for the Blind, as a bit of research. I was pleased to have solved a few misconceptions as to such a world. There was also the chance to think about such viewpoints as one of the questions asked by a student to a photograph he held: how can you see me on this slippery piece of card?

When did you become interested in design?
Aged five I took the stabilisers off my bike, then became curious as to how things worked, taking many things apart. It took quite some time until I acquired the skill to put things back together again. Alongside this habit I was interested in words and the use of language. I was always impressed with the way a few words could sit together.

In real life, did you ever come across a lucky break or happy ending?

If there was one, I think I messed up. As to a happy ending I guess it is too early to tell.

What is a normal day in the life Alex Rich?
Breakfast, followed by attempts to become efficient with correspondence to projects, combined with a bit of cycling across Tokyo for meetings, then some drawing with Mini and Seymour before dinner.

Do you work or collaborate with other people?
As often as possible. It helps maintain a bit of a balance to your own thinking.

How does it work?
Ping / Pong.

And does it work?
Almost always, although it sometimes takes longer than we had hoped.

Do you ever struggle to explain your design work or ideas to others, such as clients or friends or journalists?
It depends on whether they are genuinely interested in what is being discussed. It can be interesting to struggle with explaining things. The scary situation is when you are impressed with how articulate you were and to then read the interview pondering as to the convoluted result.

Your work seems particularly rooted in the 'outside world' as such. Do you still work out of a studio?
I like this term 'outside world'. I think most of the answers I find come not from pondering in the studio but while out and about. My current studio is a simple space with a balcony and lots of light. As it is part of my home, when the weather is bright I tend to end up going cycling.

Do life and work fit into each other neatly? What about design and life?
I still find it difficult to balance, there is no clash, but I think there are maybe too many possible combinations. Design is just a job, while life is surprisingly short. →p25

IT*S
ALL
TRUE

OUI
JA
YES

NEIN
NO
NON

ONE
LESS
CAR

SHOP LOCAL

Bread
not
Bombs

SAVE

INK

How do you gather material?
Meandering through all sorts.

Do you do much picking up or scavenging?
Once in a while a chair or the occasional crate, in London I used to gather more things than I do living in Tokyo as, for one thing, it is rare to see anything to actually rummage through.

Your style is hard to pin down. What would you say makes it distinctive?
Fashion and style change far too much and are often cyclic. Whatever I do maybe comes into fashion at one point, but at the same time I am far more interested in keeping things as simple as possible to make room for the actual content.

What do you most enjoy working with?
Language.

What materials, what methods?
Wood, many.

Is there an ideal set of circumstances?
http://en.wikipedia.org/wiki/Fureai_kippu

How would a client go about getting the most out of Alex Rich?
Not to expect me to do any polishing.

In the context of your work some people use the term 'interventionist design'. How do people, and clients in particular, generally react to it?
All of the things, which could be seen as being interventions, are simply thoughts or scenarios for me to think about, which then become models to discuss. I do not expect anyone to fully understand them beyond the fact that these works are simply propositions or observations of something.

What's the best / worst feedback you ever got?
"Is that it?" / "Nice".

What kind of people do you like to work for?
All ages.

Is there a particular 'Alex Rich work ethic'?
Try something different once in a while.

What about a design philosophy?
This is not rocket science.

How would you define what you do?
Work.

Can you give us an example of a project you particularly enjoyed?
Spending three weeks in New Zealand with furniture designer Michael Marriott, we created tangents between our two respective industries which eventually led to a series of lectures and exhibitions, whereby we discovered connections between New Zealand and what in the end felt like almost everything.

Can one teach design?
I guess there is no need. It is a bit like discussing architecture with people already content with their Victorian house.

Why did you decide to settle in Tokyo?
It seemed like a good idea, along with providing an opportunity for my daughter and I to learn some Japanese.

How long have you been there for?
Three and a half years.

Is it hard for a Westerner to work in Japan?
I think it is hard for anyone wanting to work outside the commercial framework of design. Being a foreigner is not so much a problem, I think in Japan people enjoy the currency of design as something to simply consume.

I seem to detect a certain frustration with today's visual saturation. Isn't that more accentuated in Japan? How do you feel about that?
I think in Japan people are encouraged to consume everything, fuelled by advertising and magazines. This is not something I do personally, but see it simply as part of the way society works these days, just in the same way that organic produce in Britain became just another marketing tool. More and more we simply want a quick fix to something. Design suffers from this. Things take time. We should just learn to plan more.

Is there a difference between the art and design scene in Tokyo as opposed to it in London?
The art and design scene in Tokyo is maybe more frank as to being about business, while I guess in London things are better camouflaged.

When did you start taking pictures of bird observation huts? Are they part of a project?
All kinds of small buildings, not just the one you saw. These photographs exist as a document of such humble constructions, to which I have no idea as to what they are for. I think we all seem to accumulate collections or observations of things. The benefits, I guess, are through a kind of osmosis.

Do the Swiss have a sense of humour?
OUI JA YES.

Who do you look up to in the humour/wit department?
Good question.

What makes you laugh?
Good timing.

Did anyone ever take any of your jokes the wrong way?
I am very bad at remembering jokes, which helps in such a scenario.

Do you ever come across people who take themselves just a bit too seriously?
A double-edged sword, as there is also the opposite problem with some people.

If you were to place yourself in a novel, how would you describe your character?
Alex Rich.

Do you have any addictions?
I seem to listen to more music than radio, but I think it is under control.

What's your favourite children's book?
What Do People Do All Day? by Richard Scarry and *Cup & Saucer Chemistry* by Nathan Shalit.

Did you ever have a nickname?
No, but I always liked the idea that people who live in glass houses shouldn't throw stones.

Do you have any theories about the world we live in?
I think there are more than enough already.

What would you say is definitely NOT your motto?
3 + 5 = 7

How do you see the world?
A bit of a mess in places.

Is there something really important that I should have asked but am missing?
One thing maybe. Next week is our last week in Tokyo, as we shall move to South Wales to live by the sea. I am curious as to what will happen next, I would really like to find a balance between working and all the other important things in life.

PETER ARKLE
I WISH I WAS 007

Peter Arkle writes and illustrates a regular column *The Stalker* for *Print Magazine*, draws hairs for Bumble and Bumble, publishes the newspaper *Peter Arkle News*, containing stories of everyday life, and works freelance for a variety of advertising and editorial clients. *www.peterarkle.com*

> "*I watched the new James Bond film and it made me feel genuinely depressed and wish I could be like him. I wish I wasn't joking.*"

How was your childhood?
I grew up to be a perfect Gap – medium the right balance of suffering and comfort, wealth and poverty, joy and misery, and boredom and fun... a healthy diet that included lots of potatoes.

Did you cherish any dreams?
I've always wanted to own an island or a castle. I would like to travel by vintage flying boat with perfect period clothes and luggage.

What kind of teenager were you?
Never the cool kid but not the most un-cool either. I was into heavy metal and then slowly (after being hit too often) graduated toward shorter hair and being a punk/goth/artschool kid. All my friends played in bands. I was of meant to be the lead singer in a band and then they heard me sing. This involved me singing "Working Man" by Rush while in a bathroom down a hall from the rest of the band to avoid feedback. I couldn't hear them from where I was, so they told me to do a count and start. I counted, started, sang for a while and stopped. When I went back through they were all rolling on the floor laughing. That was that. I had to leave the band. I never sing now. I pretend during "Happy Birthday".

How would you describe your character?
It's hard to tell if I am clever or dumb. I stubbornly refer to September the 11th as "nine one one" instead of "nine eleven" (because I enjoy watching people struggle to be polite and not correct me). I am a bit crass but also refined and sophisticated. I like to be contrary: I support any team that is losing. I iron my jeans, but sometimes wear the same pair for a whole week. I swear quite a lot, but when I meet someone for the first time I do little test swearings, dropping the odd one here and there to see how they react. I only properly relax when they swear too. But if they start swearing a lot, I get uncomfortable and act all proper so that they will feel guilty and stop swearing. I hate talking about real estate. I talk too much and don't ask enough questions. When I met my wife, in no time at all she knew all about me being born premature, that my dad was 68 when I was born, my cat's name, how many brothers and sisters I have, etc. etc.

Do you exaggerate?
I think in many ways illustration is all about exaggeration. It's hard to be subtle when drawing tiny little people with thick black lines. People made of ink must be happy in the way that people in silent movies used to be happy. There is no room for method acting. I'm always being caught exaggerating. I will often be heard confessing to it but also, when telling the truth, have to preface it with: "This is true. I know I always exaggerate, but..."

Is there such a thing as intelligent or stupid humour?
Some humour can actually be too intelligent. The type where you find yourself telling someone, "this is funny", but you aren't actually laughing. I think that *The Simpsons* is like this. It's really clever and I'm glad for its politics, but I rarely laugh out loud. I am too used to it. I remember that once upon a time I thought "The table's my bed" the funniest thing EVER.

Do you carry any crosses?
I can't drive (I am 39 and never learned, and really, given my way, never will. Still, I am nagging my brother to learn – he's two years older than me).

Do you ever feel like we're doomed? And how does that make you feel?
I know we are doomed. We will all die. I think we should be honest about death. I don't like phrases like "passed away." Talking about death one day in a coffee shop where I used to work, one of my colleagues said that she had thought about leaving a voicemail/answering machine message for when she was dead. It would say: "Hello this is_____. Sorry I can't take your call at the moment. I am dead." That made me laugh.

What/who do you discriminate against?
People who are mean to waiters.

Have you started reading self-help books yet?
I just tend to take whatever I read or watch to heart. I watched the new James Bond film and it made me feel genuinely depressed and wish I could be like him. I wish I wasn't joking.

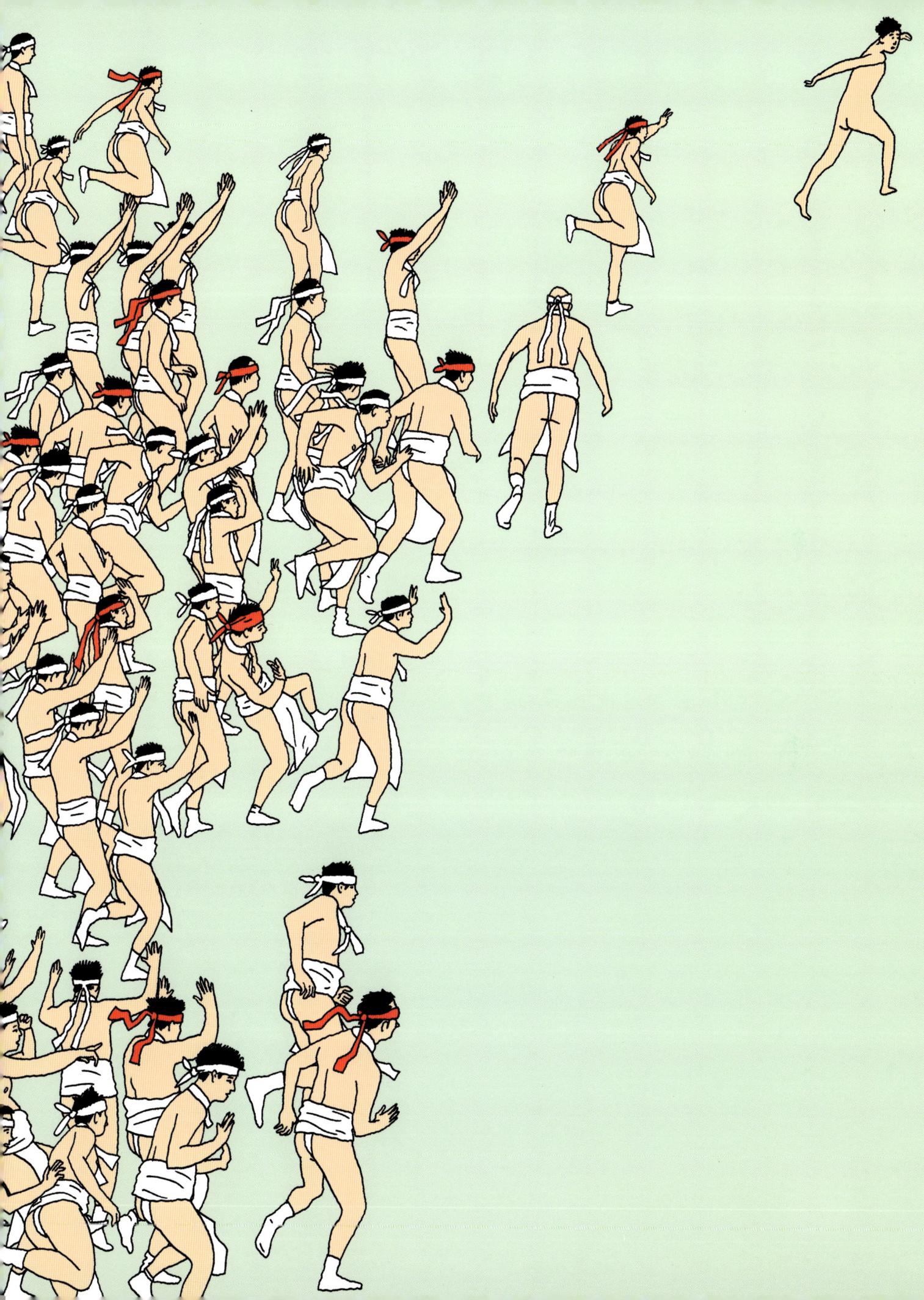

INTERESTING T-SHIRTS are worn at the MOCCA* ART FESTIVAL...

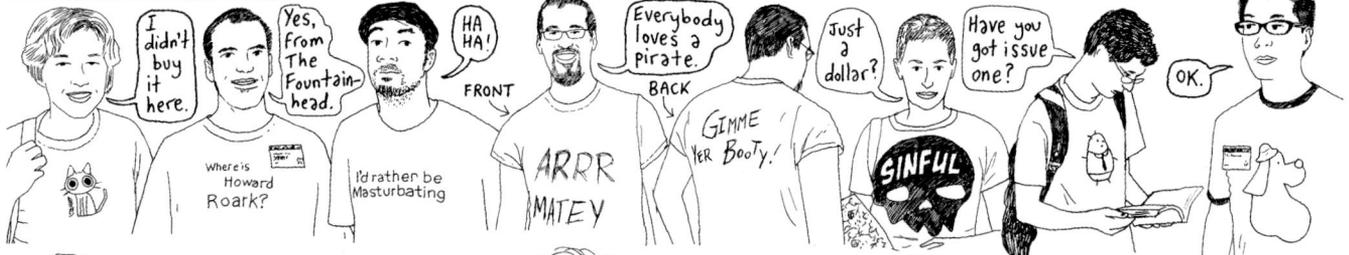

I didn't buy it here.

Yes, from The Fountainhead.

Where is Howard Roark?

I'd rather be Masturbating

HA HA!

FRONT — ARRR MATEY

Everybody loves a pirate.

BACK — GIMME YER Booty!

Just a dollar?

SINFUL

Have you got issue one?

OK.

FAVORITE PENS are talked about. Pentel.

The YOUNGEST PROFESSIONAL CARTOONIST draws.

ALEXA KITCHEN (AGE 7)

Two guys, CHRIS AND ERIK CRADDOCK, demonstrate their comic book cover that has secret things printed on it in INVISIBLE INK

Check this out!

They only show up under ULTRA-VIOLET light.

Shut up, baldy!

PLEASE NOTE: I MADE THIS UP. NEIL SWAAB WOULD NEVER LET A DRAWING OF HIS SPEAK IN SUCH A MESSY WAY. HIS LETTERING IS ALWAYS STRAIGHT AND TIDY.

I talk to NEIL SWAAB (CREATOR OF MR. WIGGLES) about SELF PORTRAITS. I make myself look WORSE.

HERE'S MY DRAWING OF HIM AND MY DRAWING OF HIS DRAWING OF HIMSELF →

AND HERE'S MY DRAWING OF A COMIC FAN WEARING A STRAW BOATER AND SOCK SUSPENDERS

*MUSEUM OF COMIC AND CARTOON ART

IS SEX NOT AN ISSUE?

THERE'S AN APARTMENT-BUILDING-SIZED COUPLE HAVING NAKED FUN RIGHT ABOVE A MAJOR NEW YORK STREET. LOTS OF PEOPLE ARE PASSING. I DON'T HEAR ANYONE SAYING ANYTHING ABOUT THE COUPLE. (BUT) WHO KNOWS WHAT THEY ARE THINKING:

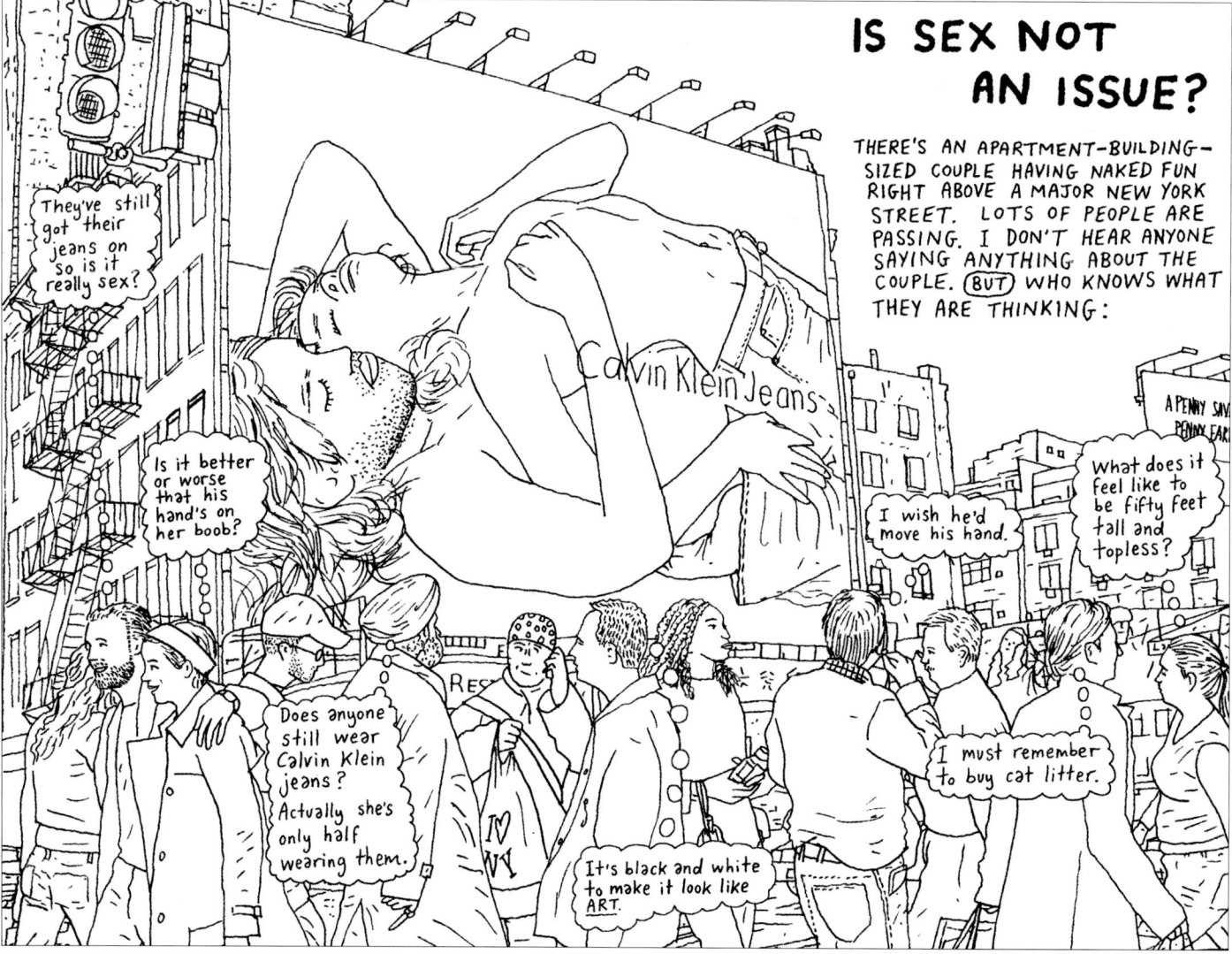

They've still got their jeans on so is it really sex?

Is it better or worse that his hand's on her boob?

Calvin Klein Jeans

I wish he'd move his hand.

What does it feel like to be fifty feet tall and topless?

Does anyone still wear Calvin Klein jeans? Actually she's only half wearing them.

It's black and white to make it look like ART.

I must remember to buy cat litter.

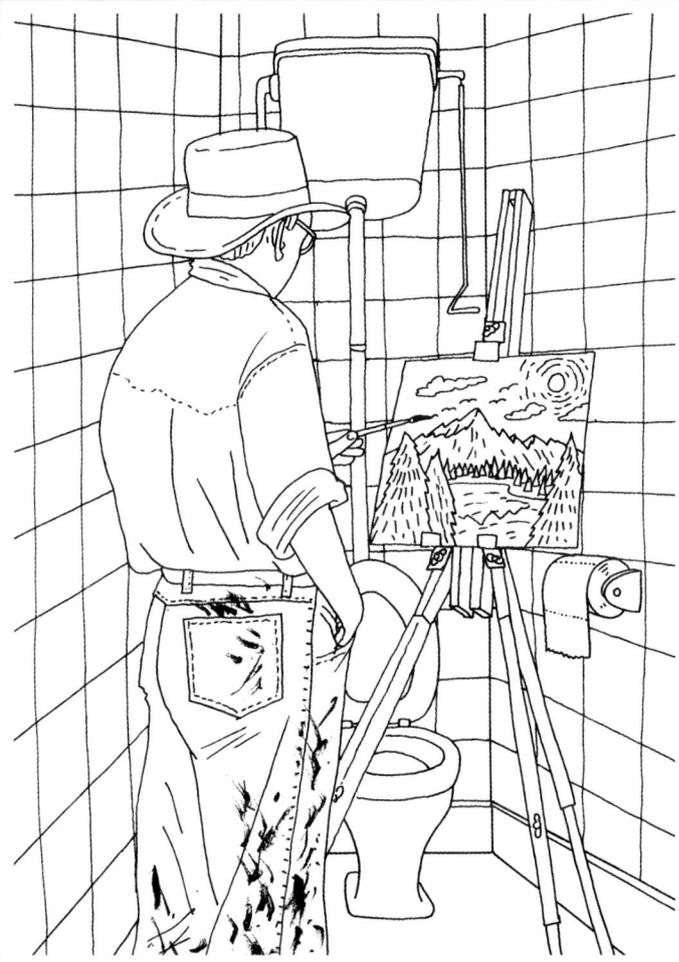

030-033:
KRISTIAN BAUTHUS
PARTY ANIMALS

Kristian was raised in the wilderness of Northern Ontario. When he wasn't listening to music and learning the ways of the forest creatures, he was drawing. This eventually led him to the Ontario College of Art and Design. Kristian has a strong aversion to capital letters, and like a nomad, moves often. However, unlike a nomad, he has no experience riding camels. He currently lives and works in Toronto. www.kbauthus.com

Title of work submitted: Party Animals
Date of completion: 2006
Brief description of work submitted:
The horribly pretentious explanation for these pieces is that they're an examination of the culture of excess we find ourselves in, using animals as a stand in for humans. The truth is I wanted to paint a bunch of cute cartoon animals doing very dirty, naughty things.

"There are two types of people in the world. People who like peanut butter and pickle sandwiches, and people who haven't tried peanut butter and pickle sandwiches."

How idyllic was your childhood?
Incredibly idyllic. And what could be a more idyllic time to grow up than the 80s?

What kind of teenager were you?
Younger, shorter, and more loud-mouthed and obnoxious than I am now.

When and where did it all start to go wrong?
When the *Cosby Show* went off air.

How would you describe your character?
Rusty diamond, world-class used car salesman and part-time vagrant.

Do you have a sense of humour? If so, what kind?
I try to. Although the things that make me laugh tend to be very, very inappropriate.

What did you really think when you first saw Your therapist?
Sorry, I can't answer this. I keep reading 'therapist' as 'the rapist', and it's really distracting.

What's the most inappropriate place/time you have ever laughed?
My grandfather's funeral. Someone had bad gas that they couldn't contain. My cousins and I couldn't stop cracking up. Because, you know, it's funny to a ten-year-old.

Did anyone ever take any of your jokes badly?
Yeah. I have no sense of decency, so I tend to cross all sorts of lines and offend people. But you know what they say: you can't make an omelette without breaking eggs.

Richard can't read his own handwriting, speak a foreign language or play a musical instrument. He can ski, but he hates skiers. What are you good at, what are you bad at?
I'm a master fire-hydrant painter. I can get a fresh coat on one of those suckers in, like, five minutes. And that's including opening and closing the paint can, and allowing for a smoke break. I'm horrible at using chop sticks. I can use them, but I have less chopstick skills than a poorly trained chimpanzee.

Is there such a thing as intelligent or stupid humour?
Yeah. I think there is. Example: someone getting kicked in the balls = stupid humour. Someone getting kicked in the balls while reading James Joyce's *Ulysses* = intelligent humour.

Do you have any theories about the world we live in?
There are two types of people in the world. People who like peanut butter and pickle sandwiches, and people who haven't tried peanut butter and pickle sandwiches.

Large feet, dyslexia, an inappropriate sense of humour and bags under the eyes are some of the crosses Richard has had to bear.

Marc has a serious tendency to exaggerate things. Do you carry any crosses?
I'm cursed with an unfortunately hilarious voice. I've had friends compare it to Sylvester Stallone, but personally I think I sound more like eeyore from *Winnie the Pooh*. I also can't dance. At all. Unless you count 'drunken idiot doing the robot' as a dance.

What/who do you discriminate against?
People with hugely oversized strollers for their babies, guys who wear sweatpants in public, ratgoofs.

What would you say is definitely NOT your motto?
I'm doing this for a love of art, and in no way for money.

Any addictions?
Cigarettes. Sweet lady nicotine is a cruel mistress.

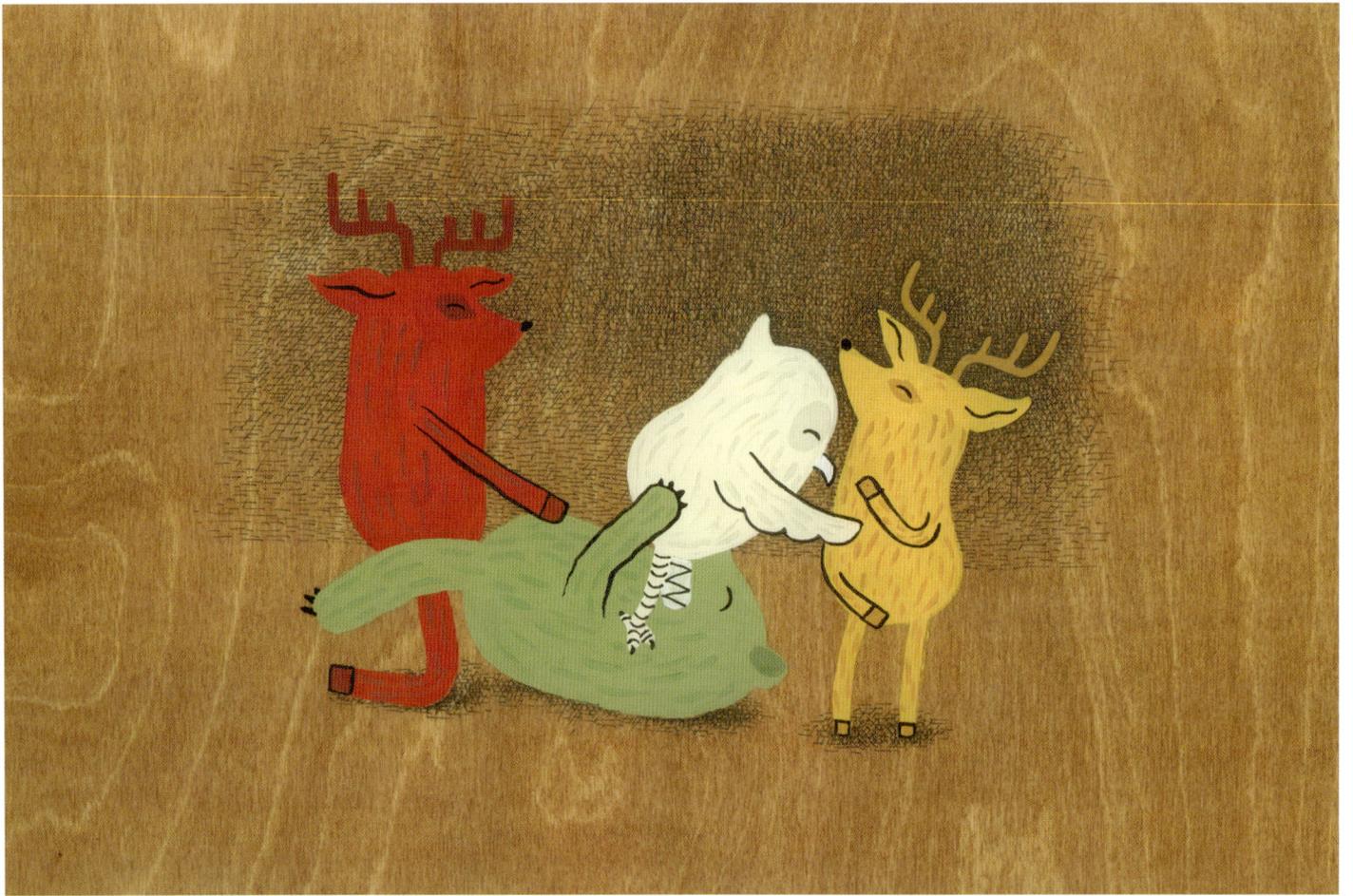
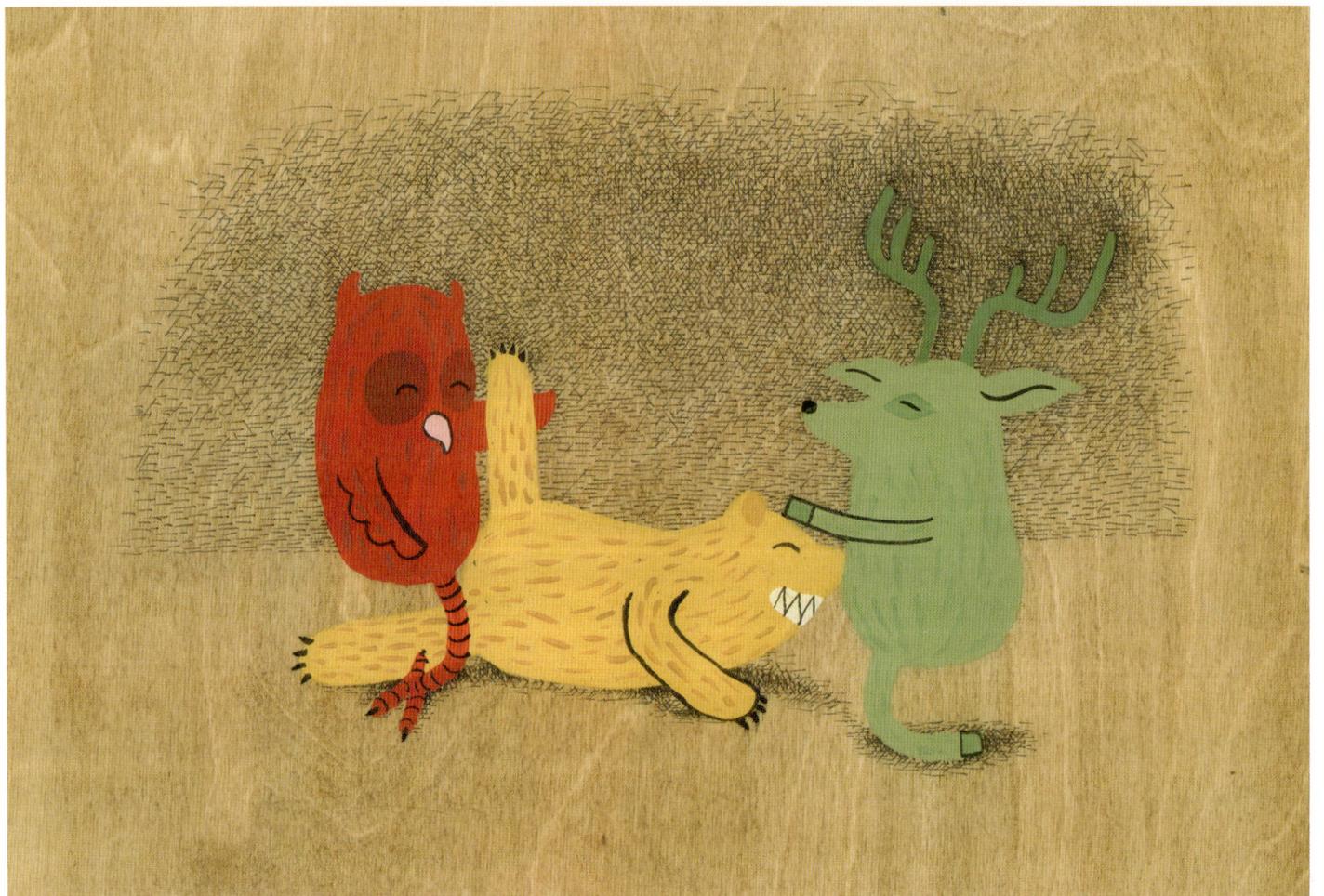

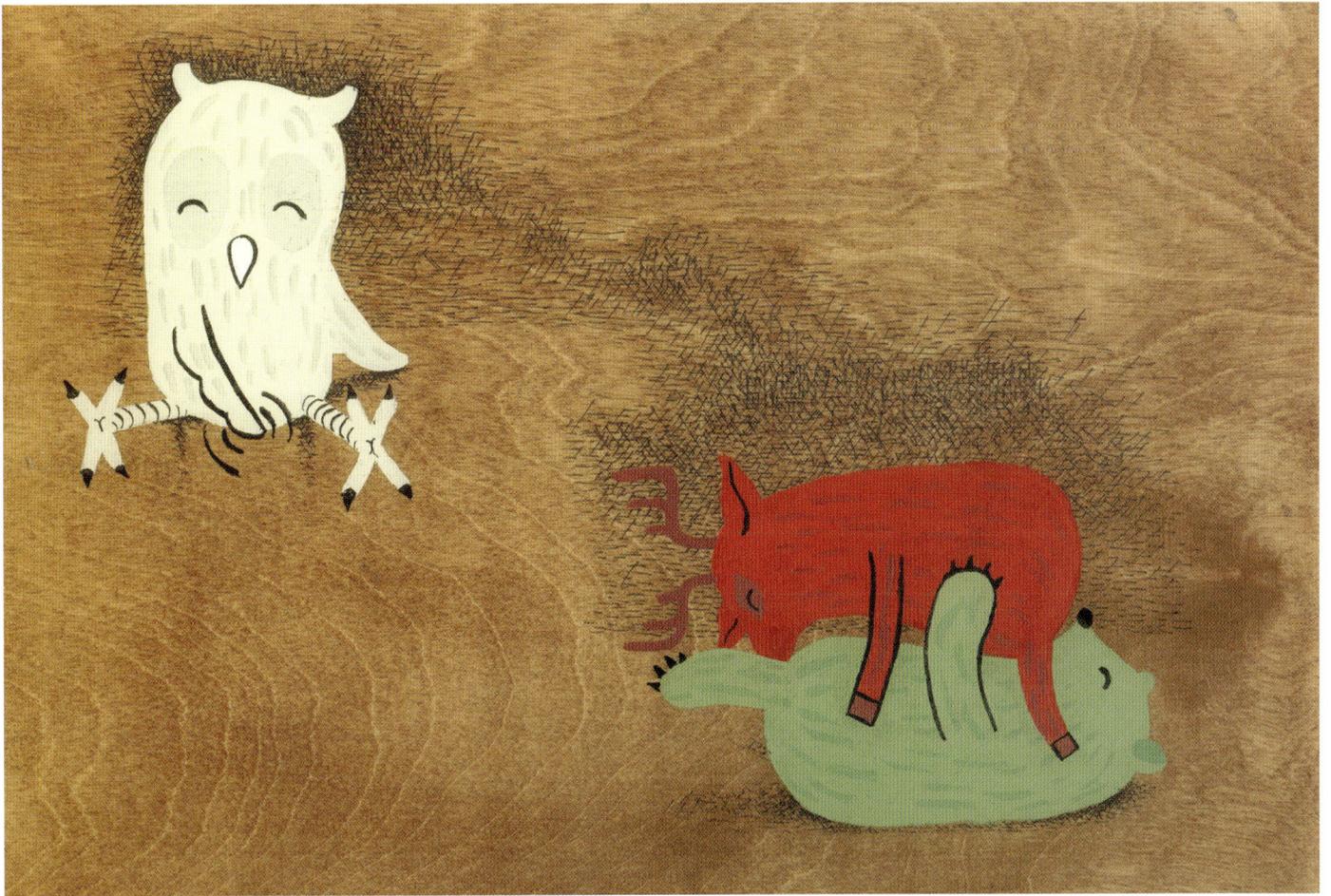

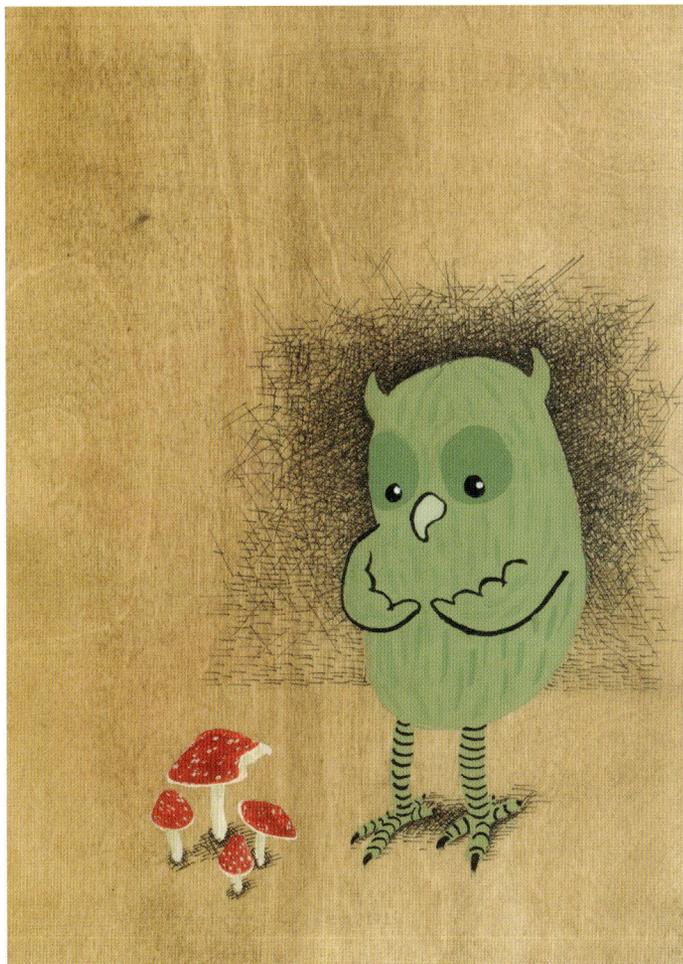

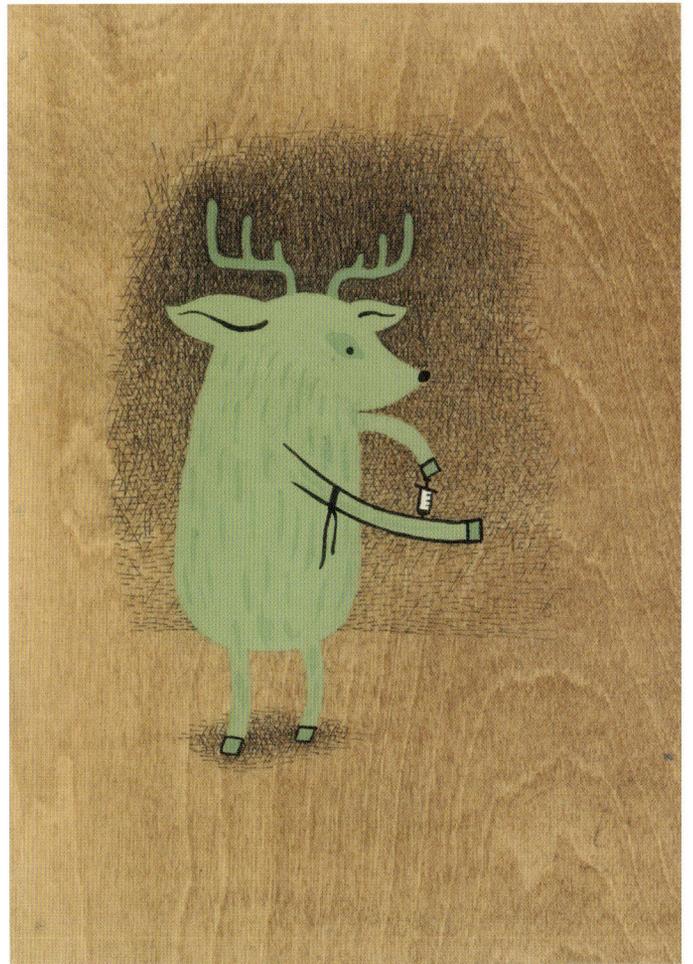

Susana Carvalho and Kai Bernau formed Atelier Carvahlo Bernau (the Hague) in 2005. They mainly design books and other printed matter for institutional clients from the cultural sector, as well as typefaces for the retail and corporate market. They also lecture and do workshops on type design and graphic design, write programs for design automation, pursue free projects and make more typefaces. www.carvalho-bernau.com

"*While everyone seems to rave about The Office or Peep Show, seeing stupid people doing exuberantly stupid things just makes us cringe. It gives us pain.*"

How idyllic was your childhood?
Susana: Moderately idyllic.
Kai: My father brought home our first Apple computer in 1982. So yes, it was!

Can you remember something that really made you laugh when you were a kid?
S: The *Mafalda* comic strips by Quino, originally from Argentina.
K: My little brother. He's probably the cutest and funniest guy I know.

Did you cherish any grandiose dreams?
S: Yes.
K: Until I was five. I wanted to become a train-conductor-slash-part-time-knight.

What kind of teenager were you?
S: An annoying and well-informed activist.
K: Similar. But only the annoying bit.

What's the worst look you can remember sporting?
S: I'm trying to avoid remembering.
K: I think my current hairdo pretty much qualifies. I can't bring myself to go and have it cut.

Do you have a sense of humour? If so, what kind?
S: Sarcastic.
K: Yes. The bad kind.

Do you laugh at your own jokes? How loud?
S: I giggle.
K: Yes. Not only very loud, but I'm also often the only one laughing.

Did anyone ever take any of your jokes badly?
S: Of course! That happens all the time with people that have a lack of humour.
K: See two questions above.

What are you good at, what are you bad at?
S: I can cook quite nicely. I am very bad at juggling and other things that require good hand-eye-coordination.
K: I can't dance, but I can kern like the devil.

Do you work with other people? How does that work? Does it work?
S&K: We work together. It's pretty much like pingpong. Apparently, it works.

Are you the type to exaggerate things? How much?
S: Not as much as he does.
K: Yeah, I exaggerate, like, a million things a day!

Is there such a thing as intelligent or stupid humour?
S&K: Yes. While everyone seems to rave about *The Office* or *Peep Show*, seeing stupid people do exuberantly stupid things just makes us cringe. It literally gives us pain.

Do you carry any crosses?
K: Bad hairdo. Bad jokes. I might have mentioned that already.

What/who do you discriminate against?
S: Bad politicians. People that make uninformed comments about vegetarianism.
K: Stupid people. Bad typography. Internet Explorer.

What's your favourite satire film, what is your favourite scene?
S&K: Tati's *Play Time*: Everyone seems to be interested in the modern, no one seems to even take note of their environment. Appearances and consumption are everything. This is actually not one specific scene, is it?

What's your favourite children's book?
S: Dick Bruna's *Story Without Words*.
K: I started reading at the age of five, there are too many books for me to pick out one.

What would you say is definitely NOT your motto?
S: "Get rich fast". Maybe I'm stupid.
K: "No one will see that". I'd rather go with Anthony Froshaug: "Half a point? A mile away!"

Do you have any addictions?
S: Chocolate. The good stuff, not cheap milk chocolate. Preferably from Belgium.
K: The internet! Music! Hi-Fi stuff! Would you like me to tell you about the advantages of my new phono stage?

Have you started reading self-help books yet? If so, which ones?
K: *How to be a graphic designer without losing your soul*, by Adrian Shaugnessey. Didn't help.

And finally, would you like to say a word about submitting to the magazine and replying to this questionnaire?
S&K: Didn't like the questionnaire too much. You guys are nosey.

Opposite
Fictitious poster for (likewise fictitious) Swiss banking group.
Part of the Neutral project.
70 x 100 cm. 2005.

Storing the Nazi treasures since 1934.

✚ **Switzerland United Banks**

LINUS BILL
IT'S RAINING

Linus Bill was born and raised in and around Bienne, Switzerland. He's currently studying photography at the School of Arts in Zurich and will move to Paris later this year as part of an artist-in-residence scholarship.
www.nieves.ch

Title of work submitted: from the book *Piss Down My Back and Tell Me It's Raining* published by Nieves, 2006, Zurich.
Date of completion: 2000-2005
Brief Description of work submitted:
The pictures in the book *Piss Down My Back and Tell Me It's Raining* where taken over the last couple of years. They are the crop of a constant attention to my environment and coincidence. It's about what you see and how you look at it. There is love, melancholy, beauty, football, irony, friendship, adventure, everyday life, humour and the right moment. And then you take this and put it together as your own imaginary world.

How idyllic was your childhood?
Very idyllic. As long as I had my safety blanket and my big sister left me alone.
Did you cherish any grandiose dreams?
I always wanted to be a pirate or an Indian. Just wild and free.
What kind of teenager were you?
The cool guy.
What's the worst look you can remember sporting?
I had a mullet and was wearing a hand-knitted pullover.
What's the most embarrassing situation you would admit to finding yourself in?
When I broke the nasal bone of a classmate who was in a wheelchair by hitting his face on the desk.
When and where did it all start to go wrong?
Right then.
If you were to place yourself in a novel, how would you describe your character?
I would be Huckleberry Finn.
Do you have a sense of humour? If so, what kind?
No. Well, I'm mischievous.
What did you really think when you first saw your therapist?
What a hippie!
Do you laugh at yourself? How often? What does that feel like?
Of course! All the time. Otherwise I would need to see a therapist.
Do you laugh at your own jokes? How loud?
I don't tell jokes.
What's the most inappropriate place/time you have ever laughed?
Funerals – that always happens to me. When things start to get serious I have to laugh.
Did anyone ever take any of your jokes badly?
See above.
What are you good at, what are you bad at?
I can kiss very well, I can't sing.
Do you work with other people? How does that work? Does it work?
I think it is very hard to find people to work with. But there are some. So you better appreciate them once you find them.
Are you the type to exaggerate things?
I don't understand that word, but I'm the type who will piss in your elevator.
We noticed that some of the submissions we received seemed a little angry, possibly maladjusted. Would you say that creative people are unbalanced?
I hate creative people!
In your opinion, is there such a thing as intelligent or stupid humour?
No. There is just good and bad humour.

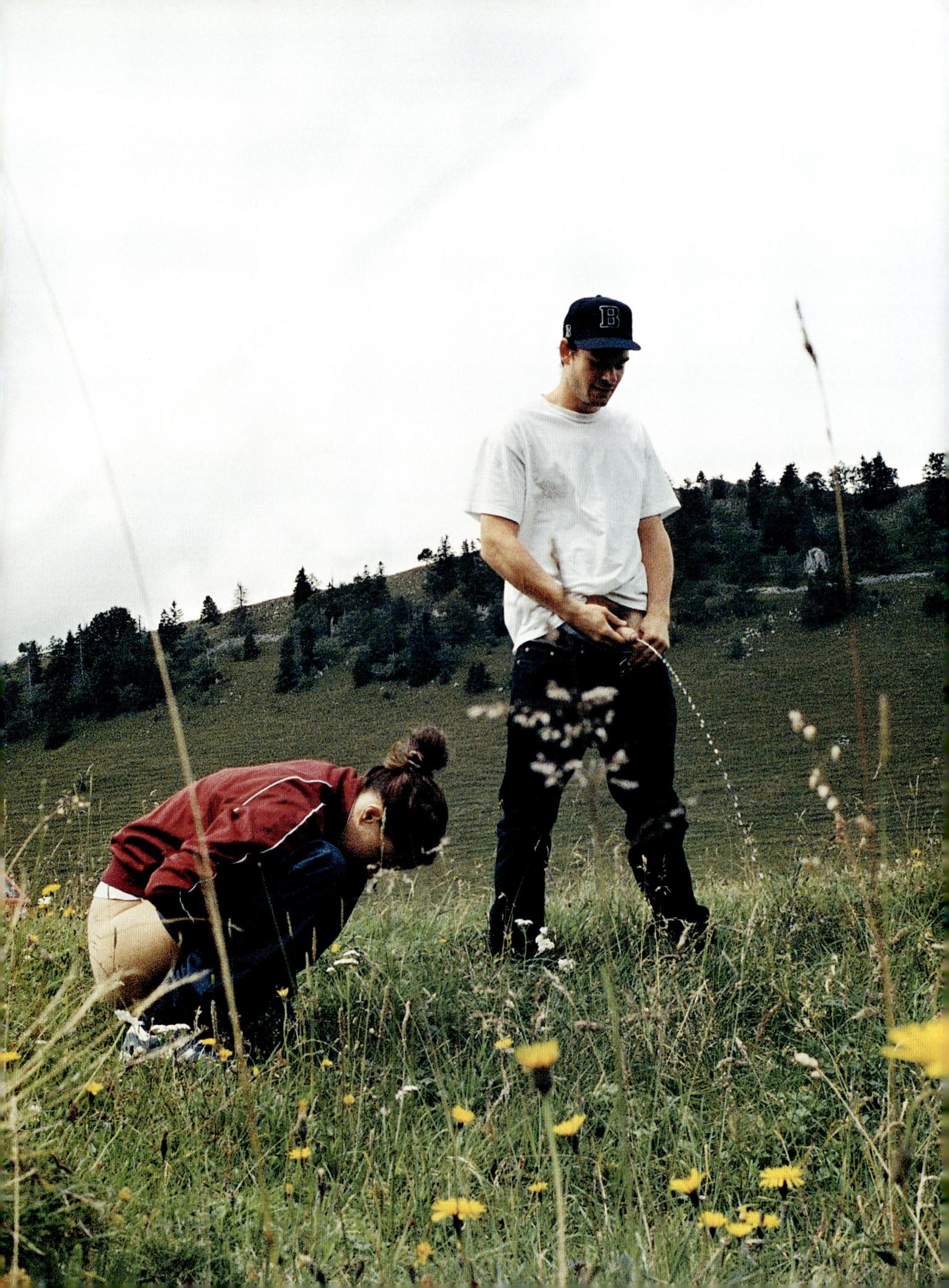

The good and the bad works with everything.
What/who would you consider an ideal subject for parody? Note that George Bush and Tony Blair are already taken.
Ahhh... maybe you two.
How do you see the world?
Very serious with hopeless motherfuckers around.
Do you have any theories about it?
Never play cards with a guy who has the same first name as a city.
Do you ever feel like we're doomed? And does that make you want to laugh or cry?
Cry.
What/who do you discriminate against?
Indians.
What's your favourite satire film, what is your favourite scene?
Pocohotass 2. When John Smith gets the ass.
What's your favourite children's book?
Where the Wild Things Are by Maurice Sendak.
Do you have a nickname? What is that? And how do you feel about it?
Mr Big Dick. I feel great about it.
What would you say is definitely NOT your motto?
Yes, you can.
Have you started reading self-help books yet?
I have read *Women* by Charles Bukowski, that helped a lot.

"*Never play cards with a guy who has the same first name as a city.*"

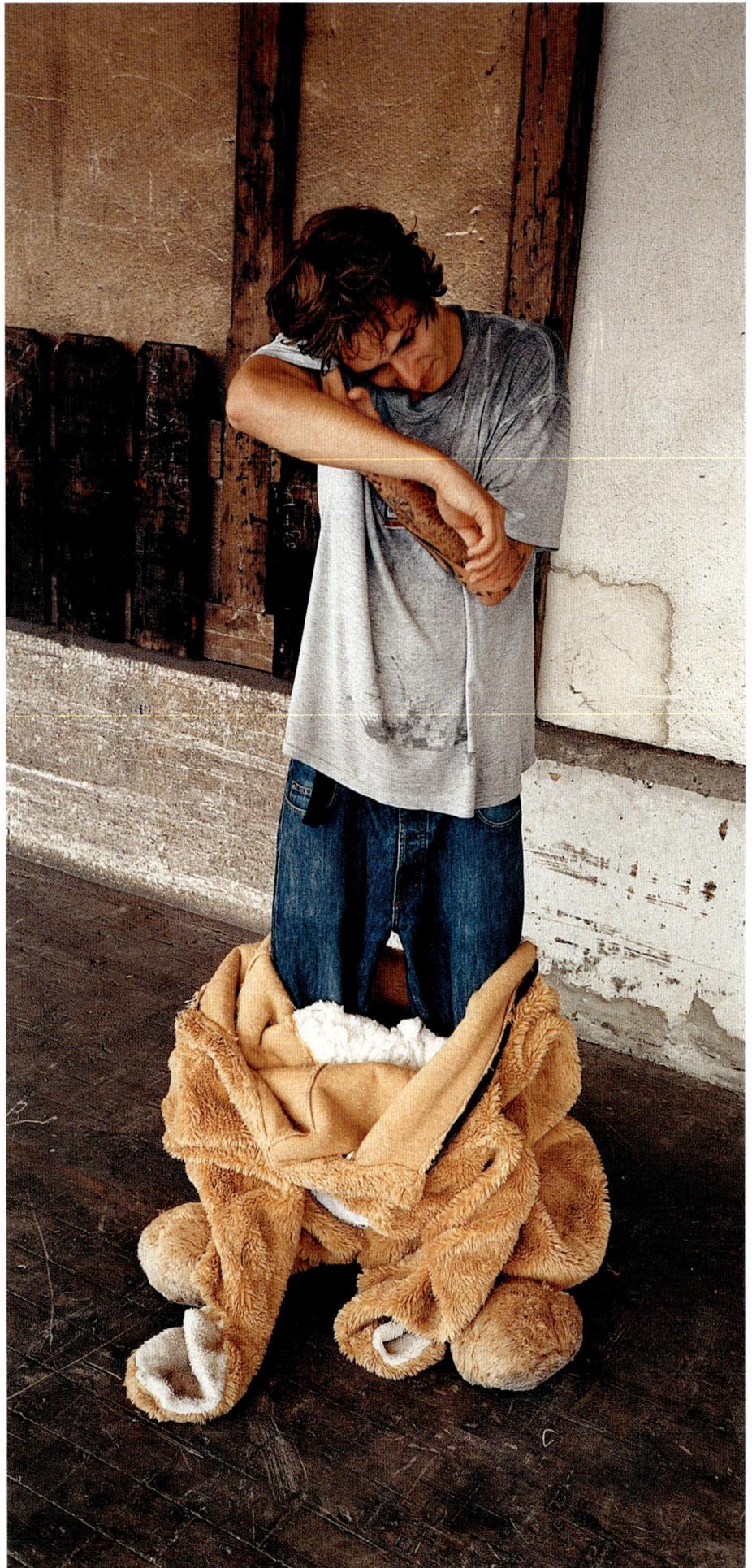

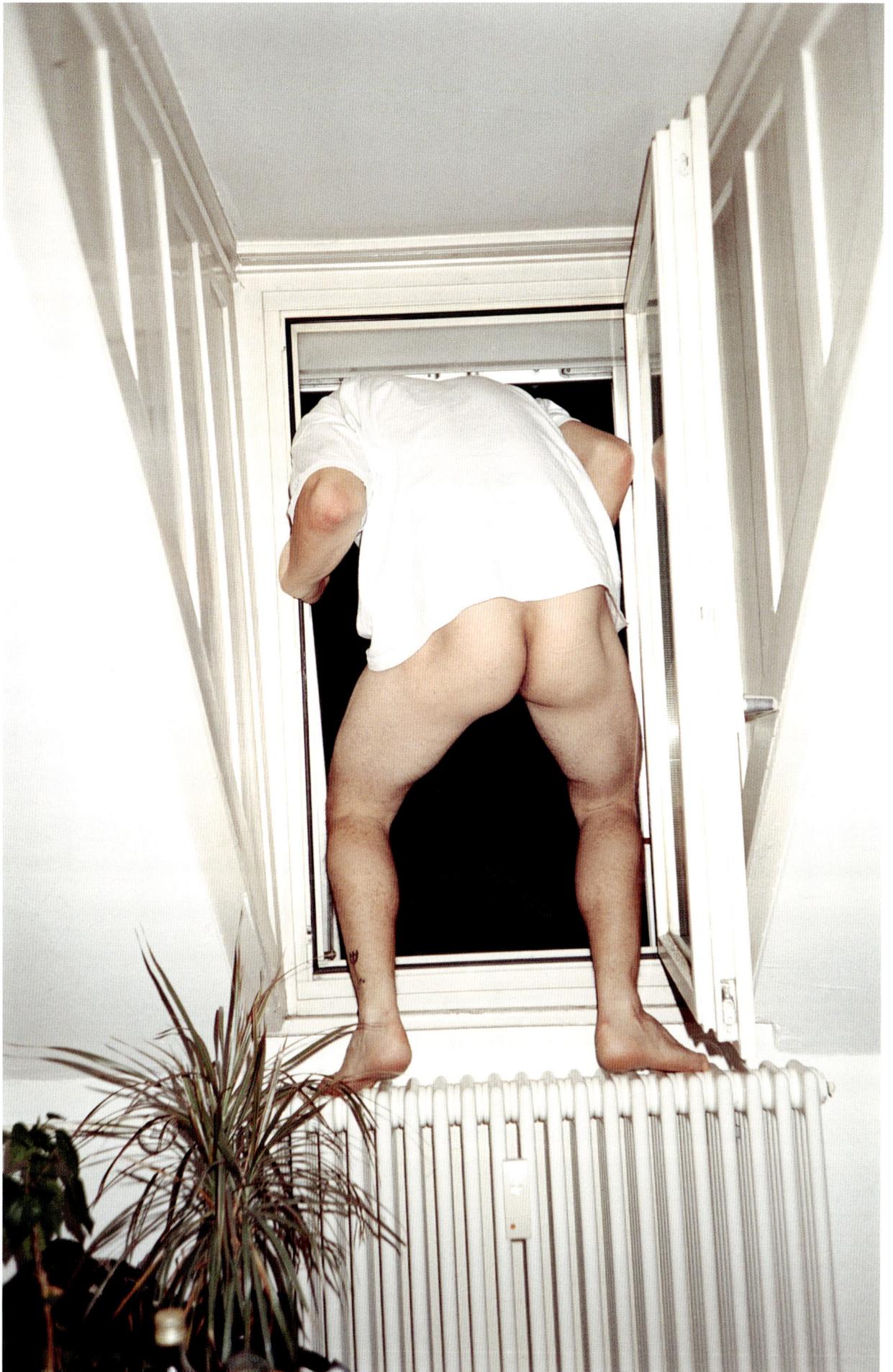

042-045:
BOUVY GILLIS
LA MORT

Aline Bouvy and John Gillis have been working in collaboration since 1999, when they were both researchers at the post-graduate programme for Fine Arts at the Jan van Eyck Academie, Maastricht. Having spent the last two years in London, they are currently living and working in Brussels. Using a large variety of media, ranging from animation films, painting, sculpture, installation and performance, irreverently mixing high and low culture.
www.bouvygillis.net

Title of work submitted: Ego devant la Mort
Date of completion: 03.06.2006
Brief Description of work submitted:
Two collaborative duos, Aline Bouvy / John Gillis and Simona Denicolai & Ivo Provoost have challenged each other to a mud wrestling match accompanied by hardcore Scandinavian Underground music. The time, date and venue has been set and a ring has been constructed out of Belgian beer crates and a tarpaulin filled with gallons of mud collected from a farm on the outskirts of the city. The mud is mixed with water and the surface covered with golden glitter making the mud dazzle under the stage lights.

How idyllic was your childhood?
Aline: Full of love.
John: Full of shit.
Did you cherish any grandiose dreams?
AB: At that time I was hoping that later I'd look like Stéphanie de Monaco.
JG: Being a Formula 1 pilot driving for Williams-Leyland.
What kind of teenager were you?
AB: I became a true rebel but never succeeded beyond my rebellion towards my parents. At 15 I ran away from home to Paris (for two days). When I eventually returned home, my Dad asked: "How was the Eiffel tower?"
JG: A wanker spending his time at art school together with all the other boring wankers.
If you were to place yourself in a novel, how would you describe your character?
JG: Very, very small, seven points maybe.
AB: Hysterical.
Did anyone ever take any of your jokes badly?
AB: Can't remember.
JG: Cunts take jokes badly.
What are you good at, what are you bad at?
JG: Good at fucking, bad at foreplay.
AB: Good at messing up, bad at cleaning up.
Are you the type to exaggerate things?
JG: Oh well, don't know what to say…
AB: That much (arms spread wide).
Are creative people unbalanced?
JG: Creative people often bore the shit out of me, so yes, they are predisposed wankers.

AB: Are you angry or are you boring? (in Gilbert & George's 'Dirty Words Pictures')
Is there such a thing as intelligent or stupid humour?
JG: I think stupid humour always works out to be the most intelligent. That's why I love Pavel Braila's sense of humour.
AB: Humour is a high form of intelligence.
How do you see the world?
JG: I don't see the world.
AB: Expensive.
Do you carry any crosses?
AB: Not that I know.
JG: Duvel and Jupiler beer.
What's your favourite children's book?
AB: I never had any children's books, I started reading proper literature at the age of 11.
JG: Moesti.
Do you have a nickname? And how do you feel about it?
JG: I've got lots of them, and not one bothers me. I got used to it as a child with red hair, so I learned the shit very early on, when my life was full of shit.
What would you say is definitely NOT your motto?
JG: A BMW or a Yamaha.
AB: Every day is the same day.

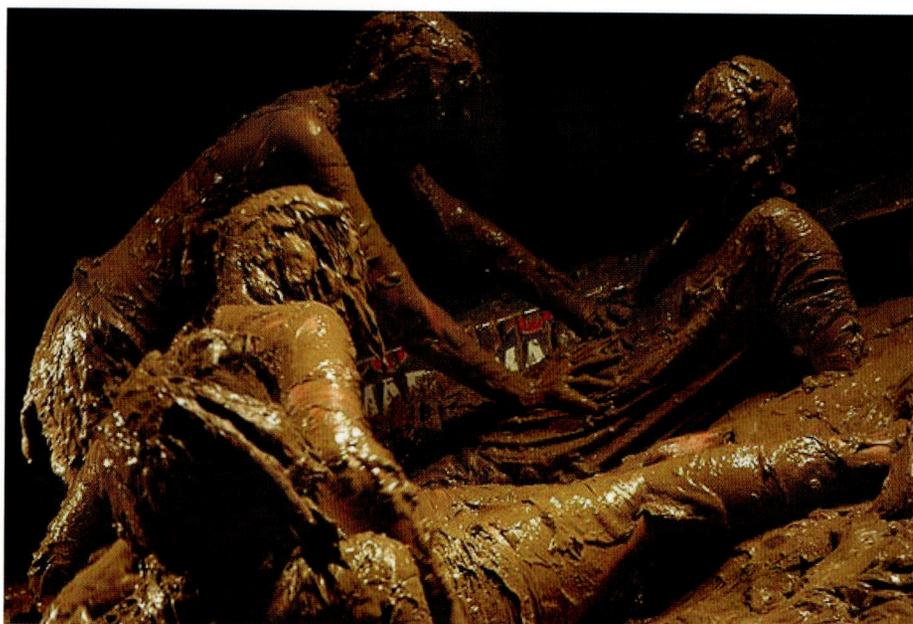

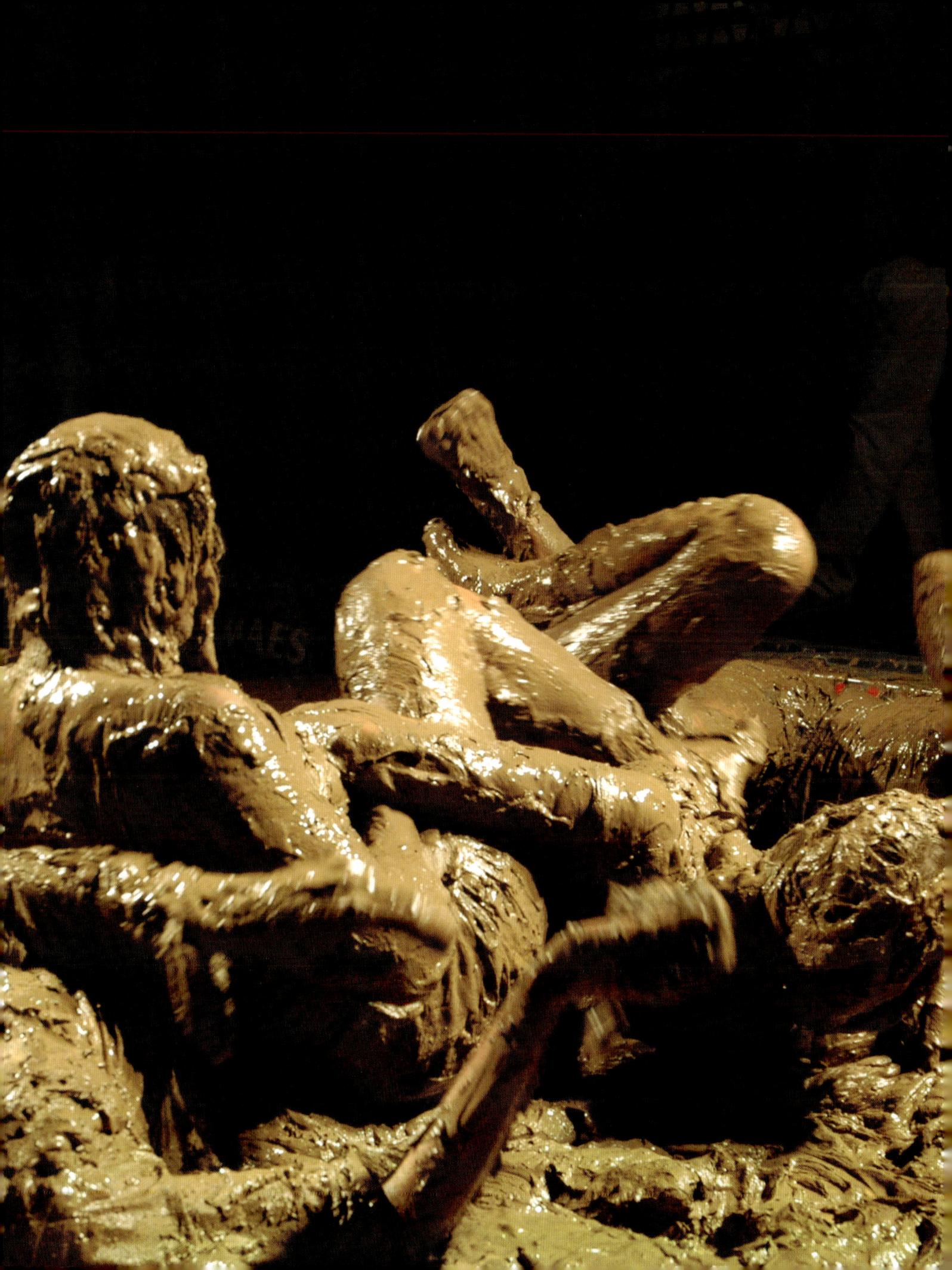

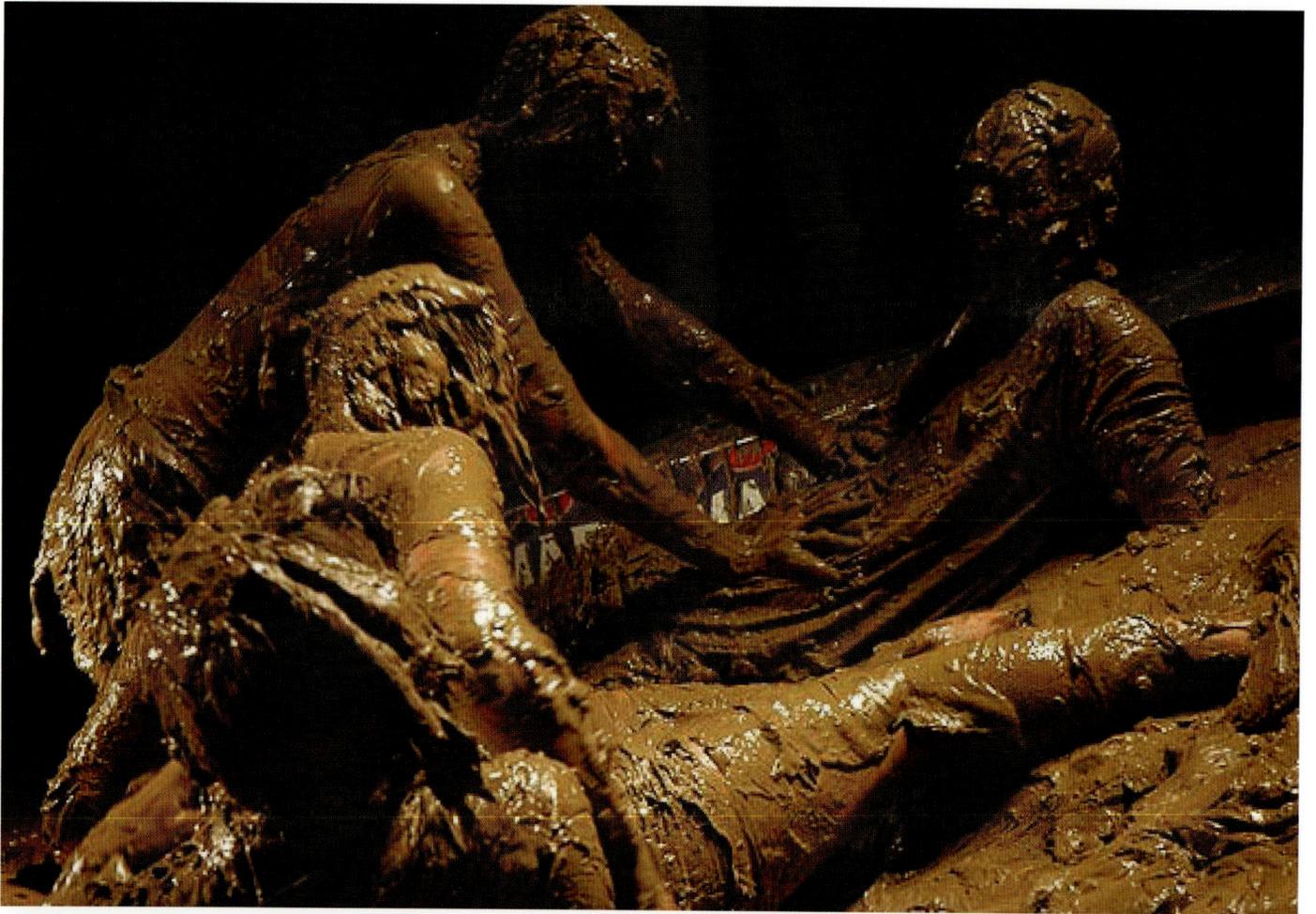
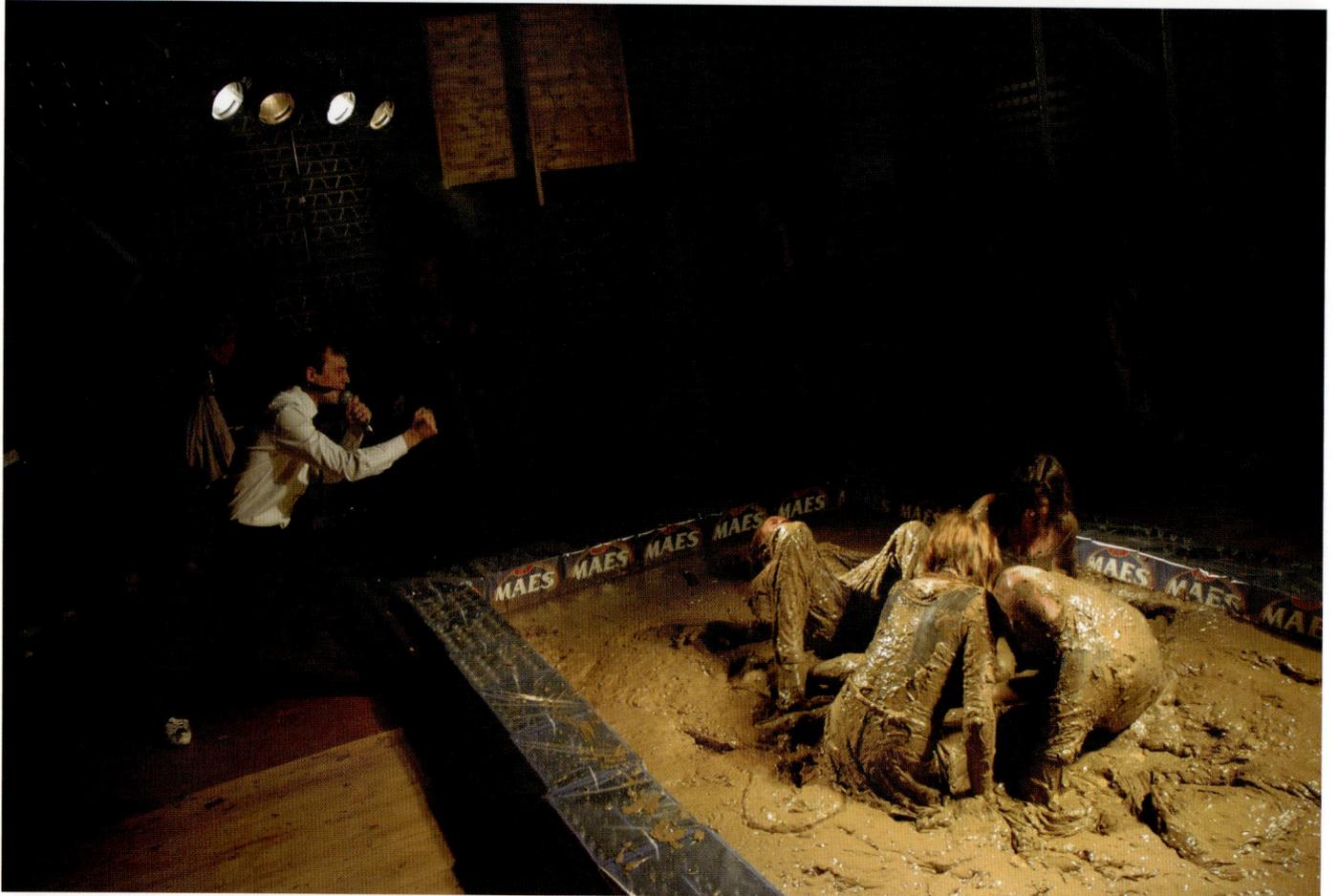

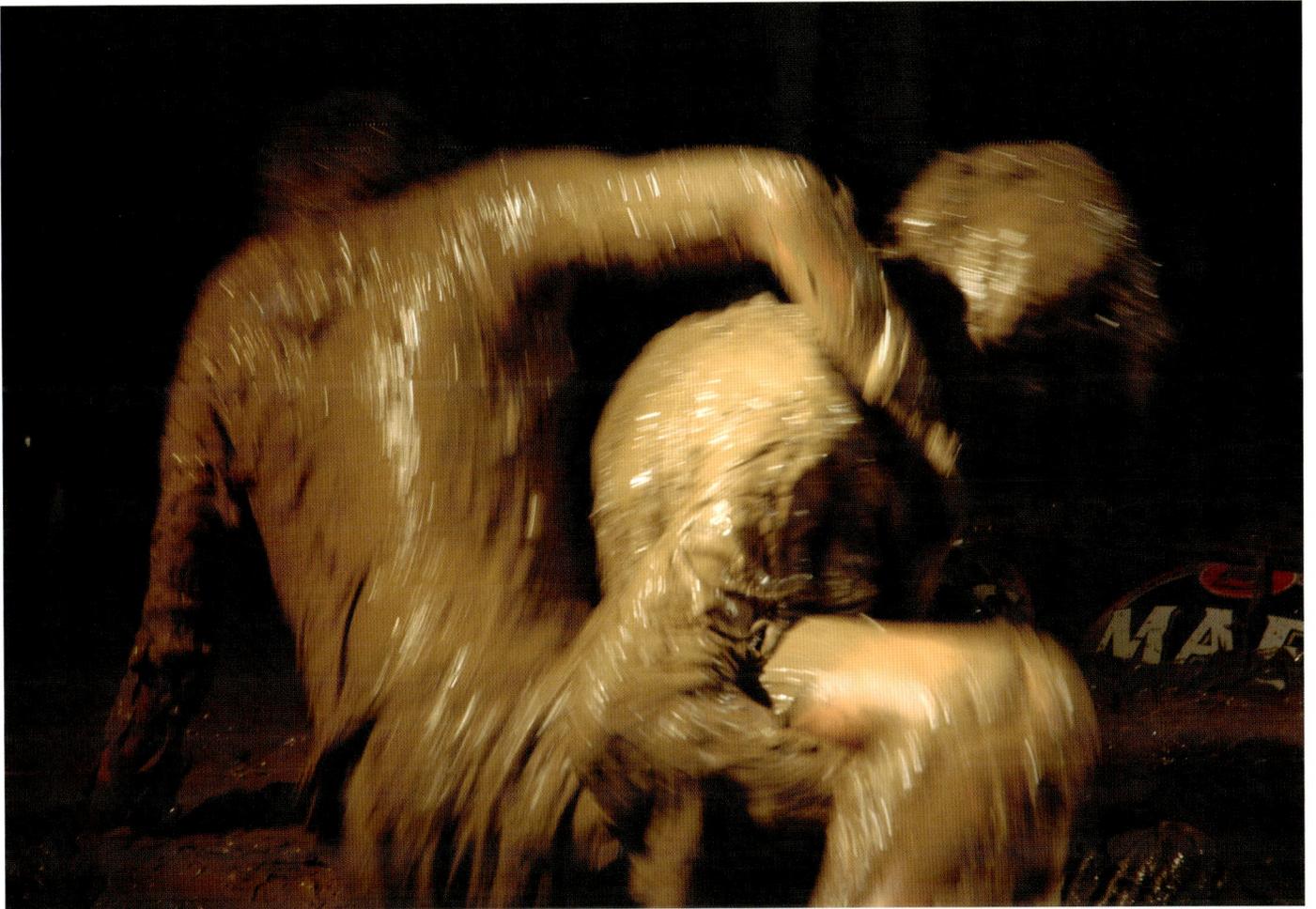

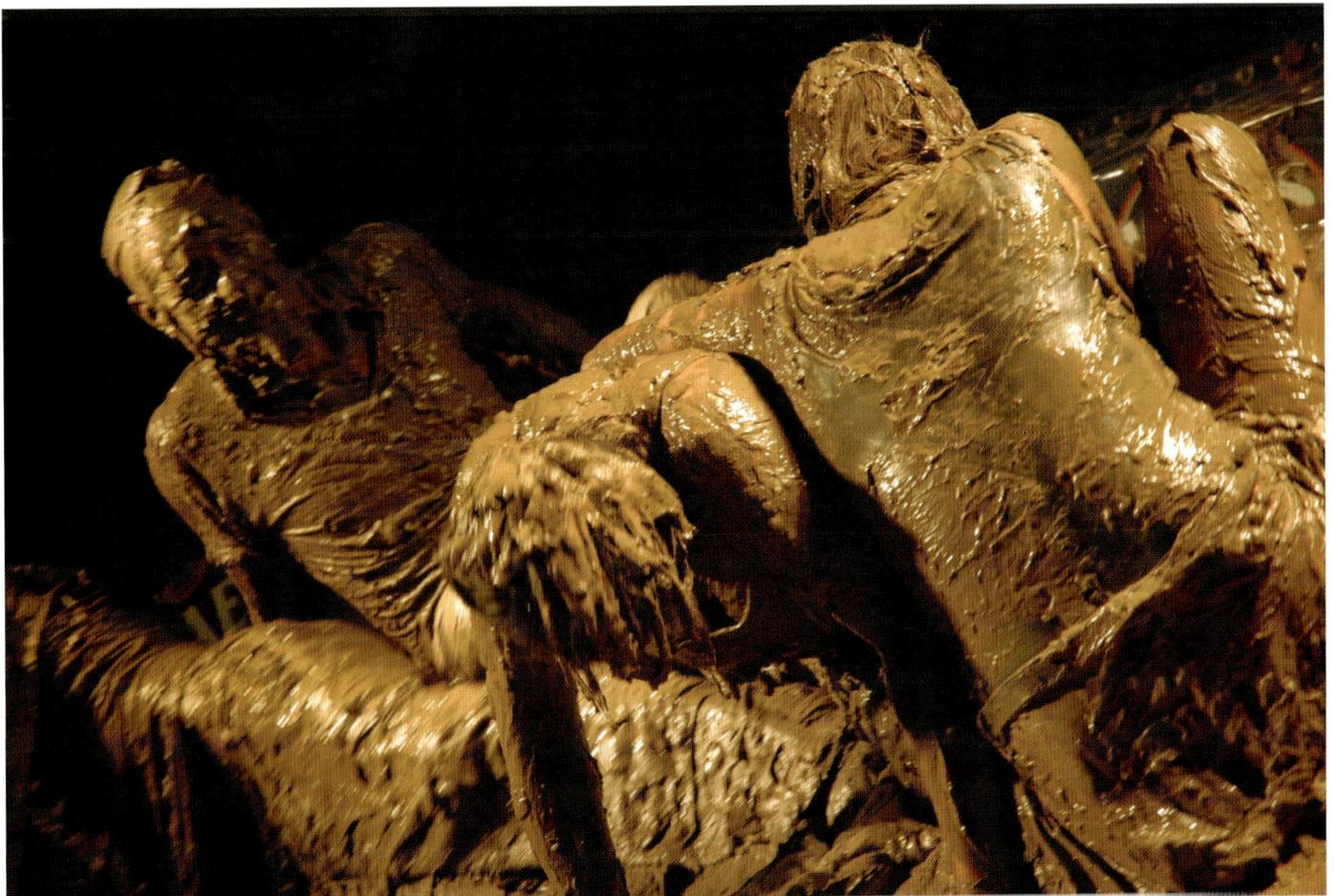

Swiss graphic designer David Clavadetscher has his own studio and is a guest lecturer at Hochschule der Künste, Bern. www.clavadetscher.org

Title of work submitted:
**** – Complete Four-Letter Words
Date of completion: 2006
Brief Description of work submitted:
You may know shit, fuck, piss. But how many four-letter words are there? When you consider all possible four-digit combinations of the 26 letters of the alphabeth (A-Z) you get 456 976 four-letter-words. Starting with AAAA and ending with ZZZZ. The complete swear words are collected in a poster.

" *I'm discriminating against discriminating people. Just the way I'm intolerant towards intolerant people.*"

How idyllic was your childhood?
Very idyllic. Close to the lake shore, amidst a fantastic Swiss mountain scenery. Playing cops and robbers, rooting out neighbours' vegetables.
Can you remember something that really made you laugh when you were a kid?
My grandpa singing.
What kind of teenager were you?
A little shy, a little intimidated, a little rebellious.
Richard's therapist wears a lot of chocolate brown, while Marc remembers his as wearing light, neutral clothes (he remembers her as rather seductive, in a motherly kind of way). What did you think when you first saw your therapist?
My girlfriend's a psychologist!
Do you laugh at yourself? How often? What does that feel like?
Yes, I do laugh at myself. Mostly in situations of failure.
Did anyone ever take any of your jokes badly?
Probably. I have the tendency to make inappropriate comments. Most of the time I manage to censor myself.
Richard can't read his own handwriting, speak a foreign language or play a musical instrument. He can ski, but hates skiers. What are you good at, what are you bad at?
I can read my own writing, but have the handwriting of a 16-year-old schoolgirl. I can speak several foreign languages but with a terrible Swiss accent.
Do you work with other people? How does that work? Does it work?
I need others to assure me in my process. But mostly I don't accept compromises in my work. So it's not easy. And it's hard to find the right partner.
We noticed that some of the submissions we received seemed a little angry, possibly maladjusted. Would you say that creative people are unbalanced?
No, I think intelligent people are unbalanced. And you need intelligence to be a good graphic designer.
Large feet, dyslexia, an inappropriate sense of humour and bags under the eyes are some of the crosses Richard has had to bear. Marc has a serious tendency to exaggerate things. Do you carry any crosses?
"Deformation professionelle". In addition, my colleagues suspect that I am colour-blind. But that's slander – nothing is proved.
What/who do you discriminate against?
I'm discriminating against discriminating people. Just the way I'm intolerant towards intolerant people.
Do you have a nickname?
I have several. None of them I'm especially proud of. I'm actually trying to extinct them. Fortunately my boyscouts' name didn't survive...
Have you started reading self-help books yet? If so, which ones? Richard's just finished The Artist's Way, *while Marc's about to start on* The Road Less Travelled. *He also has Betty Shine's* Mind Waves *by his bedside (he claims it isn't his).*
I just ordered a do-it-yourself bible. Apart from that: Paul Ardens' *It's not how good you are, it's how good you want to be.*

FUCH FUCI FUPX FUPY FVDO FVDP FVRE FVRF FVRG
FUPW FVDM FVDN FVRC FVRD FWES FWET FWEU FWEV
FVDL FVRA FVRB FWEQ FWER FWSG FWSH FWSI FWSJ
FWEO FWEP FWSE FWSF FXFV FXFW FXFX FXFY
FWSD FXFS FXFT FXFU FXTJ FXTK FXTL FXTM FXTN
FXFS FXTH FXTI FYGX FYGY FYGZ FYHA FYHB FYHO
FXTH FYGW FYUM FYUN FYUO FYUP FYUQ
FYUL FZIA FZIB FZIC FZID FZIE FZIF
FZVO FZVP FZVQ FZVR FZVS FZVT FZVU
GAJD GAJE GAJF GAJG GAJH GAJI GAJ
GAWS GAWT GAWU GAWV GAWW GAWX GA
GBKH GBKI GBKJ GBKK GBKL GBKM
GBXW GBXX GBXY GBXZ GBYA GBYB
GCLL GCLM GCLN GCLO GCLP GCL
GCZB GCZC GCZD GCZE GCT
GDMR GDMS GDMT
GEAH GEAI
GENX

048-051:
MARK DELONG
FREEDOM IN THE WORLD

Born 1978 in Fredericton, New Brunswick. DeLong is a self-taught artist working in ceramics, video, drawing and painting. He lives and works in Vancouver.

Title of work submitted:
Untitiled Mixed Media on paper 8.5"x11

How idyllic was your childhood?
Very happy young person.
Can you remember something that really made you laugh when you were a kid?
The Seafoods and Lobsters sign.
What kind of teenager were you?
Skateboarder.
What's the worst look you can remember sporting?
Big pants, tight shirts.
What's the most embarrassing situation you would dare to admit finding yourself in?
Selling juice for rent.
When and where did it all start to go wrong?
High School.
How would you describe your character?
Fat.
Do you have a sense of humour? If so, what kind?
I'm gay.
What did you think when you first saw your therapist?
What the – ?
Do you laugh at yourself? How often? What does that feel like?
In the mirror. Nice.
What's the most inappropriate place/time you remember laughing at?
At an experimental music gig.
Did anyone ever take any of your jokes badly?
Sure.
What are you good at, what are you bad at?
I'm a construction worker.
Do you work with other people? How does that work? Does it work?
No.
Are you the type to exaggerate things? How much?
I won't say much because I stutter.
Are creative people unbalanced?
Hey little partner, what's with all the questions?
Is there such a thing as intelligent humour?
We're going to continue to lead the cause of freedom in the world. The only way to defeat a dark ideology is through the hopeful vision of human liberty. (G.W. Bush)
How do you see the world?
My cat is meowing at me.
War, disease, global warming, poverty, do you ever feel like we're doomed?
Global warming is going to mutate everything on earth.
What's your favourite children's book?
Honk!
What would you say is definitely NOT your motto?
Blow it out your ass.
Do you have any addictions?
Chocolate, booze.

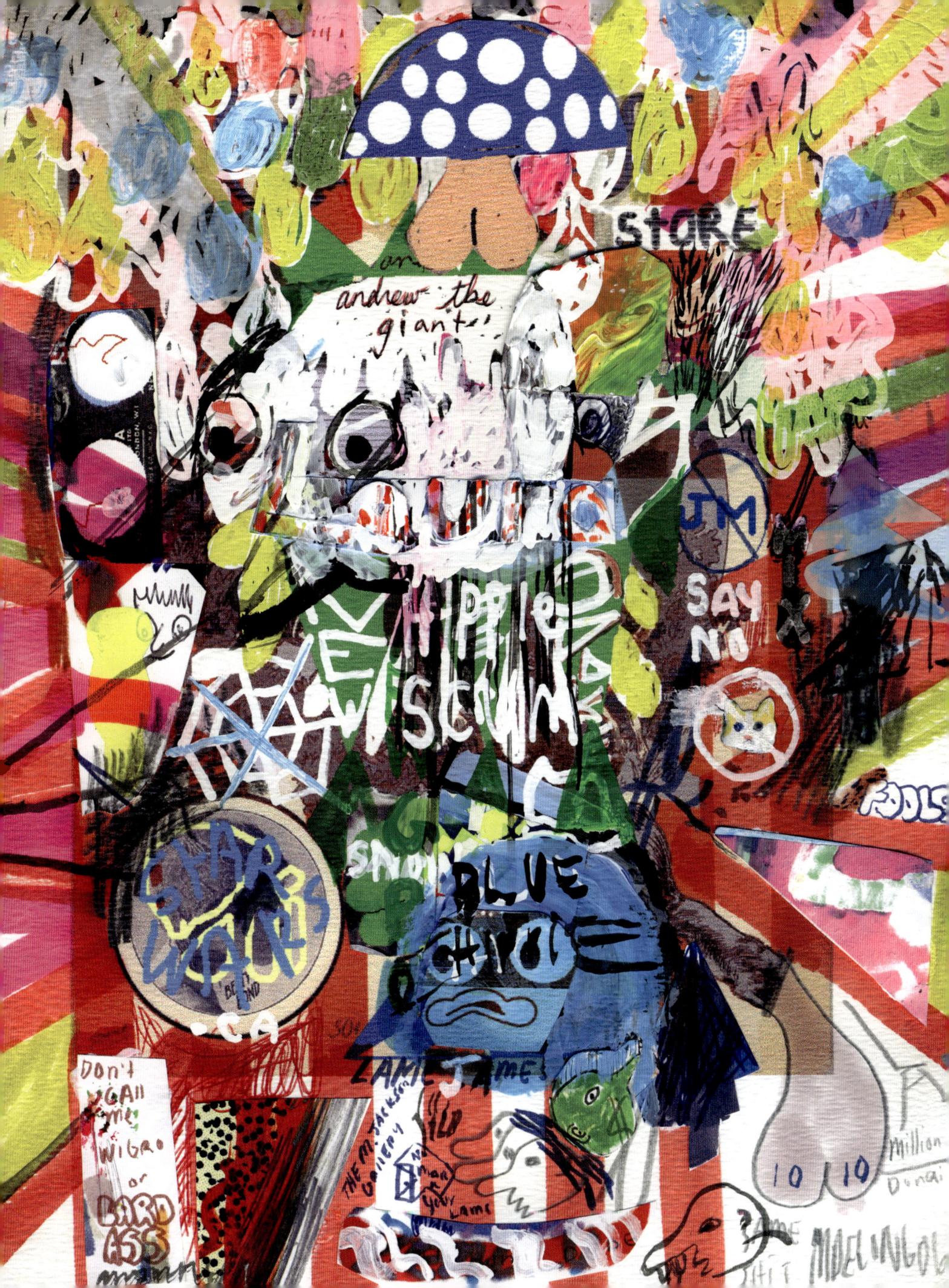

SPIDER MAN

X BOX
PATTISON.

052-057:
ANDREA DEZSÖ
UNCENSORED

Illustrator Andrea Dezsö was born in Transylvania and has lived in New York for the last ten years. Her work has been widely published and shown in the art world. Dezsö is an Assistant Professor of Media Design at Parsons The New School for Design in New York.

" I loved my stepfather's jokes about Lenin, Radio Yerevan and communism. He remembered hundreds of jokes and told them with great gusto."

How was your childhood?
I grew up ethnic Hungarian in Transylvania, Romania, a communist country during the cold war. There were shortages of every kind from medicine to food, censorship, ethnic discrimination, yet most of my childhood memories are quite sweet. My uncle and aunt adopted me when I was ten and I moved to their city, their home. I was a very eccentric child with many outlandish ideas that I often tried to put in practice, and my immediate world, family, teachers and friends were extremely patient with all that. Books were very important. We didn't have access to contemporary publications so we read the classics. We lived in books. Travelled through them. My family had to move to a bigger apartment at one point because our library did not fit in the smaller place any longer. We moved to a housing development very close to the forest and went on trips almost every weekend. During the summers we went camping and to the beach, during the winter we skied and skated. I was allowed to roam the streets, hang out with friends after school. For a while my family was able to protect me from the outer world, but then, in the eighties, it all fell apart. We were confronted with a regime that did not tolerate individualism, creativity and, ultimately, thinking of any kind.

Can you remember something that really made you laugh when you were a kid?
I loved my stepfather's jokes about Lenin, Radio Yerevan and communism. He remembered hundreds of jokes and told them with great gusto. They were all the more hilarious as they poked fun at sacred ideas and personalities. I was allowed to listen to them at home but not to repeat them to others. And if someone asked me outside our home if I was familiar with jokes that were critical of our regime, I had to pretend I was not.

Did you cherish any dreams?
I remember once putting aside my dream to become an artist for wanting to become a policewoman. I found the uniform and especially the long leather boots very chic.

What kind of teenager were you?
Rebellious. One time I got into big trouble. I must have been 14. By that time the regime in Romania was tightening its grip around the citizens: wearing wildly customized clothes to express my personality was no longer tolerated. The Securitate (Romanian Secret Police) came to our school, called in my family and threatened us with various punishments, including sending me to a correction facility for young criminals. At the same time they also kicked me out of the Union of Young Communists after just a few days of membership, for behaviour unfit for a Communist Youth. I was never readmitted.

What's the worst look you can remember sporting?
Home-made shiny yellow rayon top, with 'ABBA' embroidered on the front with gold thread that I had saved from Christmas gift packaging. Fake jeans, 'Hero' brand, made in China, maybe a bit outgrown. Terry-cloth socks. Sandals. Hair permed to an inch of its life, teased and sprayed into a huge fluffy meringue. I must have been 13.

When and where did it all start to go wrong?
It got better after I emigrated to Hungary in 1989. I was not accepted to art college in my home country due to ethnic quotas, so after three years of unsuccessfully trying to get in I moved to Hungary – a process that took 18 months and countless bribes – and started my undergraduate studies at the Hungarian University of Design in Budapest. Soon after, the Pan-European Picnic took place, the Berlin Wall came down, communist regimes toppled one after the other. The Ceausescus were executed later that year – the changes were unbelievable. We never dreamed that freedom would happen in our lifetimes. Suddenly I could read anything, watch anything, there was no more censorship, no more holding us young people back. It was exhilarating.

If you were to place yourself in a novel, how would you describe your character?
She was afraid of moths, and had a reoccurring dream of climbing up a steep hill and then not knowing how to get down.

Do you have a sense of humour? If so, what kind?
I tend to enjoy irreverent, dark, dry humor.

What's the most inappropriate place or time you have ever laughed?
Sometimes at funerals I feel that if I don't laugh my sides will split. Just imagining how inappropriate it would be if I couldn't control myself makes the urge downright unbearable. I don't remember ever losing my composure, but I did have to leave abruptly on a number of occasions.

Do you work with other people? Does it work?
I tend work well with others but usually prefer to work by myself.

Are creative people unbalanced?
I don't think so. It's just that what artists, writers and stand-up comics do with their anger is more visible. People are not →p56

MY MOTHER CLAIMED THAT

A WOMAN'S LEGS ARE SO STRONG THAT

NO MAN CAN SPREAD THEM

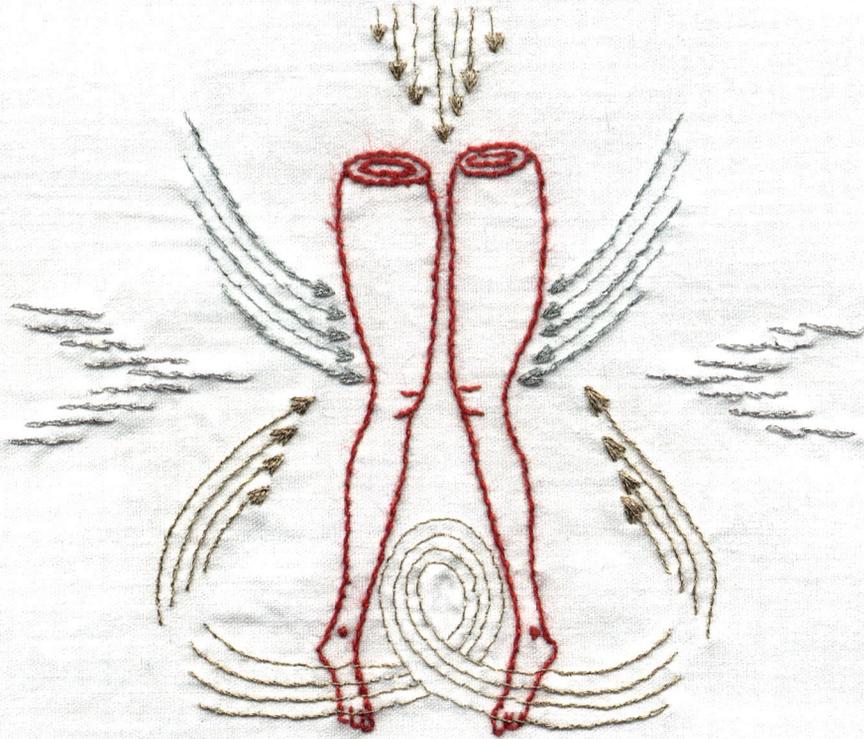

IF SHE DOESN'T LET HIM

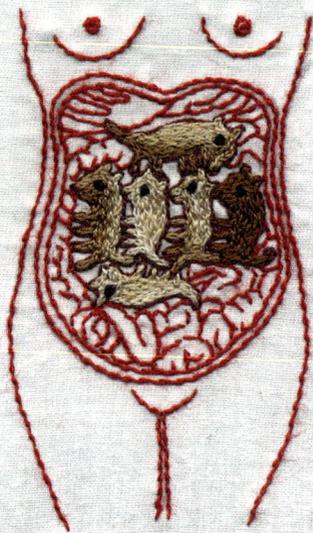

MY MOTHER CLAIMED THAT

OUR NANNY HAD SIX PUPPY DOGS

SEWN INTO HER STOMACH BY HER PREVIOUS EMPLOYER

MY MOTHER CLAIMED

that

a woman's belly starts growing

SIMPLY FROM BEING MARRIED

MY MOTHER CLAIMED THAT

EATING GREASY FOOD WITHOUT BREAD

IS WHAT GIVES PEOPLE HERPES

MY MOTHER CLAIMED THAT

MEN SUFFER WHEN THEY LOOSE THEIR VIRGINITY

MY MOTHER CLAIMED THAT

SMART PEOPLE HAVE **TALL** FOREHEADS AND

smart stupid

TRUTH: LOOKING AT YOU DOWNCAST EYES = LIE

YOU CAN TELL AN HONEST FACE FROM A DISHONEST ONE

encouraged in our society to express their anger, it's considered to be an antisocial, destructive feeling, something to be embarrassed about. We are socialized to hide our anger and maladjustment in public. Creative output is perhaps the only socially accepted way to vent anger. It's also possible that artists are just more uninhibited and care less about social expectations—which is also a socially accepted stereotype, the artist as a misfit.

Absolutely. Humour that is simplistic, ignorant, flat, that merely reinforces a stereotype, humour that's racist, sexist, homophobic, jokes who rely solely on saying a risqué word as a punchline: in my mind that is stupid humor. Intelligent humor is original, elegant, irreverent, unusual. It often has a philosophical, social or psychological undertone. It can be complex and a bit like a riddle, one has to "get it".

Do you have any theories about the world we live in?

I don't know if this is a theory but it's a thought I like. It goes like this: You can't assume anything because you never know. Keep an open mind, be curious and see what happens.

Do you carry any crosses?

I have a hard time learning my students' names, even the easy ones, like Jennifer or Nicole. I tried name-tents, name tags, pictures, stickers, associative key words, nothing seems to help. I remember the work but not the name. I'm terrible at judging time, especially when I work. What I think takes an hour really takes more like five. When I think I've been working for 15 minutes it could have easily been six hours. I also have a hard time judging space. It's hard when I have to drive through a tight space. You know the tests they give drivers to see if they are under the influence, like walk on a straight line or reach your nose with your finger with your eyes closed? I can't do those. Driving through a tunnel or a bridge is almost impossible at anything but crawling speed, because I don't know if I will fit. It's kind of a pain in the neck given that I live on an island and work on another.

Do you ever feel like we're doomed?

It can always be worse. I just visited my father in a hospital in Romania where he recently had three amputations. He told me about his two roommates – who had only two arms between them – collaborating to peel the hard-boiled egg they got for breakfast. The three of them couldn't stop laughing.

What/who do you discriminate against?

Arrogant people. Those who treat others with superiority.

What's your favourite children's book?

Richard Scarry's *Pig Will And Pig Won't*.

MY MOTHER CLAIMED THAT

ACCORDING TO THE GYNECOLOGIST MY SISTER HAS THE MOST PERFECT PINK PUSSY HE'S EVER SEEN

MY MOTHER CLAIMED THAT

IF YOU DRINK TOO MUCH WATER

A FROG WILL GROW IN YOUR STOMACH

MY MOTHER CLAIMED THAT

you can get a horrible

HEADACHE EARACHE *or* TOOTHACHE

from

SITTING BY AN OPEN WINDOW ON A

CAR BUS *or* TRAIN

058-059:
E-TYPES
ROOM 404

Strategic design agency e-types, Copenhagen, Denmark were founded in 1997. They work with graphic design and brand strategy. Clients include the Danish newspaper Dagen, the Danish Ministry of Defense, Georg Jensen, Aquascutum and Levis.
www.e-types.com

Title of work submitted: Room 404
Hotel Fox, Copenhagen
Brief Description of work submitted:
The Hotel Fox commissioned a broad selection of creatives to design different rooms of Hotel. E-Types hope that when staying in their room, guests will think and reflect upon the different issues embedded in the design. Working only with type (all typefaces are designed by e-Types) e-Types has played with the idea of the traditional hotel room.

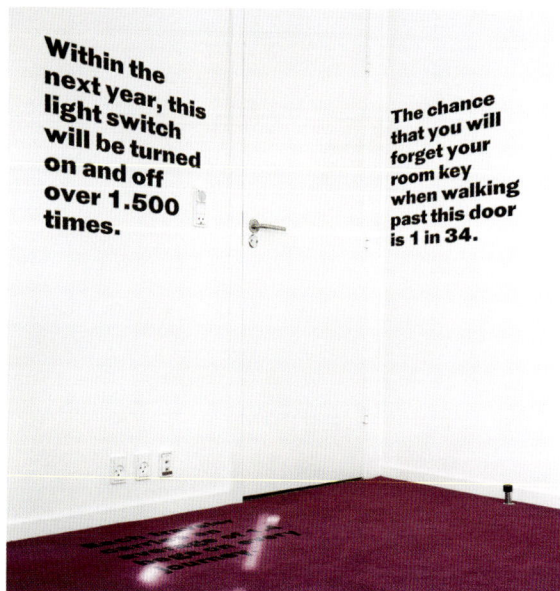

Within the next year, this light switch will be turned on and off over 1.500 times.

The chance that you will forget your room key when walking past this door is 1 in 34.

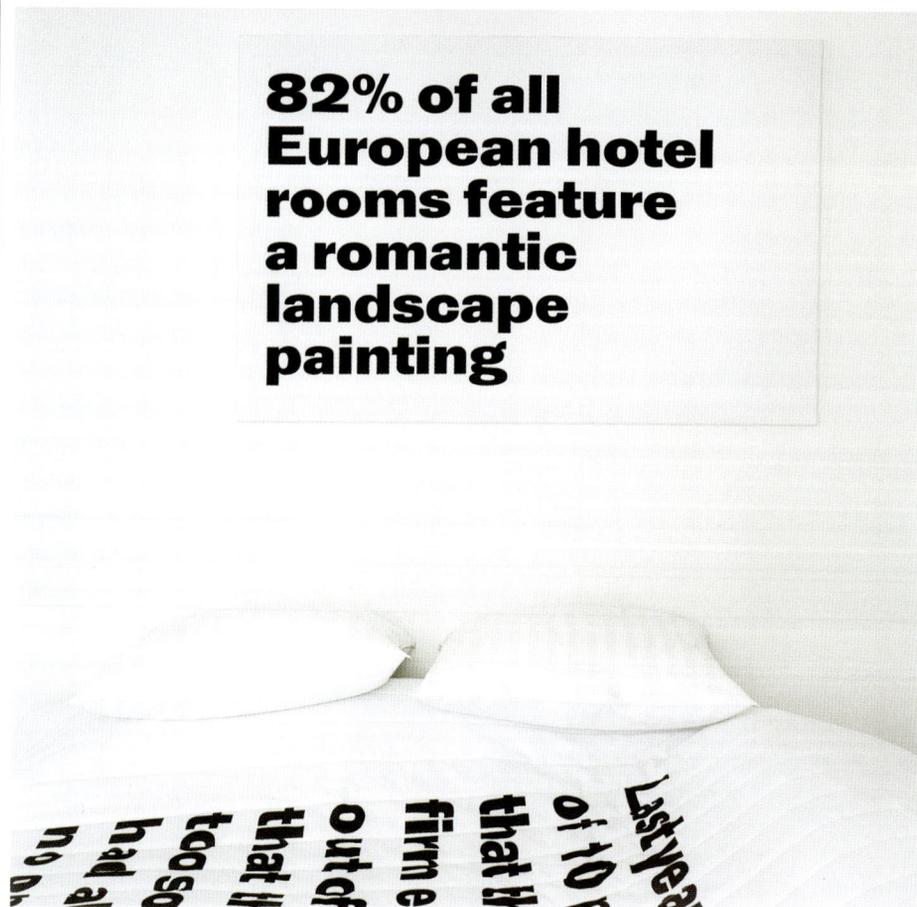

82% of all European hotel rooms feature a romantic landscape painting

94% of all hotel guests expect no surprises when entering their room.

Dominic Early created Earlybird Designs, a greeting card company based in London. *www.earlybirddesigns.com*

Title of work submitted: Greetings card range called "don't beat about the bush"
Date of completion: April 06
Brief Description of work submitted:
Innuendoes, old grannies, bishops, tits, there's nothing funnier than the word beaver. Or baps, or a man with a turtle on his head. These cards were inspired by pictures I found in strange old magazines about cookery or gardening. I don't know why people still laugh at Steve showing off his big cock. But they do.

I will carry on until the laughing stops. But maybe because we are all so childish it won't stop. Titter titter.

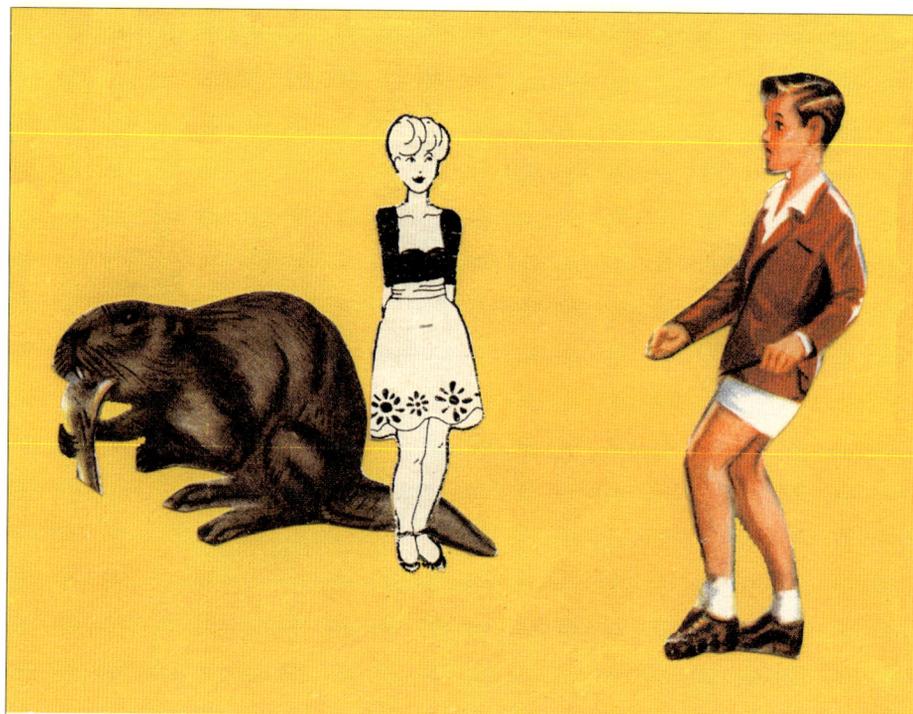

Scott was excited that Amanda had finally agreed to show him her beaver

How was your childhood?
I lived in the middle of a village surrounded by fields, farmers, cows and mud. Which is great until you reach adolescence, then you just sulk and try to escape.

Can you remember something that really made you laugh when you were a kid?
My older brother Jono's presence in a room used to crack me up for no reason. I have no idea why. He still manages to have me in stitches over nothing.

Did you cherish any grandiose dreams?
Not me, I'm a right simpleton. Playing football in the rain and then going home for a nice cup of tea in front of the TV was my idea of a grandiose dream.

What kind of teenager were you?
A greasy, lazy, dreamy one. I think I spent years of my teenage life staring into space.

Actually, I still do that now.
What's the worst look you can remember sporting?
At about 16 I decided to grow long hair, and while going through the 'in-between' stage I had two wings coming out of my head. I looked totally ludicrous. My mum and dad still have photographic evidence in their lounge, which is devastating.

What's the most embarrassing situation you would admit to finding yourself in?
At around the same age I made a tape of love songs for my girlfriend, on which I sang and played guitar. Excruciatingly painful to listen back to now, but at the time I thought I was John Martyn or Nick Drake. With wings.

When and where did it all go wrong?
Growing pubes has a lot to answer for, I think. No one understands me. Boo hoo.

If you were to place yourself in a novel, how

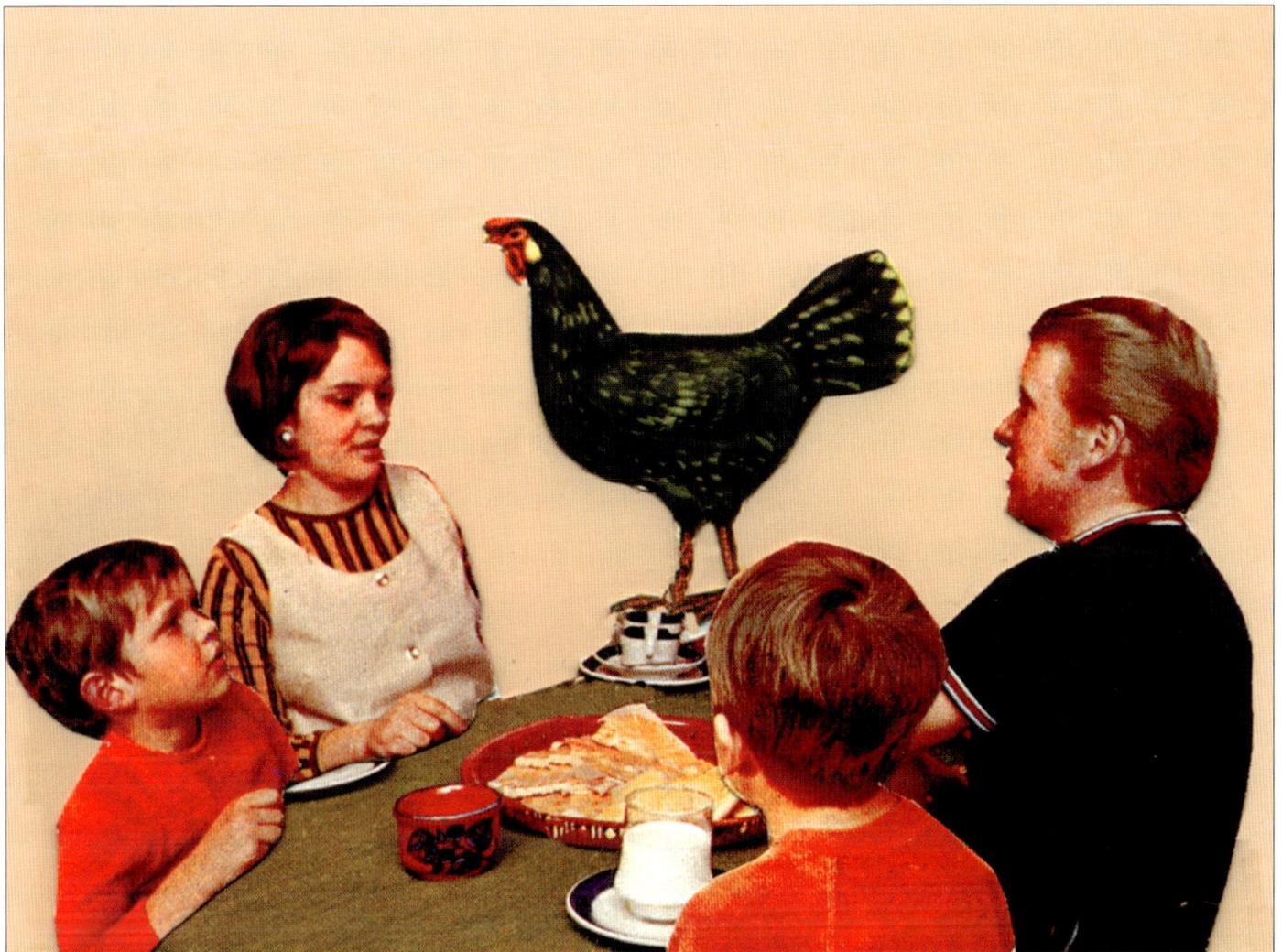

Towards the end of the evening
Steve liked to show off his big cock

would you describe your character?
Definitely not the lead, Maybe a character that doesn't really have any relevance and nobody really knows why he is in it.

Do you have a sense of humour?
Of course, but what kind depends on what mood I'm in. My greeting-card designs suggest I'm a *Carry On Matron*-type of man and I admit that I did laugh out loud at *Coronation Street* the other day.

Do you laugh at your own jokes?
I sometimes try not to laugh at my own jokes, but you can get carried away if the other person is laughing. There's nothing worse than laughing heartily at your own joke and you being the only one.

What's the most inappropriate time you have ever laughed?
I do tend to smile at inappropriate times.

When someone tells you bad news I find it difficult to hold back a smile. I have to concentrate really hard – then it looks like I'm concealing a yawn and that's worse. Someone's telling you their mum has died and you look bored.

Did anyone ever take any of your jokes badly?
I'm sure I've offended almost everyone I know at some point.

What are you good at, what are you bad at?
I'm good at playing the drums but don't play anymore because I live in a terraced house. I'm really bad at listening. I switch off like a light. I revert back to the teenager staring into space thing. I cannot concentrate on anything I'm not interested in. Hence my exam results. I'm also rubbish at swimming, I swim like dog.

Do you work with other people?
I work with my wife Heidi. We run earlybird

designs together. I make rude cards and she sells them. It works well 'cos she does her thing and I do mine.

Are you the type to exaggerate things? How much?
Yeah, for a story. Anything to increase the volume of the laugh.

Are creative people unbalanced?
Creative people are a nightmare sometimes but the world needs them.

Is there such a thing as intelligent or stupid humour?
Yeah, intelligent humour can be a taste thing, a lot of the time the subject of it doesn't really get it because they are so close to it. As for stupid humour, everyone laughs at farts, don't they. Why? 'Cos they are funny. Why? I don't know, they just are.

How do you see the world?
Put it this way: in 100 years, who will give a toss?

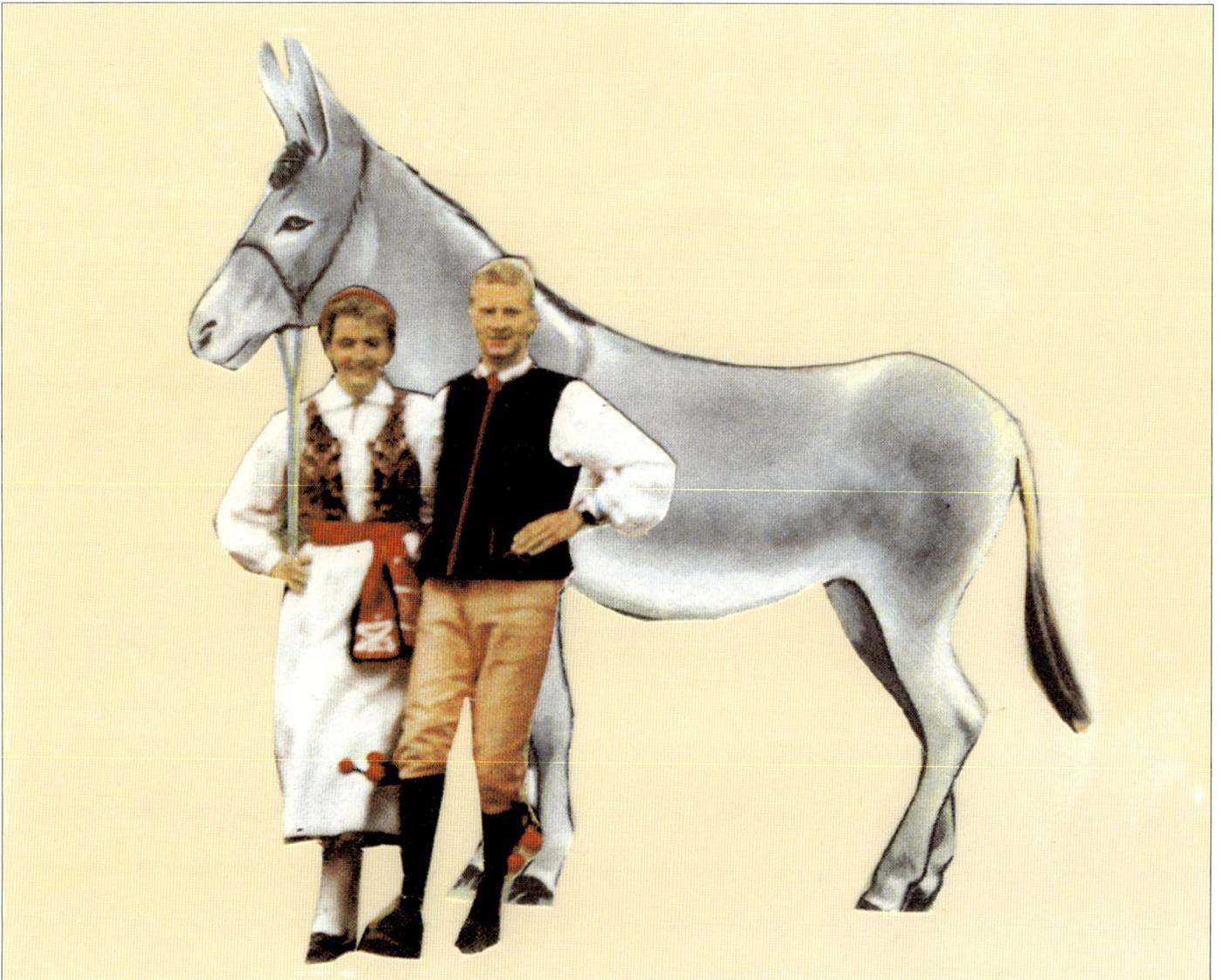

Mark loved Jo's massive ass

Do you have any theories about it? Would you mind sharing one with us?
I worry about whether I will live to see Tottenham Hotspur win the Premiership.
Do you carry any crosses?
I don't think so. I have no hair down either side of my legs, as if I shave them. But it doesn't really bother me.
What's your favourite satire film, what is your favourite scene?
I've been watching Alan Partridge's *Knowing Me Knowing You* recently. I know it's not a film but I cannot remember the last time I laughed out loud so much.
What's your favourite children's book?
The Twits by Roald Dahl.

Do you have a nickname? And how do you feel about it?
Roge. My siblings call me that. I have no idea why and neither do they. I quite like it.
What would you say is definitely NOT your motto?
If at first you don't succeed try again. It's rubbish. Mine would be: if at first you don't succeed then pay someone who can do it much better than you.
Our maintenance man Steve tells us he's addicted to shegods.com. We're doing everything we can to help. Do you have any addictions?
Tottenham Hotspur is slowly killing me.
Have you started reading self-help books yet? If so, which ones? Richard's just finished The

Artist's Way, *while Marc's about to start on* The Road Less Travelled. *He also has Betty Shine's* Mind Waves *by his bedside (he claims it isn't his).*
After the birth of our son Oliver, Heidi and I read *Babywise*. Cracking read, great self-help book.
And finally would you like to say a word about submitting to the magazine and replying to this questionnaire?
Testing.

062

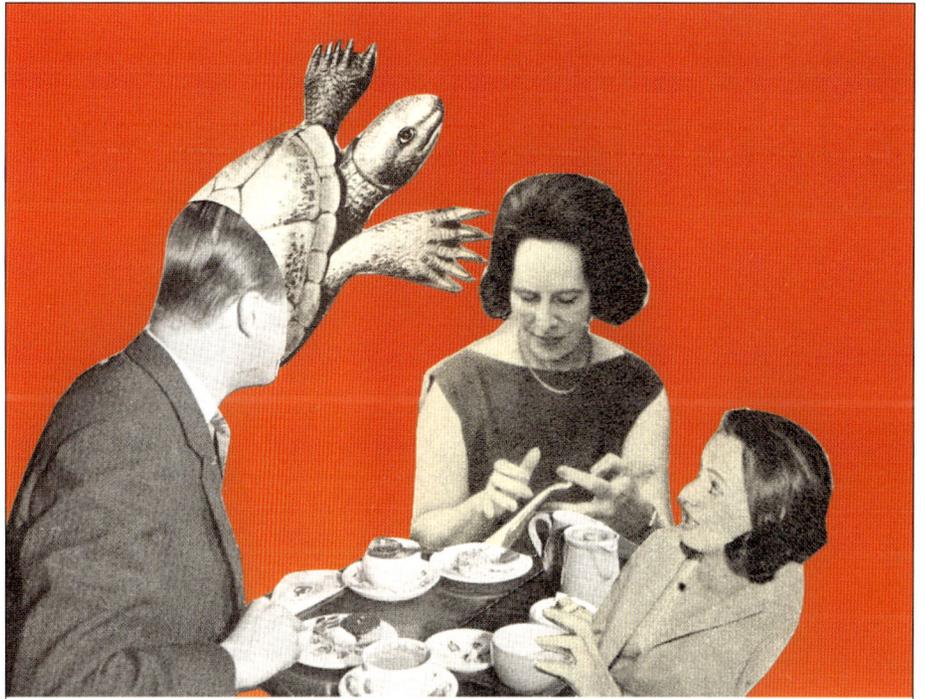

James had to be excused
because he had a turtles head

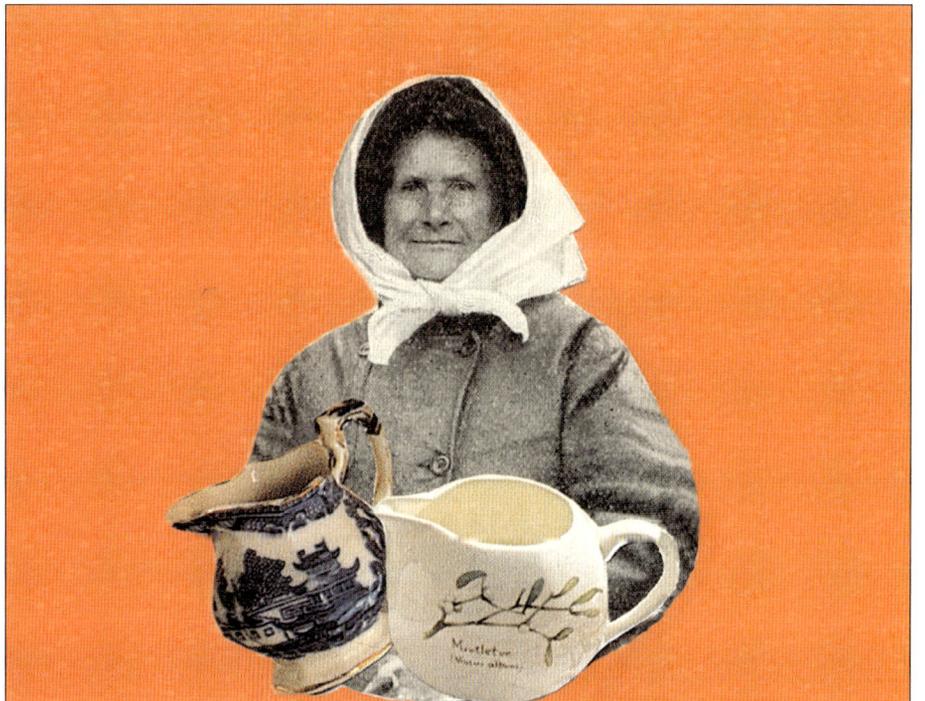

Sally had a great pair of jugs

064-069:
ANDRÉ ETHIER
IDYLLIC

Painter André Ethier lives and works in Toronto, Canada, his work explores racial and sexual stereotypes found in fairytales and religious myth. He's represented by the Derek Eller Gallery, New York.
www.derekeller.com

Brief Description of work submitted:
Ethier paintings rely completely on his subconscious and the subconscious of others. His stumbled upon themes explore undiscovered lands by a symbolic male and the sexualization of foreign culture through a xenophobic eye. The symbolic woman is included as a foreigner, which allows for the representation of the male and his sexual domination of some imagined wilderness. Ethier paints a grotesque landscape of fear and farce.

How idyllic was your childhood?
Idyllic enough.

Did you cherish any grandiose dreams?
Not really. Nothing inappropriate.

What's the worst look you can remember sporting?
Full-on 1993 New School skateboarder. My pants were huge. We were always looking for jeans in size 38 to 40. We were awesome.

What's the most embarrassing situation you would admit to finding yourself in?
I would admit to seriously embarrassing shit, if we were friends. Actually, we don't even have to be friends. If a conversation gets boring, I'll go straight to the exchange of embarrassing situations.

If you were to place yourself in a novel, how would you describe your character?
Tall. Good looking.

Do you have a sense of humor? If so, what kind?
Sure, I have a sense of humor. This seems like a trick question.

Do you laugh at yourself?
I laugh at myself all the time, and I'm probably only recognizing the tip of the retarded iceberg. It feels good.

Do you laugh at your own jokes? How loud?
I laugh at my own jokes so hard that I don't even bother to finish telling them.

What's the most inappropriate place/time you have ever laughed?
I can control myself. I wouldn't ruin your wedding or anything.

Did anyone ever take any of your jokes badly?
I'm sure, but they probably didn't get hurt as much as I wanted them to.

How do you see the world?
I don't really have a world view with a comma in the middle of it. How about: WTF, FTW.

Do you have any theories about it?
I theorize that the world is carried on the back of a giant space turtle and will exist forever.

We all have our burdens to carry. Do you carry any crosses?
Not really. Smoking.

Does war, disease, global warming, make poverty history, make you laugh or cry?
I haven't cried since my seventh grade science-fair project on brain sex was unfairly criticized by hippies. They were surprisingly harsh.

What/who do you discriminate against?
Nerds. Rich motherfuckers.

What's your favourite satire film, what was your favourite scene?
Spaceballs. The whole film is to the point.

What's your favorite children's book?
The novelisation of *The Three Amigos*.

Do you have a nickname? And how do you feel about it?
My wife calls me Baby. It suits me fine.

What would you say is definitely NOT your motto?
Carpe diem.

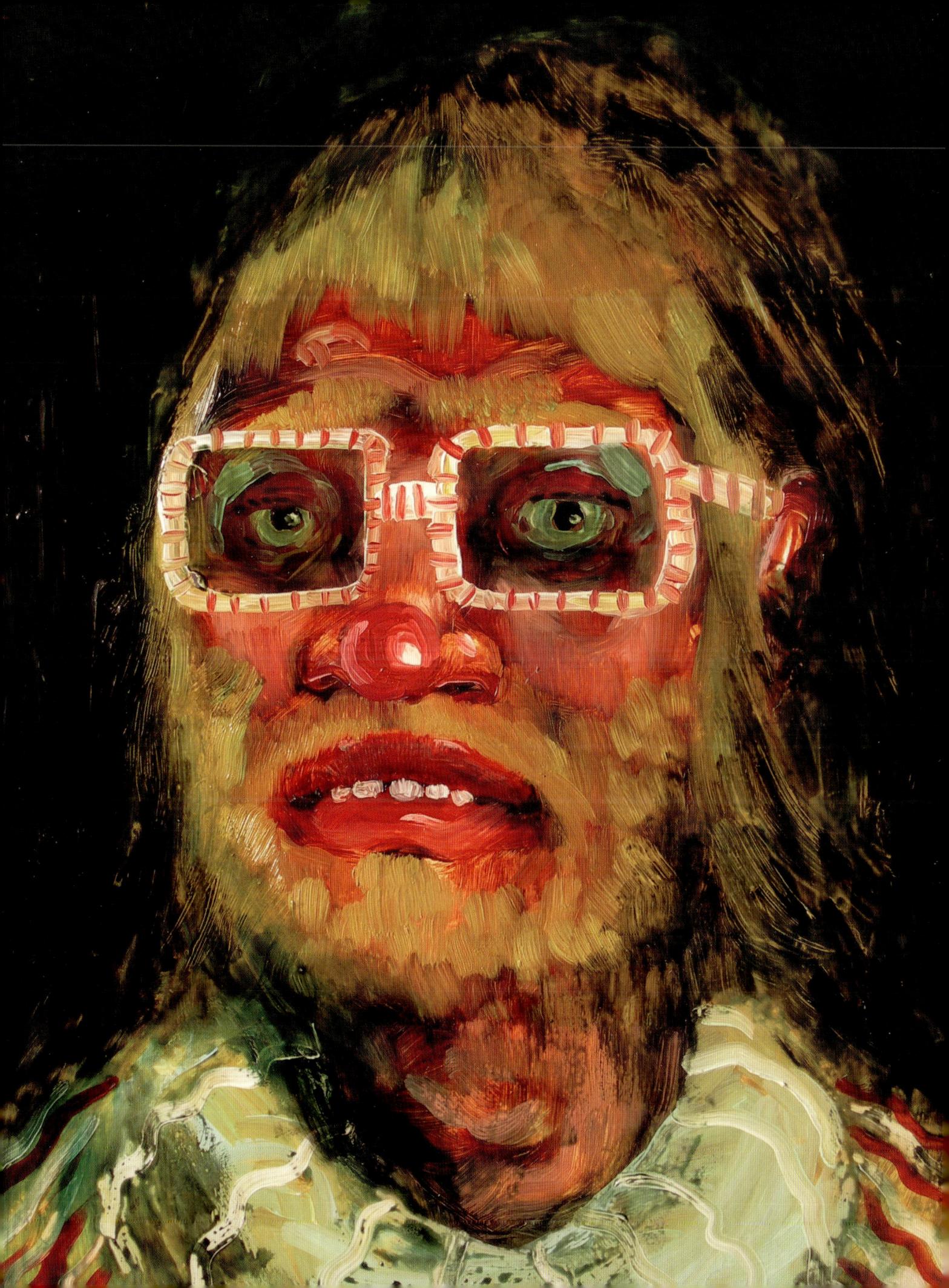

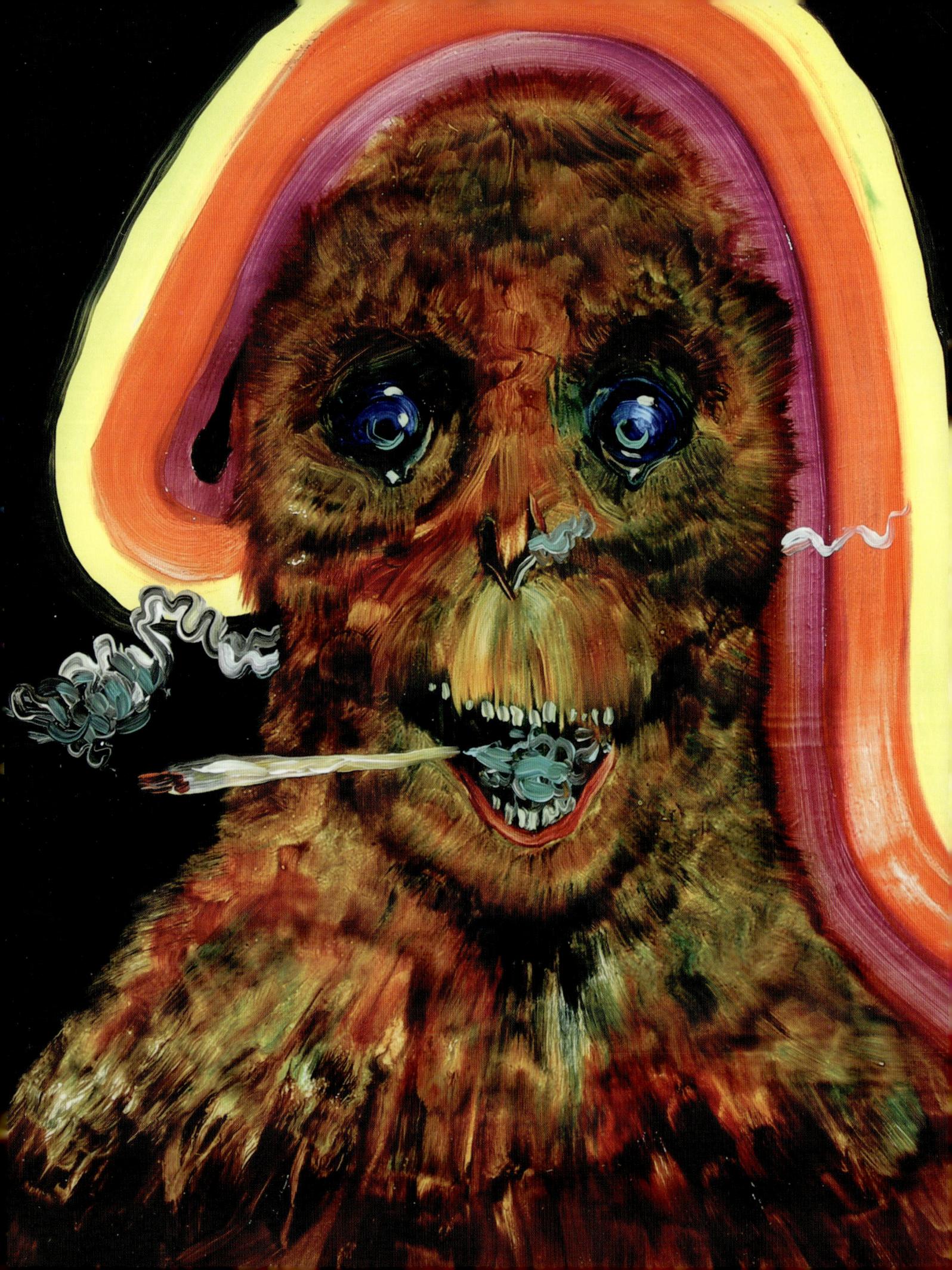

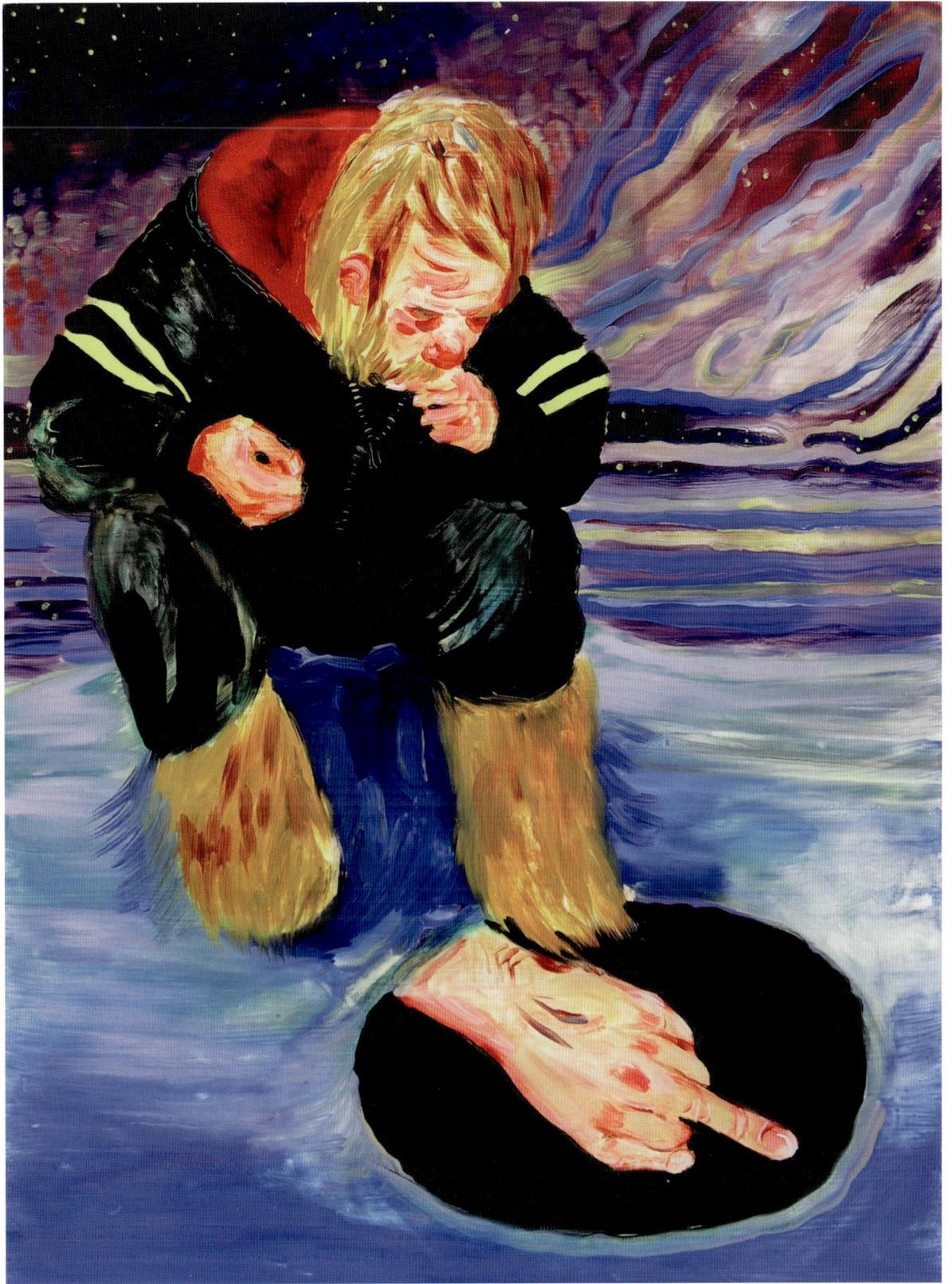

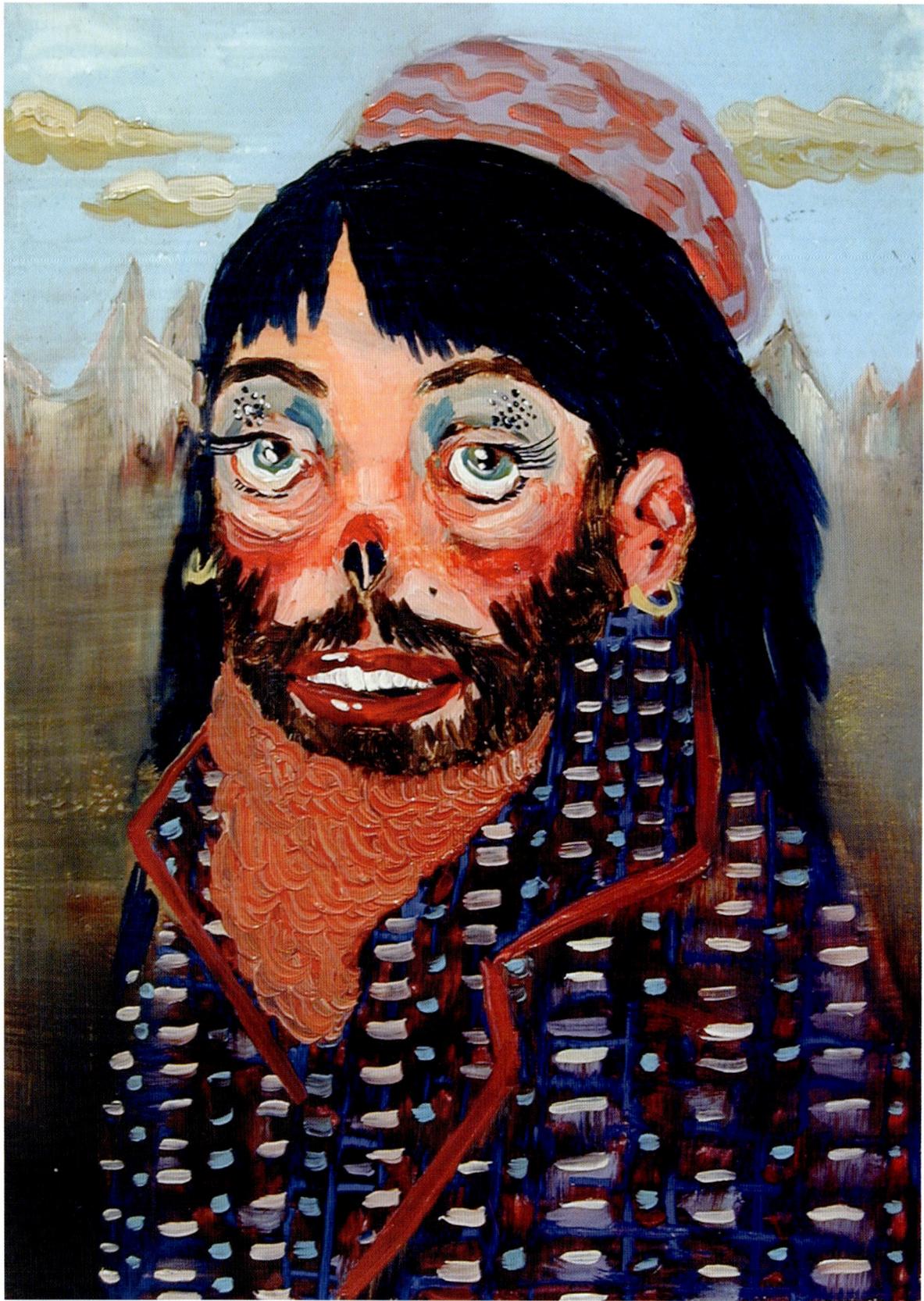

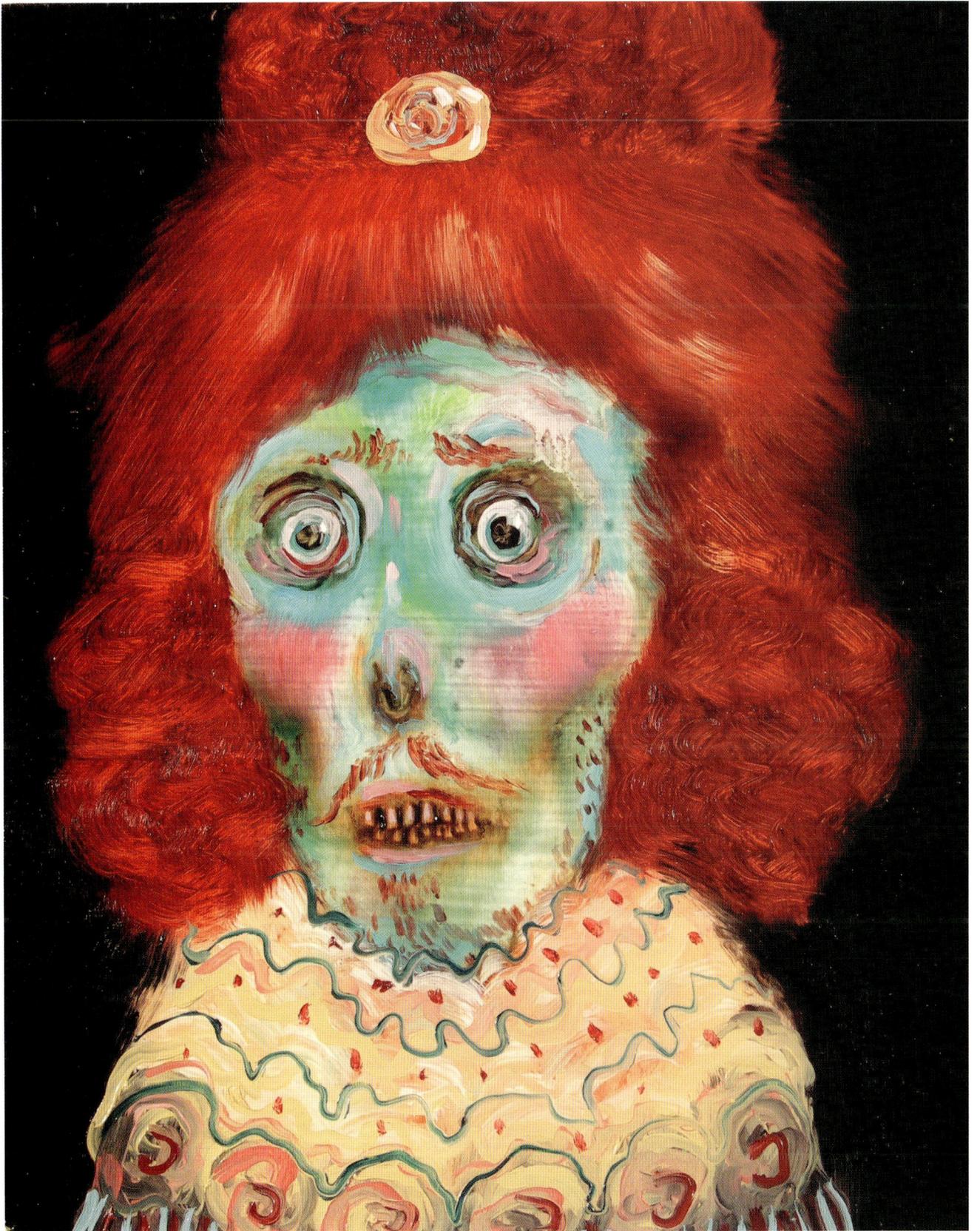

070-075: EVAH FAN
BAD HAIR DAY

Californian artist Evah Fan is interested in wordplay and language. Fond of the cold climates, five feet and one inch tall (with shoes), she is known to chew with her mouth open during meals and has unexplained urges to hunt her missing socks.
www.potatohavetoes.com

Brief Description of work submitted:
These are paintings I've done in the past year and a half. My artwork draws inspirations from weird true events, make-believes, *Twilight Zone* and connotations. With increased pun and narrative word-plays in mind, as I am very fond of language itself.

"*I'm good at paying attention to the road while walking, but I'm bad at finding my way around town. I am also good at spotting stray cats around town, but do poorly when it comes to finding my own cat around the house.*"

How was your childhood?
I recall my childhood being rather busy. Busy collecting loose paper, busy jump-roping down the streets and busy doodling while watching cartoons on Saturday mornings. I guess there's a sense of pure happiness beneath all that busy work.

Can you remember something that really made you laugh when you were a kid?
My memory escapes me. I seem to have made others laugh due to my clumsiness.

Did you cherish any grandiose dreams?
I cherish only shattered dreams that involve rapid eye movement.

What kind of teenager were you?
Hmm... I often pulled the 'five finger' discount at the stationary stores. I popped fewer pimples than I do now. I remember a record high of watching four movies at the theatres in one day. Busy eyes.

What's the worst look you can remember sporting?
Short, short haircut, super-baggy Yo-Papa gear and a hunchback to hide my chest growth.

What's the most embarrassing situation you would admit finding yourself in?
I've accidentally walked into the mens' restroom quite a few times.

When and where did it all start to go wrong?
When I read too many Roald Dahl Books. I love his stories...

How would you describe your character?
Kind-hearted yet mischievous little matchseller, note the cold winter nights with little hopes of a good meal.

Do you have a sense of humour? If so, what kind?
I would like to think that I'm humorous in one way or other. Often the kind that nobody else gets, self-amusing per se.

What did you think when you first saw your therapist?
A gossiper.

Do you laugh at yourself?
 I do! Very often! It is sensational! Highly effective in boosting low self-esteem!

Do you laugh at your own jokes?
Sometimes. Loud enough for my cat to gaze this way.

Did anyone ever take any of your jokes badly?
I don't tell very good jokes to begin with, often I just make comments that jumpstart everyone else's jokes.

What are you good at, what are you bad at?
I'm good at paying attention to the road while walking, but I'm bad at finding my way around town. I am also good at spotting stray cats around town, but do poorly when it comes to finding my own cat around the house. →p75

Opposite
'Bad hair day'

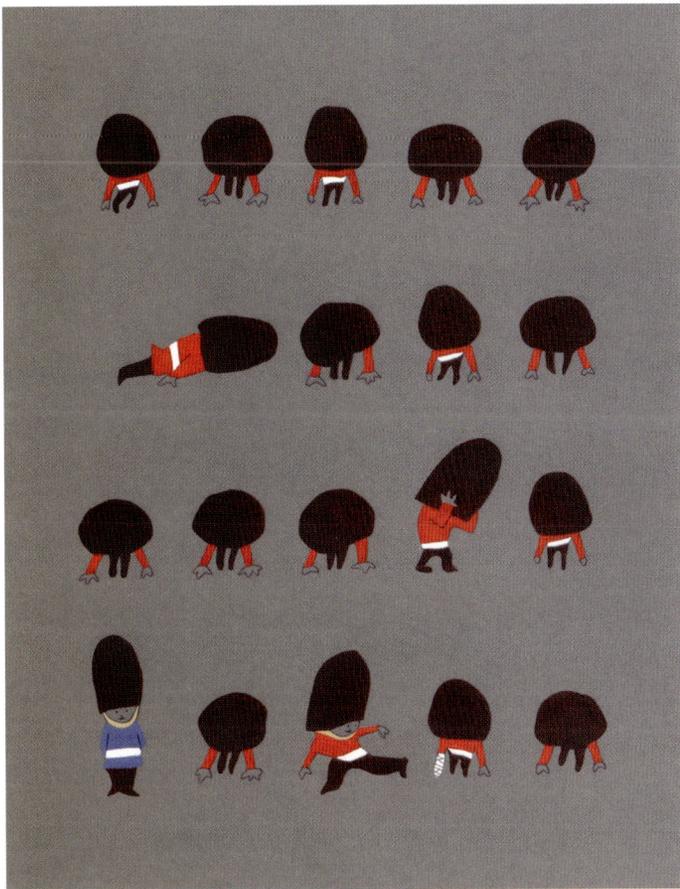

Previous page
'Caught red-handed'

Top left
'Drills'

Top Right
'Add to taste'

Bottom
'Very very hungry people'

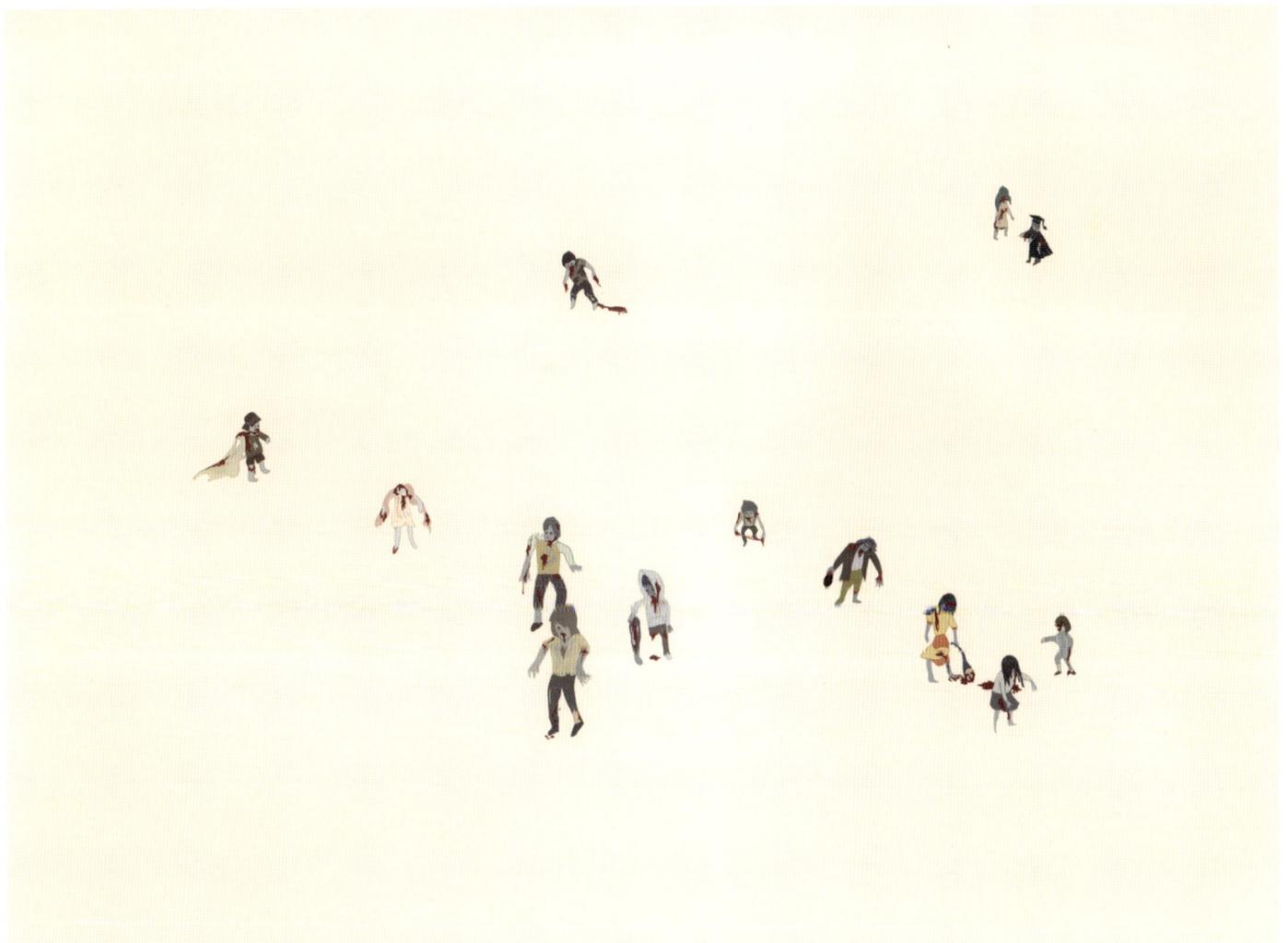

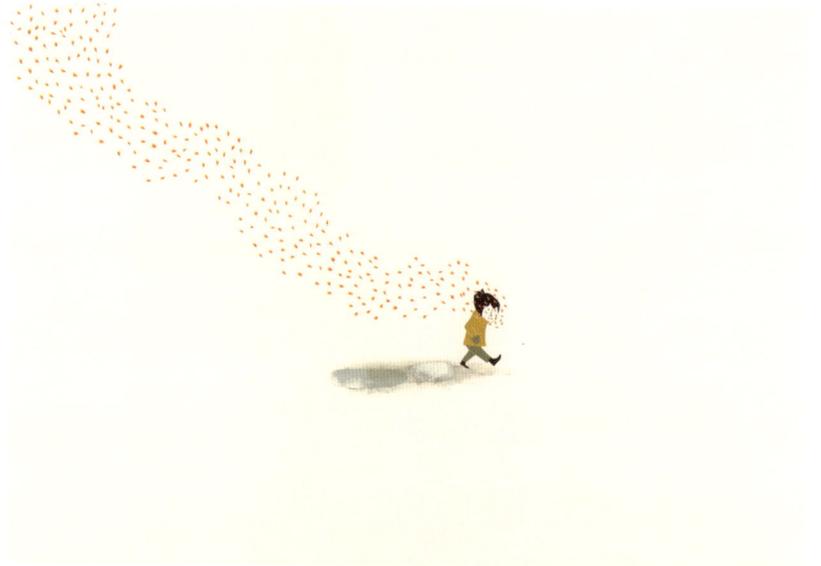

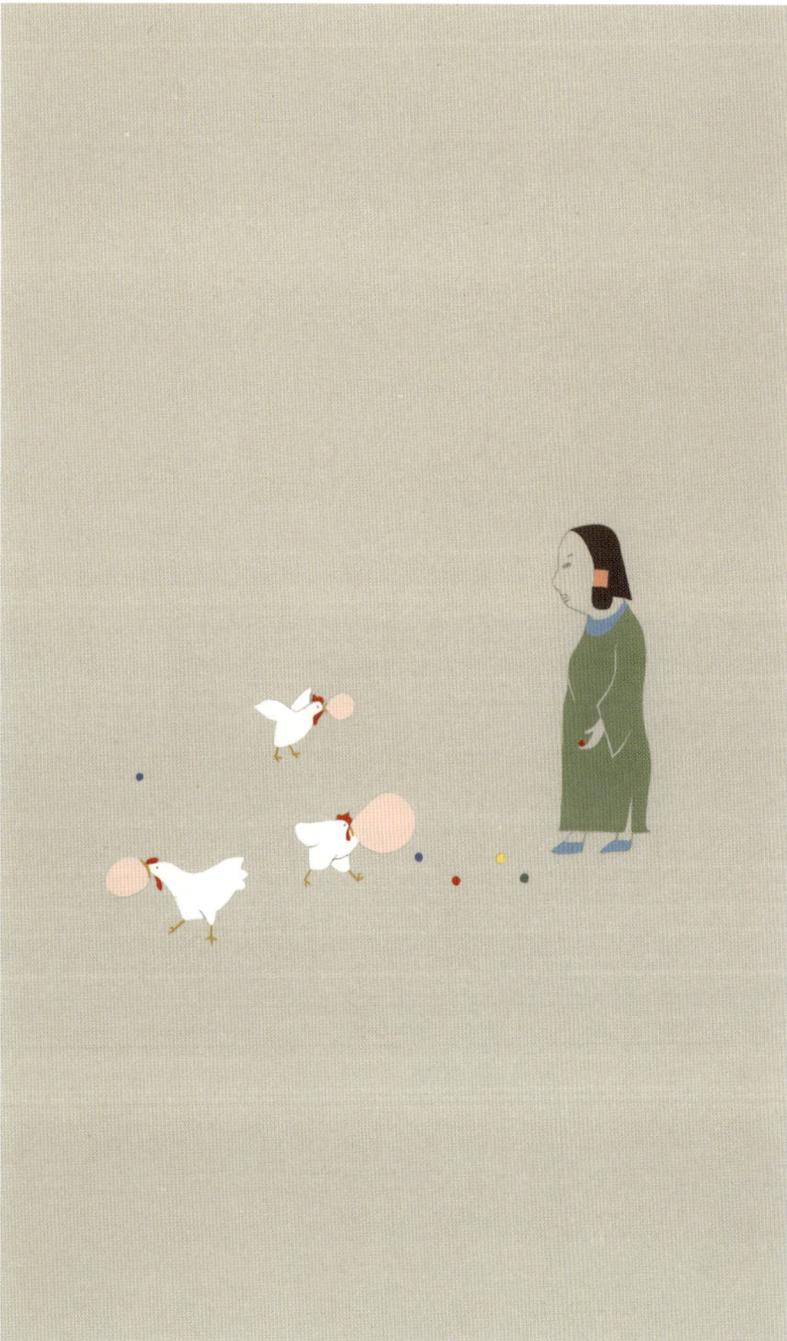

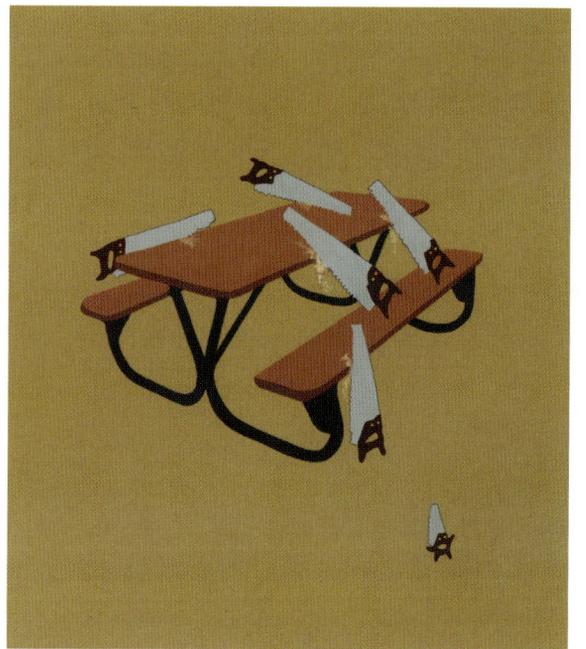

Above Left
'Race'

Left
'Breast lift '

Above Right
'Swarm '

Above
'Picnic in the woods '

Opposite Top
'Obese wan Kenobi'

Opposite Bottom
'sneaky snake'

Are you the type to exaggerate things? How much?
That's it, that's my embarrassing skill. Not too outlandish, just a little.

We noticed that some of the submissions we received seemed a little angry, possibly maladjusted. Would you say that creative people are unbalanced?
Yes! Well, I can only vow for myself, they seem to creep up like that.

In your opinion, is there such a thing as intelligent or stupid humour?
No, I think so long as it makes you laugh, it counts as some sort of humor, no need to categorize.

What/who would you consider an ideal subject for parody? Note that George Bush and Tony Blair are already taken.
Colon; large intestine.

Some people seem to see the state of the world as 'serious, but not hopeless', others see the world as 'hopeless, but not serious.' How do you see it?
Hopeless, and serious.

Do you ever feel like we're doomed? And does that make you want to laugh or cry?
Yes, we're doomed; I would like to vanish from time to time. I'll try my best to be a conscious green citizen of the world.

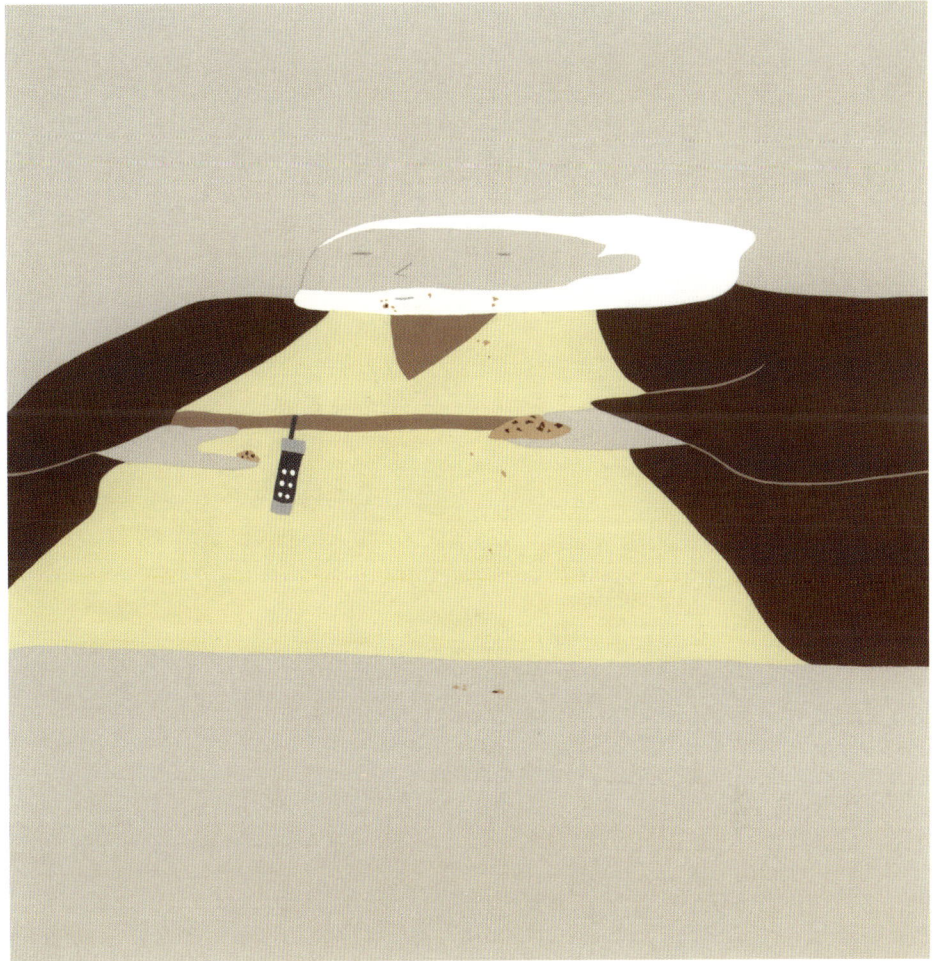

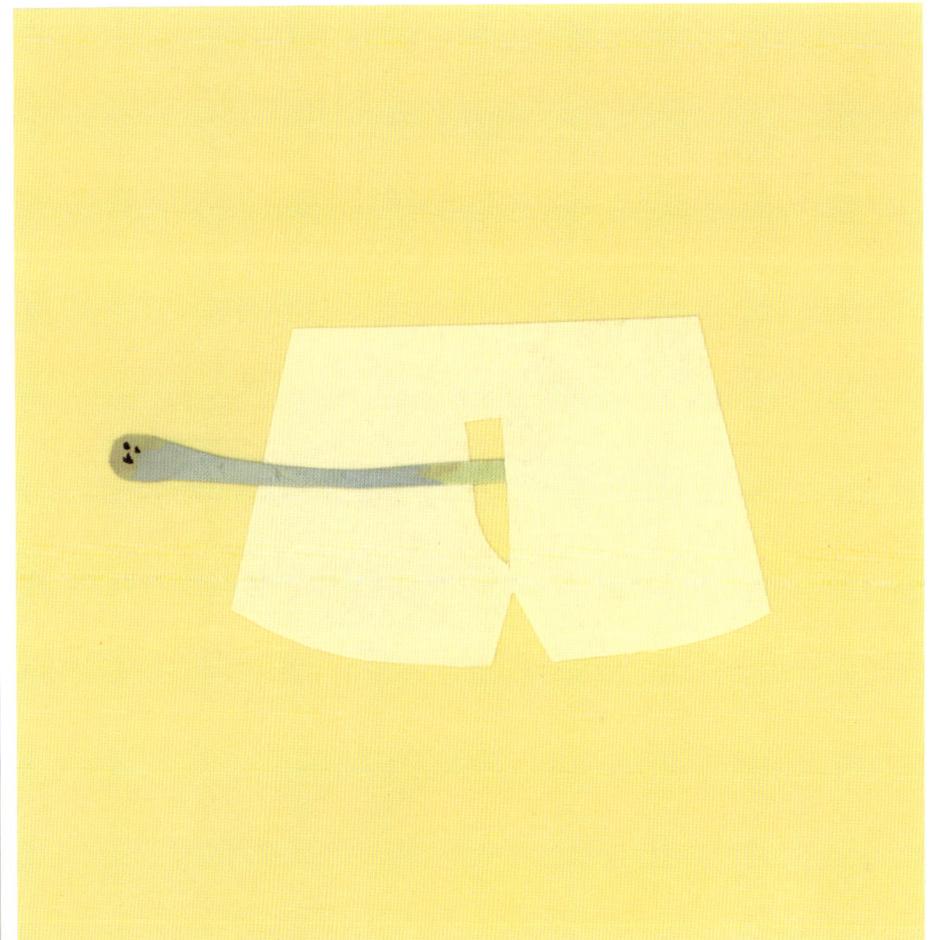

What/who do you discriminate against?
Bad drivers and inconsiderate peeps.

What's your favourite satire film, and what was your favourite scene?
Harold and Maude's social satire. I loved his realistic mock suicide scenes.

What would you say is definitely NOT your motto?
Don't worry, be happy, crap!

Our maintenance man Steve tells us he's addicted to shegods.com. We're doing everything we can to help. Do you have any addictions?
Nicotine, it keeps me sane.

Have you started reading self-help books yet?
My friend once gave me one of Dr Phil's books to lift my spirits when I was depressed. I found it silly. The book is in perfect condition if anyone wants to check up on it!

"Yes, we're doomed; I would like to vanish from time to time. I'll try my best to be a conscious green citizen of the world."

FULGURU
PAPER INVASION

Cedric Decroux, Yves Fidalgo. A Swiss-based design duo from Lausanne. (tick tock, tick tock, tick tock).
www.fulguru.ch

Title of work submitted: Paper Invasion
Date of completion: 2003

How was your childhood?
Cedric: An ocean of cheese fondue.
Yves: As sweet as a day of winter.
Can you remember something that really made you laugh when you were a kid?
C: Tickling under the arms.
Y: Making a hole with a nail and hammer on the old coke bottle caps, then shaking it until it burst like a volcano, then drinking the rest of coke, and starting again.
What kind of teenager were you?
C: Spots and Doc Martin's.
Y: Back of the class.
What's the worst look you can remember having?
C: Too many to remember.
Y: The one I am having now actually.
When and where did it all start to go wrong?
C: One year after my birth: I tried to eat a car.
Y: Two weeks before my birth: the day I was supposed to be born.
If you were to place yourself in a novel, how would you describe your character?
C: David.
Y: Goliath.
Do you have a sense of humour? If so, what kind?
C: Yes, a good one.
Y: Of course not.
What did you think when you first saw your therapist?
C: She's sexy.
Y: I am looking forward to meeting her.

Do you laugh at yourself?
C: Yes.
Y: Depends if I am alone.
How often?
C: As much as possible.
Y: Whenever I am alone.
How does that feel like?
C: Funny.
Y: Lonely.
Do you carry any crosses?
C: Palmate toes.
Y: The one on our flag
What/who do you discriminate against?
C: Mosquitos
Y: Words starting with "Y"
Do you have any addictions?
C: Cheese fondue
Y: Pepper
Do you have a nickname? And how do you feel about it?
C: Z, it's a long story
Y: Yves is short enough, please don't remove anything from it.

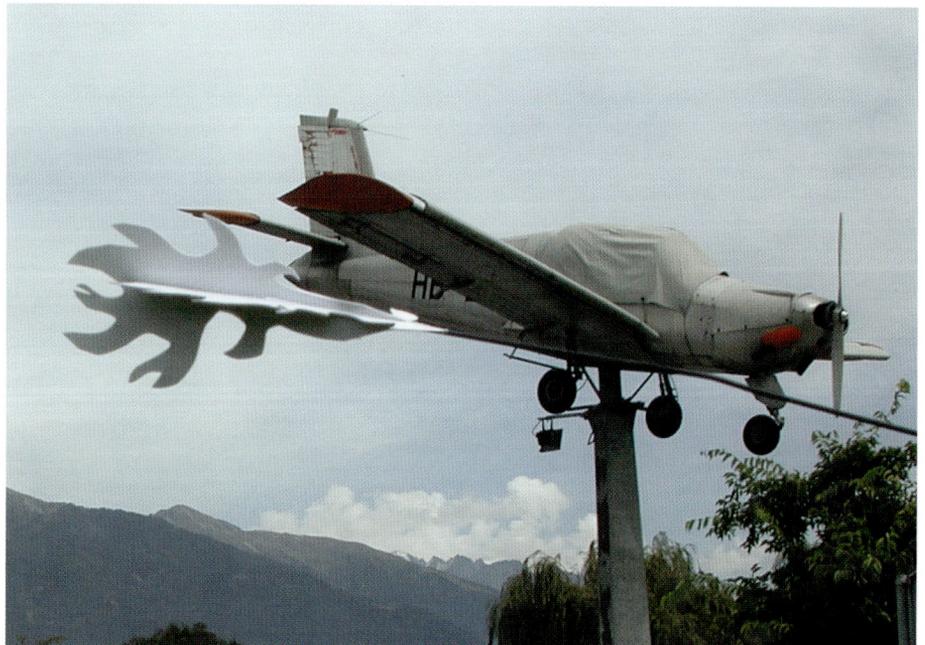

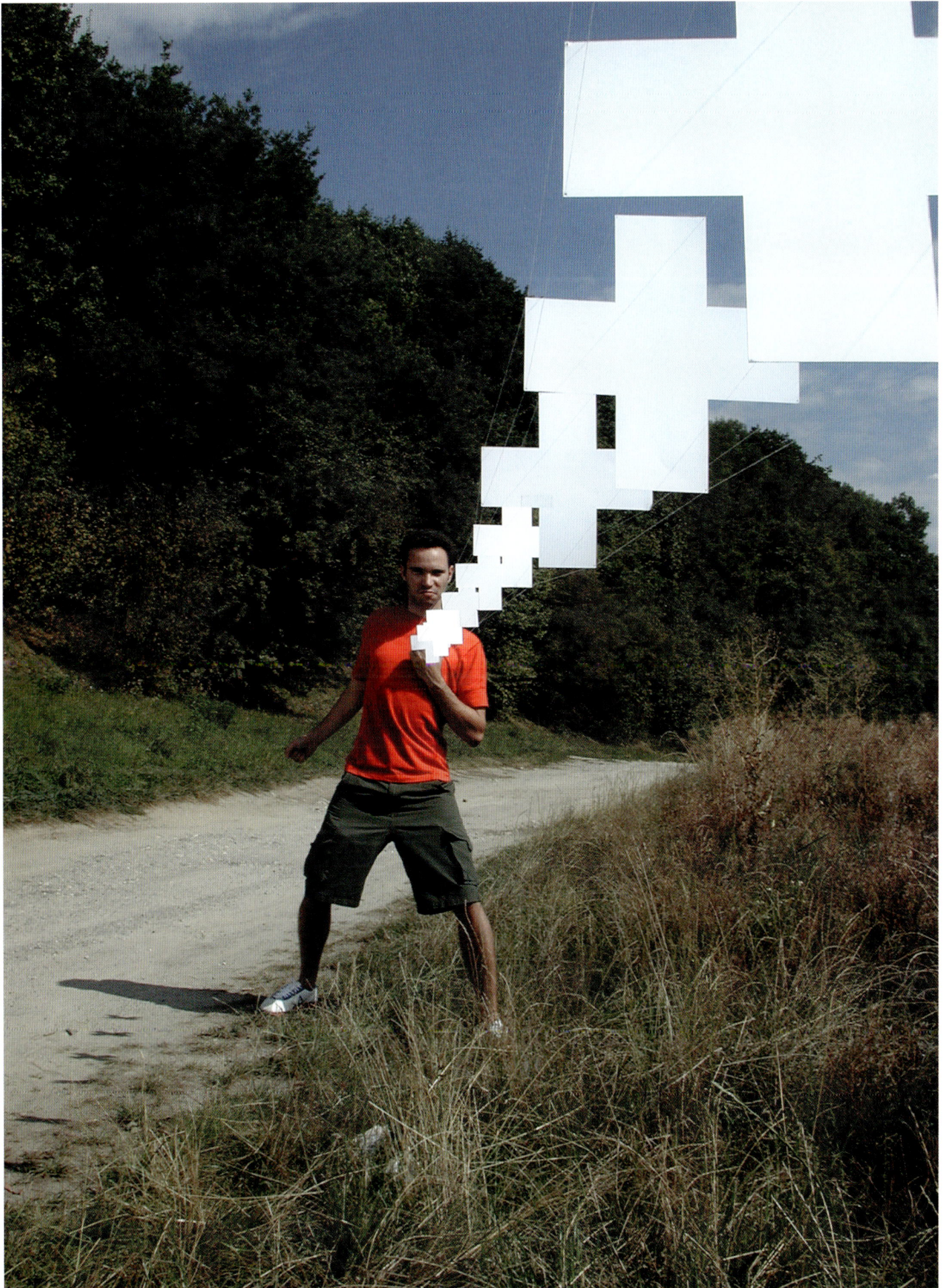

080–083:
STEVEN GUARNACCIA
SEND IN THE CLOWNS

Steven Guarnaccia is Associate Professor of Illustration and Chair of the Illustration Department at Parsons The New School for Design. He was previously art director of the Op-Ed page of the *New York Times* and the author and illustrator of numerous children's books, as well as books on popular culture and design.

Brief Description of work submitted:
I found myself obsessively drawing these clowns in my sketchbook, and wondered where they came from. They certainly bear some relationship to early French clowns. But they probably bear just as much relationship to the illustrated man at the circus. It's as if the clown make-up won't wipe off. I'm neither a fan nor afraid of clowns. But I do like the idea of the face covered with images. And I can't stop drawing them. Though now I seem more interested in drawing their pets. Are they funny? Are clowns funny?

How idyllic was your childhood?
Hospital-bed-bound with rheumatic fever. Missed out on socialisation through sport. On the other hand I got lots of drawings done while the other kids were playing Little League.

Can you remember something that really made you laugh when you were a kid?
Making crank phone calls with my best friend, pretending to be gimpy walking down the street.

What kind of teenager were you?
Obedient, dazed by girls.

What's the worst look you can remember sporting?
Short curly hair on sides and top, long enough in back for the kid behind me to bury 20 pencils in it.

What's the most embarrassing situation you would admit to finding yourself in?
Fourth grade. Fly zipper stuck in the down position coming out of the boy's room.

When and where did it all start to go wrong?
When I realised there's no such thing as a famous illustrator.

Do you have a sense of humour?
I think I'm polymorphously humorous.

What did you think when you first saw your therapist?
He's not getting anything out of me.

Do you laugh at yourself? What does that feel like?
Yes, all the time. Ruefully familiar.

Do you laugh at your own jokes? How loud?
No, but I tell them with avid anticipation in my eyes.

Are you the type to exaggerate things?
I exaggerate more than any living soul on the planet.

What/who would you consider an ideal subject for parody? Note that George Bush and Tony Blair are already taken.
Ceci n'est pas une pipe.

Some people seem to see the state of the world as 'serious, but not hopeless', others see the world as 'hopeless, but not serious'. How do you see it?
Neither serious nor hopeless. More hopious than seriless.

Do you have any theories about the world we live in?
Life is neither too long nor too short.

Do you carry any crosses?
I'm a keyboard dyslixec.

What/who do you discriminate against?
The poorly written.

What's your favourite satire film, what was your favourite scene?
Dr Strangelove. Peter Seller's apologetic phone call.

What's your favourite children's book?
Alice in Wonderland.

Do you have a nickname? What is that? And how do you feel about it?
Steve-o. Only one person calls me that, so it's ok.

What would you say is definitely NOT your motto?
Slow and steady wins the race.

Do you have any addictions?
Book-buying.

Have you started reading self-help books yet?
The Book of Nonsense.

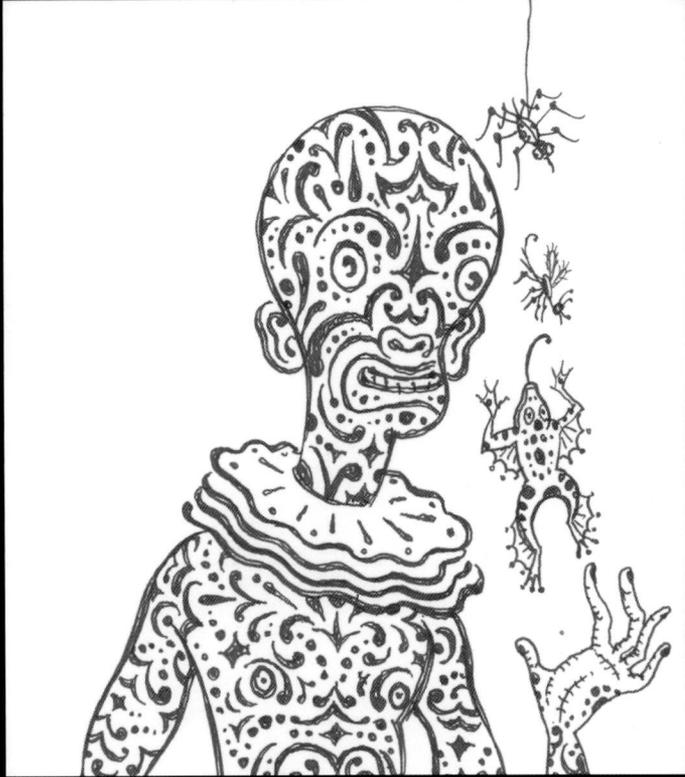
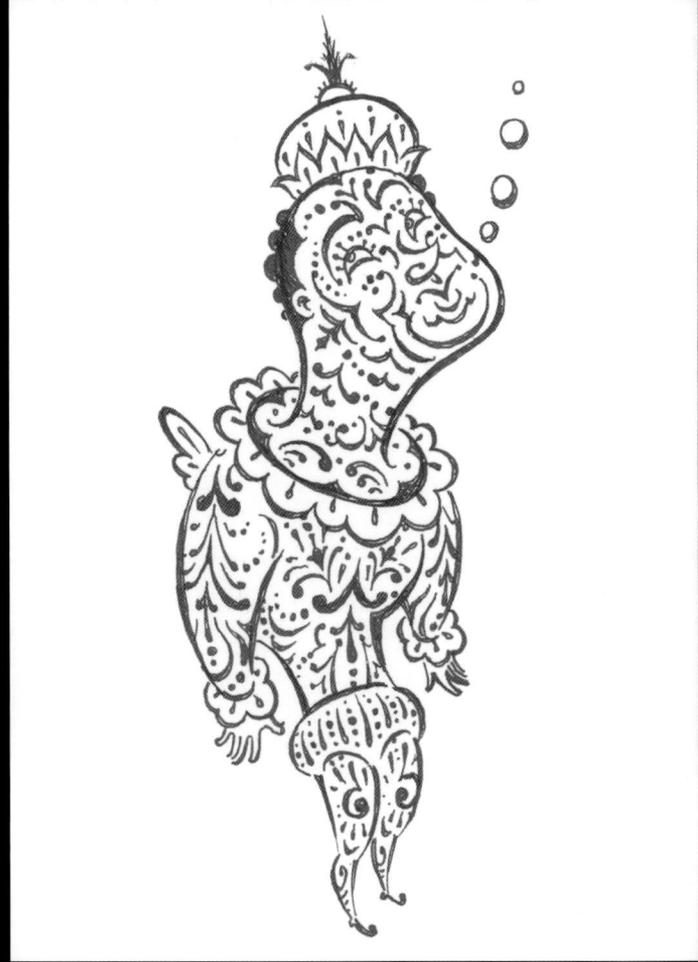
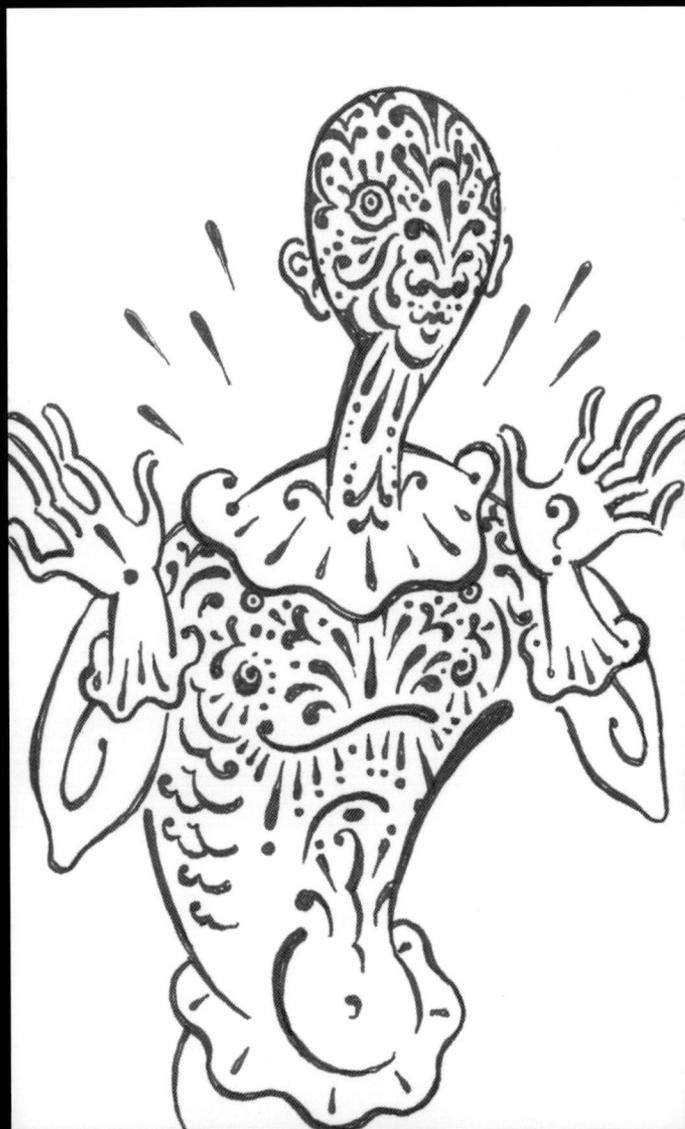
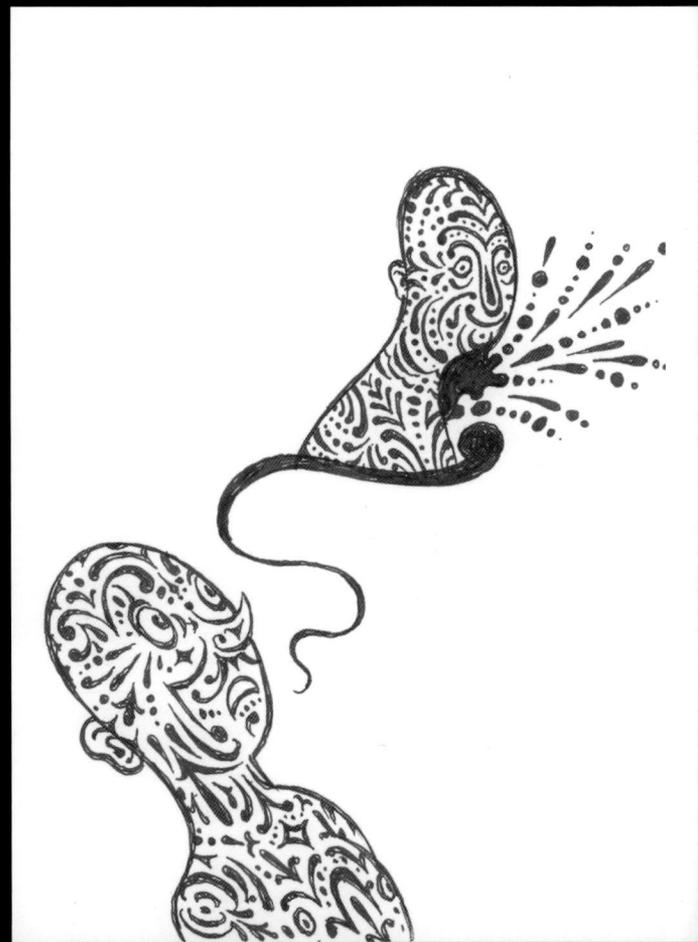

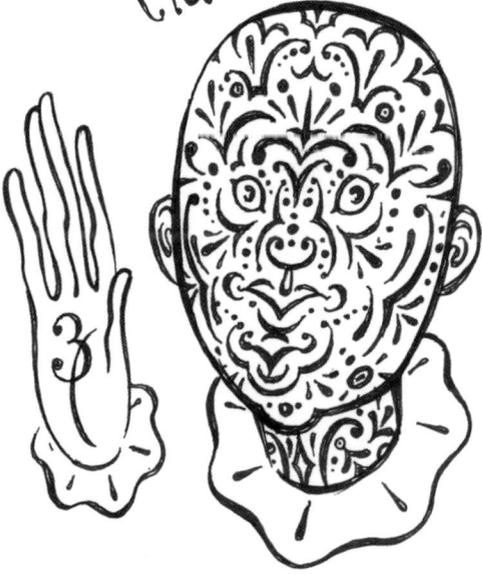

class clown

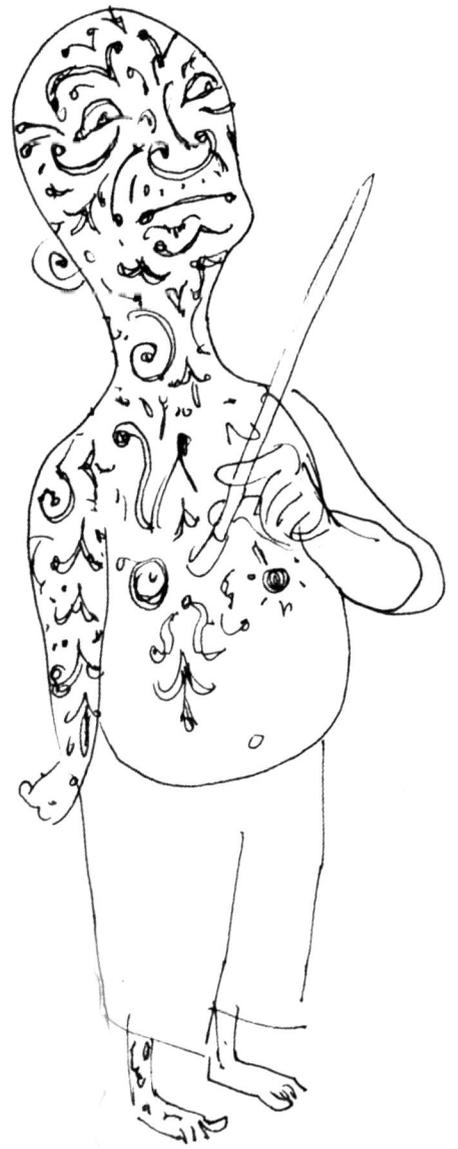

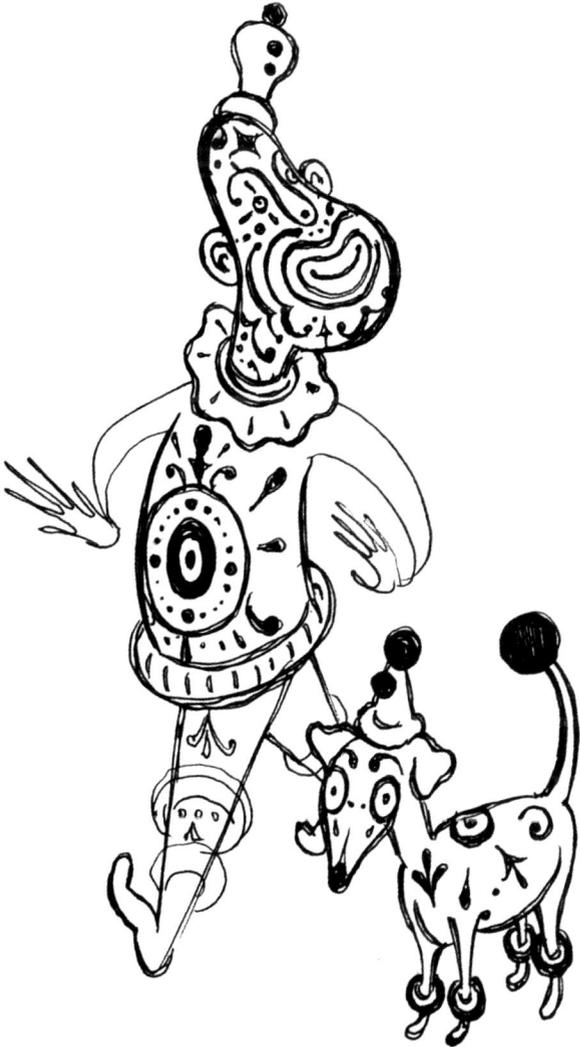

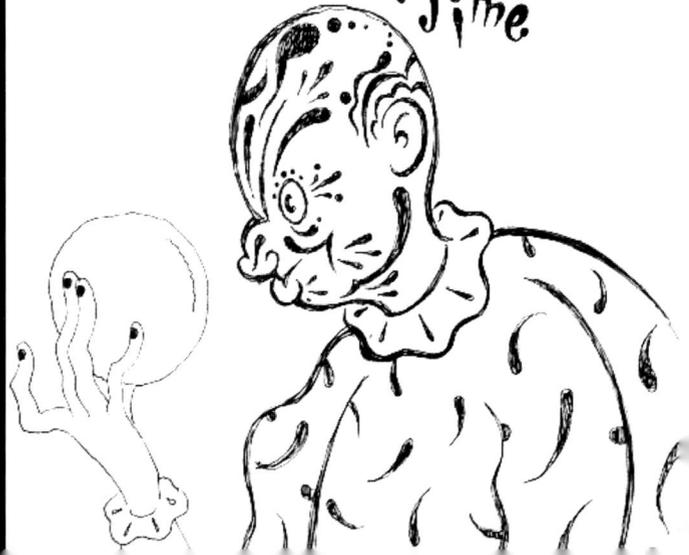

CLOWN Time

084–087:
CHRIS HAUGHTON
HIDING

Chris Haughton was born in Dublin and studied design and illustration at Ireland's National College of Art and Design. After working in Hong Kong he moved to London where he now illustrates for several magazines and newspapers including *Time*, the *Guardian*, the *Times*, the *Independent*.
www.vegetablefriedrice.com

"*I nearly got punched on a train in Russia when I was just trying to make conversation with this guy. I don't know what the hell he thought I was saying. I had had a few beers though.*"

How was your childhood?
It was ok. Kind of normal, I suppose

Did you cherish any grandiose dreams?
Erm... nothing too exciting. I think I wanted to be an archaeologist for ages because of a dinosaur book I had.

What's the worst look you can remember sporting?
It came from my father and it was one of scorn and derision.

What's the most embarrassing situation you would dare to admit finding yourself in?
When I was working as a waiter in a restaurant in San Francisco, all the Mexican guys in the back found a pile of semi-pornographic gay magazines in my bag (I found them in a bar or somewhere). I had to spend the whole summer telling them I wasn't gay and they were pinching my ass every time I went into the kitchen.

When and where did it all start to go wrong?
It's been ok so far, thanks Richard.

What did you think when you first saw your therapist?
I don't have a therapist but I would like one. I went to the Freud Museum a few months ago and it made me think that it would be really good to have a therapist.

Do you laugh at yourself?
Not really. I cringe at myself a lot. I forget things so often that it's not funny at all. I lock myself out about once every month.

Do you laugh at your own jokes? How loud?
I used to completely work from home on my own. My flat mates would all have gone to work/college and I'd wake up at about eleven and try to start working away on my own. I'd come up with stupid ideas that aren't very funny, but I'd start thinking they were hilarious and go way off on a tangent... then two hours later I'd think it was all really crap and I'd say to myself 'What am I doing?'. That's OK for a while but after a few months you can feel yourself losing it. I'm in a studio now with other people, so it's a bit better.

What's the most inappropriate place/time you have ever laughed?
Probably at some film that I thought was funny but wasn't. You know the scene in *Happiness* where Philip Seymour Hoffman's character is crazy about his next-door neighbour, but when he goes into her flat he can't think of a word to say to her? I don't think I was supposed to laugh at that bit. That whole film is hysterical. Also, at work, a girl told me that when she was younger her family was too poor to buy HobNobs. She wasn't joking.

Did anyone ever take any of your jokes badly?
I nearly got punched on a train in Russia when I was just trying to make conversation with this guy. I don't know what the hell he thought I was saying. I had had a few beers though. I think he had too. I had to move down the other end of the carriage.

What are you good at, what are you bad at?
I'm very good at not leaving the house.

Do you work with other people?
I mostly work away in my own room in a large studio space, I worked in a fairly large animation studio for a while, but I came to the conclusion that it was better for me to work on my own before I killed half of the people I was working with.

Are you the type that exaggerates things? How much?
Not really. I'm very excitable though. I'll get really excited one day about something, but the next day I'll have totally forgotten about it.

What/who would you consider an ideal subject for parody? Note that George Bush and Tony Blair are already taken.
I'm finding it hard to think of people or things that wouldn't be ripe for parody. Advertising is a good one but it's a bit too obvious because everybody knows its all just shit.

Do you have any theories about the world we live in?
I don't have anything approaching a theory, but I really like the saying 'bad is never good until something worse happens'.

What/who do you discriminate against?
People with different opinions to mine. They're idiots.

What's your favourite children's book?
Alice In Wonderland. It's brilliant.

Do you have any addictions?
Not really. I drink a lot of coffee but I don't even really like it. I think I only do it because getting up to boil the kettle every twenty minutes is a good way of not thinking for a few minutes. I'm probably addicted to the internet.

Have you started reading self-help books yet?
I don't start doing that. Is that what happens? I always wonder why those sections are so big in the bookshops. I read a great book called *Zen Mind, Beginner's Mind,* which is almost like a self-help book written in very strange English.

Opposite
'Hiding'

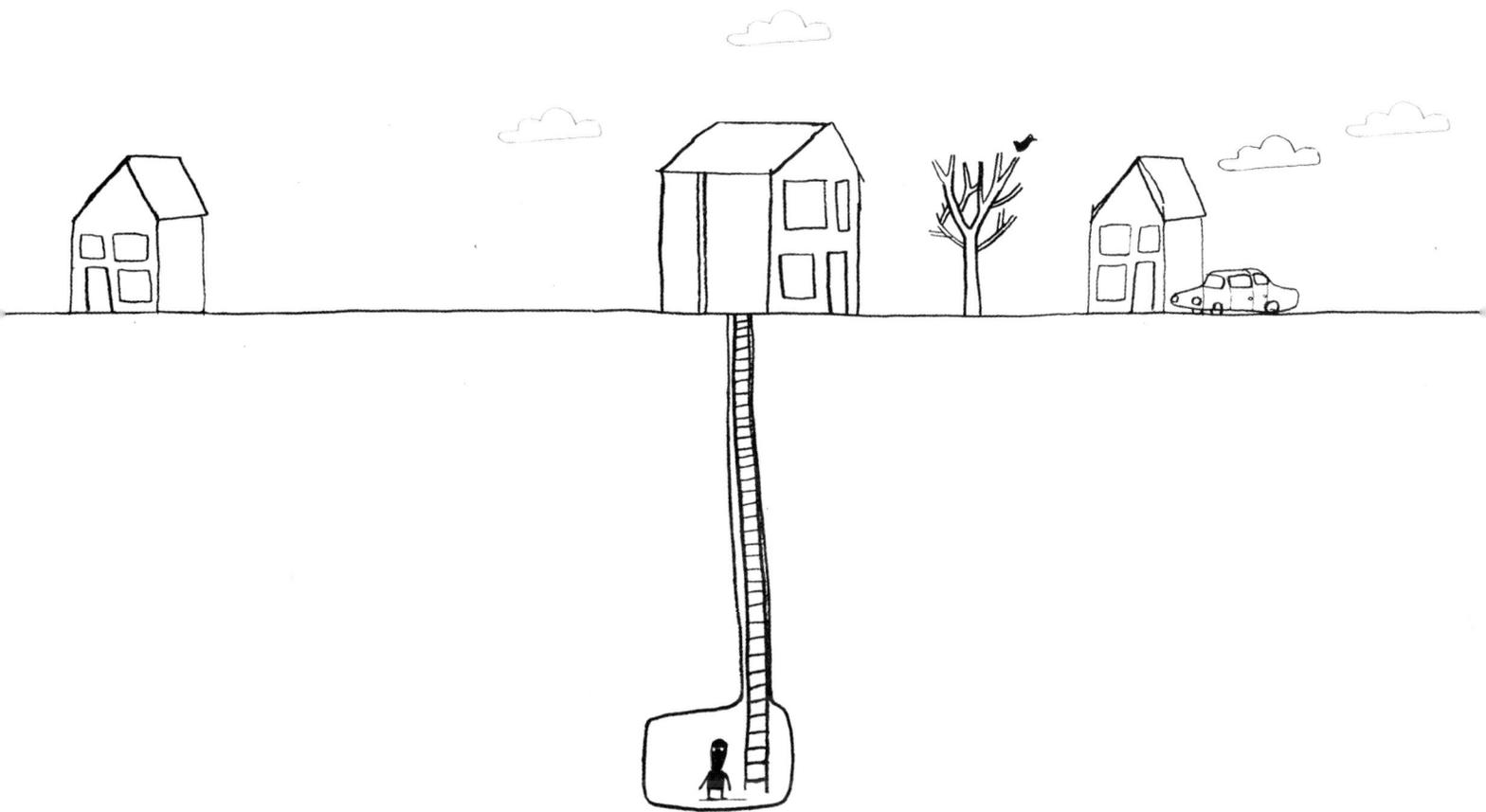

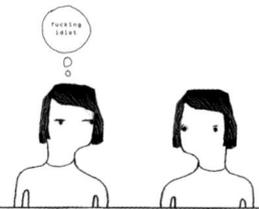

congratulations!

088-093:
ANDREW JAMES JONES
OOOOOOOOH

Andrew James Jones grew up in North Wales. At eighteen he moved to Bristol to embark on an environmental science degree which he had no interest in whatsoever, dropping out he began to drink and draw. Evicted, he found himself living in York, where he was introduced to a wider world of art, which lead to him moving to Cardiff to complete his degree in fine art. Qualified and an egg and cress sandwiche under arm, he moved to London and watched his money burn...
www.stolenideas.com

Date of completion: 2006
Brief Description of work submitted:
Combining found photography, hand drawn imagery and writing the work submitted is a small slice of my ongoing investigation into the notion of the contemporary grotesque. Clashing the disparate concepts of the abject and the humorous into a single and contained image in an attempt to activate a fluctuating unresolved response within the audience.

How was your childhood?
It was rather good as I lived on the an estate on the side of a mountain in north Wales so there was equal measure of trouble and nature.
Can you remember something that really made you laugh when you were a kid?
I saw a seagull explode.
Did you cherish any grandiose dreams?
Not really, I know my place.
What kind of teenager were you?
A tall one.
What's the worst look you can remember sporting?
I think 'Heavy Metal Musketeer' was a particularly bad one.
When and where did it all start to go wrong?
What do you mean 'wrong'?
Do you have a sense of humour? If so, what kind?
No. None whatsoever.
What did you really think when you first saw your therapist?
Where's my choc ice?
Do you laugh at yourself? How often? How does that feel?
It feels good at first, but then it makes me angry and usually ends up as a cry.
What's the most inappropriate place/time you remember laughing at?
When a friend had an epileptic fit.
What are you good at, what are you bad at?
Good at evading responsibility, bad at putting it back together.
How do you see the world?
At the top of its game.
Do you have any theories about it?
Yes and no.
Do you carry any crosses?
Premature ejaculation.
Do you ever feel like we're doomed? And does that make you want to laugh or cry?
What is all this 'we' business? You are doomed and it makes me laugh.
What's your favourite satire film, what is your favourite scene?
Dr Strangelove, the bit where they chase him up the stairs and he throws down the cans of paint on ropes and it smashes them right in their faces.
What would you say is definitely NOT your motto?
Meat is murder.
Do you have any addictions?
I might as well face it: I'm addicted to love.
Have you started reading self-help books yet?
I am currently reading Cut It Out, a guide to self-surgery so I wont die.

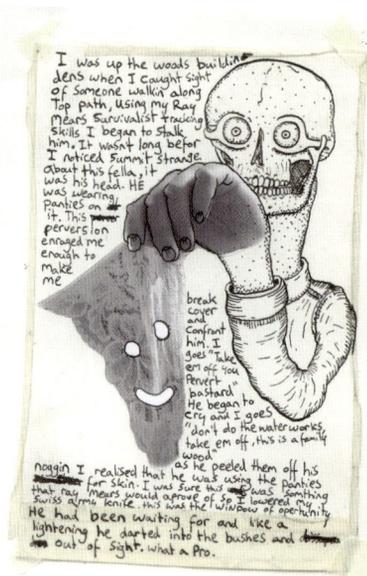

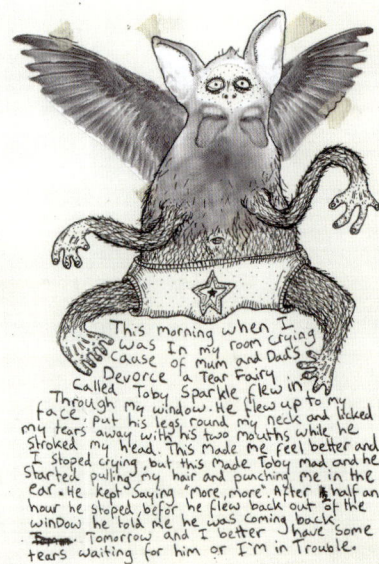

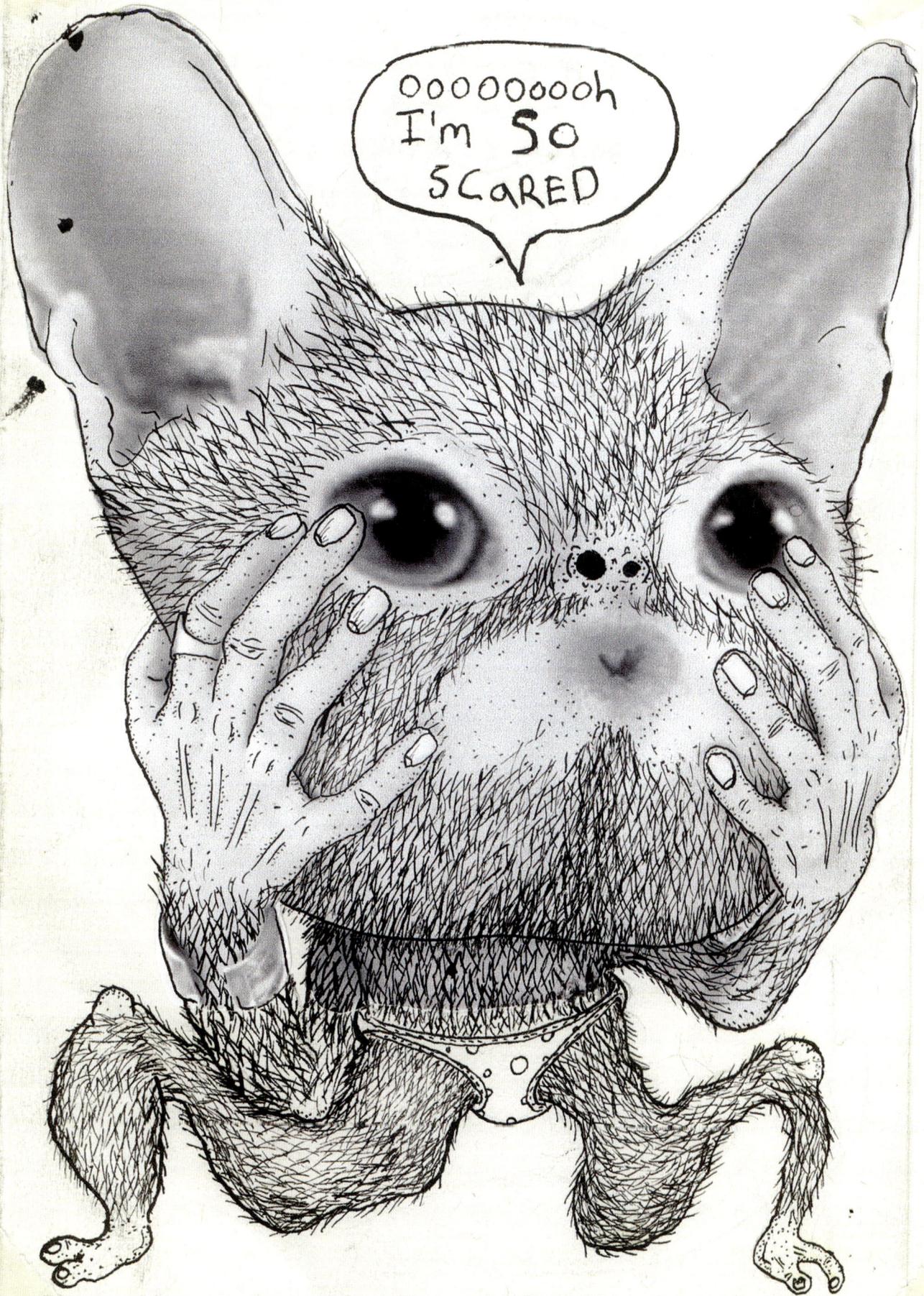

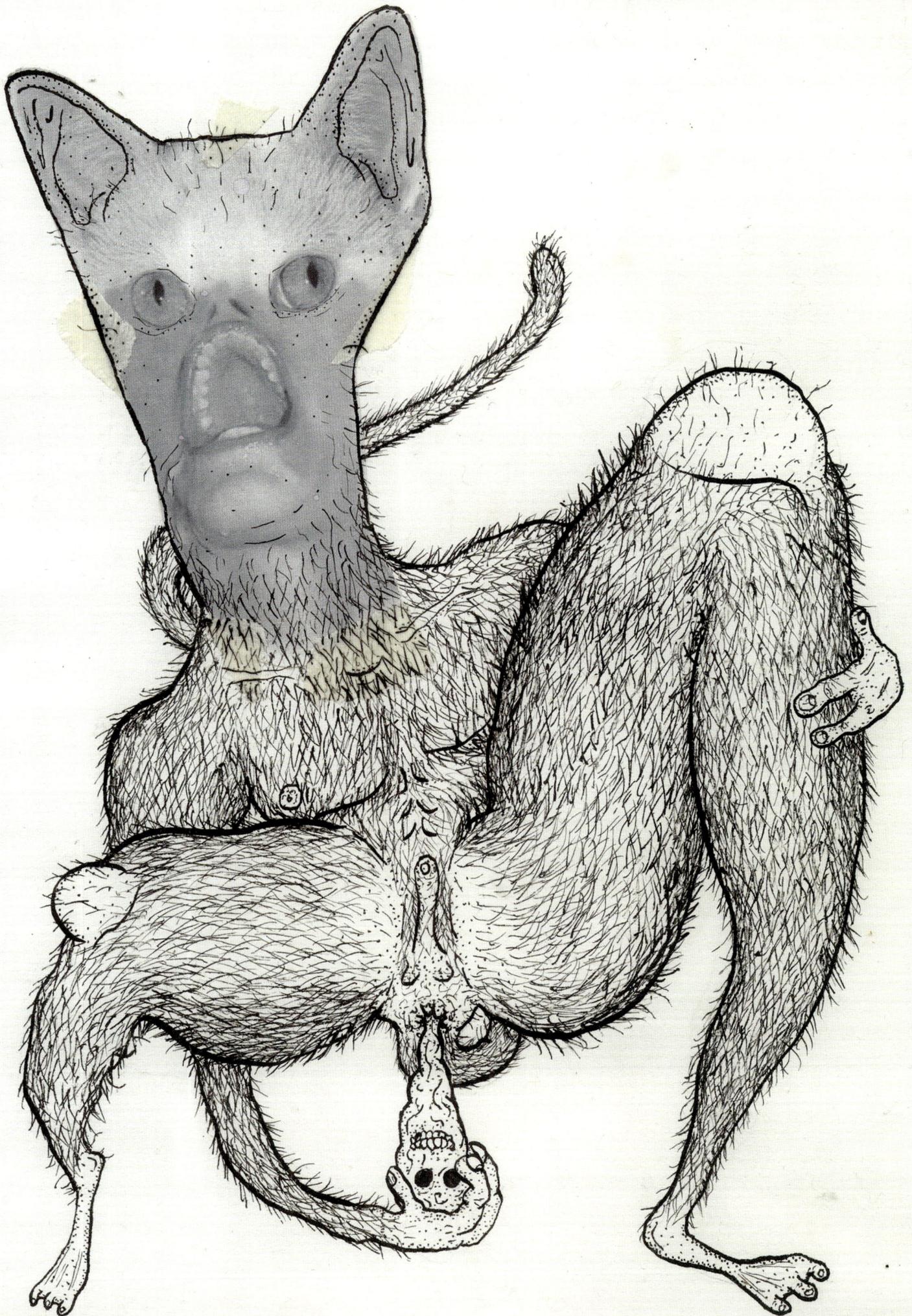

They was all
in a
circle
Round
Peggy
Philips
and they
was all
pointing
at her
lolly
stick
replacement
teeth
and pissing
it right in
her face like.
I thought this
to be a bit ~~far~~
fuckin harsh and
began to let them
know it, but
befor I had a
chance to go
off on one
propper I
caught sight
of the joke that was
written down the length
of ~~the this~~ her Third
incisor and found
myself pissing it along
with the rest.

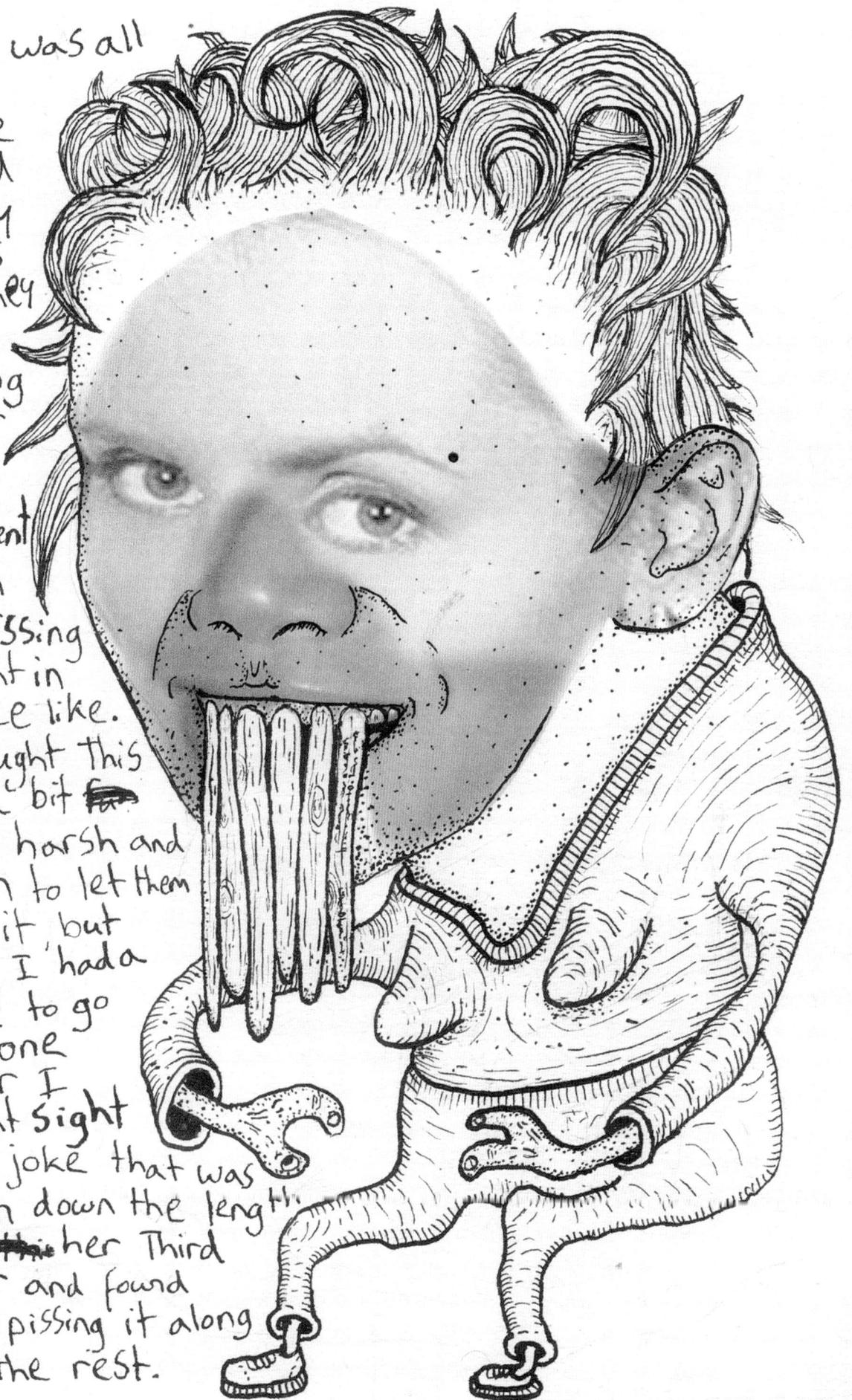

kenneth launched at them with his lucky lump hammer and caved in Neil's wife and kids right in his face. WE watched Neil's expressions go from shock to sad to pissin' livid. Neil looked like he was about to snap an attempt to do a killing on kenneth but then Dave cleverly popped a tortilla chip in his mouth, Taken aback he began to chew and ~~a~~ a smile spread, then he pulled a funny face, we ~~at~~ all burst out ~~laughin~~ laughing and had a pillow fight it was great, those guys are double mega crazy mental.

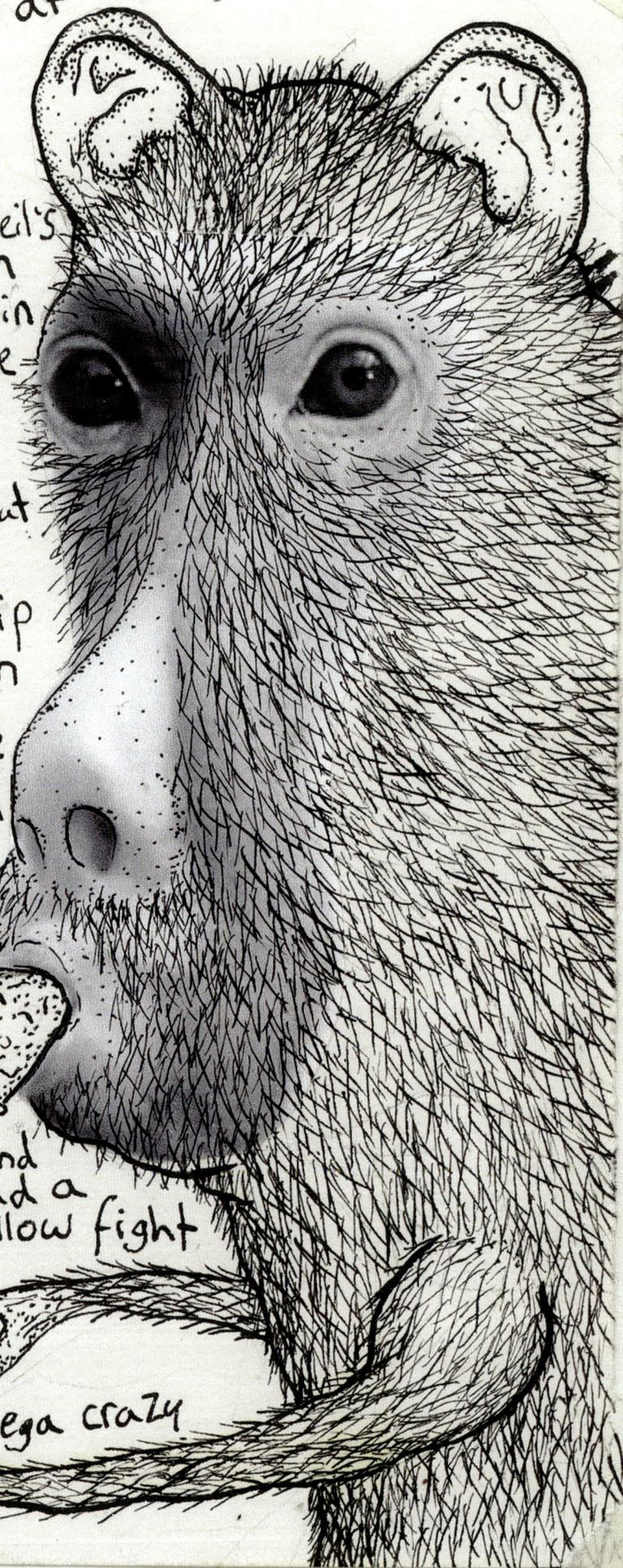

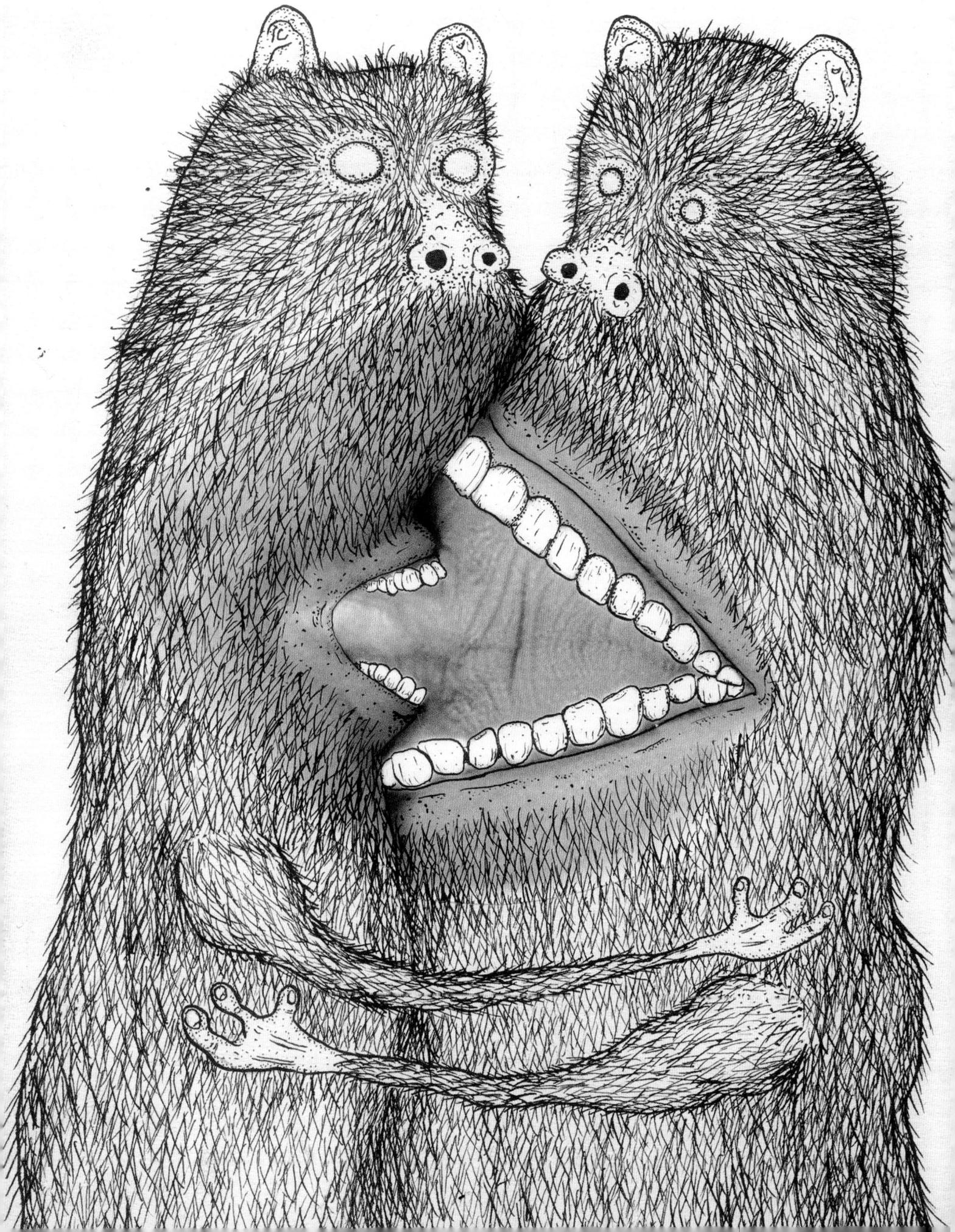

THIS IS THERAPY

Born in Liverpool, home of petty crime, Ringo Starr, and the phrase 'do one shitehawk', London-based illustrator has produced artwork of varying standards for ten years since a widely misspent education. Sometimes he draws stuff for grown-up publications such as The Guardian and The New York Times. Sometimes he whores himself out for brands such as Orange, Vodafone, and Nissan. Mostly he likes to do nothing in particular, for which his talent knows no bounds.

"'Adrian' can be abbreviated in quite a few ways, although the ingenuity of 'Aids' at the height of the epidemic's notoriety rankled me a little."

How was your childhood?
Everything was blissful until I became aware that my actions had consequences.

Can you remember something that really made you laugh when you were a kid?
Monkey Magic. My sister on roller skates.

Did you cherish any grandiose dreams?
I cherished (and still cherish) sleep.

What kind of teenager were you?
… I dunno.

What's the worst look you can remember sporting?
Tight blizzard-wash jeans, mirrored aviator sunglasses (bought from local chemist for £3.99), blue waistcoat, mum's white blouse, coral necklace, espadrilles. Kind of 'Sonny Crockett meets Nick Kershaw'.

What's the most embarrassing situation you remember finding yourself in?
Bumping into a girl I fancied from school in the queue for 'It's a Small, Small World' in Disneyworld, Florida, wearing a Goofy baseball cap and the mirrored aviator sunglasses.

When and where did it all start to go wrong?
Disneyworld, Florida, 1988.

How would you describe your character?
The opposite of 'tall, dark and handsome'… 'short, lightweight, and kind of unconventional in the looks department'.

What did you think when you first saw your therapist?
I hold no courtship with fruit cakes.

Do you laugh at yourself?
All the time… I'm fucking hilarious, me. It's a little bit depressing to be honest.

Do you laugh at your own jokes? How loud?
Yes, because I'm fucking hilarious. Very, very loud. You wouldn't believe how loud. Very loud indeed.

What's the most inappropriate place/time you have ever laughed?
Christmas Nativity Carol Service, 1989 (attended by all local dignitaries, MPs, etc). The boy standing next to me was not the brightest and sang the lines "and from the virgin's womb" as "and from the virg-ins wom-b". Got dragged down the aisle by the ear by the woodwork teacher and spent the whole duration of the service outside in the snow.

Did anyone ever take any of your jokes badly?
There's a knock knock joke… a German one. It goes something like this: "Knock knock", "Who's There?" "SHOW ME YOUR PAPERS!!!". I told the joke to a German.

What are you good at, what are you bad at?
I have a rare and prodigious talent for not doing very much in particular. I'm hopeless when it comes to anything that involves numbers.

Do you work with other people?
Well, I share a studio with other folk and that works out just fine. I'm not an 'office comedian' if that's what you're fishing for.

Are you the type to exaggerate things?
Only a little bit.

Are creative people unbalanced?
What kind of a stupid cock-sucking question is that?

Is there such a thing as stupid humour?
Absolutely. There's always time for laughing at stupid people.

Do you have any theories about the world?
Well you see, the thing about the world is that it just keeps on spinning, so eventually we'll all get a bit dizzy and fall off.

Do you carry any crosses?
Having 'problem hair' (as in 'on my head') has always been a bit of a burden although it's something I've learnt to come to terms with in adult life, mainly by shaving it very short so it's almost a deliberate 'hair style'. Having said that, the number of times people have asked me what it would look like if I let it grow ("Would it be like an afro? You should do it, it would be sooo cool"). Shitehawks.

Do you ever feel like we're doomed?
I just start to feel a little bit dizzy, personally.

What/who do you discriminate against?
Dickheads.

What's your favourite satire film?
I would like to say something that would make me appear complex and well-informed… I'm trying… but I keep on coming back to Raquel Welch in *Bedazzled*.

What's your favourite children's book?
Mr Tickle.

Do you have a nickname?
'Adrian' can be abbreviated in quite a few ways, although the ingenuity of 'Aids' at the height of the epidemic's notoriety rankled me a little. 'Bog Brush' and 'Brillo' (something I can only presume to have referenced my curly locks at the time) fucked me right off. Right now I have no nickname that I choose to be aware of.

What would you say is definitely NOT your motto?
Be prepared.

Have you started reading self-help books yet?
Absolutely not. I might write one one day though… something like 'The Path to Fucking Hilarious'.

And finally: would you like to say a word about submitting to the magazine and replying to this questionnaire?
This is real therapy.

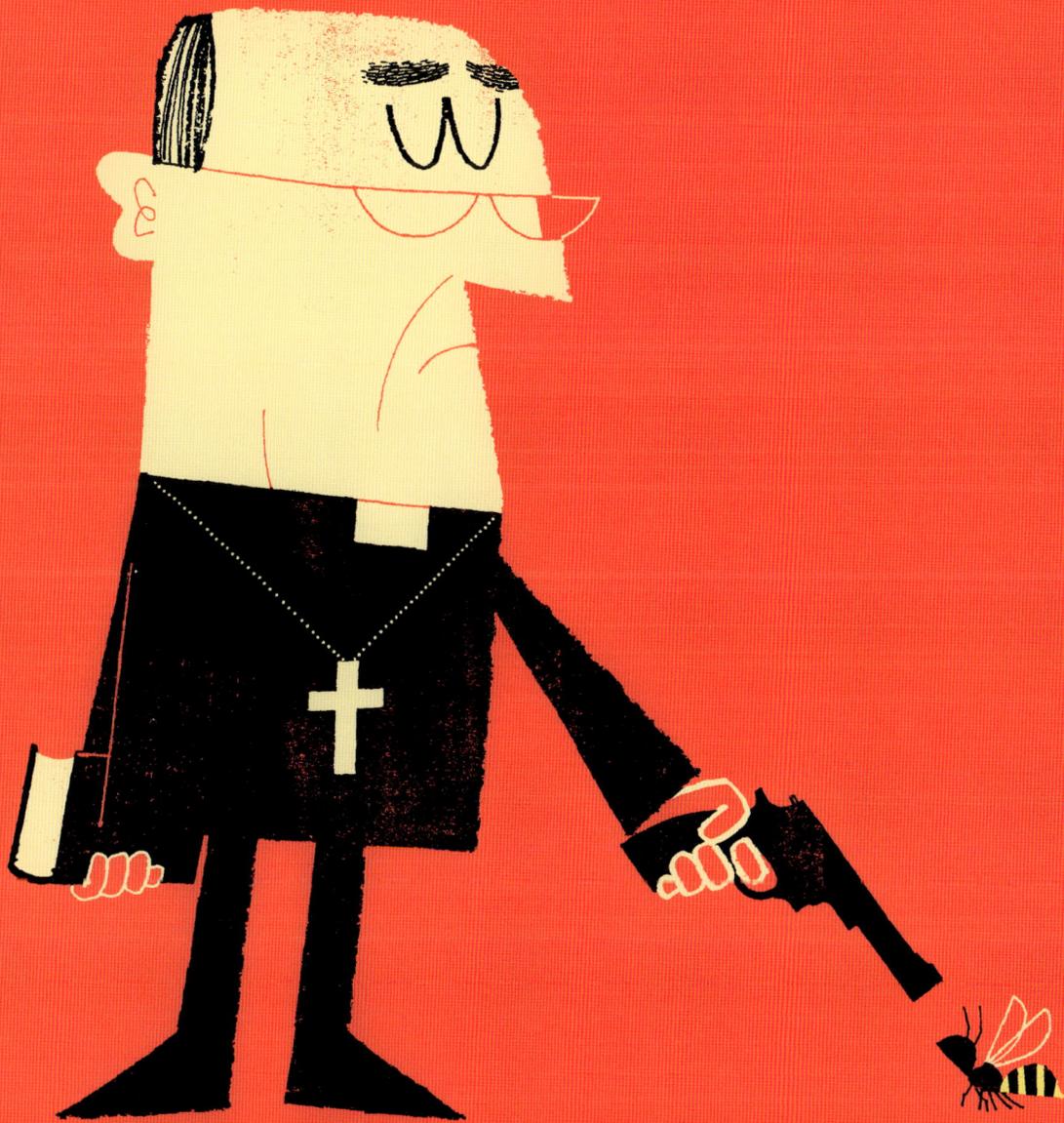

SAY YOUR PRAYERS.

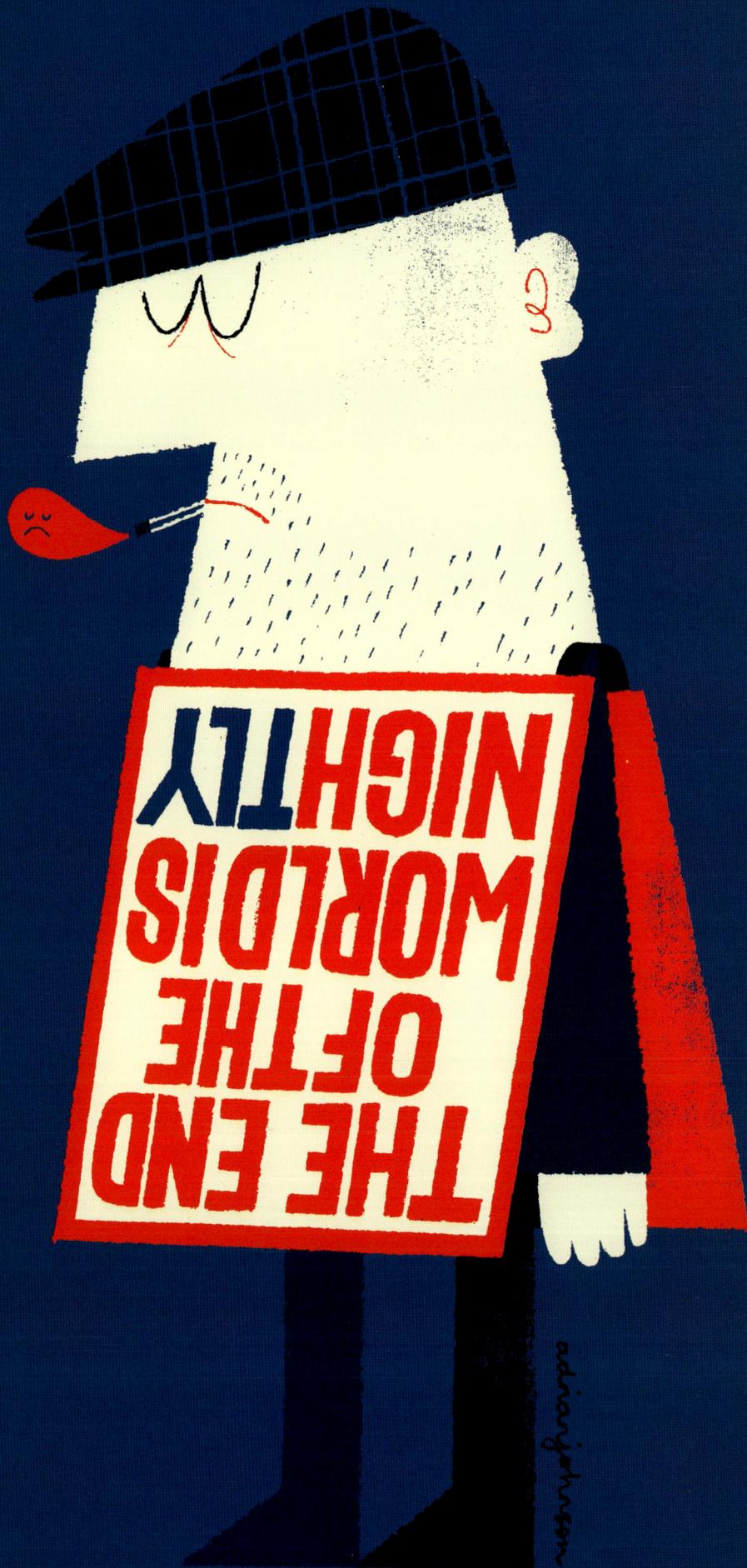

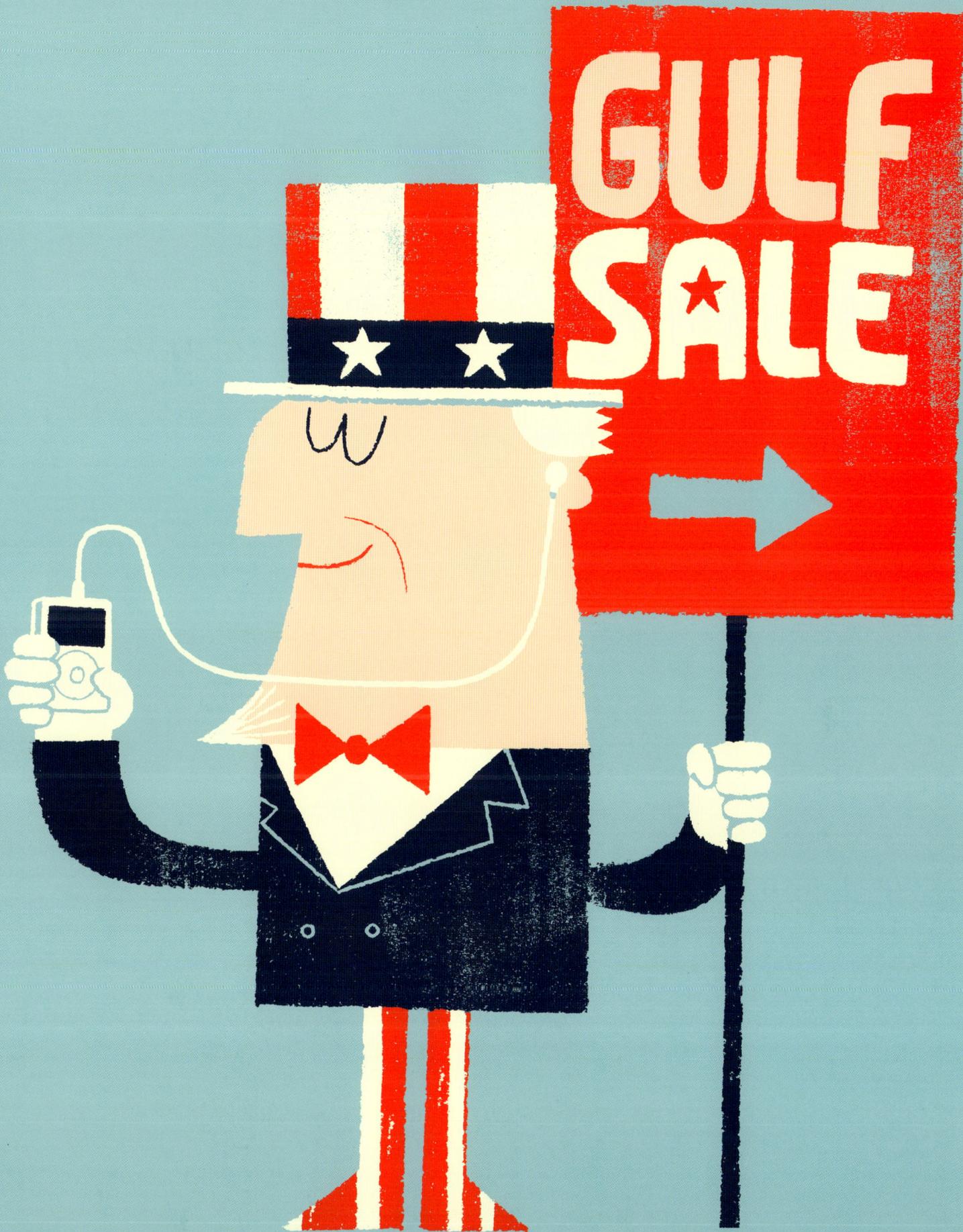

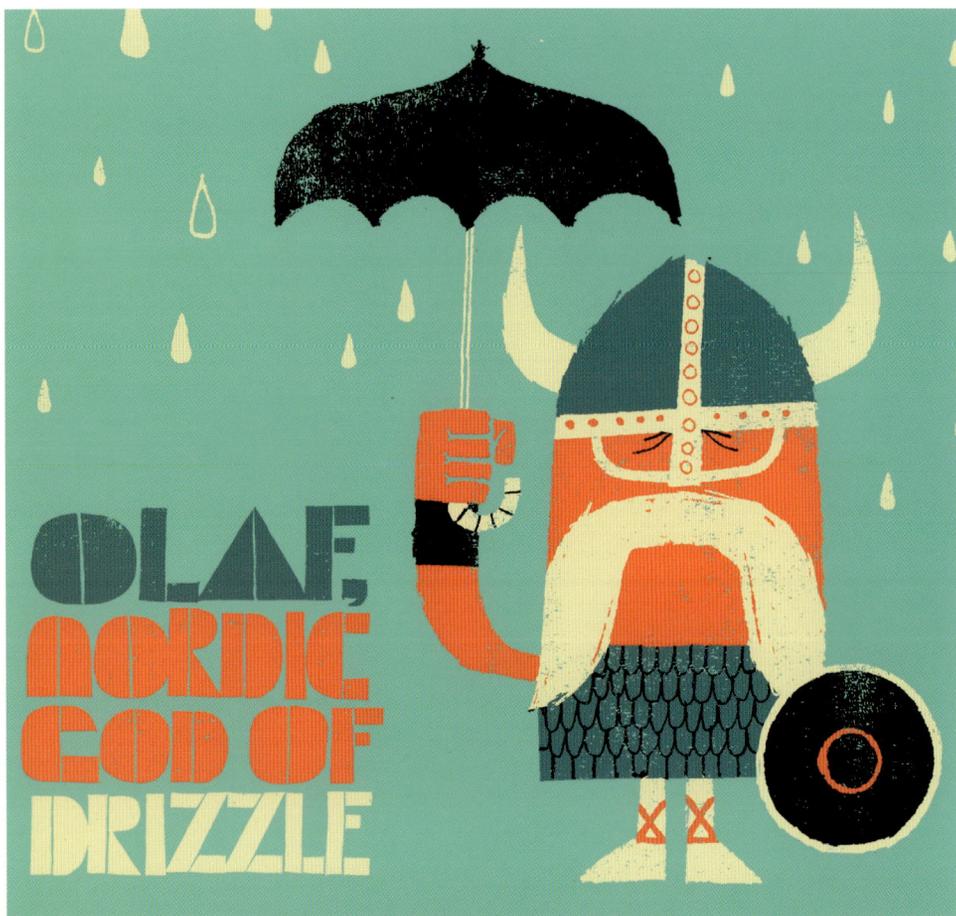

OLAF, NORDIC GOD OF DRIZZLE

IF YOU'RE HAPPY AND YOU KNOW IT SLAP YOUR FRIENDS.

'WHY DO YOU ALWAYS HAVE TO BE SO FUCKING NEGATIVE?'

HEY BOBBY

KesselsKramer is an independent international communications agency located in Amsterdam. They've produced communication solutions for a diverse range of clients, such as Diageo, Diesel Jeans, Levi's, the Hans Brinker Budget Hotel, Unilever and Bavaria Beer. They were also responsible for the internationally awarded documentary film, *The Other Final* which chronicled the football match between the world's two lowest-ranked teams, Bhutan and Montserrat which took place on the same day as the 2002 World Cup Final.
www.kesselskramer.com

Title of work: Bavaria Stuntmail
Date of completion: March 2007
Brief Description of work submitted:
Proper communication is tough for the modern tough guy. That's why more and more real men are using the new communication service called Bavaria StuntMail. Say sorry for sleeping with a friend's girlfriend. Say thanks for dinner. Ask a friend to take care of you when you're sick. Say it the easy way – and the manly way – with these personalized e-mailable stunt films. A series of classic stunts – men on fire; men throwing themselves onto dinner tables; men swimming with sharks – are great replacements for your weak communication skills. Real Men everywhere say it with *www.bavariastuntmail.com*

Opposite
"Hey Peter, good luck quitting smoking."

How idyllic was your childhood?
At ten years old, we're still living our childhood. It's idyllically busy.
Can you remember something that really made you laugh when you were a kid?
Sometimes the work we make makes me laugh. Or when an art director swallows a marble.
What kind of teenager were you?
Greasy, boisterous, productive.
What's the most embarrassing situation you would dare to admit finding yourself in?
It was in Turkey, it was dark, nobody really knows and no one really talks about it. Not anymore.
How would you describe your character?
Schizophrenic.
Do you have a sense of humour? If so, what kind?
About 38 different senses of humour, each with its own unique flavour.
What did you really think when you first saw your therapist?
What the fuck are you doing in my chair?
Do you laugh at yourself? How often? How does that feel like?
Yes. Often. It feels necessary.
Do you laugh at your own jokes? How loud?
When it hits the mark. As loud as a Saxon concert.
What's the most inappropriate place/time you remember laughing at?
There isn't an inappropriate time.
Did anyone ever take any of your jokes badly?
Sometimes, but humour is subjective.
What are you good at, what are you bad at?
Good at communication for other people. Bad at questionnaires for self.
Are you the type that exaggerates things?
Yes. The size of Belgium.
We noticed that some of the submissions we received seemed a little angry, possibly maladjusted. Would you say that creative people are predisposed?
Just the busy ones.
Is there such a thing as intelligent or stupid humour?
Best is a cocktail of both.
Do you have any theories about the world we live in?
It's only when we're in the shit do we start to dig ourselves out. I think Descartes said that.
Do you carry any crosses?
We work in a church. Lots of crosses.
What's your favourite satire film, what was your favourite scene?
Dr Strangelove. All scenes with Peter Sellers (which is pretty much all scenes).

What's your favourite children's book?
Where the Wild Things Are.
Do you have a nickname?
Some call us KK. Everyone at KK has his or her email nickname. One is special-k. Another is Miss Pantone. No we don't get to choose our own. It's a cross to bear (see previous question).
What would you say is definitely NOT your motto?
Do Nothing.
Our maintenance man Steve tells he's addicted to shegods.com. We're doing everything we can to help. Do you have any addictions?
Making stuff.
Have you started reading self-help books yet? If so, which ones?
I've started reading *Self Help Books, Burn in Hell.* It's pretty good.
And finally (remember: your opinion is important to us) would you like to say a word about submitting to the magazine and replying to this questionnaire?
Thanks. It's been enlightening.

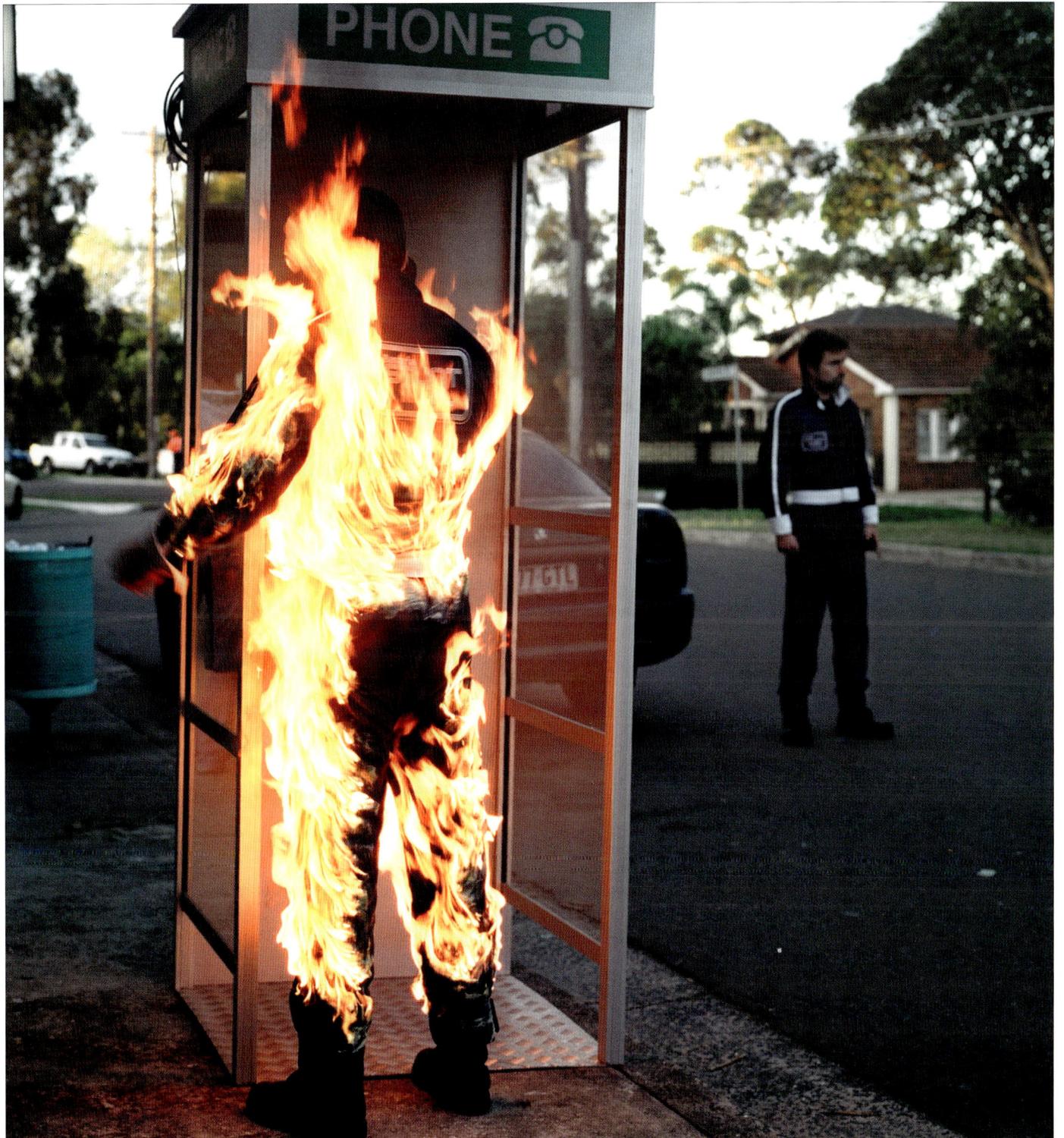

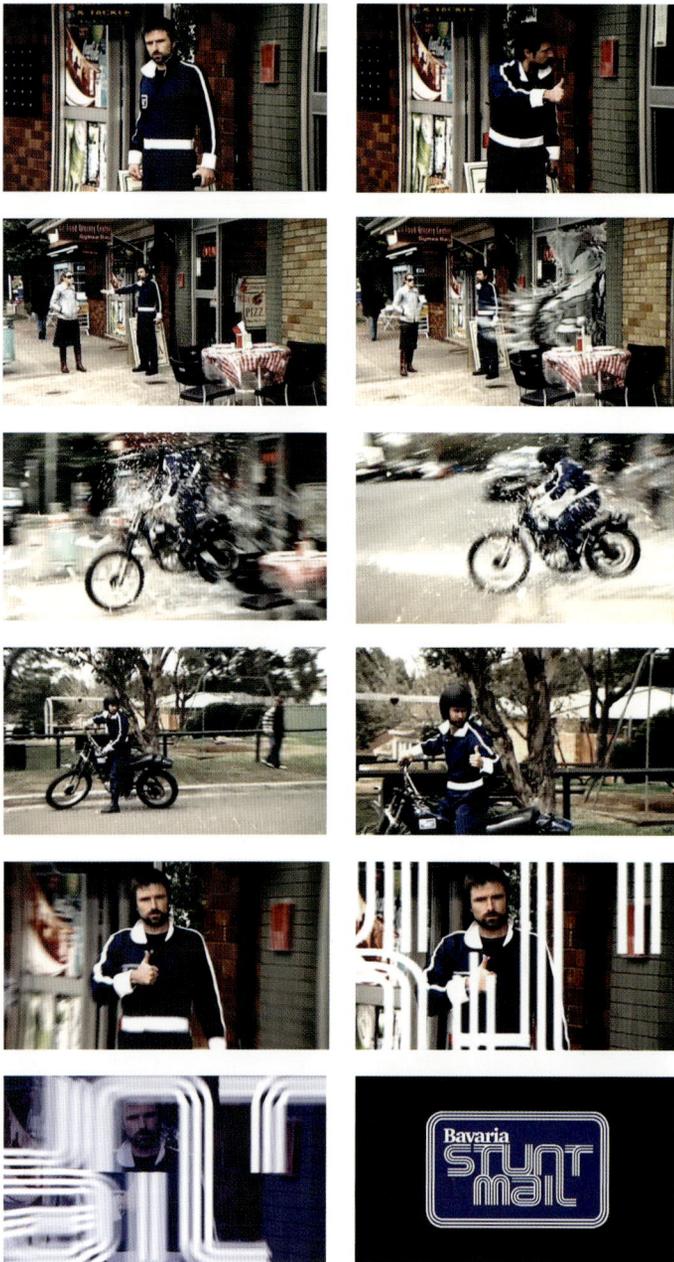

Above
"Hey Bobby, can you bring
me back some take away
home I'm starving."

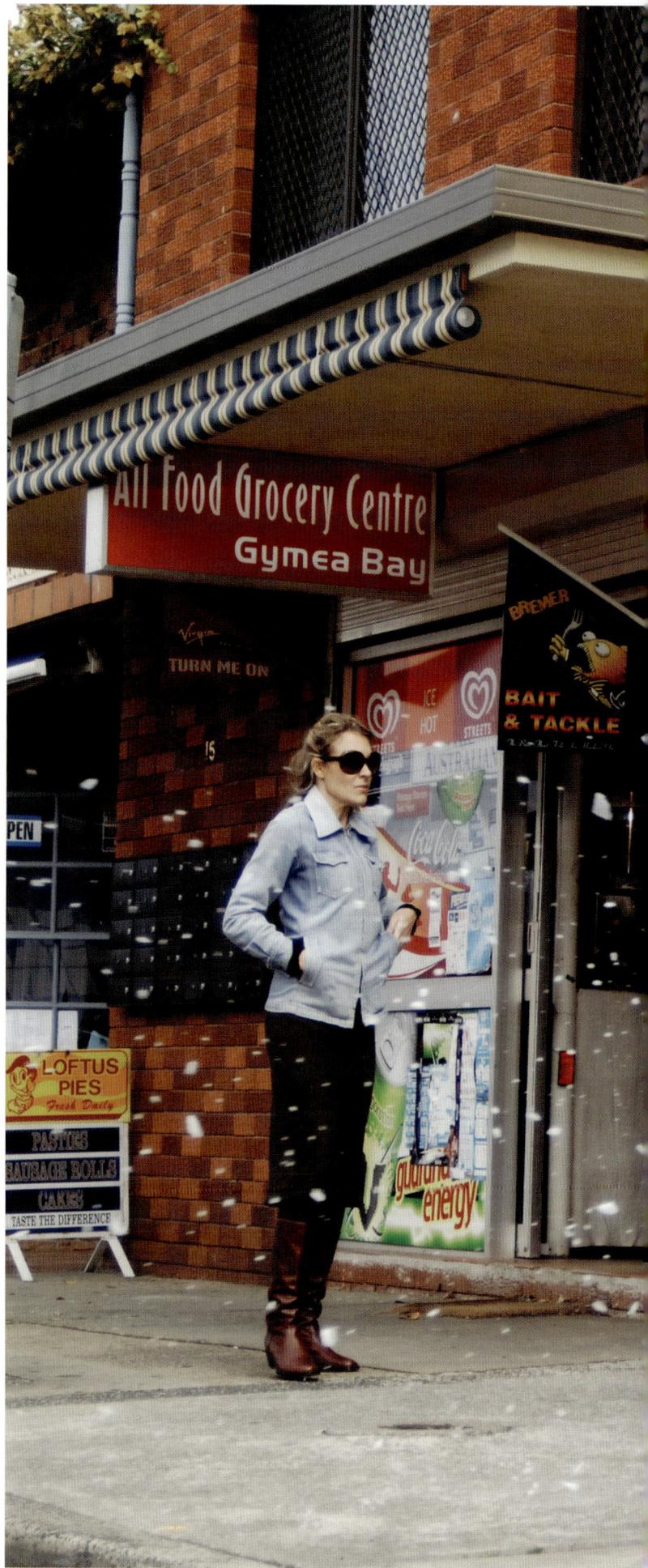

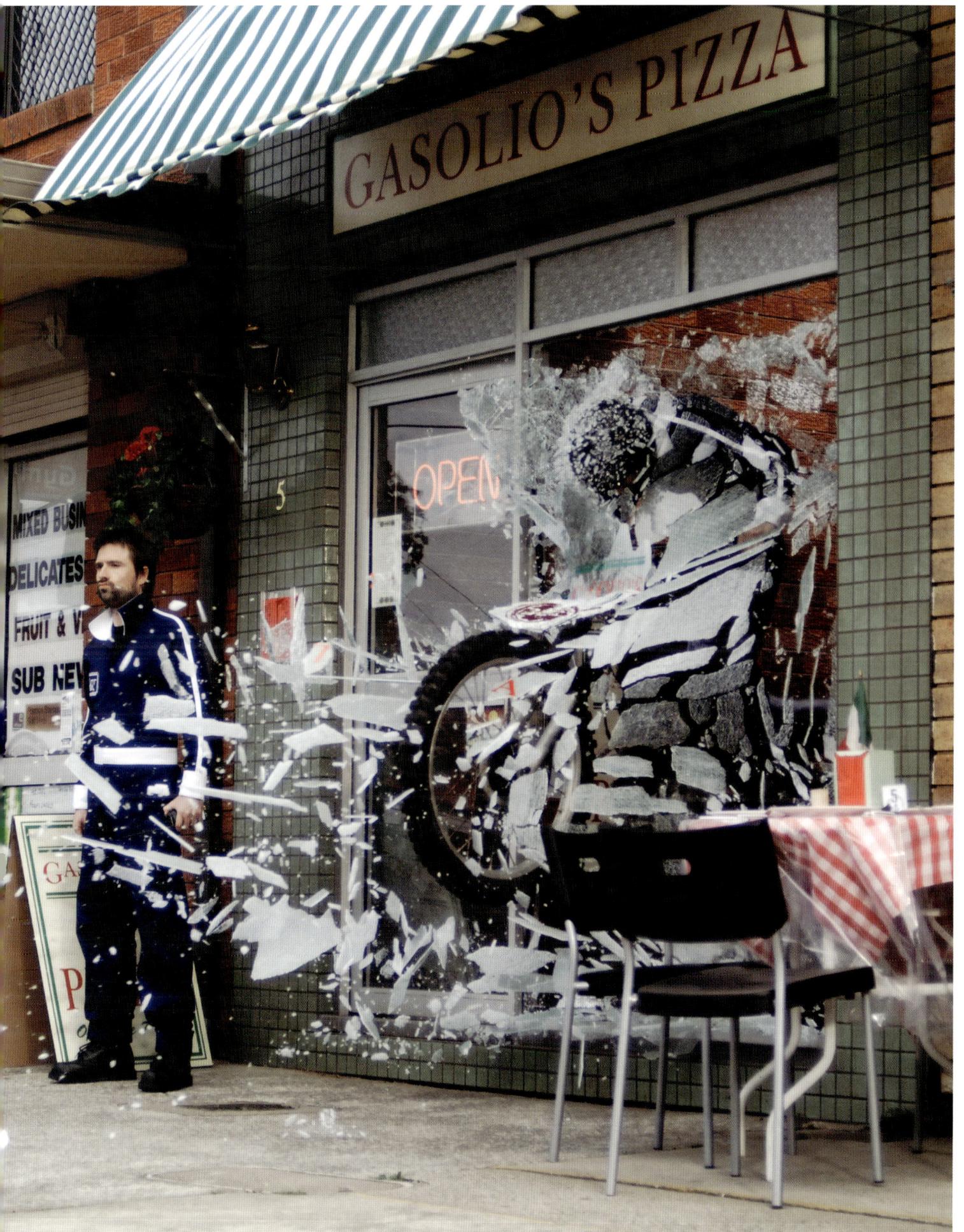

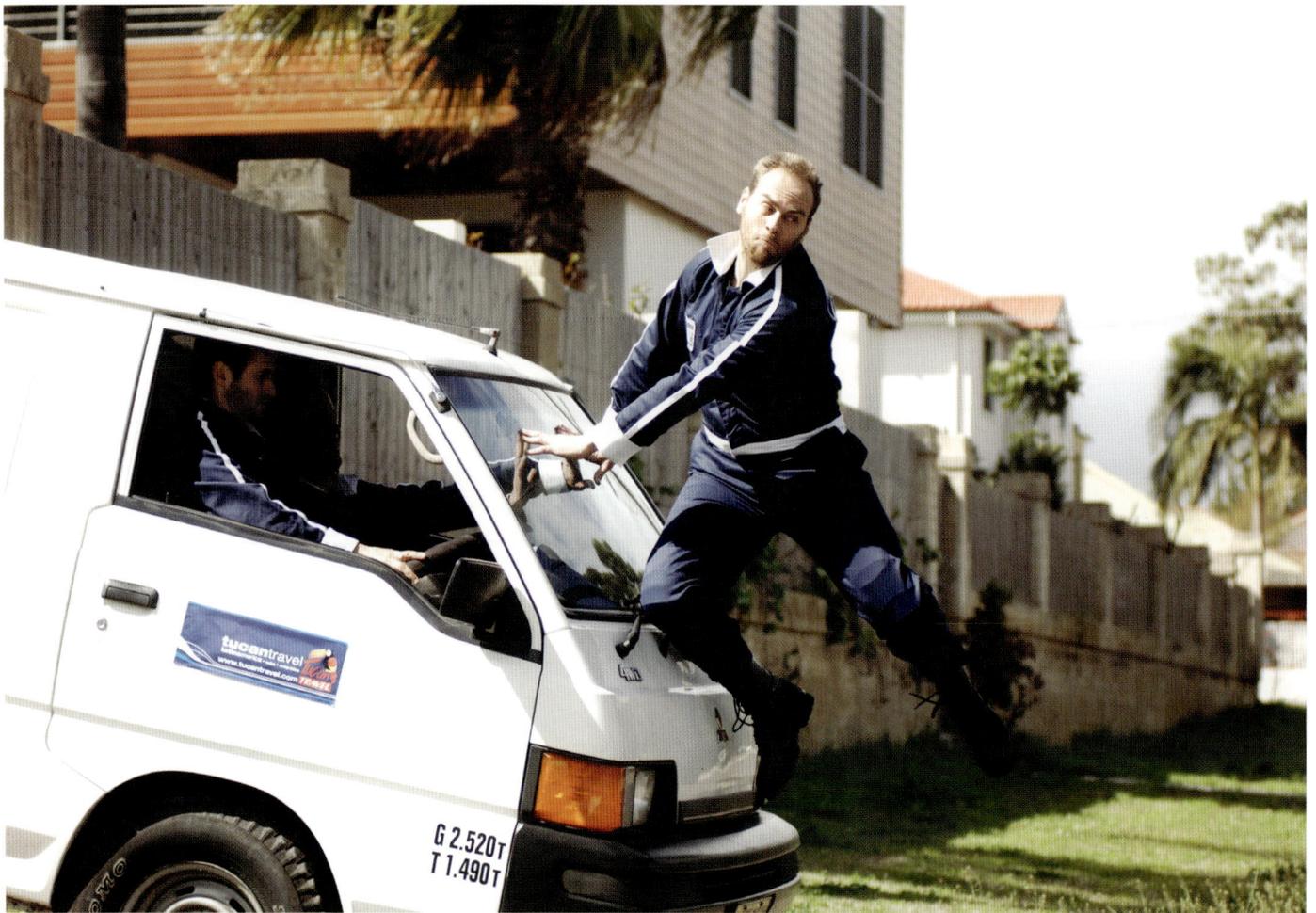

Above
"Hey Charles, need a
lift tomorrow?"

Right and opposite page
"Hey John, sorry I forgot
all your birthdays."

Provocateur, satirist, agitator, photographer, Les Krims was born in 1942. He is noted for his highly original, dark, edgy and flawlessly set pictures (he calls them 'fictions') as well as for his long-standing grudge against conformism and any form of 'leftist twaddle'. Originally from Brooklyn, he moved to Buffalo, NY in 1969, where he now lives and works. www.leskrims.com

"I also remember making up my first joke (5th or 6th grade). It was: Just because you smell of ape shit doesn't make you Tarzan."

How idyllic was your childhood?
I'm not sure I've ever met anyone whose childhood was idyllic—mine wasn't.

Can you remember something that really made you laugh when you were a kid?
Hearing for the first time someone speak aloud Lewis Carroll's 'Jabberwocky.'

Did you cherish any grandiose dreams?
No. But my life could not have turned out better. What a wonderful surprise it's all been.

What kind of a teenager were you?
My daughter, who's now a junior in college, affectionately calls me a nerd. That's probably an accurate description compared to her friends. I attended a "science high school" called Stuyvesant, in New York City. In homeroom I first discovered a Lotus was an automobile and a flower. A few of my classmates (Tommy Lipman, for one) refused to say the Pledge of Allegiance for "religious reasons" (my first encounter with leftist activists). The really smart kids in my class worked on a cyclotron in Stuyvesant's basement in their spare time.

I was an introvert, had few social skills, was interested in microscopy (what could be more nerdy?), not much interested in sports (though I did try out for Stuyvesant's football team), lifted weights (not nerd, but definitely prole), and enjoyed fishing off the rock jetties at Coney Island, or the piers at Sheepshead Bay.

When I was 14, somewhere in Manhattan Beach, California, jammed in the front seat of a car between two kids I'd met earlier that day through my father's girlfriend, the demented jerk driving pulled out a pistol, leveling two shots at kids playing frisbee with their scull caps standing in front of an ultra-reformed Jewish temple. The gun turned out to be a starter pistol loaded with blanks, but for a few moments I believed prison would be my next stop. I spent my 15th and 16th summers squeezing orange juice for the 'Hunt Breakfast', at The Dunes Hotel in Las Vegas (after my parents divorced, my father lived in California for a while, then moved to Las Vegas, and when I was old enough, I often spent most of the summer living with him). On some afternoons I'd swim at the pool at The Desert Inn (my father knew a pit boss there). I had furtive, lousy sex years before my pals back East. I learned to smoke, tasted my father's Jim Beam, and got a Nevada driver's license at 15. My dad and I ate at snazzy drive-ins, which sold secret-sauced burgers and curious smelling tacos (nothing like that back East, yet), or at one of the downtown casinos where everything was free. I owned a pink sport coat with grey flecks, and had no idea how bad it looked.

By my 18th summer, I'd been studying art for a year at The Cooper Union (NY). That summer, as well as my 19th and 20th summers, were spent living in converted chicken coops, or places equally ratty, working as a waiter at a Borscht Belt hotels in the Catskill Mountains, saving enough cash to get me through another year of commuting to art school in rush hour, going and coming, on the 'D' train.

Do you have a sense of humor?
I once heard the comedian Mel Brooks analysing what's funny. He said, "Any word with a 'P' is funny. Pickle, prune, are funny words." I also remember making up my first joke (5th or 6th grade). It was: "Just because you smell of ape shit doesn't make you Tarzan." Recently I read a bit about Alexander Pope. The author related that Pope in the company of Jonathan Swift and John Dryden perfected the art of ad hominem satire. I have a great affection for ad hominem satire.

What's the most inappropriate place/time you remember laughing at?
Thirty years ago here in Buffalo, I went to a poetry reading where Robert Creeley was to hold forth. The funky venue was packed with stoned hippies. As soon as Creeley began to "read" I became convulsed in laughter. I couldn't stop laughing. I had to leave, but before I did, snapped my fingers a few times "beat" style and whispered "Yeah, man." Maybe certain poets are like the letter 'P.'

Did anyone ever take any of your jokes badly?
Too many times. I'll relate one example. In the mid-1970s, the historian Nancy Newhall died. It's how she died that's key. Mrs Newhall was a champion and promoter of what on the Left Coast was called the 'West Coast School' of photography, which revolved around the likes of Ansel Adams and Edward Weston.

These photographers made pictures of trees, rocks, weathered buildings, and peppers (or people who reminded one of a pepper). On the East Coast we affectionately referred to the work as the Rock and Root School.

As a conservationist and outdoors person, Newhall would make expeditions to desolate places only affluent people would want to see. In the midst of a boating expedition on the Colorado River, on July 7, 1974, camped at the end of the day, no doubt worshiping nature, and likely drinking heavily, a tree fell on Nancy Newhall. The Nature Goddess killed her. →p111

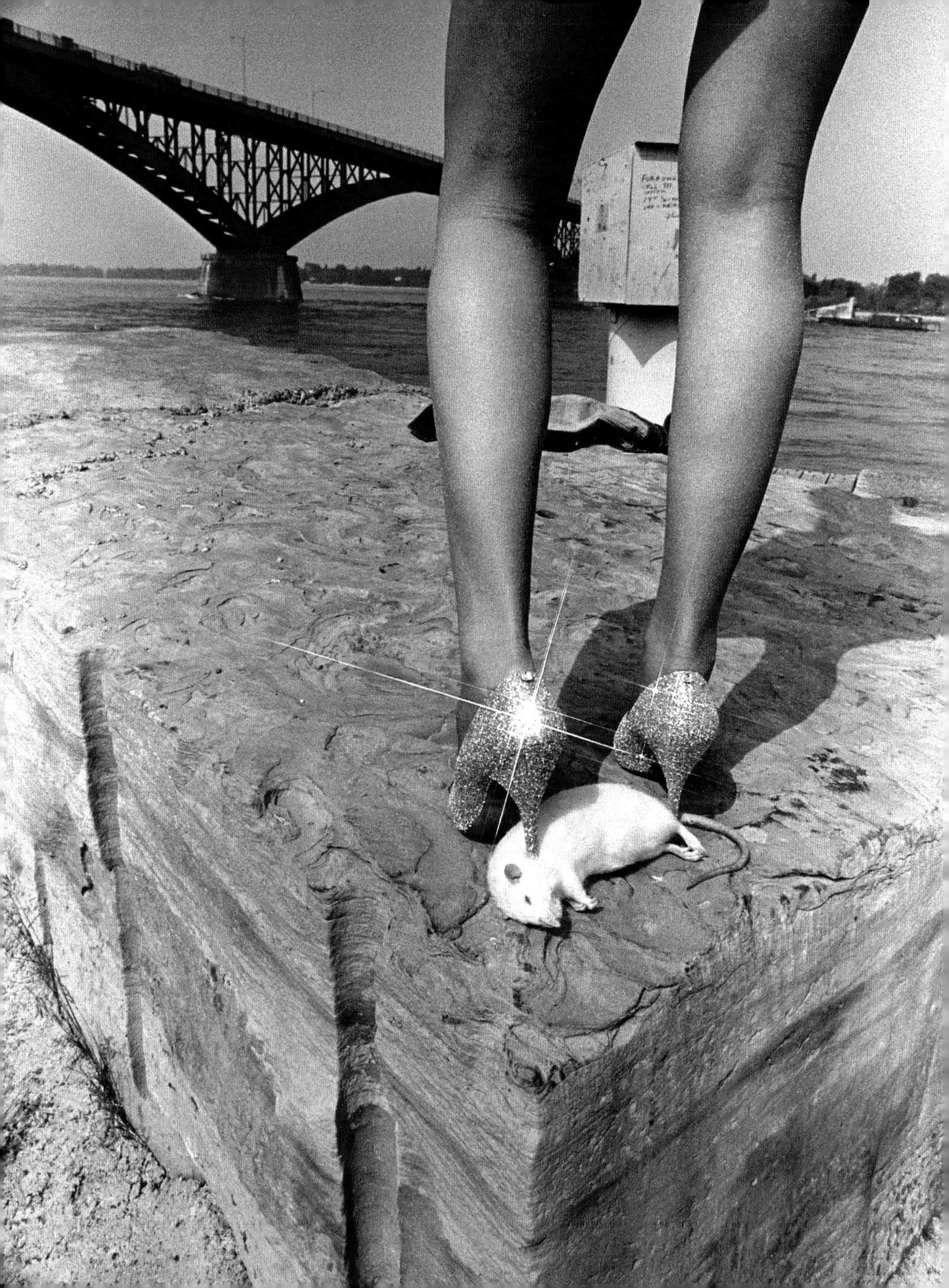

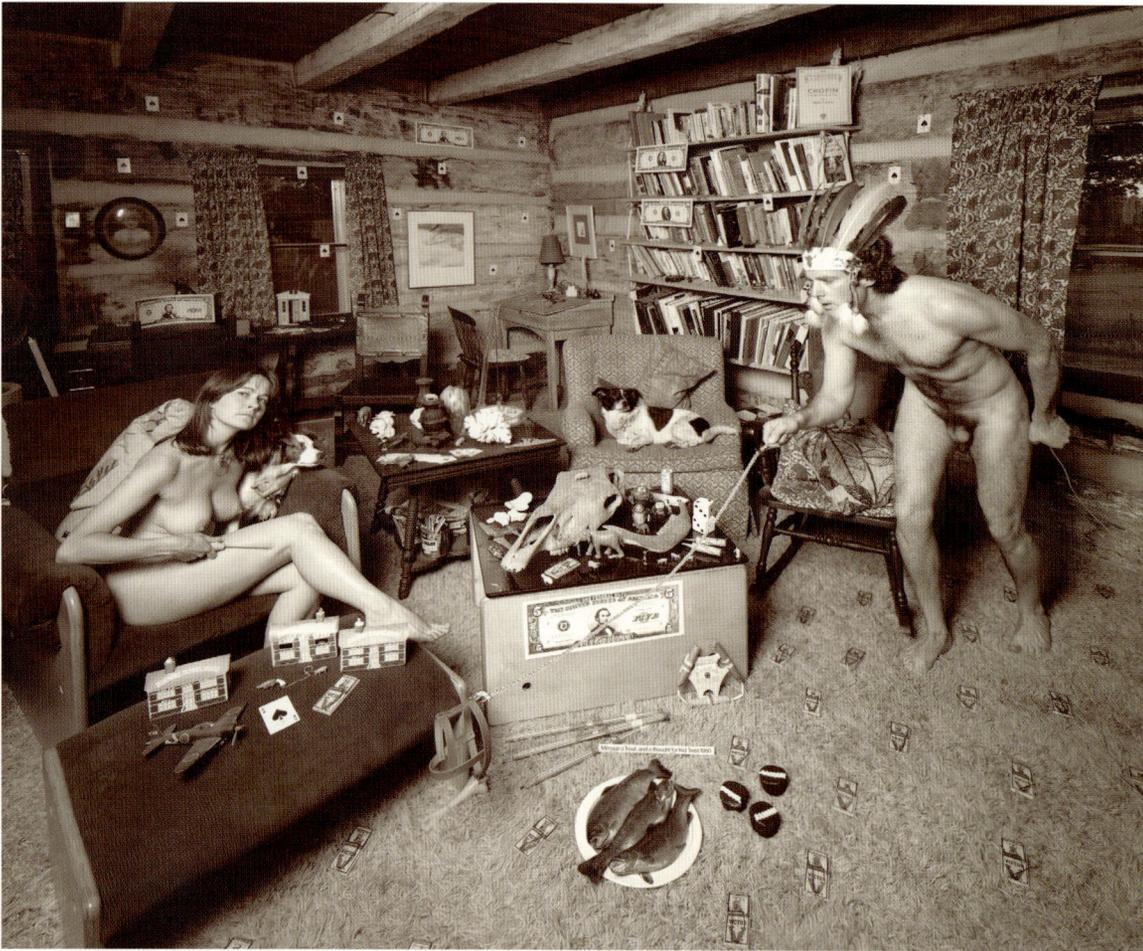

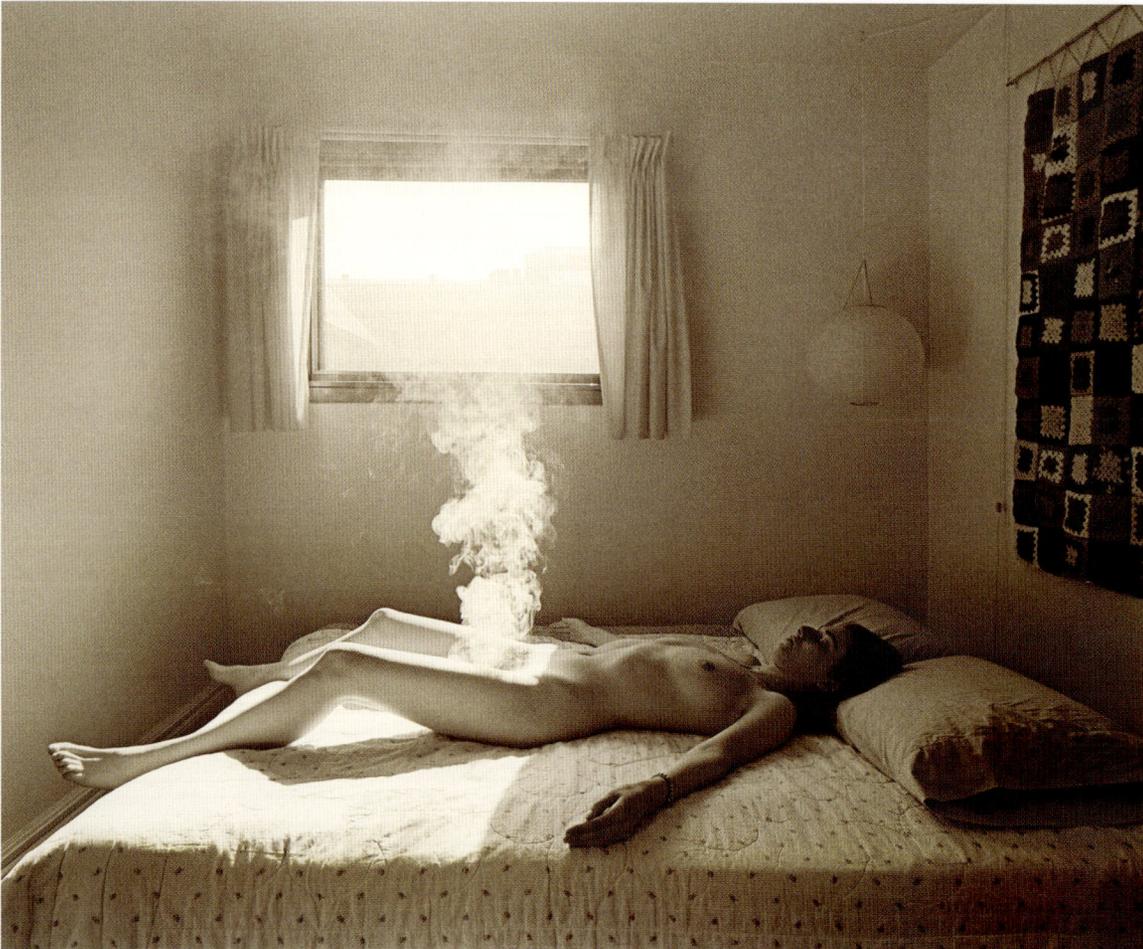

Previous page
'Homage to crosstar
filter photograph'
1970/2002

Left top
'Menage a Trout; and
a thought for Kid Twist'
1980

Left bottom
'Fall on Fargo Avenue,
Facing the West Side
Armory' Buffalo,
New York 1969

Opposite top
'Les krims Peforming
Aerosol Fiction with
Lesie Krims'
Fargo Avenue, Buffalo,
New York 1969

Opposite bottom
'The Static Electric Effect
of Minnie Mouse on Mickey
Mouse Ballons'
Rochester, New York 1968

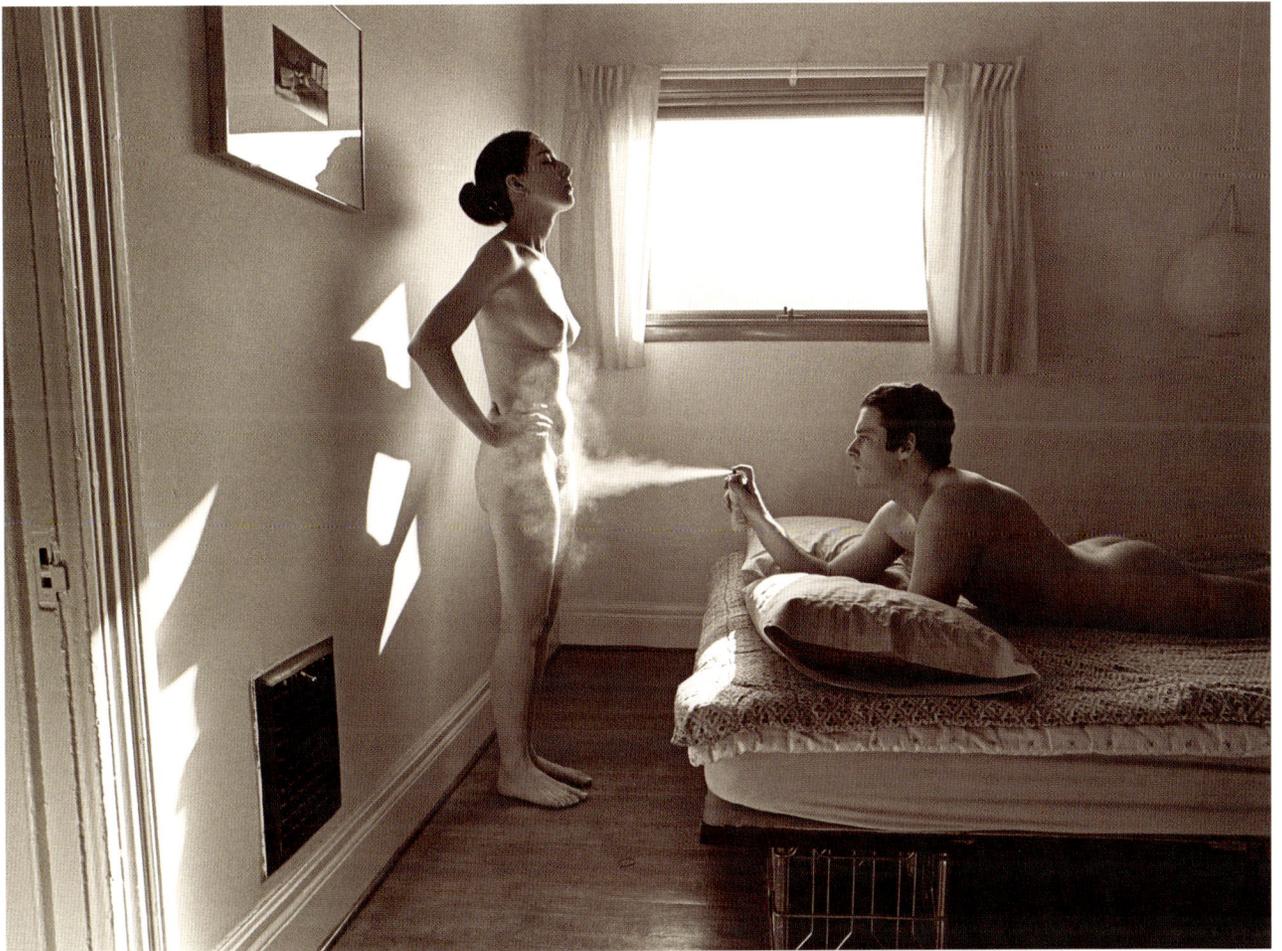

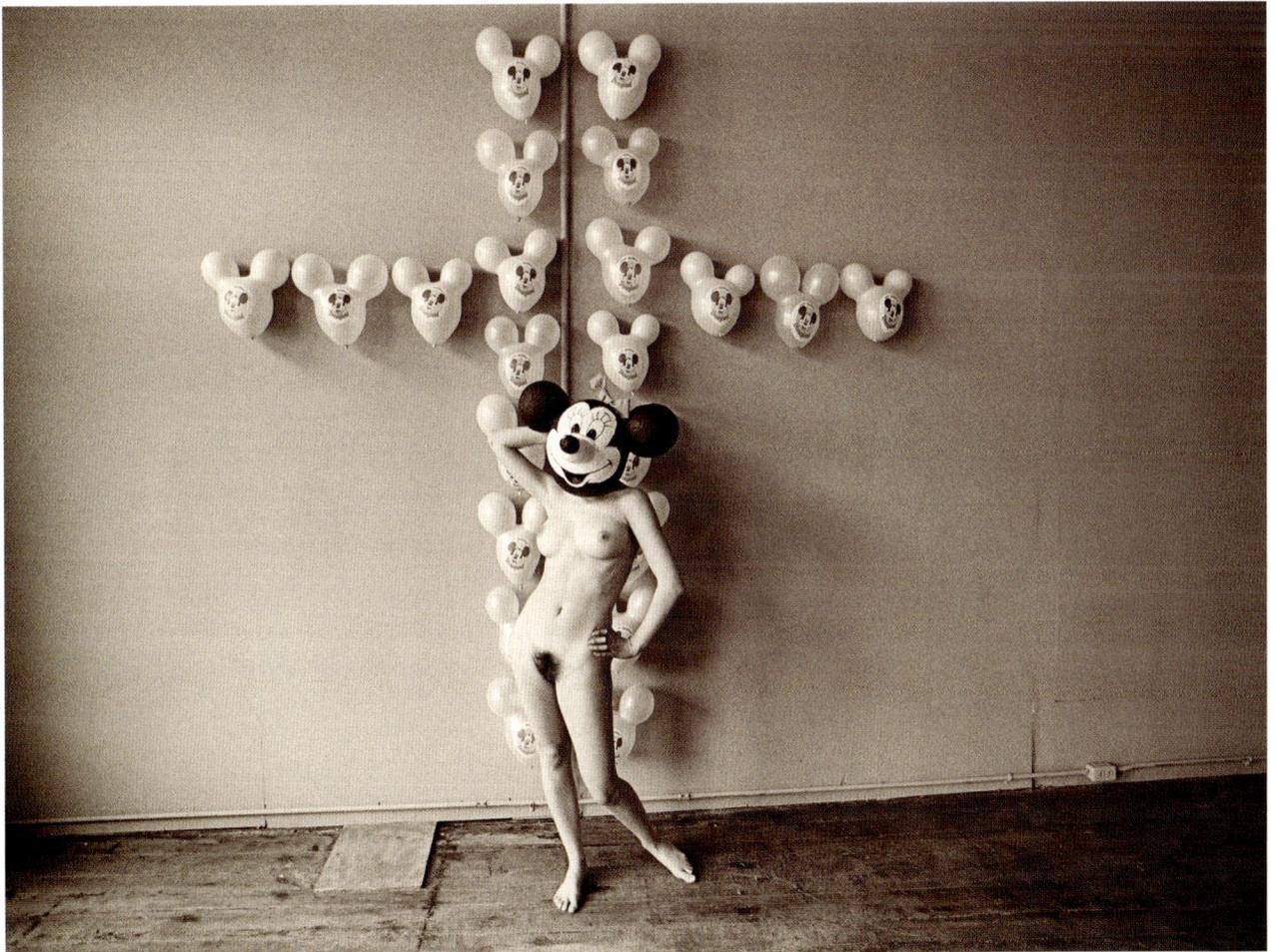

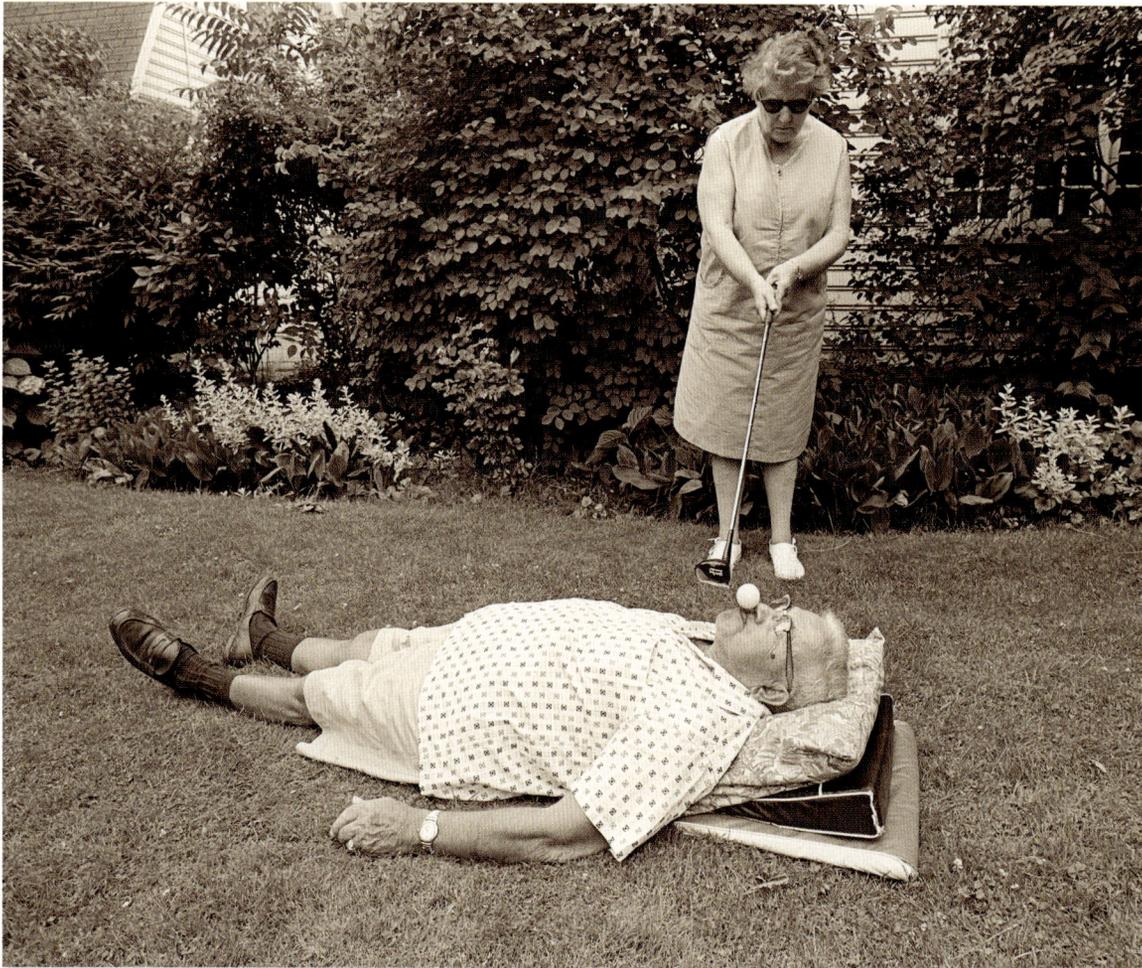

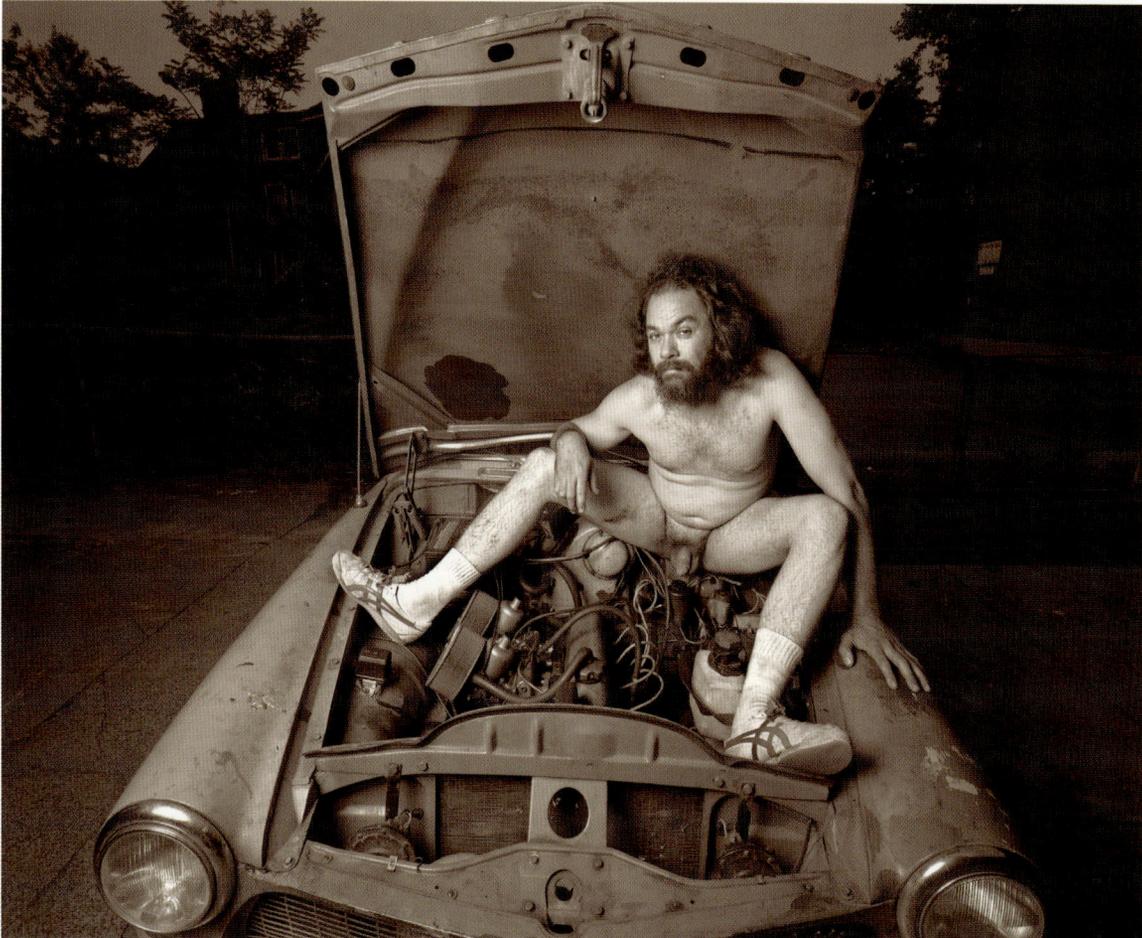

Left
'Mrs. Braveerman, an early feminist, teeing a golf ball in her husband's mouth much as rascists did laughs with black caddies in the segregated south ' Rochester, New York, 1968

Below
'Paul Diamond, seated in the engine compartment of his 1963, 122S Volvo wagon' Buffalo, New York, 1978

Opposite
'Mom's Snaps, 1970'

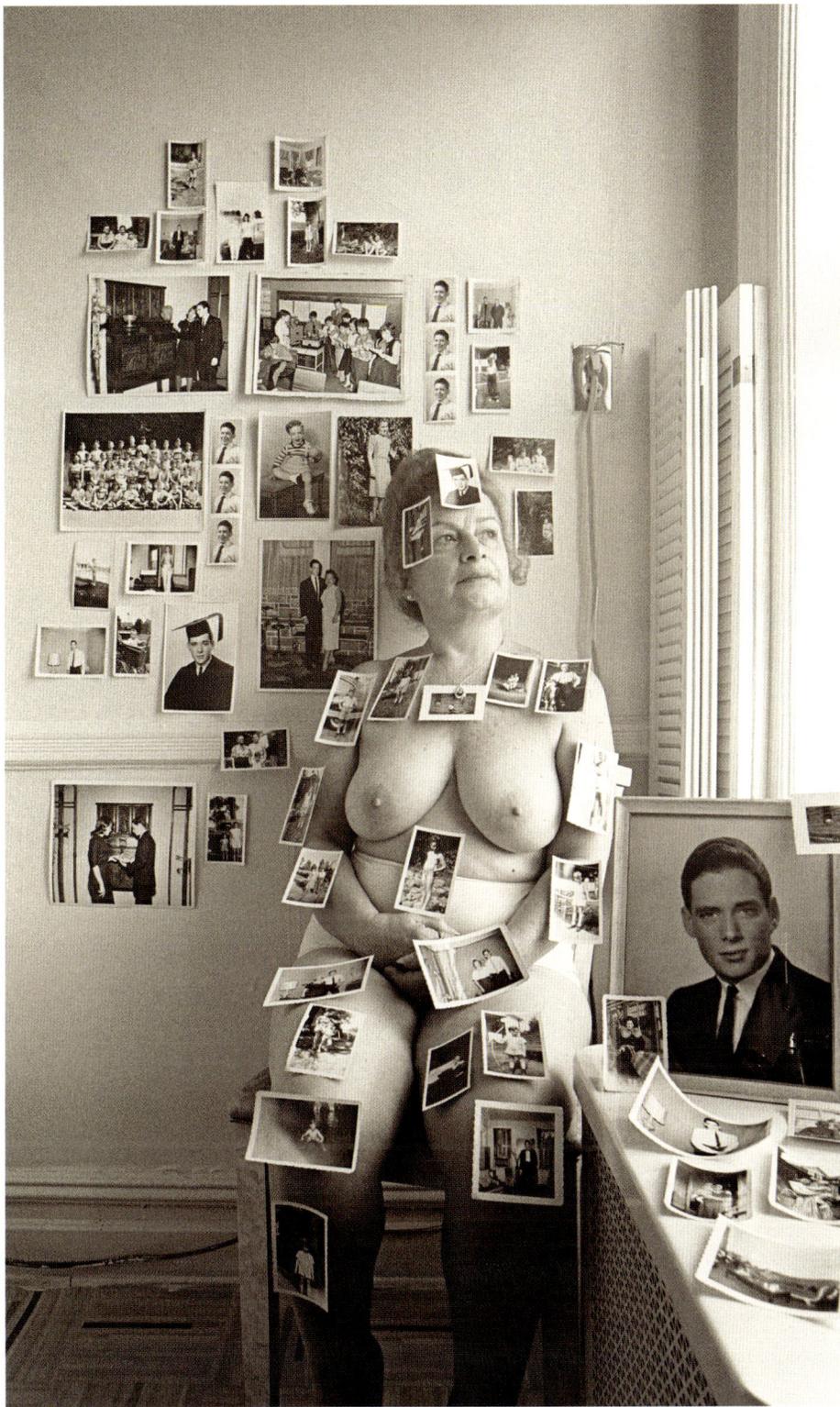

> "I despise bad bread. America is full of bad bread and people who eat bad bread. Bad bread should not be allowed in any Kosher delicatessen."

were whittled by hand, just enough to imply a 'rustic' look, then distributed as a pattern on the floor of a picture titled, 'A Rake's Revisionist Regress; Nancy N. Memorial Sticks Scattered; an Assortment of Effective Remedies; Buffalo Fashion: Christmas Presents for Nuns; She Had Any Number of Lines; and a Colored Picture, 1980.' When the picture was done I drove to The George Eastman House (a photography museum in Rochester, NY) with a handful and staked them in potted plants throughout the place. It was soon after this that I became an outcast in the American world of art photography.

There was also this kidnapping of a 14-year-old boy in Memphis, Tennessee....

In your opinion is there such a thing as intelligent or stupid humor?
Working out that conundrum would best be left to a deconstructionist. Turning "therapist" into "[the]rapist" is hilarious if you're a nihilist, I guess. But whoopee cushions, plastic vomit, and small, wind-up mechanical nuns coughing sparks do also come to mind.

What/who would you consider an ideal subject for parody?
Males of all ages who wear their hats turned backwards. Just think what could be done with a nail gun to make sure their hats stayed on their heads forever.

Rappers who grab at their genitals while performing might be worth a doctoral thesis or two written by multi-culti whizzes at Fordham or Yale. The resulting publications might be titled, "Dyyaah!" and "Whuzzup?"

How do you see the world?
I observe it carefully through bifocal lenses. The world is a wonderful place—especially the Western World.

Any theories about it?
I believe the spirit of Charles Dickens roams the English-speaking world offering us clues to the character of certain people. The clue is manifest in the person's name. Why else would the director of my mother's nursing home be a Mr Hellbringer, or the comptroller of the Polaroid Corporation be one Mr Swindel, or the doyen of affirmative action and equity and diversity at my campus be one Mrs Battle? My name spelled backwards is SMIRK. There is a reason for all of this!

Do you carry any crosses?
That's a Christian thing. I'm not Christian. I'm a militant agnostic. I carry on, and wouldn't mind carrying a gun.

What/who do you discriminate against.
I despise bad bread. America is full of bad bread and people who eat bad bread. Bad bread should not be allowed in any Kosher delicatessen. I also think that men who hang their glasses at the 'V' of the open neck of their shirt, or grasp them in their mouth by biting on one earpiece, or perch them on the top of their head should be forced to curtsey when leaving a room.

Do you have any addictions?
Really good bread, German cars, and tight black net shirts.

What would you say is definitely NOT your motto?
"Romance is rape embellished by meaningful looks." That was Andrea Dworkin's motto – one of her less flatulent.

A few years later, in 1979, I was beginning to make pictures for a portfolio I'd call 'Idiosyncratic Pictures.' These were quasi-allegories about art, photography, and anything of interest to me ("fractured fairy tales" is a Hanna-Barbera term, which also might apply). To provide context for one element in a picture, I made up a story: I'd sent an expedition to the spot on the Colorado River where Newhall had died, salvaged a piece of the tree that killed her, milled this log into small commemorative sticks, and gold stamped the phrase 'Nancy N. Memorial Stick' on each. I really used Popsicle sticks. These

A delightful emerging artist loved by many, appreciated by few. Born in Yokohama, Japan in 1982. Shizuka struggled in her early teens in Scarsdale, NY and later obtained a BFA in Communication Design at Parsons, NYC.

She believes in conceptual work, detests 'soul less' pretty work, likes to get her hands dirty, loves printmaking and the smell of ink and is subconsciously always looking for a fistfight. She curses loud and repeatedly when alone, makes good salmon, and brownies, (not together) and can sleep for up to 20 hours a day. She's a great dreamer, a great artist, a great person and great gal.
www.punchpapers.com/shizukak

"When I box I imagine Rocky training, and when I took dance lessons I imagined I was a great dancer. It has to do with my ability to dream, i.e. neglect reality. This is also why I am bad at being on time."

How was your childhood?
I have a very foggy memory of my childhood. I used to make mud balls in the corner of the playground in kindergarten and my brother used to shoot at me with his air gun.

Can you remember something that really made you laugh when you were a kid?
In my early teens, there was this Japanese girl in my junior high school in Scarsdale that was "unvisionable." She was dressed up for Halloween one day. I asked her what she was, she answered "Alice in Wonderland." That really made me laugh.

Did you cherish any dreams?
My aunt recalls me telling her that I wanted to be a pig. And marry my (very mean) brother.

What's the most embarrassing situation you would remember finding yourself in?
The fact that my gynecologist in Japan knows my family is pretty bad. When that time comes.

When and where did it all start to go wrong?
In 5th grade elementary school in Japan, when my classmates loved me for the fact that I was obsessed with our teacher's mole on his neck. And a year later in Scarsdale when Erica and the other girls didn't accept me into their circle of bitches just for the color of my skin.

Do you have a sense of humour?
I hope so, since I don't have the boobs or long silky legs. My humour is of self-mockery. I like to make people laugh at me as much as they laugh with me. I love the kind of humour in *Family Guy* – bizarre and clever. Or in *Curb Your Enthusiasm* – pitiful and heart-felt. But I gotta say I also love Japanese comedy that only the Japs can understand – the things non-Japs might only consider really stupid or plain weird. I hope I possess both aspects of the two cultures in terms of humour.

What did you think when you first saw your therapist?
A real smart way to get me talkin' about it!! Frankly I've been refusing to see any after my "guidance counselor" in Scarsdale revealed to my parents all the problems I told her regarding the pain my parents were causing me from their then falling-apart marriage. Plus therapists are too expensive. Friends are free.

Do you laugh at yourself?
Yes, I'm afraid so. Every day like Mozart does in the film *Amadeus* but with much less intensity. Every now and then for whatever happened that is too hard to handle with a mere "Oh fuck this" or a chocolate bar. It's sort of therapeutic. It asks for forgiveness, you know? Rarely (but usually when I have had some booze) when I accomplish making a clever joke. It feels like crying when I laugh at my pitiful happenings in life. It feels rewarding when I laugh at my clever jokes.

Do you laugh at your own jokes?
Ya. I think I laugh quietly, inside. Like a modest kinky Japanese.

What's the most inappropriate place/time you have ever laughing?
When I saw a plane crashing into the World Trade Center for real. On my way to my morning class.

What are you good at, what are you bad at?
I'm good at acting up a role in my daily life. Like when I box I imagine Rocky training, and when I took dance lessons I imagined I was a great dancer. It has to do with my ability to dream, i.e. neglect reality. This is also why I am bad at being on time. Or remembering the past or memorizing dates or how much I earned last year. This also explains why I can be reckless and go super fast on go-karts and snow mobiles.

Do you work with other people?
Yes. I can put on a "working Shizuk" mask and work with others – communicate, ask for things, get what I want, etc... do what I gotta do in all seriousness. I must say I don't really enjoy going to work in an office every day. I never really had bad experiences in terms of people I work with. Call me an over-thinker, but especially when you work in a small company there are so many things to think about: either be ten minutes late and look a little bad or grab a good cup of coffee in the morning; how to ask the co-worker how his/her weekend was without making it sound like it's a Monday morning routine; making sure that when the boss passes by your screen you aren't always checking your personal email, etc. I can say I like when I work alone and have some friends give me feedbacks although they can totally confuse me sometimes. Plus if you knew how working in a teeny tiny apartment in the city feels like... All in all there's no easy way out whether you work with others or by yourself. If I were given a job which involved sleeping I would be mostly good at it.

Are you the type to exaggerate things? How much?
Not really. Although maybe I do more than I think. I know that trick. It's definitely convenient to take advantage of it sometimes. And if I really think about it, how can you sell or gain anything without a little exaggeration? Saying my life is falling apart, I don't know if I wanna live anymore, is one example of gaining something: pity. And, oh god, this is why I don't

Life is all tangled up into a knot and

peace be the place we go back to in the end

you keep trying to untangle it, but it

Eternal say I say to the world and may I

stays untangled a bit for some time and

I forever exist when there also exist

then everything somehow tangles itself and

all motion comes from your own

you some times tangle things up in hopes of

and quest for knowledge is our biggest

untangling it and you have to go back to

how to lose it. Hope keeps us alive

where you were and start untangling again.

Happiness is there if you know

If we lived in the house together,
same

we'd be running around the house, all naked ♥

We don't
look the same
feel the same
taste the same
but we both smell the same,
don't we ?

like writing cover letters: "I graduated from this great college, I got these awards, look at me! I am great!" You skip the part where you failed a class or that you only got yourself into a big company out of pure luck. Especially in the US – or more specifically NYC maybe – you are demanded to sell yourself. The bigger, the more, the better. Especially if you are from a foreign land trying to work in the US you gotta prove you are better than those Americans! It gets even more complicated in Japan, you gotta sell yourself without showing off.

Are creative people unbalanced?
I say we humans are all maladjusted and angry in one way or another. The question is whether you wanna express it or not. And everyone expresses it differently. By serving bad coffee or not picking up after your dog or spending mad money on strippers to name a few. In my case I portray these feelings – dissatisfaction or joy – in my drawings. People tell me my drawings are always a little sad. I guess I am not "a happy person". I don't understand when people say they are.

Do you carry any crosses?
I was told that I'm not very good at controlling the volume of my voice. I mentioned earlier that I am a "low-talker" – sometimes people have hard time listening to my mumble-jumble. And other times I talk too loudly, especially on cell phones.

Do you ever feel like we're doomed?
I must say I've only lived in a very lukewarm little world of my own. I always had enough to eat, cozy place to sleep and take a dump, etc. so with that background no matter how many headlines are on the news screaming of the war and tragedies I feel like this world still has good things to offer. I don't say I am not affected by those things happening outside of my nest. Those things don't make me laugh nor cry. It may be easier if you could do either of that. I just feel like I swallowed a big chunk of molten lead sometimes when I hear the news.

What/who do you discriminate against?
Girls who like to point at every celeb at the Oscars and have something not nice to say about them. They are much less welcome than the boys who do the same. I'm also very sensitive when it comes to people who can't tell the difference between China, Korea and Japan. Oh, and people who claim they are "a happy person." And finally: stupid pot-heads.

What's your favourite satire film, and what is your favourite scene?
Dr Strangelove. The scene where Major Kong, the cowboy, rides the missile and goes down with it from the plane screaming "Yaahooo!" You all know what I'm taking about?

What's your favourite children's book?
Everyone Poops by Sarukani Gassen (a Japanese folktale which involves crime and punishment), Hansel and Gretel (which also involves the theme mentioned before PLUS the candy house – oh yeah), and of course, the children/adult book The Little Prince.

Do you have a nickname?
At the current moment the most occasionally used one is "Shizuk." I feel like: it's me. I once read a Japanese men's fashion magazine that listed pleasant (GOOD) and unpleasant (BAD)

Chuckle.

Chuckle.

What's so funny?

He comes to me.

It's funny because it's so nice.

I say.

It's so nice, we are.

morning 10/28/04

camouflage

she has bruises sometimes.

It's time you and I exchange phone numbers.

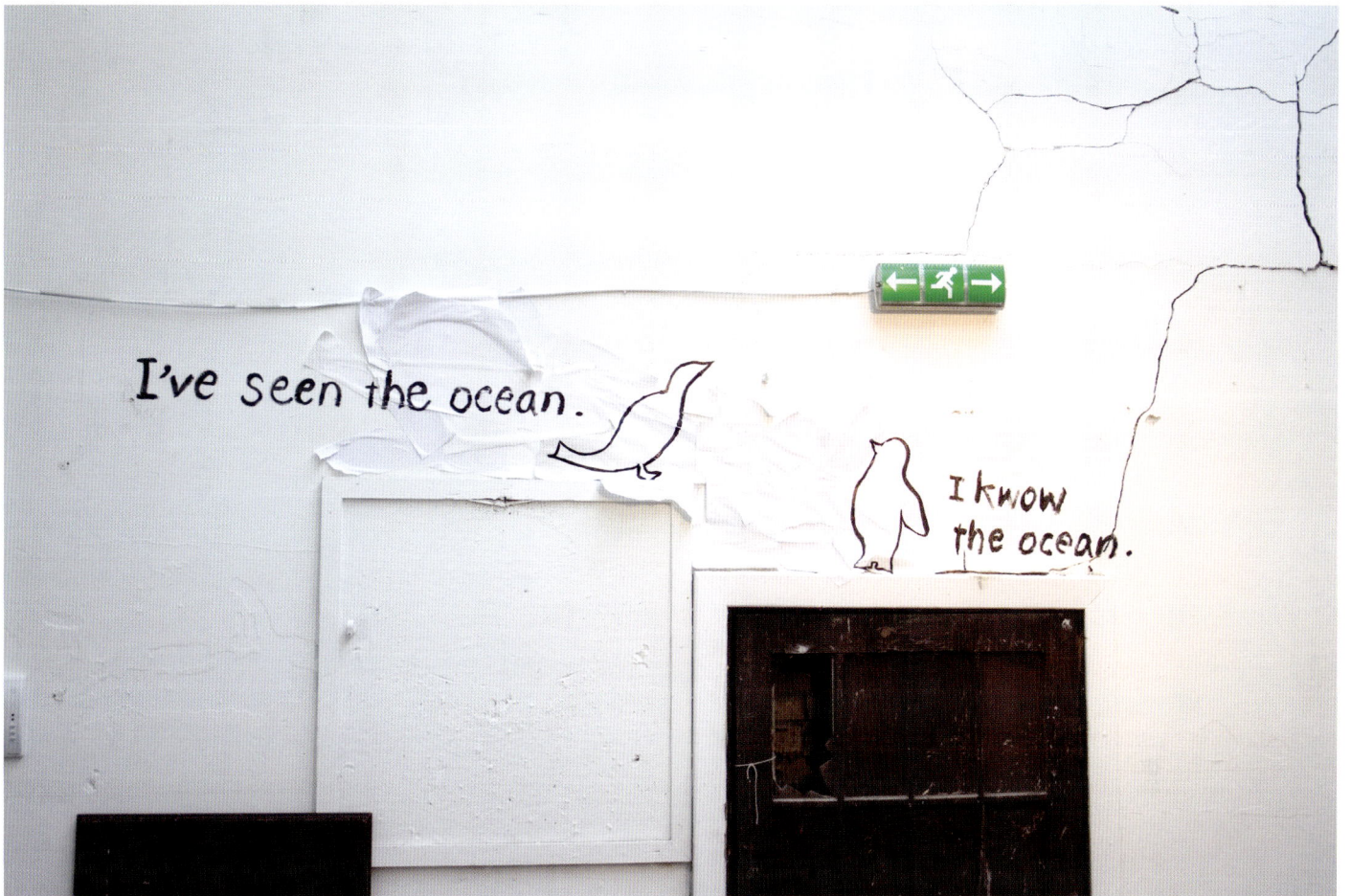

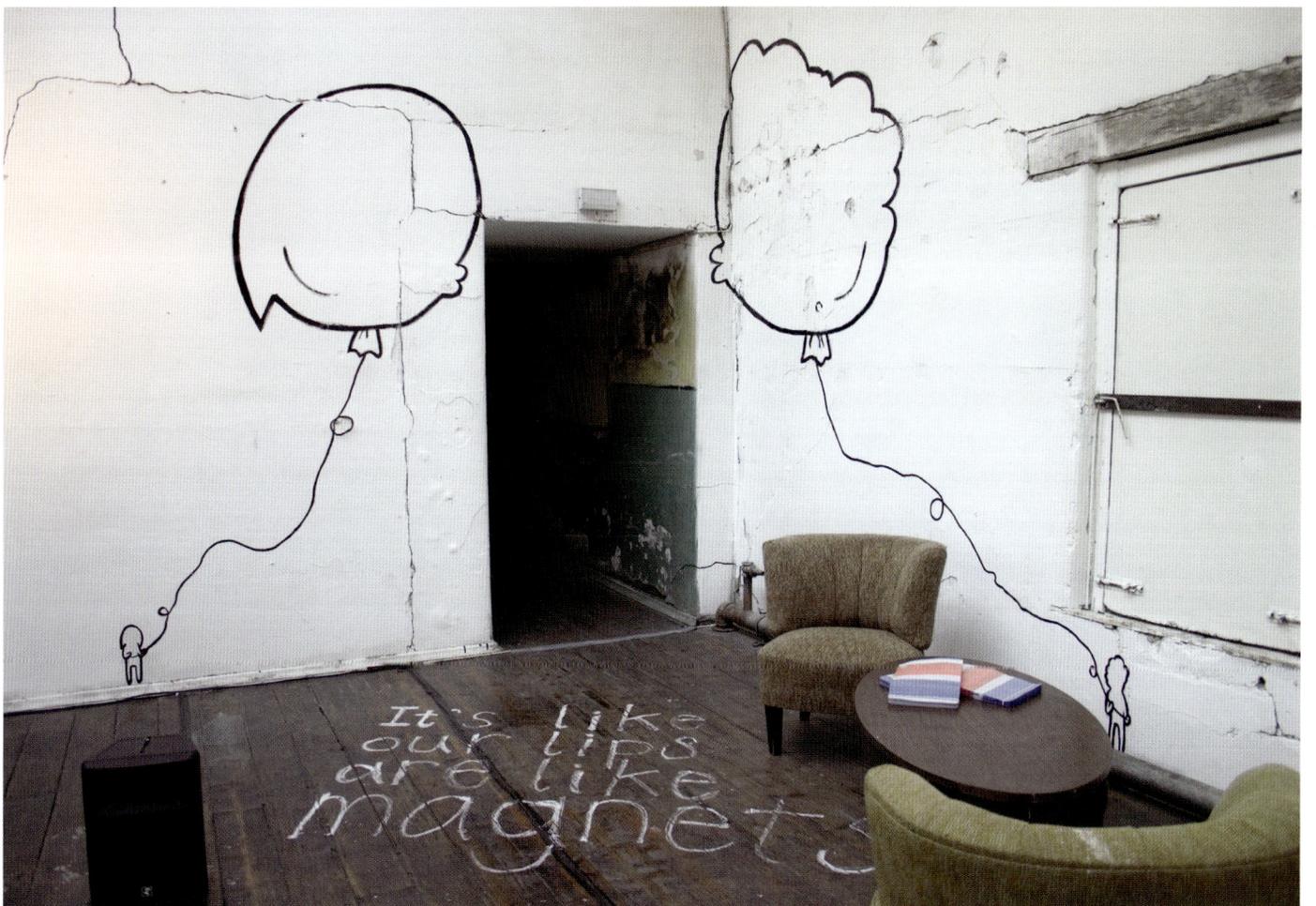

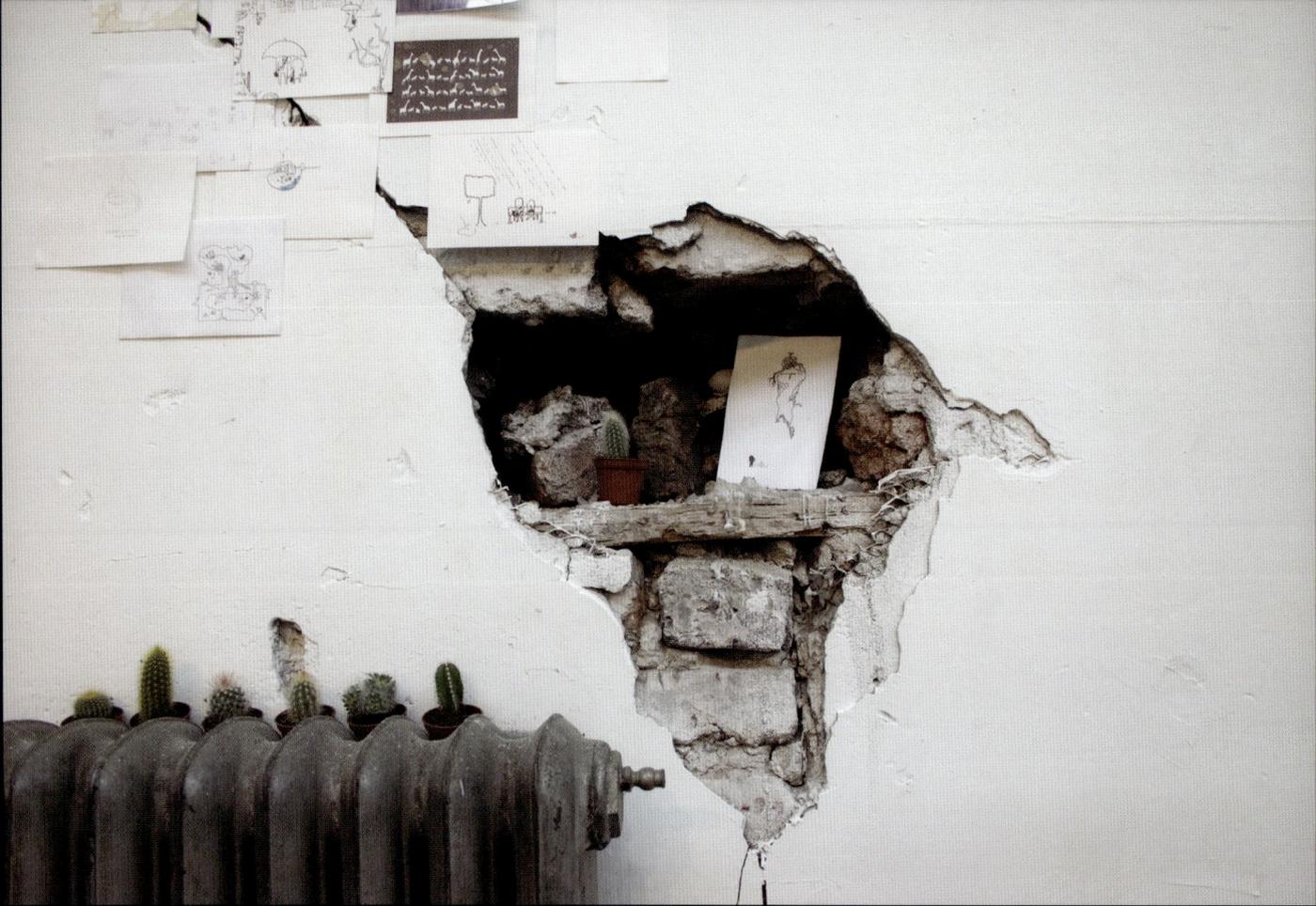

i can't draw today

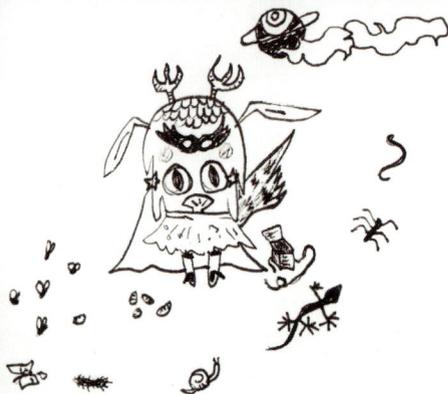

I'm really going to
dress up next year.

I wish everyone
wore pijama all the time
all around this world.

He makes fun of me
I'm always in a pajamas (p'i'jama, as he says it)
at home, as soon as I get home.
shirt tucked into striped grey cotton pants.

names of girls that the readers voted on and the name "Shizuka" was listed as the number one most unfortunate name of all. I didn't know what to think about that. Anyways, I use the name "Colette" on Jamba Juice lines and used "Linda Salmon" when I was arrested for public urination. But nobody calls me by those names. My boyfriend occasionally calls me "Boob" or "Poop" and I love him for it.

To be a good housewife.

Sweet Food – it's a title of a dessert recipe book with mouth-watering photos. I keep flipping through its pages to mini éclairs, petits pots de crème, strawberry and mascarpone bars – none of which I have enough tools to make them with so I am minimized to staring at their photos and rereading the recipes every day.

Letters To A Young Artist and *A Year In The Merde*.

I would like to thank whoever made these questions which made me discover myself. Speaking of picking your brains... My noodles have gained more wrinkles on them now. And being more of a sea anemone than a shark thanks for excavating me from millions and billions of artists and graphic designers out there.

"I once read a Japanese men's fashion magazine that listed pleasant (GOOD) and unpleasant (BAD) names of girls that the readers voted on and the name 'Shizuka 'was listed as the number one most unfortunate name of all. I didn't know what to think about that."

We've somehow managed to need each other.

We don't look the same feel the same taste the same but we both smell the same, don't we?

We've somehow managed to need each other.

118–123:
TAYLOR McKIMENS
GTA ALL DAY

Taylor McKimens was born in 1976 and grew up in Winterhaven, California, a small town on the borders of Arizona and Mexico. Strong comic book influences and a childhood in a small desert border town lend an edge to the tragico-comic energy of his pieces, and moments of elegant painterliness can invest even his ugliest image with a complex beauty. His comic book *The Drips*, was recently published by Picturebox Inc, and his artwork has been featured internationally in venues such as P.S.1 MoMA, Deitch Projects, and Clementine Gallery in New York, The Watari Museum of Contemporary Art in Tokyo, Galleri Loyal in Stockholm, Annet Gelink in Amsterdam, and Perugi Artecontemporanea in Padova, Italy.

"It just makes me want to keep playing Grand Theft Auto all day."

Opposite
'Gum Report'
16.5 x 11.75 inches
acrylic and gouache on
paper from "The Drips"
comic book published
by Picturebox Inc. 2006

How idyllic was your childhood?
I'd give it a 6 on a scale of 1 to 10.

Can you remember something that really made you laugh when you were a kid?
The farting scene in *Blazing Saddles*.

What kind of teenager were you?
Teen wolf.

What's the worst look you can remember sporting?
Mullet.

When and where did it all start to go wrong?
I think it was on my birthday in Seattle, Washington.

If you were to place yourself in a novel, how would you describe your character?
I guess I'd avoid placing myself in a novel like *The Plague*, just so that I would never have to describe my character.

Do you have a sense of humour?
Dry.

What's the most inappropriate place/time you remember laughing at?
My dad's funeral. But he would've thought it was funny too.

Did anyone ever take any of your jokes badly?
Pretty much everyone.

What are you good at, what are you bad at?
I like fishing, and I've never been on skis. Richard hates skiers?

Do you work with other people? How does that work? Does it work?
I'm much better working alone.

Are you the type to exaggerate things?
Probably the opposite.

In your opinion, is there such a thing as intelligent or stupid humour?
I would think so, but it's maybe not all that easy to differentiate.

What/who would you consider an ideal subject for parody?
Cookie Monster. (He's not eating those cookies. He just crumbles them up and drops them all over the table. Cookie Slob more like it.)

Some people seem to see the world as 'serious, but not hopeless', others see the world as, 'hopeless, but not serious.' How do you see it?
Seriously hopeless, but hopefully not serious?

Do you have any theories about the world we live in?
I believe the children are the future.

Do you carry any crosses?
I've got a few, but so does everybody. Maybe one of them is I'm not good at talking about myself. Making me especially bad at questionnaires... Sorry.

Do you ever feel like we're doomed? And does that make you want to laugh or cry?
It just makes me want to keep playing *Grand Theft Auto* all day.

What/who do you discriminate against?
Animals that bite.

What's your favourite satire film, what was your favourite scene?
Is *Stir Crazy* satire? I like the scene with Richard Pryor and the match.

What's your favourite children's book?
Mad magazine

What would you say is definitely NOT your motto?
A penny saved is a penny earned.

Do you have any addictions?
I think I'm permanently damaged from just looking to see what shegods.com is. Maybe I'm ready for that therapist now...

Have you started reading self-help books yet?
I like *How to Draw Horses*. My favourite is the appaloosa.

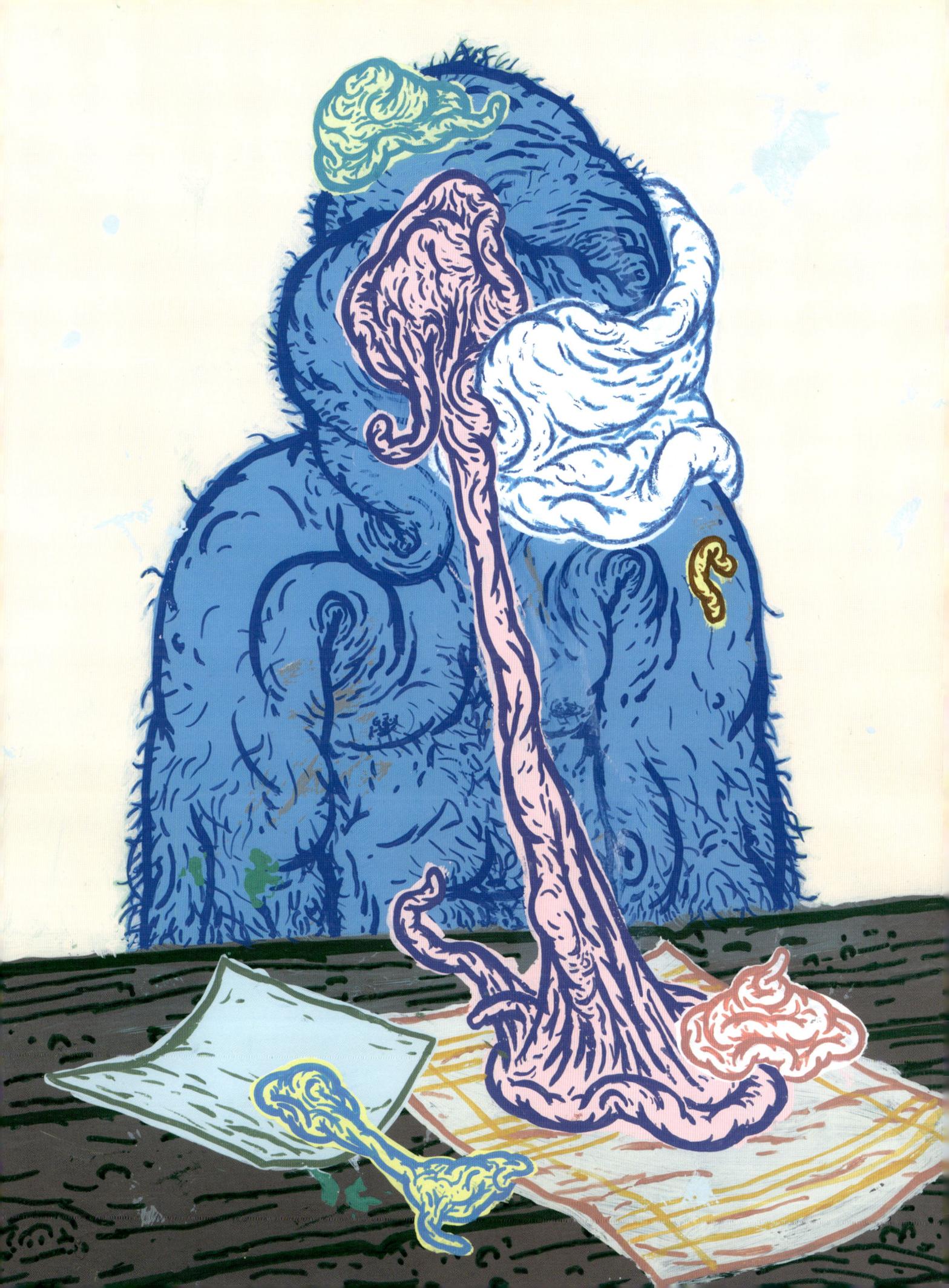

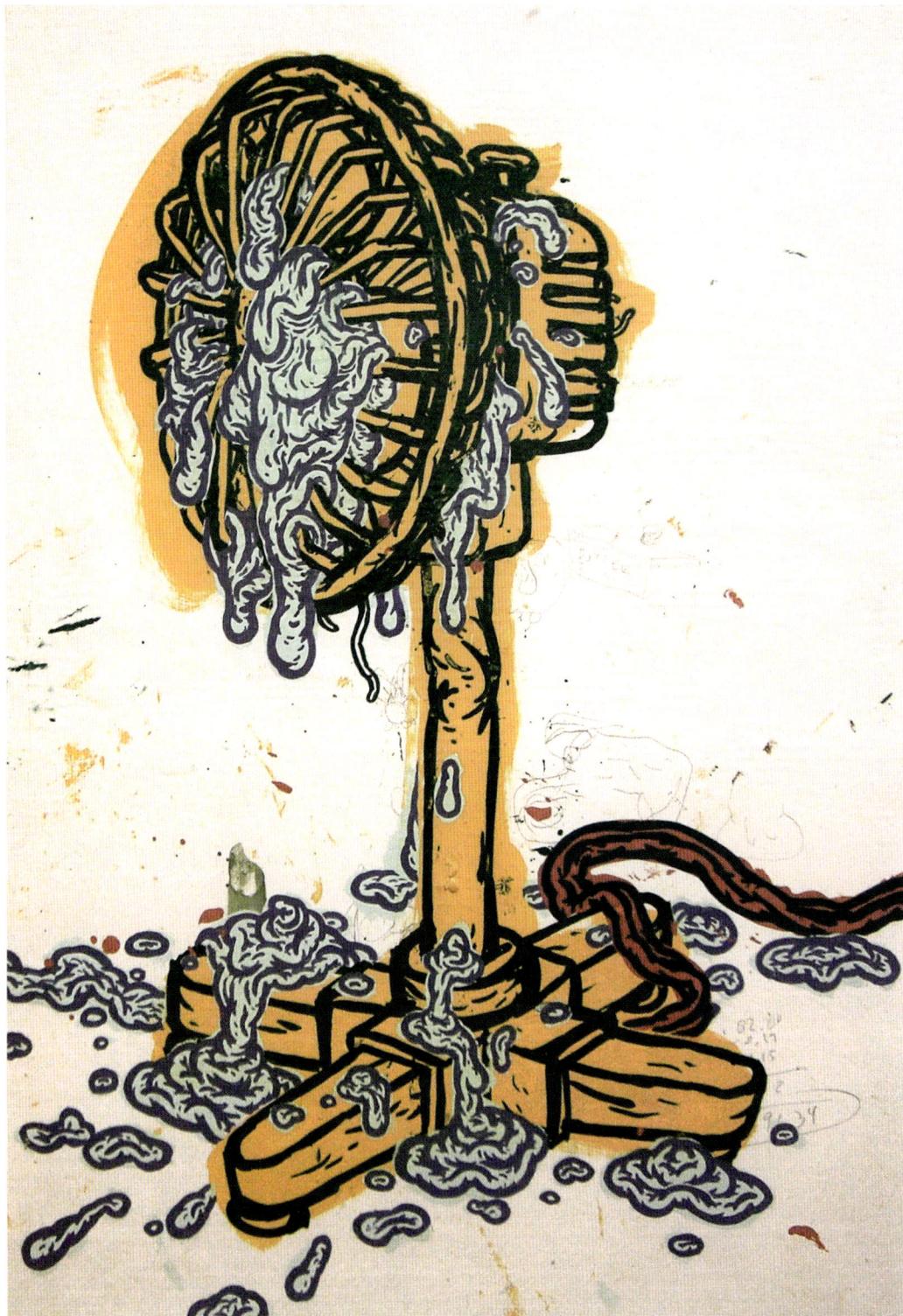

Above
'Blue Goo Hits The Fan'
16.5 X 12 inches
acrylic and gouache
on paper

Above right
'Fence Blob'
9 x 13 inches
acrylic gouache and
opaque pen on paper

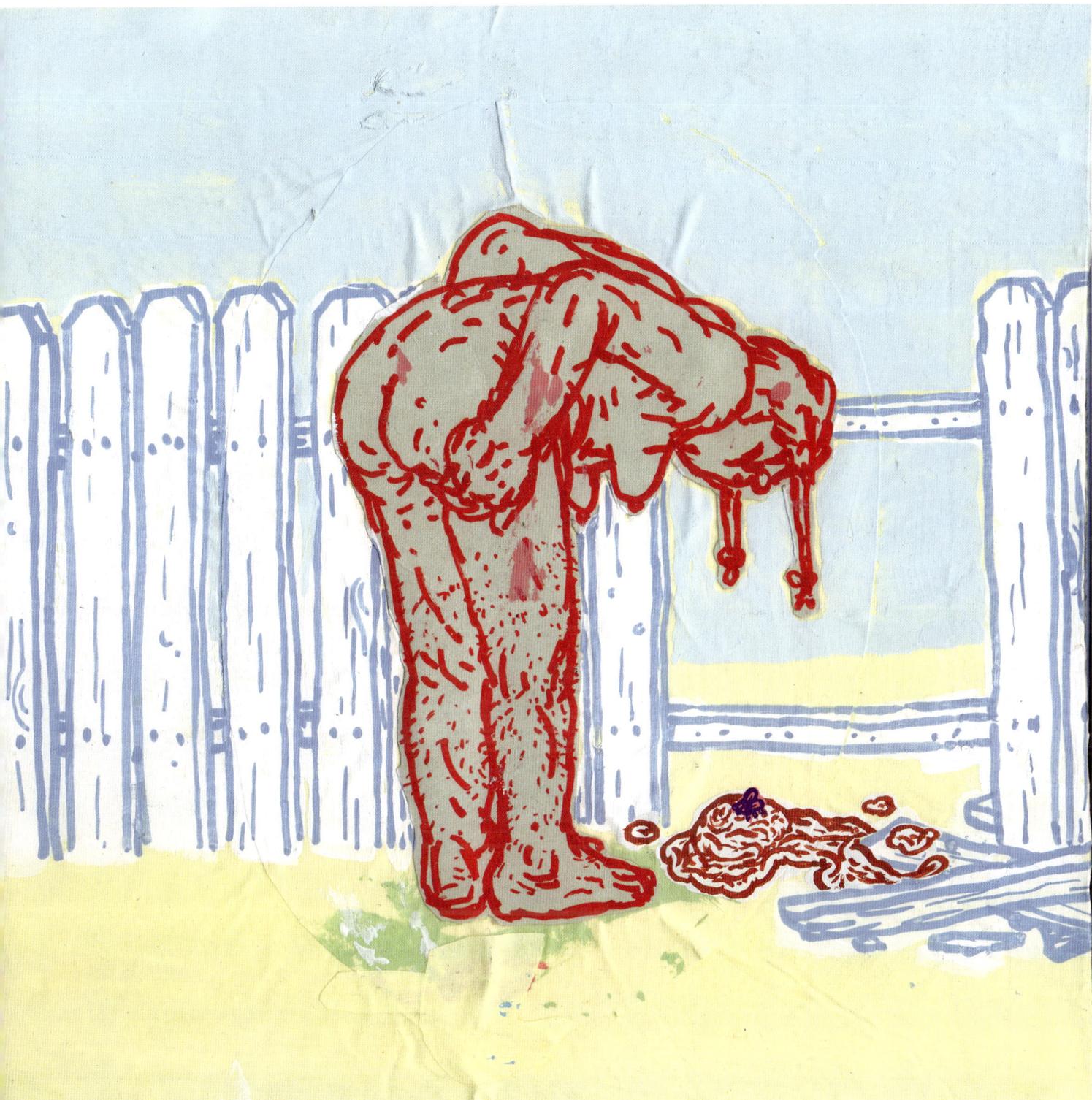

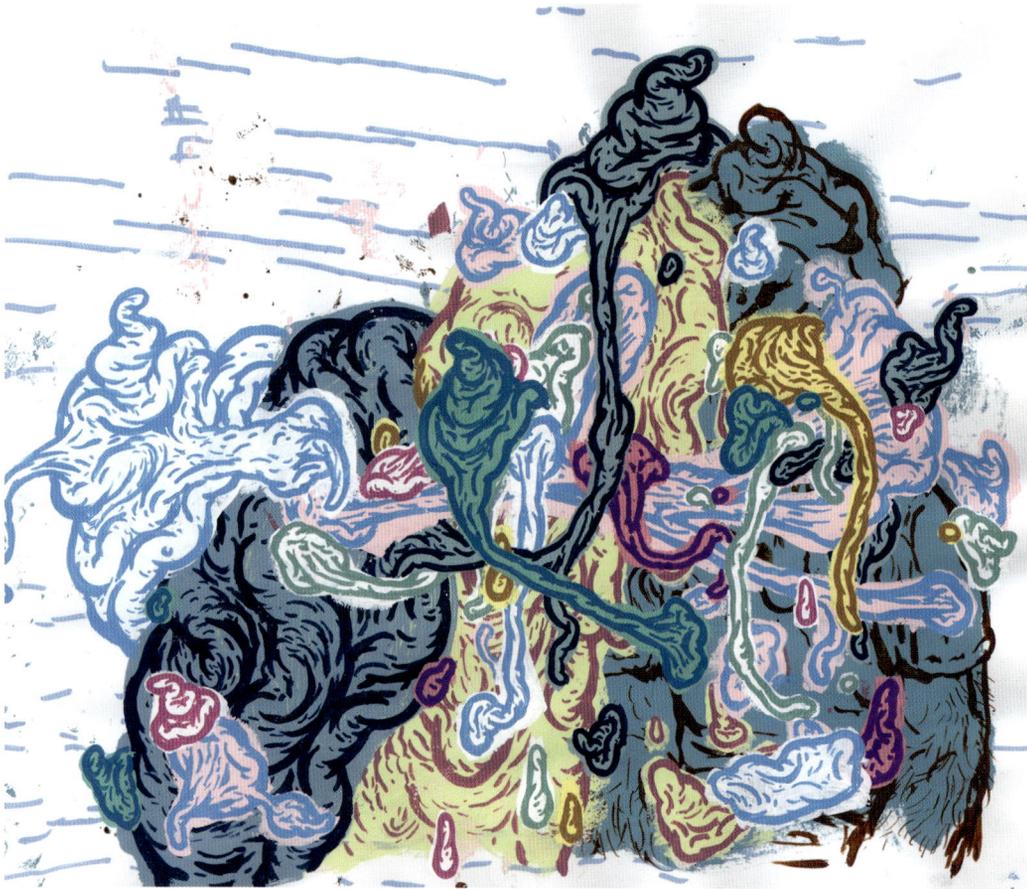

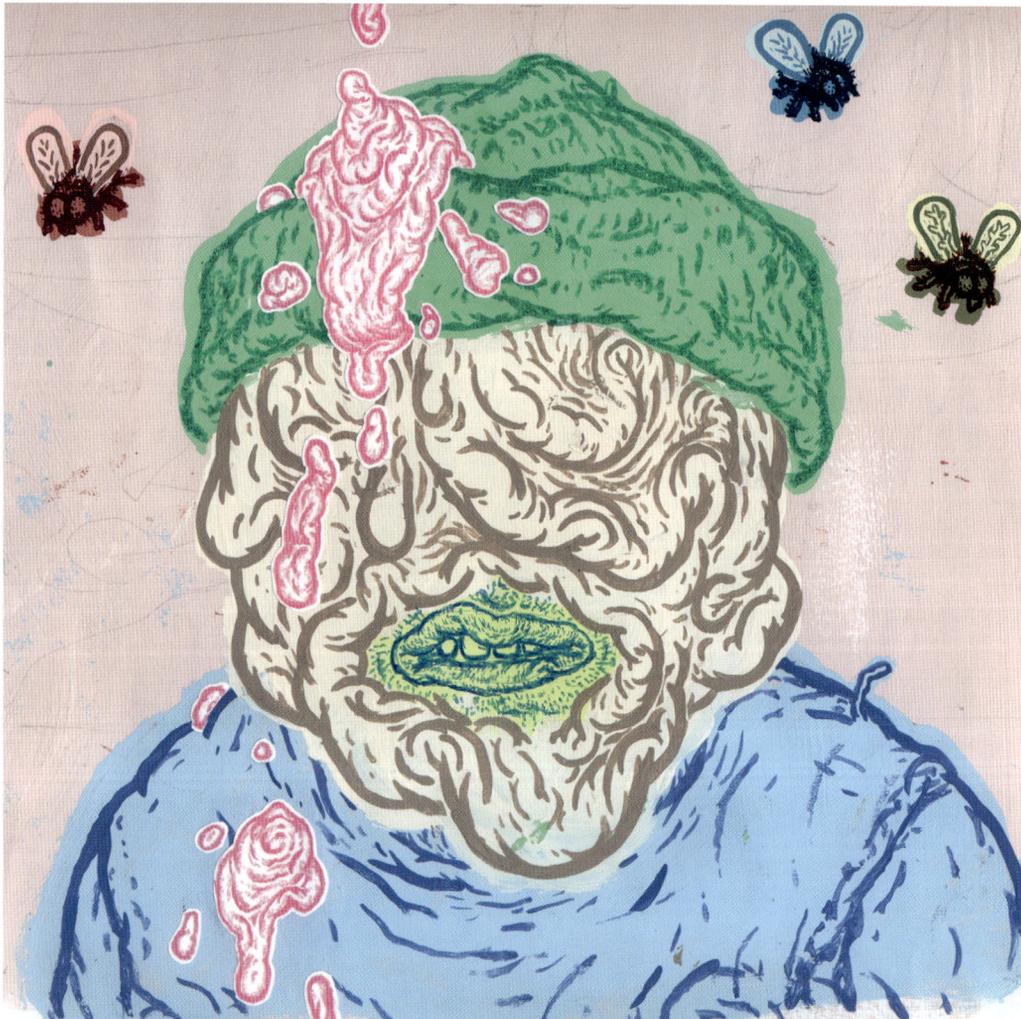

Above
'Pile'
10 X 13 inches
acrylic and gouache
on paper

Left
'Head Shot'
9 X 10 inches
acrylic and gouache on
paper from "The Drips"
comic book published by
Picturebox Inc. 2006

Opposite above
'Ice Cube Tray'
17 X 8 inches
acrylic, gouache and
opaque pen on paper

Opposite below
'Cassette Deck'
12.5 X 17 inches
acrylic, gouache and
opaque pen on paper

124–129: NICOLAS MAHLER
YOU SHOULD STOP THIS

Nicolas Mahler lives in Vienna, Austria, where he writes and illustrates books for mostly French and Canadian publishers. He also makes short films.
www.mahlermuseum.at

Title of work submitted: "Poems"
Date of completion: End of 2006
Brief Description of work submitted:
"Poems" is a series of preposterous black and white drawings. All my "poems" are published in book form by "les éditions de la pastèque", a publisher from montreal.
www.lapasteque.com

"*The submission was fun, but I really hated this questionnaire. You should stop this.*"

How idyllic was your childhood?
How do you measure "idyllic"?
Can you remember something that really made you laugh when you were a kid?
No. Does this sound sad?
Did you cherish any grandiose dreams?
No.
What kind of teenager were you?
Too awful to remember.
What's the worst look you can remember sporting?
I forgot.
What's the most embarrassing situation you would admit to finding yourself in?
Stop this.
When and where did it all start to go wrong?
It did NOT got wrong.
If you were to place yourself in a novel, how would you describe your character?
I'd rather be in a short story.
Do you have a sense of humour? If so, what kind?
Everybody has some sense of humour. Do I have to answer the second part as well?
What did you think when you first saw your therapist?
I cannot afford one.
Do you laugh at your own jokes?
It is more of a knowing smile.
What's the most inappropriate place/time you have ever laughed?
Maybe at some bad comedian, which is really embarrassing.
Do you work with other people? How does that work? Does it work?
Does not work.
Are you the type to exaggerate things? How much?
If it helps in any way, yes. Why not.
In your opinion, is there such a thing as intelligent or stupid humour?
All I know is that intelligent people usually have an awful, stupid sense of humor.
Some people seem to see the state of the world as 'serious, but not hopeless', others see the world as 'hopeless, but not serious'. How do you see it?
Not as a one-liner.
Do you have any theories about the world we live in? Would you mind sharing one with us?
No.
Do you carry any crosses?
What?
Do you ever feel like we're doomed? And does that make you want to laugh or cry?
You sound like the news, I do not see a question in this.
What/who do you discriminate against?
Other people.

What's your favourite satire film, what is your favourite scene?
Maybe some self-important arthouse movie. *Damage* by Louis Malle had me on the floor. Ingmar Bergman has some great moments too.
What's your favourite children's book?
One about a clinic for animals.
Do you have a nickname?
I had one, but that's history.
What would you say is definitely NOT your motto?
Having a motto.
Do you have any addictions?
Making books.
Have you started reading self-help books yet?
No, but I was thinking about writing one.
And finally would you like to say a word about submitting to the magazine and replying to this questionnaire?
The submission was fun, but I really hated this questionnaire. You should stop this.

curiosity

stupidity

time

space

humour

drama

ambition

success

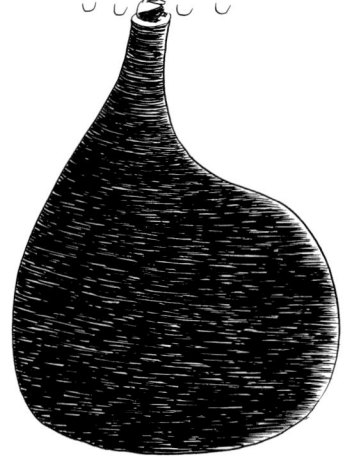

image

sound

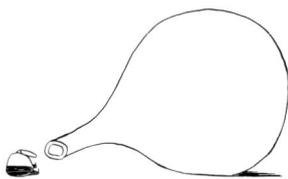

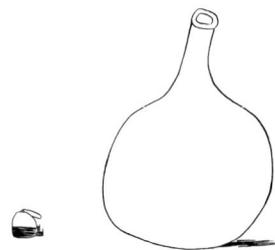

day

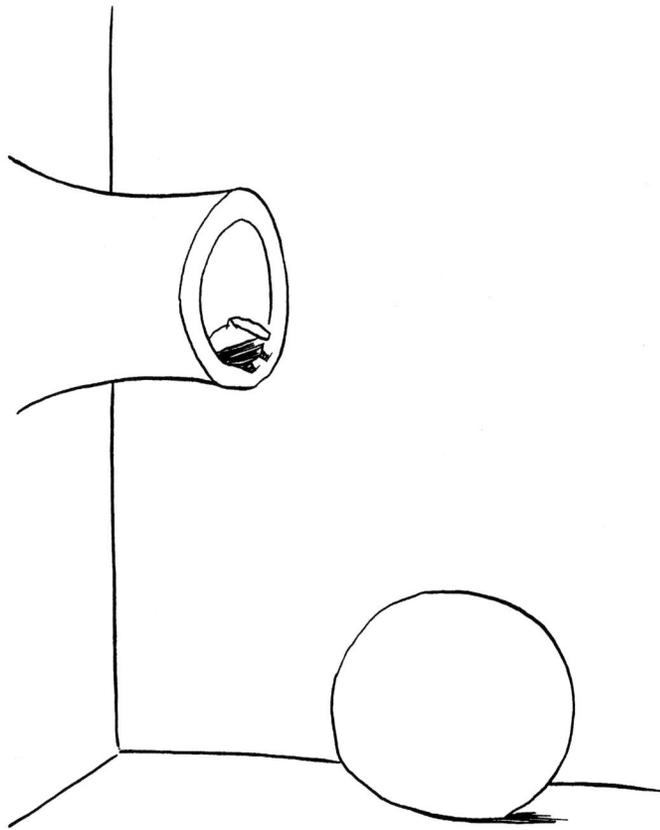

night

130–133:
OGILVY
BAG OF INSPIRATION

While left to play in the sand dunes, Ben Callis, Justin Barnes, Mike Watson & Jon Morgan all claim to have first met in Marrakesh, where their respective parents were travelling on the introspective hippy trail.

According to the Ogilvy boys, it's a well known fact that drunkenness is a neural pathway to creative enlightenment. They argue that great thinkers, poets and hooligans throughout history have summoned the magical properties of alcohol to help refine and define the answers to which they've been reaching for.

In their latest installment, an LP entitled *Bags of Inspiration*, a collection of experimental music mixes, they discuss and argue only through the excessive consumption of alcohol one can become really successful.

To illustrate their point, they depict themselves dressed as some of who they believe are the most successful people in today's society. Inside the cover they've designed a selection of beer mats which detail a day in the life of a highly paid and alcohol – soaked creative.

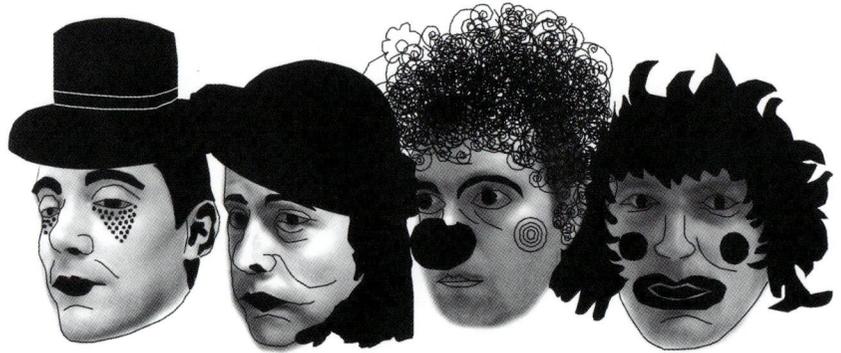

INVESTOR ACCOUNTABILITY PRODUCER
baileys
0090

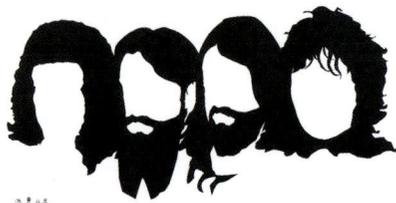

HUMAN GROUP ENGINEER
moon-moos special
0081

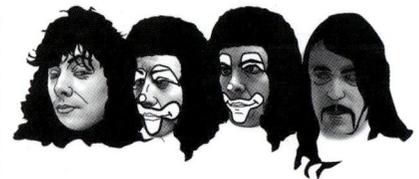

HUMAN BRANDING DIRECTOR
commemorative
0082

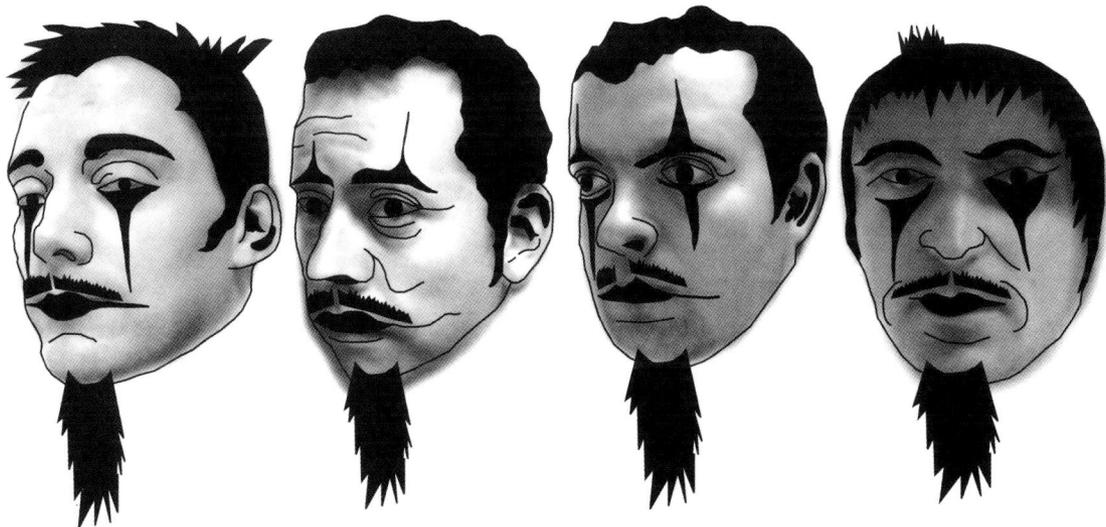

MULLAH
ward eight
0196

HALF SEAS OVER
Bag of inspiration #3
W
ANY PORT
IN A STORM
11pm
240fl oz
It takes a lot of alcohol to make a big cheese

UNDER The TABLE
Bag of inspiration #3
It takes a lot of alcohol to make a big cheese
NO LISTEN TO THIS. LISTEN, LISTEN, IF I TALK LOUDER I WILL BE EVEN MORE INTERESTING
3AM
260FL OZ

anyway the other night i said to sir bob (thats what we call him down the arts club) bono asked me to sing on his solo venture (which is top secret)so i was in the studio an...	...and she's all over me like aher night i said to sir bob...	...wn the arts club) bono asked me to...	...his...venture (which is top secret)so i wa...	...the solo an...sting and trudy drop by an s...	...rash. no joke. anyway the...b (thats what we call him down...e to sing on his solo venture (wh...ecret)so i was in the studio and sting an...y and sh...ver me like a...the oth...
Pub Bore
to s...	...club)
bon...	...ch is top...	...rudy
...	...she's all over me...rush. no joke,
...the...night i said...(thats what we call him down the arts club) bono asked me to sing on his solo...	...was in the
5pm	120 fl oz
Bag of inspiration #3
It takes a lots of alcohol to make a big cheese

GO ON
ONE MORE
Bag of inspiration #3	It takes a lot of alcohol to make a big cheese
1pm	40 fl oz

FIRST DRINK OF THE DAY - NOT MUCH TO SAY
VERBALLY
CONSTIPATED
You Desire
MORE BEER
Bag of inspiration #3
It takes a lot of alcohol to make a big cheese
12pm	20 fl oz

TIPPING THE SCALES
ONE TOO MANY TO GO BACK TO WORK
2pm	60fl oz
Bag of inspiration #3
It takes a lot of alcohol to make a big cheese

BLIND DRUNK

4am 280 fl oz

Bag of inspiration #3
It takes a lot of alcohol to make a big cheese

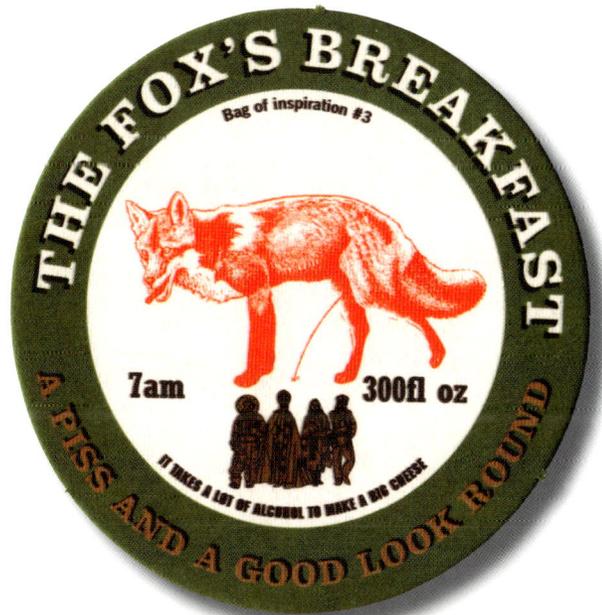

THE FOX'S BREAKFAST

Bag of inspiration #3

7am 300fl oz

IT TAKES A LOT OF ALCOHOL TO MAKE A BIG CHEESE

A PISS AND A GOOD LOOK ROUND

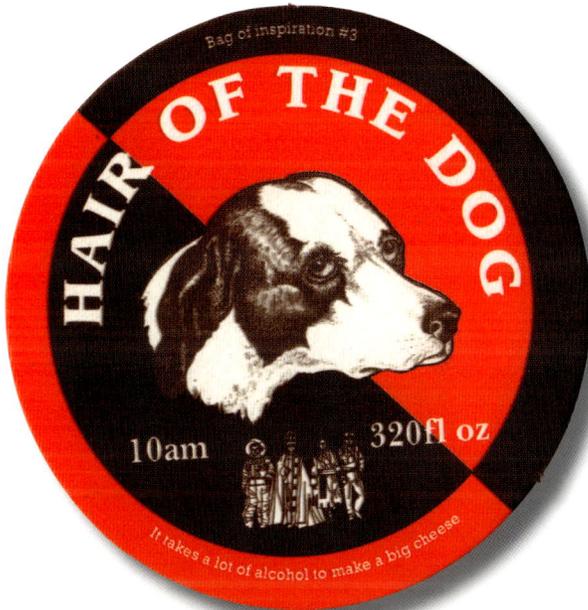

HAIR OF THE DOG

Bag of inspiration #3

10am 320fl oz

It takes a lot of alcohol to make a big cheese

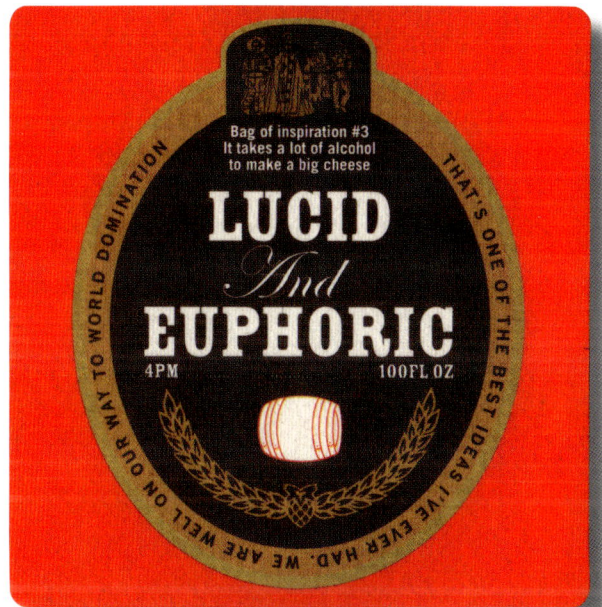

Bag of inspiration #3
It takes a lot of alcohol
to make a big cheese

LUCID
And
EUPHORIC

4PM 100FL OZ

THAT'S ONE OF THE BEST IDEAS I'VE EVER HAD. WE ARE WELL ON OUR WAY TO WORLD DOMINATION

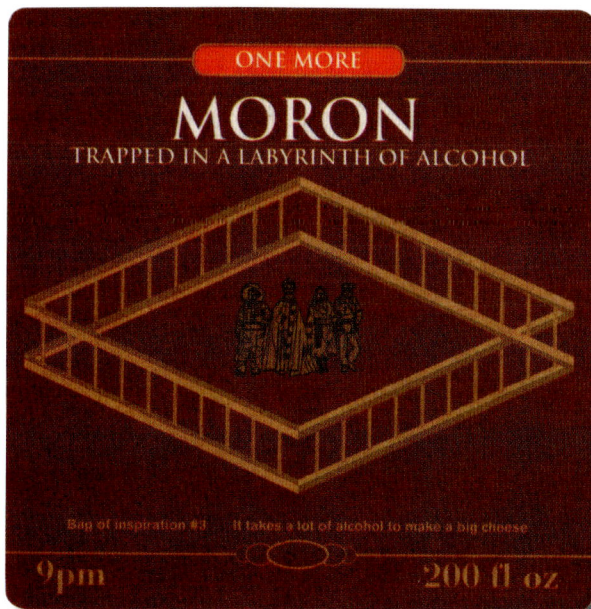

ONE MORE

MORON

TRAPPED IN A LABYRINTH OF ALCOHOL

Bag of inspiration #3 It takes a lot of alcohol to make a big cheese

9pm 200 fl oz

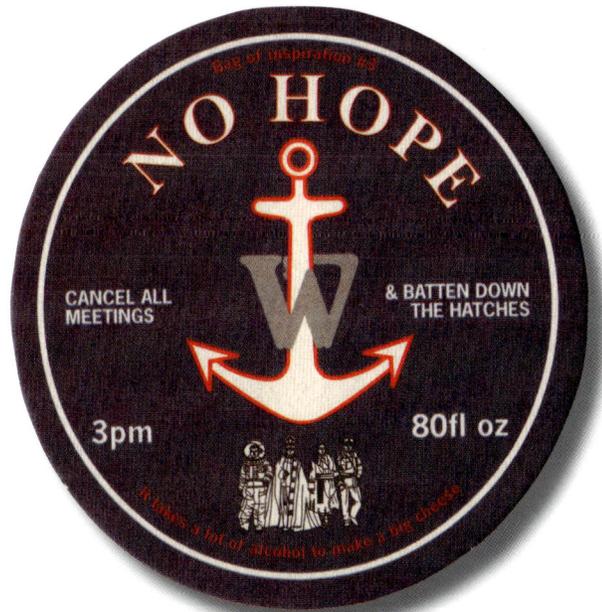

Bag of inspiration #3

NO HOPE

CANCEL ALL MEETINGS & BATTEN DOWN THE HATCHES

3pm 80fl oz

It takes a lot of alcohol to make a big cheese

Leif Parsons was educated in Canada and New York and has degrees in Philosophy and Design. He has been working as an illustrator for a number of years and has been published by a variety of editorial and commercial clients including *Harpers*, *New York Times*, *McSweeney's* and Nike. He simultaneously has been executing personal work, which has been shown in LA and NYC.

Parsons currently lives in Brooklyn and does a weekly illustration for the *New York Times Magazine*. He has recently been focused on trying to find the line between looseness and tightness, between deliberate idea and spontaneous expression, between observation and imagination.

How idyllic was your childhood?
Medium, kids can be shits...
Can you remember something that really made you laugh when you were a kid?
Calvin and Hobbes.
What kind of teenager were you?
Rock and roll (kinda – actually, it was more hip-hop).
What's the worst look you can remember sporting?
Hair slicked in front of face, covering one eye...
What's the most embarrassing situation you would dare to admit finding yourself in?
Parents walking into the living room while I was in mid-action with girlfriend (long story really...)
When and where did it all start to go wrong?
Wrong?
If you were to place yourself in a novel, how would you describe your character?
Jumpy.
Do you have a sense of humor? If so, what kind?
Not so much – unfortunately my sense of humour is usually at the cost of others.
What did you think when you first saw your therapist?
Sexy.
Do you laugh at yourself?

All day every day...
Did anyone ever take any of your jokes badly?
Most of the time really..
What are you good at, what are you bad at?
I am getting better at jogging, but I am not the most patient of individuals...
Are you the type to exaggerate things? How much?
Enough to amuse, hopefully.
Are creative people unbalanced?
A little nuttiness or drug use never hurt the work.
What/who would you consider an ideal subject for parody?
Cars...
How do you see the world?
Slightly fucked.
Do you have any theories about it?
We are overly dependent on cars...
Do you carry any crosses?
Can't spell.
What's your favourite satire film, what is your favourite scene?
The Jerk, trying to keep time.
What's your favourite children's book?
In the Night Kitchen.
What would you say is definitely NOT your motto?
Johns Electronics and Computer Repair.

Right
'Pigs vs cows'
Drama Magazine 2006
Art director: Joel
Speasmaker, Mixed media
Published at 9" x 8"

Opposite
'Significance (circles)'
Self promotion poster 2003
Pencil on paper 23" x 17"

VS

the significance of circle

punk | thought bubble | snow man middle | H² | go *green* | jelly bean | atom | moon | hot wheels | sack

sun | gall stone | cup | never ending | mine yours ours | fat | tunnel | hole

sunny garbage | puddle | rabbit poop | ny the wrong way through a telescope | pin | a | nest | shoe | donut | luggage

rookie | *Pure chocolate* the greatest cookie | pig tails | bowling | urinal | mouse | cigarette | funky 70's chair

potato | eye patch | alien | left ball | grrrr | eye | magnified period | din | seed | i

8 race track | not a circle | see through ash tray | tape | 3 | plane loosing it | ½ avocado | pebble | peach in transport

silicone | nip | tintin | shower *w. drop* | the light | pimple | empty pool | trap | basket

olive | the pit | pancake | loli | potato 2 | crack | leaky | facial hair | glasses

straw | suction cup | tomato | yo-yo | almost perfect | grape almost raison | 3-d | the i want to fuck c.d.

you | rat | melon | golf | button | stink bomb | wire | ass hole | i hate you no! yes! people

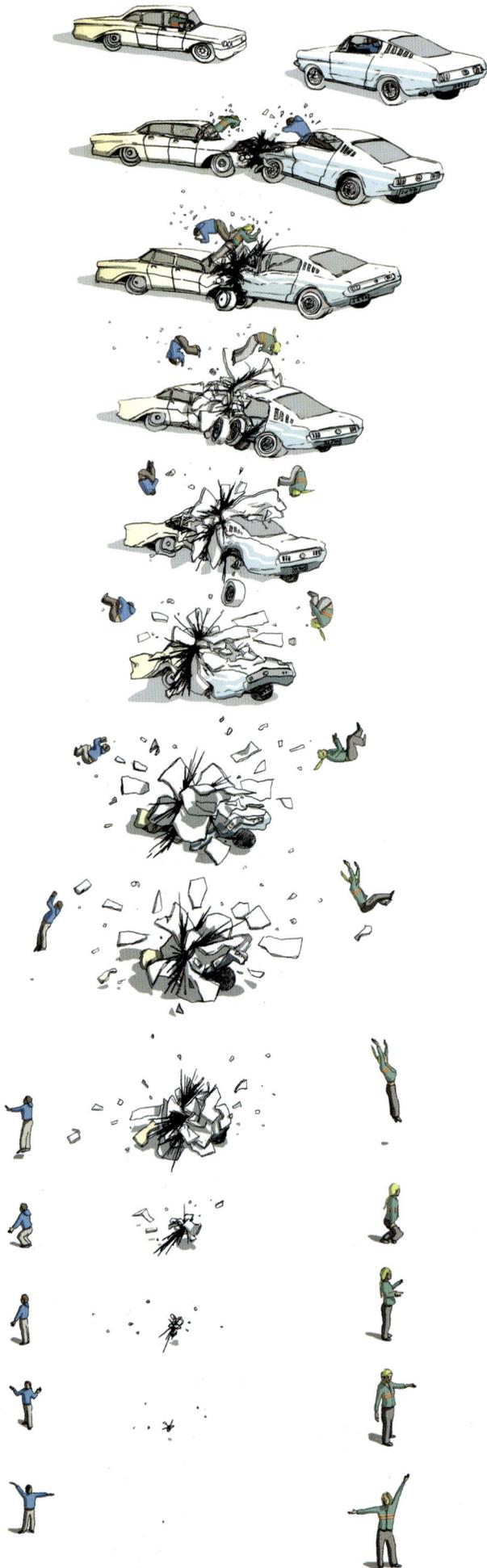

urban

de-extender

Personalized

Inflatable

edible

quiet

floaters

sexy

fancy

mic

cross town

replacement

light

ME

YOU

SPEED

RADAR

(DON'T WORRY)
RADAR DETECTOR

(HA)
RADAR DETECTOR
DETECTOR

(BUT WAIT...)
RADAR DETECTOR
DETECTOR DETECTOR

DETECTOR DETECTOR
DETECTOR DETECTOR

DETECTOR DETECTOR
DETECTOR DETECTOR
DETECTOR

ETC......

Opposite
'Ephemeral (car crash)'
Walrus Magazine –2006
Art director: Antonio DeLuca
Mixed media
Published at 8" x11"

Top
'Shoes'
Self promotion 2004
(part of a multipart newsprint
promo about commuting)
mixed media 7" x 9"

Right
'Detector detector'
Self promotion 2004
Mixed media 5" x 6"

138–145:
ANDREW RAE
INCL. © FREE IMAGES

Illustrator Andrew Rae currently lives and works in East London where he is a member of the illustration collective Peepshow. He started out in 1998 producing flyers for Perverted Science. He was Art Director on the BBC 3 show *Monkey Dust* and directed the on-air identity for MTV Asia in 2005. Recently he made a short film *The Stunt* for Channel 4 and has a weekly slot in the *Guardian*.
www.andrewrae.org.uk

"Everyone you meet is bad at something, even if they're really intelligent or athletic or beautiful or whatever. There is always something they absolutely stink at. You've just got to find out what it is."

How idyllic was your childhood?
Very idyllic, I spent the long summer days dressed as a soldier terrorizing old ladies up on the downs. I had a really cute little Kalashnikov Ak 47 assault rifle that I used to love.

Can you remember something that really made you laugh when you were a kid?
Yes, Adrian Cross had a leather jacket that he could squeeze his legs up into so they looked really short and then do a little dance, I think that's one of the funniest things I ever saw.

Did you cherish any grandiose dreams?
Yes indeed I wanted to be in a rock n roll band but I was better at drawing.

What kind of teenager were you?
A self-obsessed spotty irritating spiky haired little twat in a pair of Farahs and HiTecs that his Mum bought him.

What's the worst look you can remember sporting?
I had my hair in curtains and a shell suit top that I wore with flared white jeans.

What's the most embarrassing situation you would dare to admit finding yourself in?
I don't get that embarrassed.

When and where did it all go wrong?
Not sure, but I pretty much slept through school. I was reading the other day that children don't really wake up until about 10 so to make them get up earlier is just mean. Some schools had improved results by putting back their start time, unfortunately I'm still in this state, which isn't helped by the fact that all the best television seems to be on late at night.

How would you describe your character?
I wouldn't mention that I had a beard till about half way through so you've made a picture in your head already and then I've ruined it.

Do you have a sense of humour? If so, what kind?
I hope so, but then that's not a very funny answer so maybe not.

Do you laugh at your own jokes? How loud?
Yes, I do and also a good trick is to have funny friends who say witty things quietly under their breath, that way you can pick their funnier comments and say them louder when people are listening.

What's the most inappropriate place/time you remember laughing at?
Not sure, but I clearly remember a time when everyone in a maths lesson inexplicably went quiet at the same time leaving me to clearly utter the word 'tits' to the room.

Did anyone ever take any of your jokes badly?
I was accused of being racist when dressing up as Jimi Hendrix for a talent competition one time.

What are you good at, what are you bad at?
I play the piano well by my standards but badly by anyone else', s so I'm good and bad at that.

Do you work with other people?
I work with other people a lot more now than I used to as I've been doing more animation. I've never been much of a team player but I really enjoy working with people I like and respect.

Are you the type that exaggerates things?
I've exaggerated more than anyone else in the universe.

We noticed that some of the submissions we received seemed a little angry, possibly maladjusted. Would you say that creative people are predisposed?
Fuck off.

In your opinion, is there such a thing as intelligent or stupid humour?
Intelligent humour makes you smirk but it's the really stupid stuff that makes you laugh.

What/who would you consider an ideal subject for parody?
Maybe Tom Cruise. I saw him on Parky when I was on a plane the other day. When asked if he's getting married anytime soon, he said he loves being married to a woman (funny choice of words that isn't it). Then again *South Park* have done it better than I could already.

Some people seem to see the world as 'Serious, but not hopeless', others see the world as, 'Hopeless, but not serious.' How do you see it?
The second one.

Do you have any theories about the world we live in?
Everyone you meet is bad at something, even if they're really intelligent or athletic or beautiful or whatever. There is always something they absolutely stink at. You've just got to find out what it is.

Do you carry any crosses?
I grew a ginger beard, so I can only blame myself.

Do you ever feel like we're doomed? And does that make you want to laugh or cry?
Yes I do, and I can go both ways. Mostly though I think people need to slow down at making more people cause I think we've got enough. What the hell are they all doing every day? You know those people you see shopping on weekdays? Why are they there? Don't they have something to do? I blame the Pope for banning contraception. Miserable old sod. Just cause he's not allowed to do it don't ruin it for everyone else.

What/who do you discriminate against?
Everything. As long as you have a go a →p143

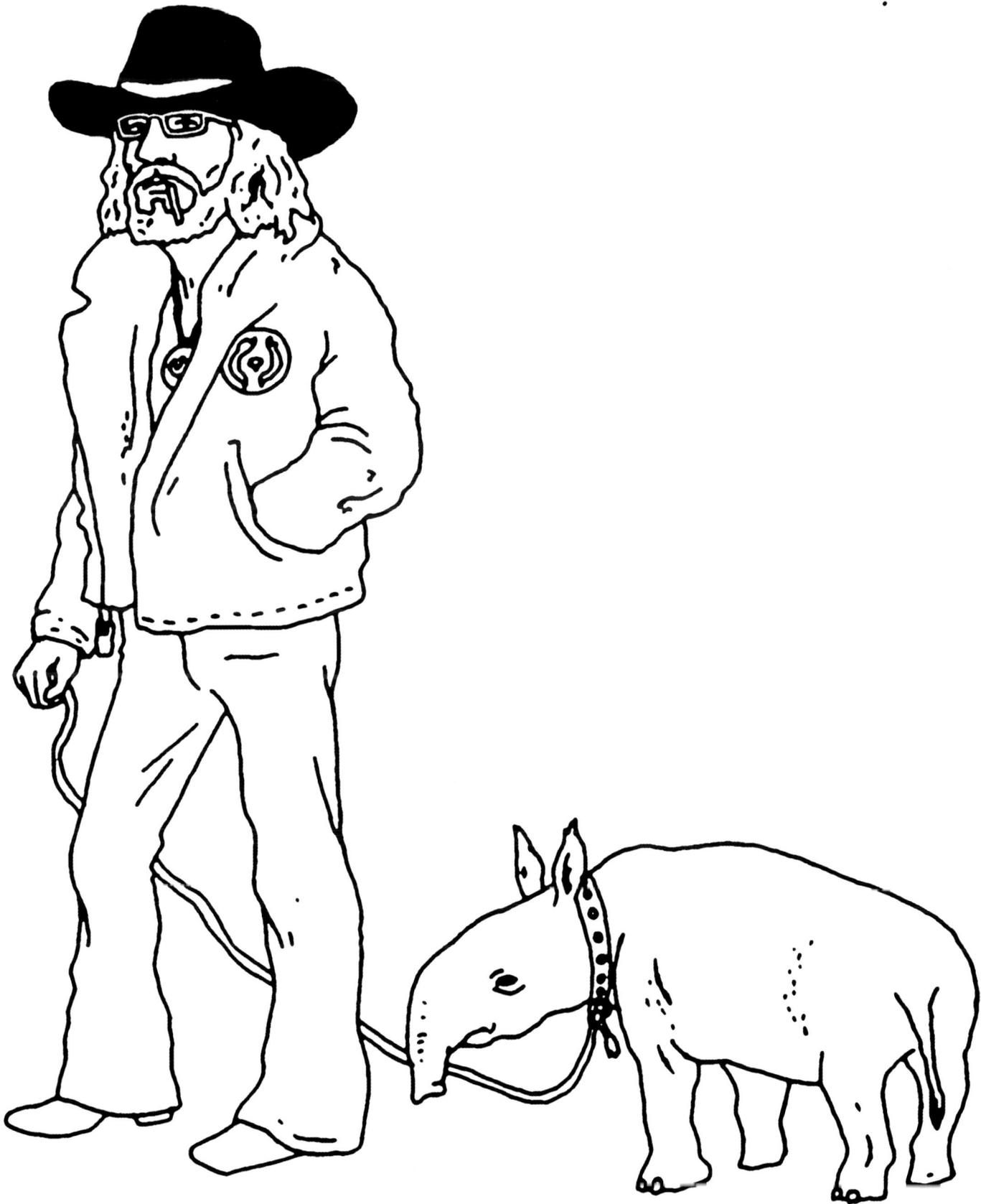

YOU'RE NOTHING WITHOUT A TAPIR...

THE HUMAN BODY

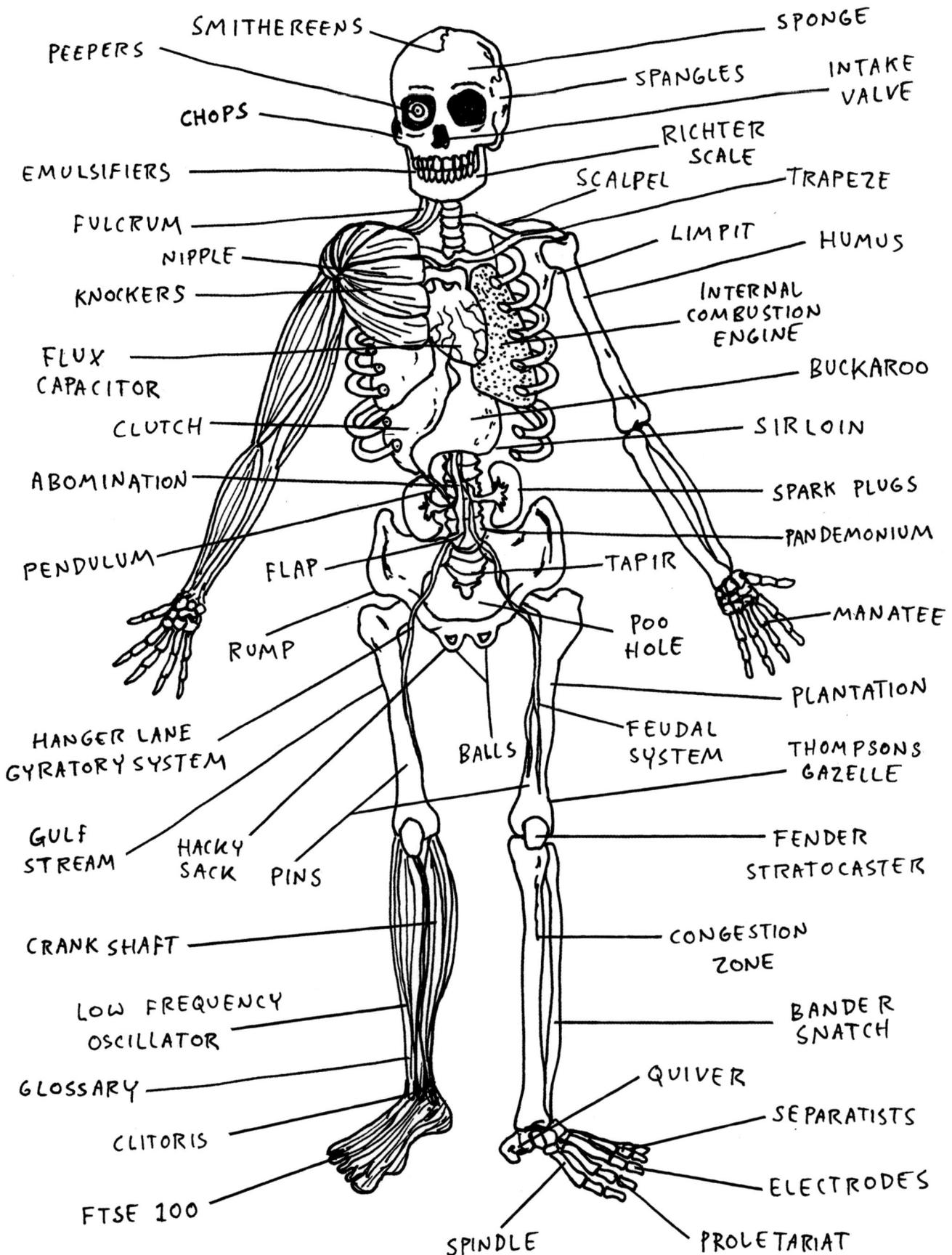

PEEPERS

SMITHEREENS

SPONGE

SPANGLES

INTAKE VALVE

CHOPS

RICHTER SCALE

EMULSIFIERS

SCALPEL

TRAPEZE

FULCRUM

LIMPIT

HUMUS

NIPPLE

KNOCKERS

INTERNAL COMBUSTION ENGINE

FLUX CAPACITOR

BUCKAROO

CLUTCH

SIRLOIN

ABOMINATION

SPARK PLUGS

PANDEMONIUM

PENDULUM

FLAP

TAPIR

MANATEE

POO HOLE

RUMP

PLANTATION

HANGER LANE GYRATORY SYSTEM

BALLS

FEUDAL SYSTEM

THOMPSONS GAZELLE

GULF STREAM

HACKY SACK

PINS

FENDER STRATOCASTER

CRANK SHAFT

CONGESTION ZONE

LOW FREQUENCY OSCILLATOR

BANDER SNATCH

GLOSSARY

QUIVER

CLITORIS

SEPARATISTS

FTSE 100

ELECTRODES

SPINDLE

PROLETARIAT

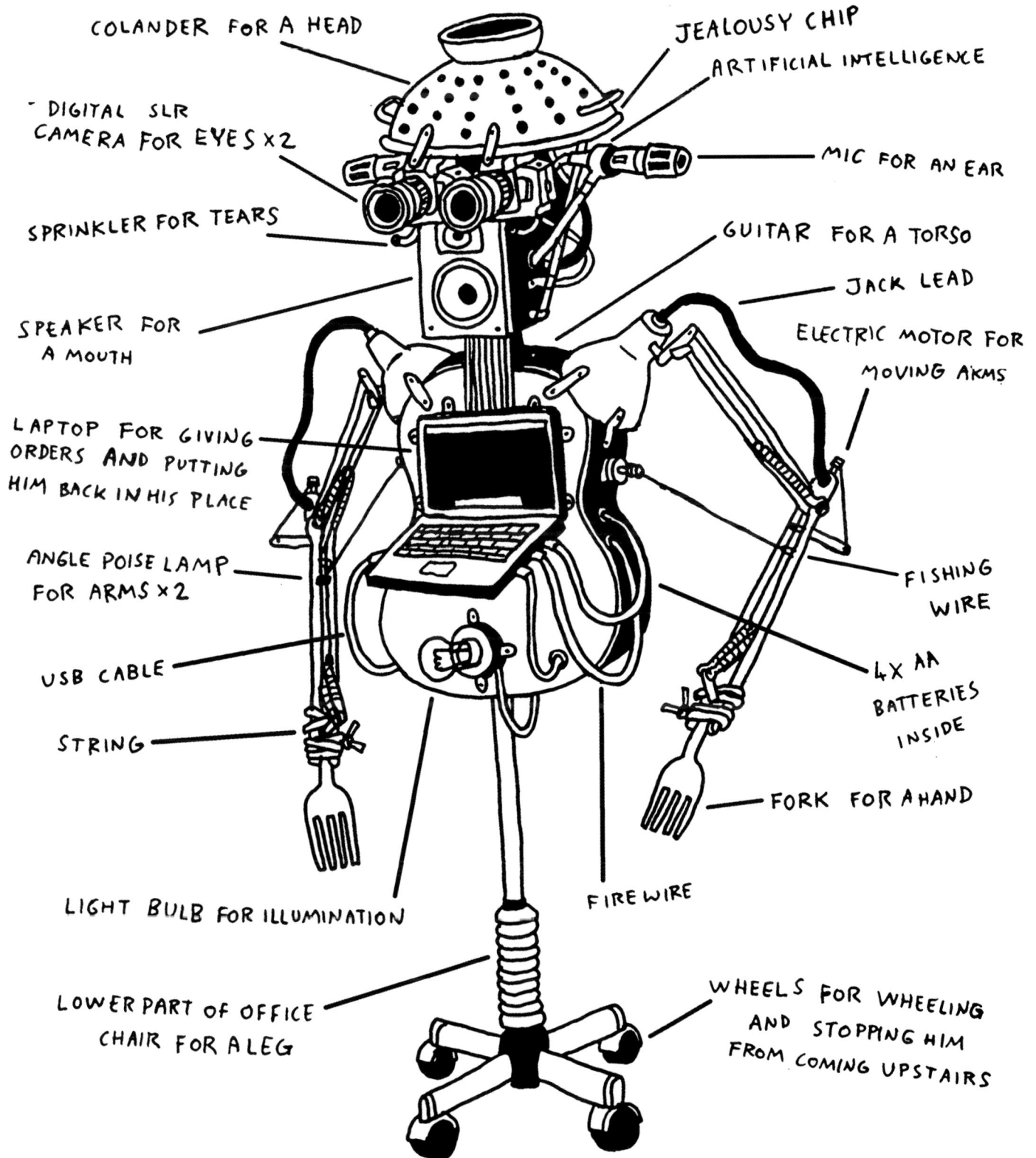

PLANS FOR A ROBOT FRIEND
MADE FROM HOUSEHOLD OBJECTS

COLANDER FOR A HEAD

JEALOUSY CHIP
ARTIFICIAL INTELLIGENCE

DIGITAL SLR CAMERA FOR EYES x2

MIC FOR AN EAR

SPRINKLER FOR TEARS

GUITAR FOR A TORSO

JACK LEAD

ELECTRIC MOTOR FOR MOVING ARMS

SPEAKER FOR A MOUTH

LAPTOP FOR GIVING ORDERS AND PUTTING HIM BACK IN HIS PLACE

ANGLE POISE LAMP FOR ARMS x2

FISHING WIRE

4 x AA BATTERIES INSIDE

USB CABLE

STRING

FORK FOR A HAND

LIGHT BULB FOR ILLUMINATION

FIRE WIRE

LOWER PART OF OFFICE CHAIR FOR A LEG

WHEELS FOR WHEELING AND STOPPING HIM FROM COMING UPSTAIRS

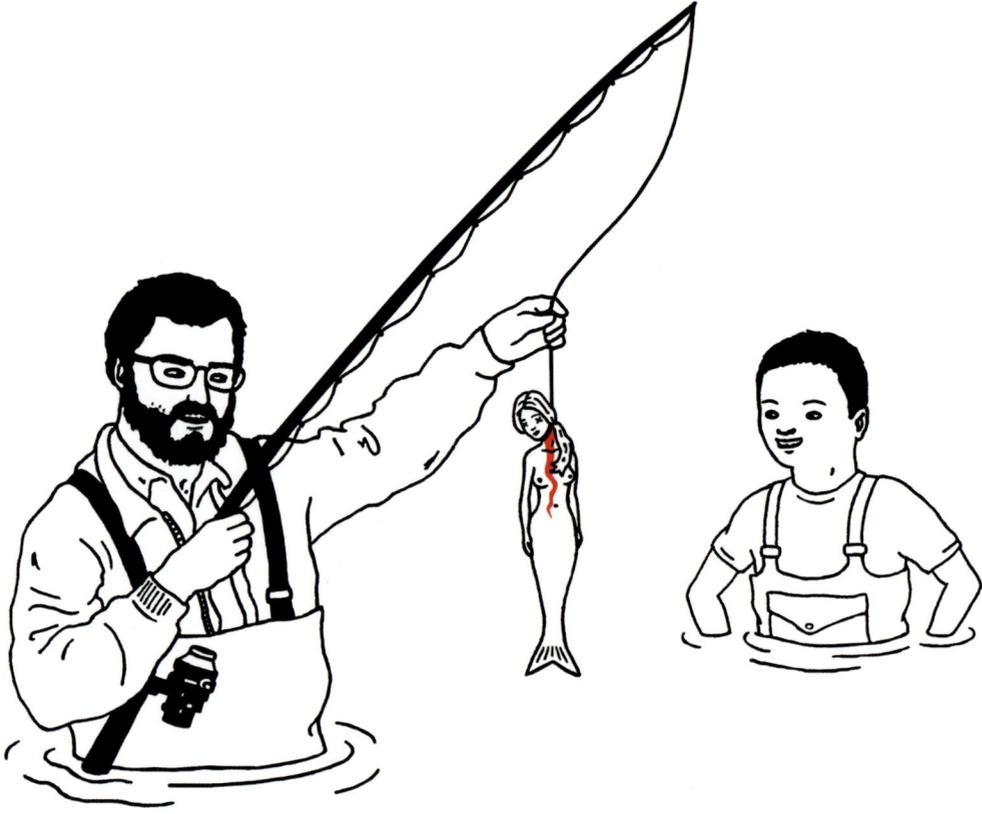

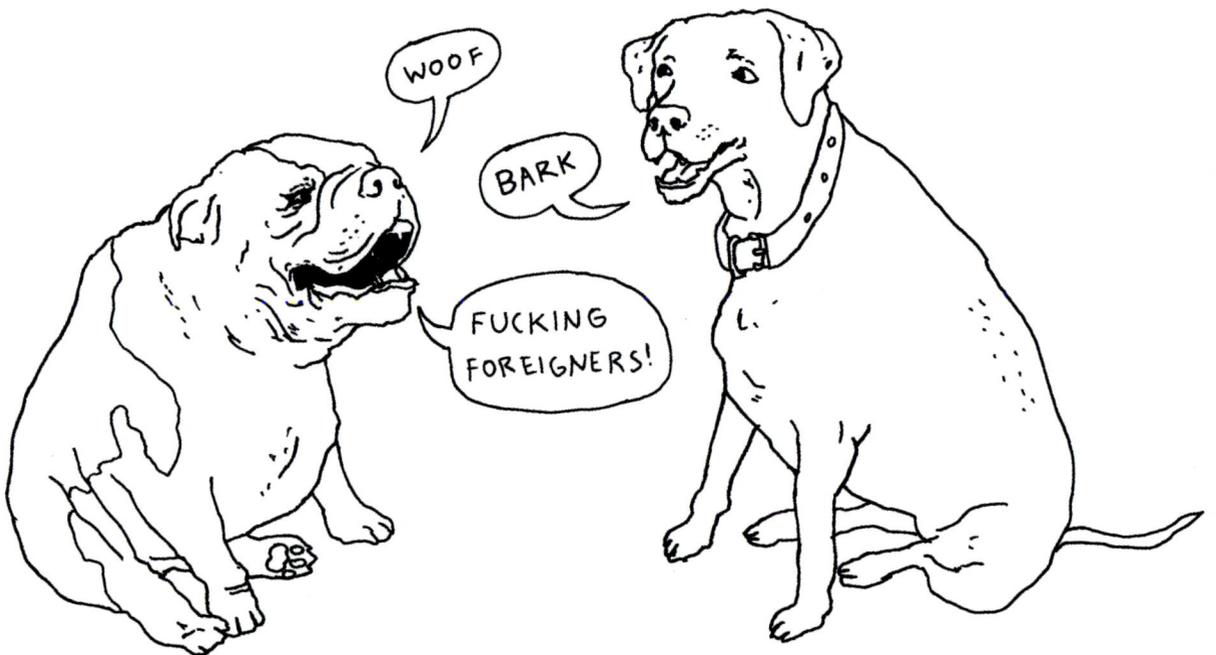

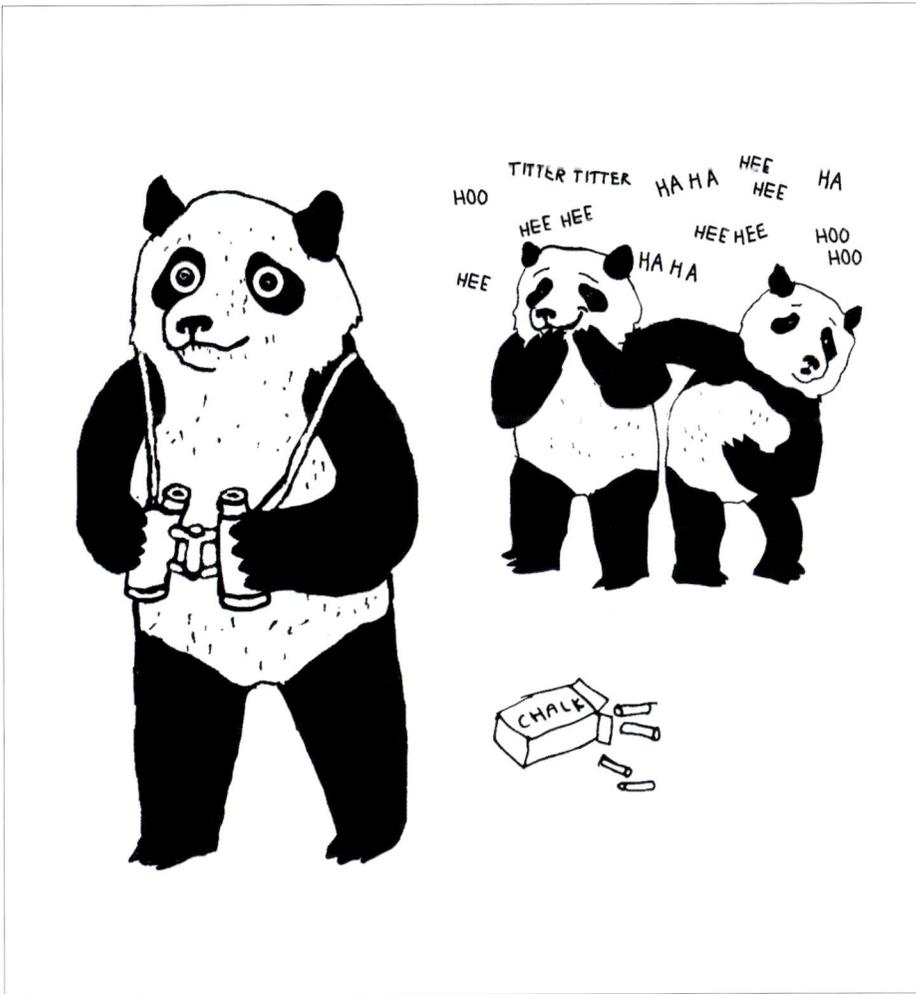

everything equally then you can't be considered prejudiced.

There's a bit in the extras of *Spinal Tap* where Christopher Guest is comparing Asian music to the music of the old west that is very funny. His sequence about naming nuts in Best In Show is pretty special too.

No

I read once that Naomi Campbells motto is "be honest to yourself, it's important to retain your integrity and remain true to who you are" and she's a bitch so I don't pay too much attention to that one.

Used to be cigarettes but I've got that beat now.

No, I flicked through a book at the airport last week called *How to get Rich* or something like that. The page I landed on said that you need to buy things and then sell them for more than you bought them for. Brilliant. The book was made from very cheap paper and cost about £16 pounds. Hmmmm...

I'm sure there are better things I could be doing with my time.

"*I read once that Naomi Campbells motto is 'be honest to yourself, it's important to retain your integrity and remain true to who you are' and she's a bitch so I don't pay too much attention to that one.*"

COPYRIGHT FREE PAGE

50 CENT AND HIS FANCY THINGS

TRINKETS

FONDANT FANCIES

WIND CHIMES

MY FLOW, MY SHOW BROUGHT ME THE DOUGH THAT BOUGHT ME ALL MY FANCY THINGS!

FROSTED GLASS DOLPHIN

WHIMSICAL UNICORN NIGHT LIGHT

DAINTY ROSE TEA SET

CAT PORTRAITURE DECORATIVE PLATES

THANKSGIVING PILGRIMS CERAMIC FIGURINES

YIN YANG FRIDGE MAGNET

COLLECTION OF DECORATIVE THIMBLES

WEE BEAR VILLAGE

WHEREVER I LAY MY HAT THATS MY HOME...

YIPPEE

OH BUGGER

EDISON INVENTS THE LIGHT BULB

146-147:
ALEJANDRO SARMIENTO
INFLATABLES

Born in General Villegas in 1959, he graduated from the Facultad de Bellas Artes de la Universidad Nacional de la Plata in 1986 and has since then been working freelance as an industrial designer. He is currently developing objects made out of recycled and standard materials and with simple technologies. His work has ranged from designing sets for film and theatre to stationery, kitchenware, furniture, exhibition and packaging design.
www.alejandrosarmiento.com

Description of work submitted:
Standard inflate ball: design Exploration. The sphere, represented by the moon, is the first and most spectacular vision that man has had. Since then, the sphere has been used in all its dimensions and for different purposes. Another constant element is the attempt to reduce its friction, and depending on what it is going to be used for, to change its materiality with the aim of providing a better performance and a faster speed.

I decided to work with standard inflatable balls of various diameters. They are sold as a toy and they have no technical specifications which allows to determine its useful life. Therefore, useful life is only linked to the ball's life wishes.

Can you remember something that really made you laugh when you were a kid?
Yes, I laughed a lot, as a result of mischief with friends. The train passed by the town only on Sunday, so we would go to the railway station and wait for the train to start the engine. Then everybody would wave goodbye through the window and, when the train started going, we would stand on a row along the platform with a newspaper roll in our hand and hit them on their heads as the train left. That was funny. Then we would laugh at the angry and helpless face of the travellers.
What's the most embarrassing situation you would admit to finding yourself in?
In a sports competition at school, somewhere full of students from different schools. In the middle of silence, I shouted to a girl that I loved her. After that, I spent 15 days at an aunt's in a different town.
What are you bad at?
I play the guitar in a rock band called "Las Canoplas" [an old-fashioned, quite tacky word for pencil case], and I am a terrible executer of this instrument.
How do you see the world?
I see the world as a rotten peach: it has beautiful colours, you can still smell the perfume, but it is inevitably rotting.
Do you have any theories about it?
I think the world repeats itself cyclically in all aspects, and this is the mechanism which accelerates the wear and tear.
What/who do you discriminate against?
Simplicity [understood as the easy way to do something, a shortcut.
Do you have a nickname?
Yes, it is "Carro", meaning "cart". I was given this nickname because I collect things from the street. I don't mind it, I got used at it at school.

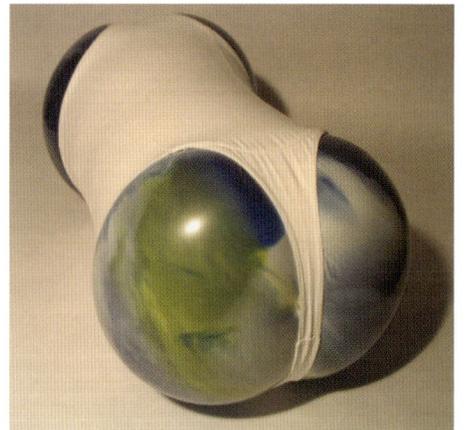

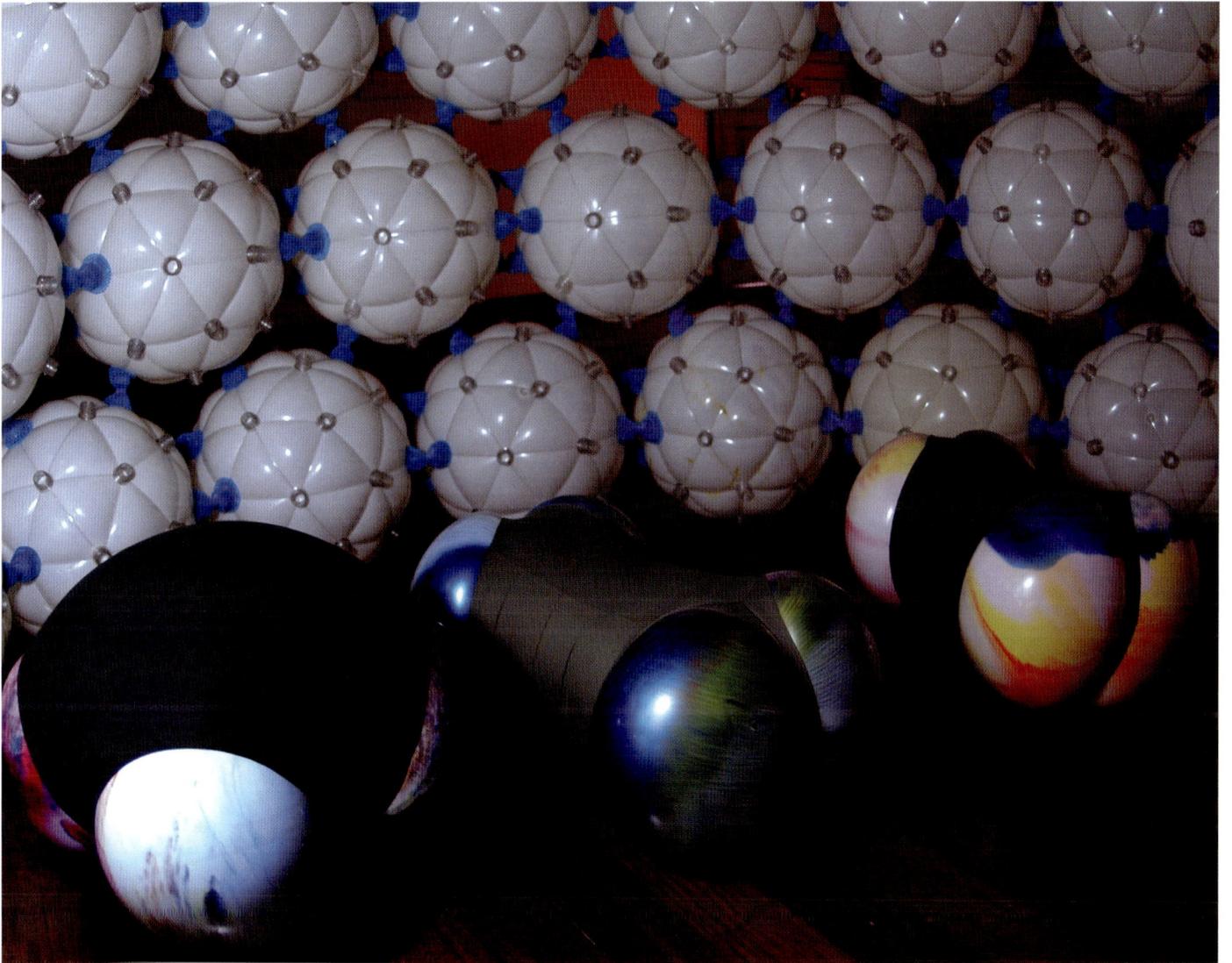

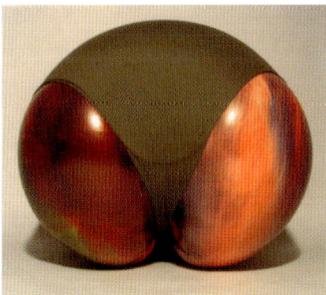
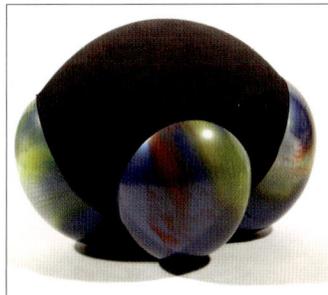
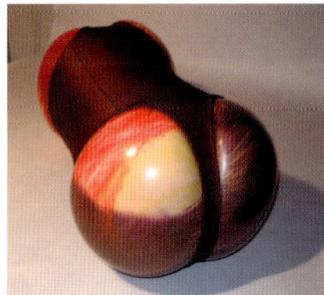
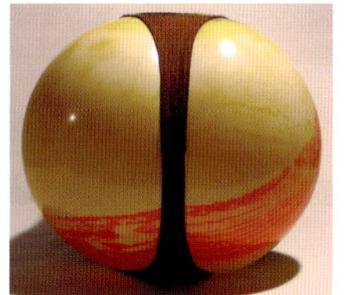

148–153:
LIEVEN SEGERS
PORTRAIT OF THE ARTIST

Lieven Segers is an artist from Antwerp, Belgium. He studied photography and started drawing when he locked himself in a studio for seven days and seven nights.
www.lievensegers.be

How idyllic was your childhood?
Very idyllic, with a lot of trees and a lot of attention.

Did you cherish any dreams?
I wanted to become a rockstar and die before I was 30.

What kind of teenager were you?
A terribly annoying teenager that listened to The Doors and was searching for freedom.

What's the most embarrassing situation you would dare to admit finding yourself in?
Being totally naked around other naked people. I hated nakedness.

If you were to place yourself in a novel, how would you describe your character?
A portrait of the artist as a fucking stupid young man.

Do you have a sense of humour?
Yes

What did you think when you first saw your therapist?
That he looked like the only Belgian astronaut, Dirk Frimout.

Did anyone ever take any of your jokes badly?
Yes

In your opinion, is there such a thing as intelligent or stupid humour?
Intelligent humour is always funny, stupid humour is only funny when you're drunk.

Do you have any theories about the world we live in?
When you go out to get bananas you mostly come home with something else.

Do you carry any crosses?
Tattoos from a time when I felt kind of free.

What's your favourite satire film, what is your favourite scene?
Pasolini's *Hawks and Sparrows*, the scene where the small birds spread the love word.

Do you have a nickname? And how do you feel about it?
Can't tell you.

Have you started reading self-help books yet?
Just one, about self-hypnosis.

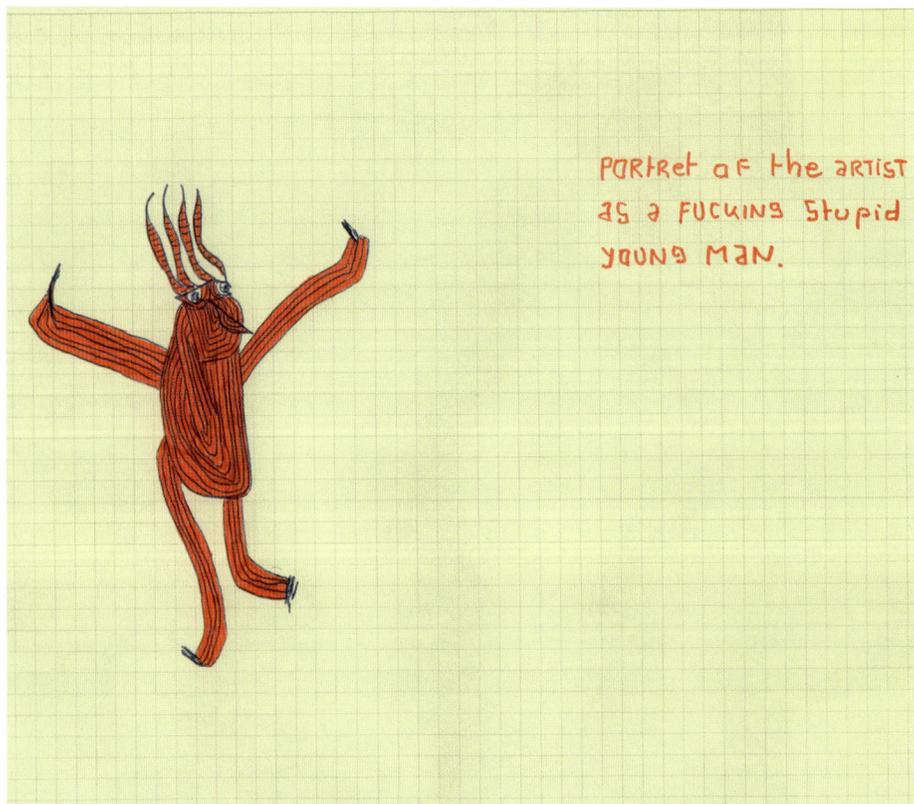

portret of the artist as a fucking stupid young man.

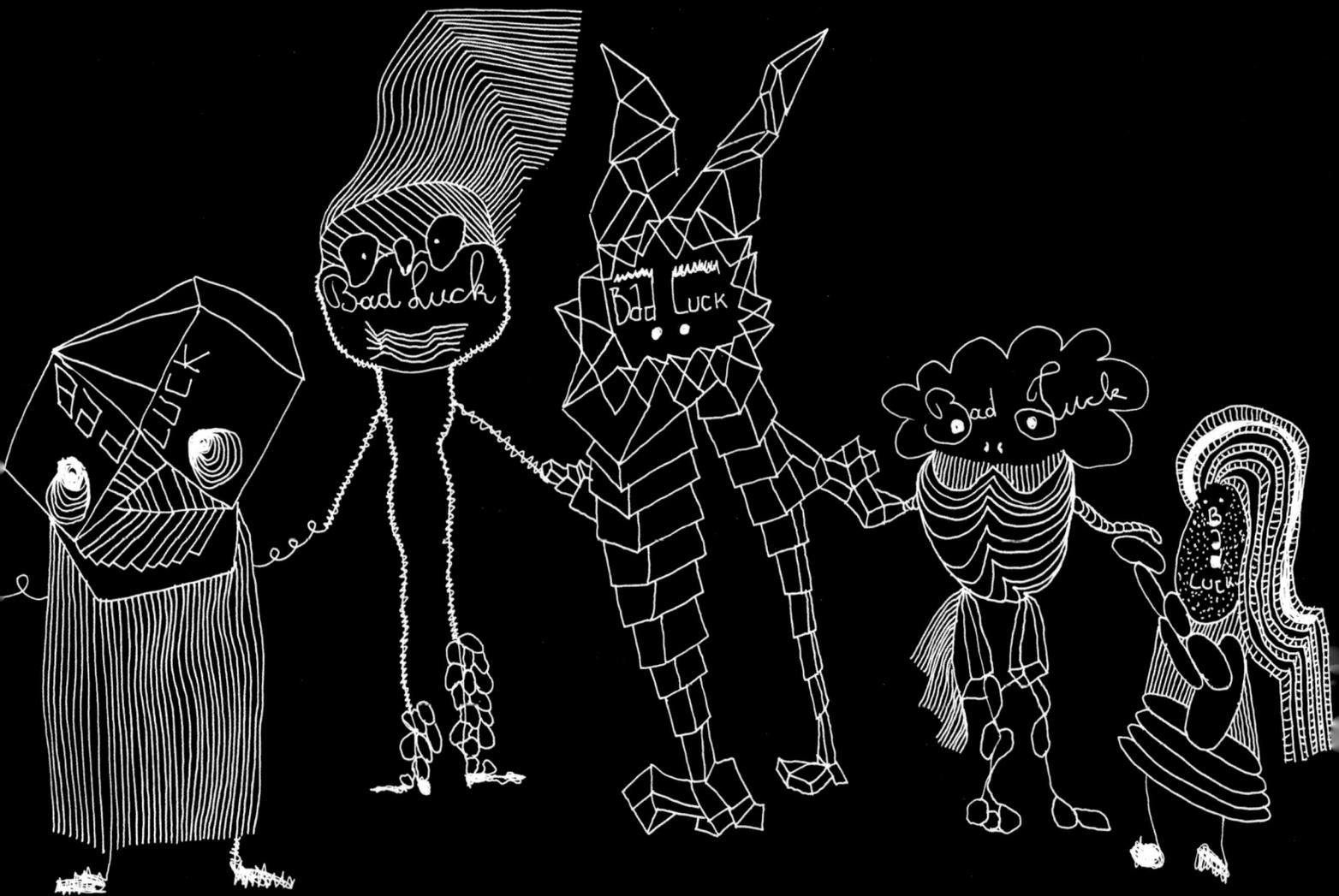

Bad Luck never comes alone. the FUCKER has got FRIENDS

One day I painted myself totally black with a permanent marker. I wanted to go into the city but something told me not to. One day I will locate this something and I will kill it with my bare hands.

Picture
of
erected
Penis

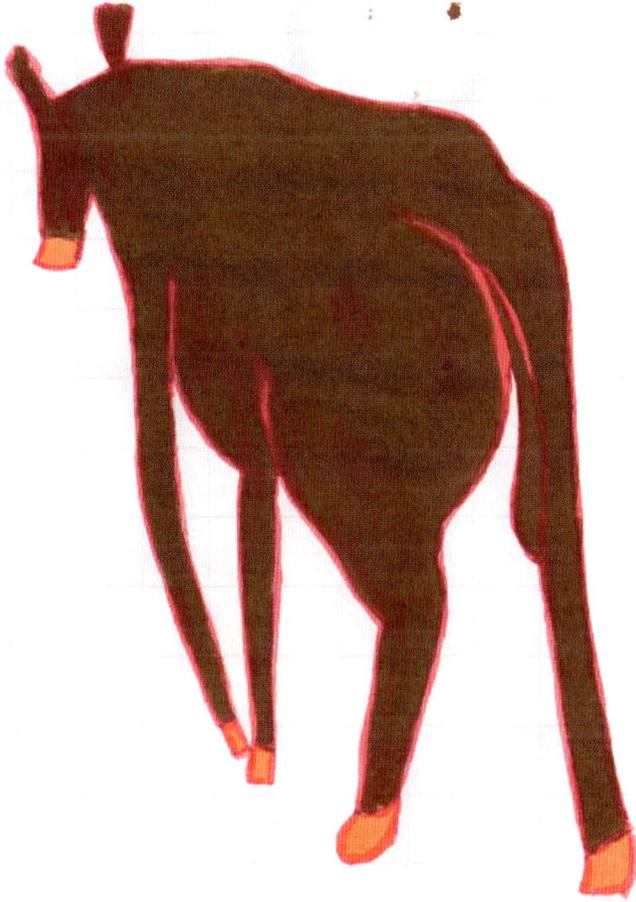

IF YOU WERE FORCED
TO have sex with AN ANIMAL of your choice
wichone would you choose
and why?

I'm
SORRY,
I REALLY
do NOT
UNDERSTaND
what you are
Saying

154–159: MATT STUART
FISHERMAN

Matt Stuart is a photographer based in London.
www.mattstuart.com

How was your childhood?
I had a wonderful childhood. I was born in the leafy suburbs of North West London in a block of flats where I made lots of friends and played cowboys and indians.

Can you remember something that really made you laugh when you were a kid?
When Chet got turned into a poo in the film *Weird Science*.

Did you cherish any grandiose dreams?
To make a living doing something I love. Luckily, I have realised this dream.

What kind of teenager were you?
Terrible... rude, irritating, sarcastic I was the whole lot. A parent's worst nightmare.

What's the most embarrassing situation you would admit to finding yourself in?
Drowning in the county swimming gala when I was 14 and being fished out in a big keep net by my teacher in front of every kid in the borough.

When and where did it all start to go wrong?
When I discovered skateboarding at the age of 12 after watching *Back to the Future*. It went wrong then for eight years at the Southbank in London. It's great being wrong isn't it?

Do you have a sense of humour? If so, what kind?
It's not bad, prone to sarcasm though, and it occasionally bites.

What did you really think when you first saw your therapist?
I haven't ever needed a therapist, but if I did I would be wary of one wearing brown.

Do you laugh at yourself?
I laugh at myself a lot. Probably ten times a day. I spend a lot of time in my own company, so I need to keep myself entertained.

Do you laugh at your own jokes? How loud?
I laugh at my own jokes but I far prefer to laugh at my friends' jokes.

What's the most inappropriate place/time you remember laughing at?
Weddings, churches, funerals, all the usual suspects.

Did anyone ever take any of your jokes badly?
Yes, but I try to mend any damage as soon as possible, I hate to upset people.

What are you good at, what are you bad at?
I have been good at playing the trumpet, skateboarding and photography. I haven't been very successful at much else. I am terrible at DIY, I can't swim very well (see previous drowning) and my driving can be bad, especially when I spot a potential photo. I speak French very badly and my dancing always ends up resembling a martial art. →p158

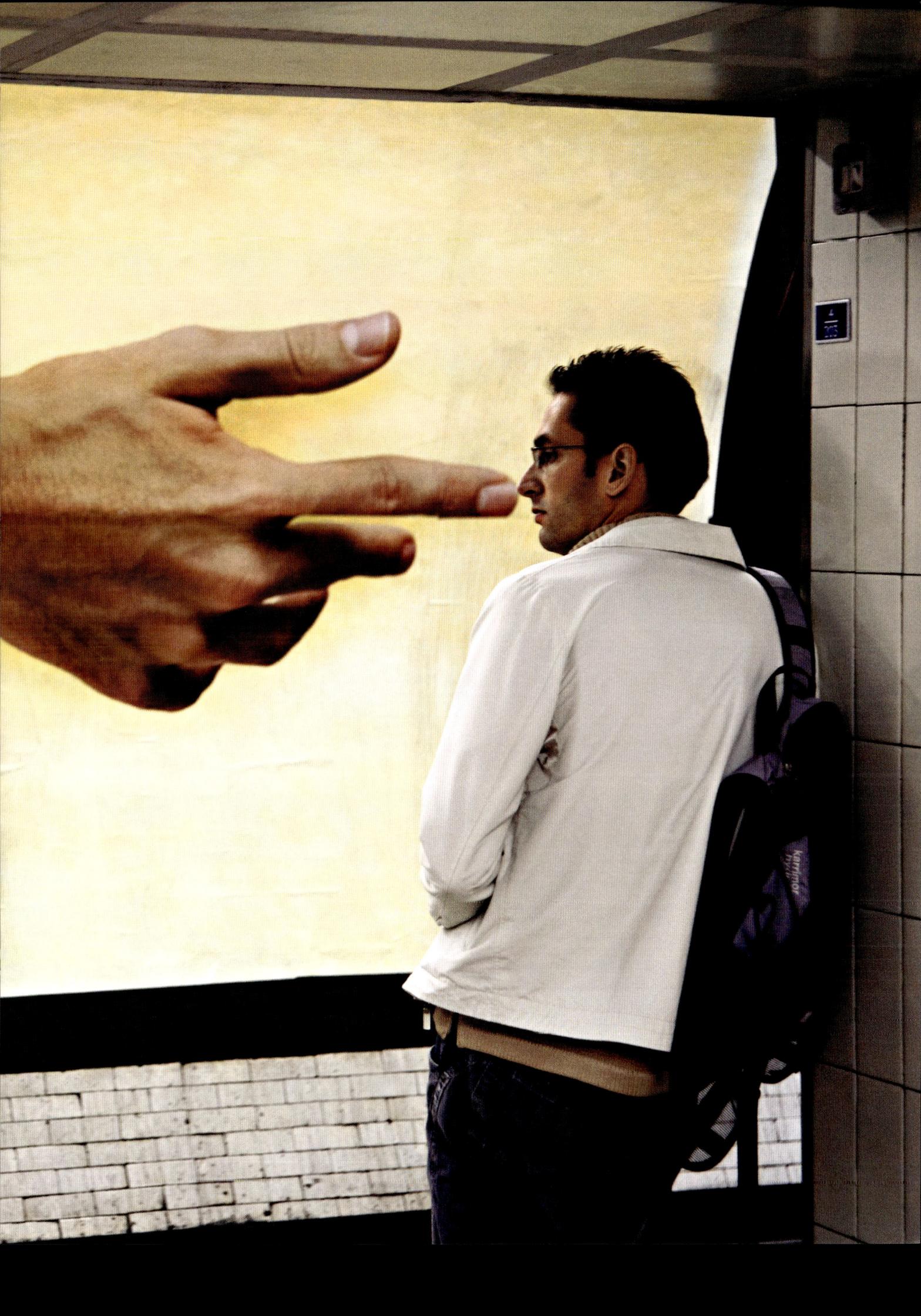

HARRY
OPENIN

Do you work with other people? Does it work?
For my personal work I don't work with other people. I collaborate well with myself.

Are you the type to exaggerate things?
I exaggerate pictures that I've missed. Just like a fisherman… "It was this big, beautiful colours, best thing I have ever seen".

In your opinion, is there such a thing as intelligent or stupid humour?
Yes. I believe there are lots of types of humour, most demand a lot of confidence, that is why a lot of photographers avoid it, get it wrong, it isn't funny, and then you feel an idiot.

What/who would you consider an ideal subject for parody? Note that George Bush and Tony Blair are taken already.
Dictators are always good value. Whether they are in charge of a country of millions or a class of thirty.

Do you have any theories about the world we live in? Would you mind sharing one with us?
To quote Ferris Beuller "…life moves pretty fast. If you don't stop to look once in a while you could miss it."

Do you carry any crosses?
Brutal honesty and a receding hairline.

What/who do you discriminate against?
Stingy people, people who don't have a sense of humour, arrogant people and people that feel the world owes them something.

What's your favourite satirical film, what was your favourite scene?
Life of Brian. "He's not the Messiah, he's a very naughty boy"

What's your favourite children's book?
Richard Scarry's Lowly Worm books were wonderful and of course Maurice Sendak's *Where the Wild Things Are* and *In The Night Kitchen.*

Do you have a nickname?
My wife Martha has a million nicknames for me. My friend Simon calls me Stupot, I don't mind that. Louis and Dan call me a variety of different names Mattu, Matty, Rat, to name a few. Louis is the only person who can call me Matty but he has to say it in an Australian accent otherwise I find it offensive.

What would you say is definitely NOT your motto?
In God We Trust.

Do you have any addictions?
www.in-public.com and I have just fallen in love with throwing boomerangs, preferably left-handed ones.

Have you started reading self-help books yet?
I have just started reading 'Fatherhood the Truth' by Marcus Berkman a very funny book about being a prospective dad, and I love my dad's book, 'A Smile in the Mind' about humour in graphic design.

And finally (remember: your opinion is important to us) would you like to say a word about submitting to the magazine and replying to this questionnaire?
I am really excited and honoured to collaborate on an issue dedicated to Humour, I think it 's a subject which people fight shy of analysing. Hopefully my photos will be funnier than my interview answers… I am a picture person not a word man. I might not remember your name but I'll remember your face forever.

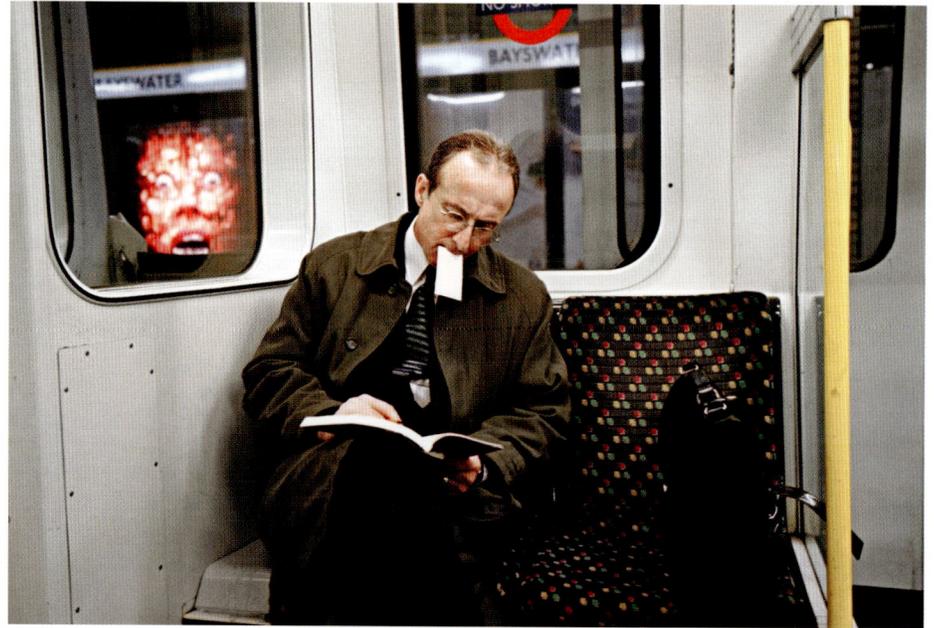

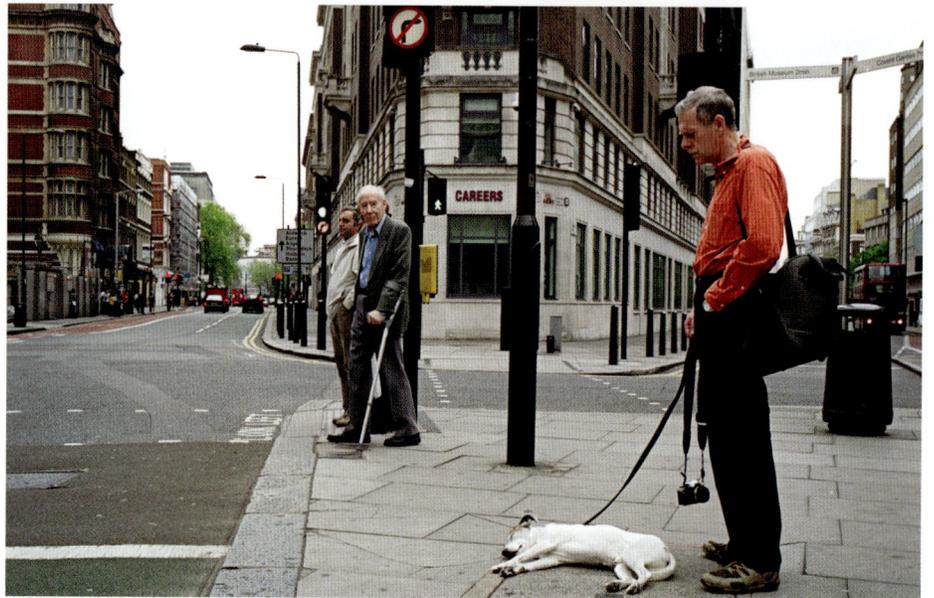

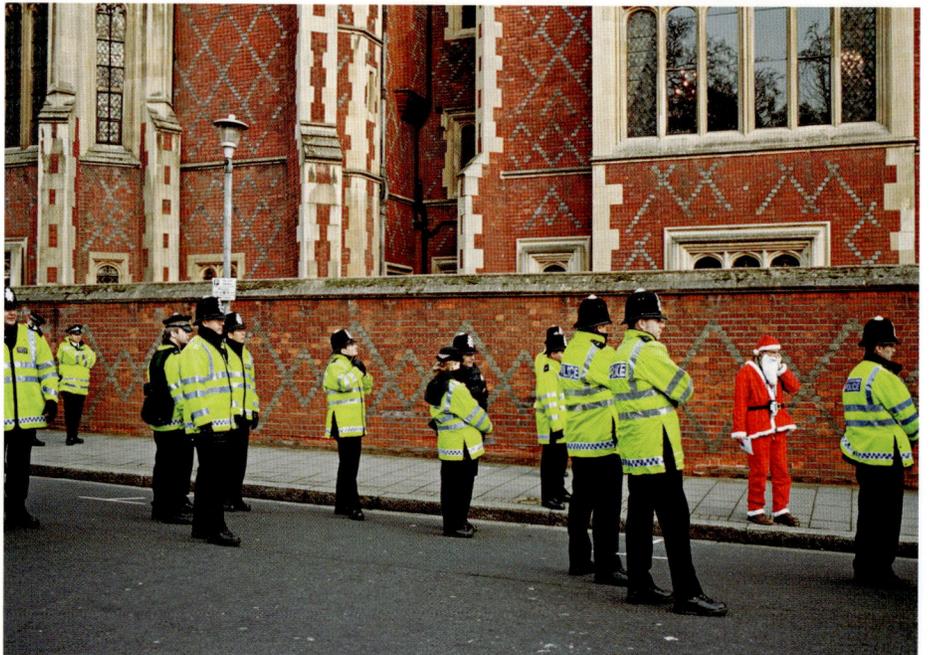

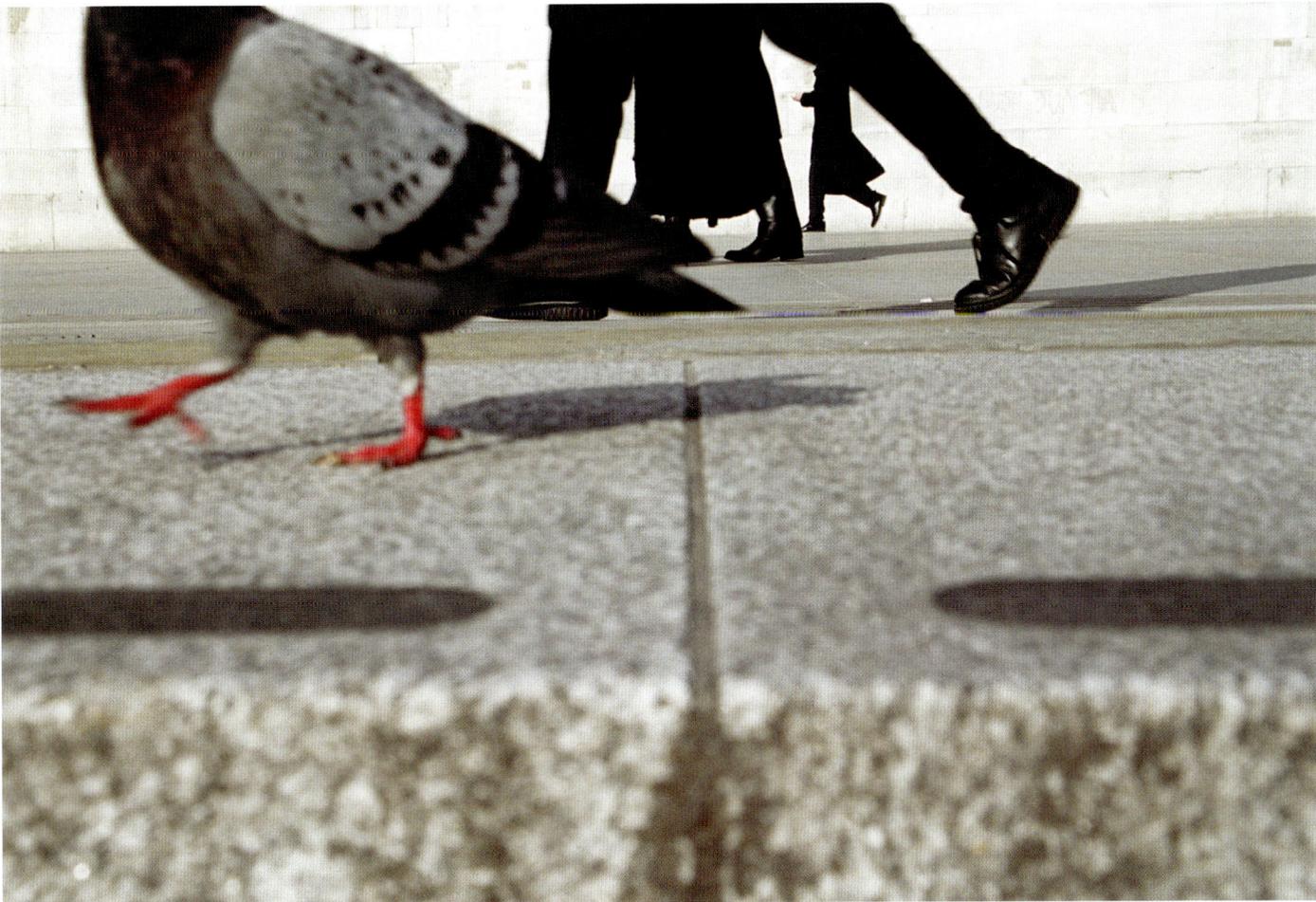

GARY TAXALI
TOUPÉE FLYING OFF

Gary Taxali was born in Chandigarh, India in 1968. A year later, he and his family emigrated to Toronto, Canada. In 1991, he graduated from the Ontario College of Art and immediately began working as a professional illustrator. A few years later, he started showing in various exhibitions and galleries throughout North America, including the Luz de Jesus Gallery in Los Angeles. In 2005, he launched his first vinyl toy, The Toy Monkey, which includes a special edition specifically created for The Whitney Musem of American Art in New York City. Gary also devotes a portion of his time to lecturing and teaching, and he is a Founding Member of IPA (The Illustrators' Partnership of America).

"Funny, I like yoga, but I hate yoga people. I'm not really good at anything. I don't possess 'life skills', as they say. I'm good at hating people. That's something I'm proud of."

How was your childhood?
I have a strong recollection of drinking chocolate milk and watching cartoons every early Saturday morning. I don't know how more idyllic a childhood could be than that.

Can you remember something that really made you laugh when you were a kid?
Watching a man's toupée fly off in the wind.

What kind of teenager were you?
I was the kind of teenager that every girl wanted. I was the school stud, because in my school, being a scrawny Indian kid who knew how to draw pictures was terribly sexy. The school existed on Fantasy Island. Don't bother looking for it; it doesn't exist anymore.

What's the worst look you can remember sporting?
Classic Rock meets New Wave meets No Wave.

When and where did it all start to go wrong?
Au contraire! The question should be: when did things start to go right? The answer is last week. (Her name is Anna.)

If you were to place yourself in a novel, how would you describe your character?
I would be the security guard who is waiting for his retirement.

What did you really think when you first saw your therapist?
The first time I saw my probation officer I thought his off-the-rack, ill-fitting suit made him look like he was trying too hard.

What's the most inappropriate place/time you have ever laughed?
During a funeral eulogy (unfortunately I was the one giving the eulogy).

What are you good at, what are you bad at?
Funny, I like yoga, but I hate yoga people. I'm not really good at anything. I don't possess 'life skills', as they say. I'm good at hating people. That's something I'm proud of.

Would you say that creative people are unbalanced?
I think all people are maladjusted. Creative people just like to brag about it as they think that it gives their work 'edge'.

Is there such a thing as intelligent or stupid humour?
Absolutely. *Withnail and I* = intelligent. *Showgirls* = unintelligent (stupid humour).

How do you see the world?
I see the world as Reality TV. Although, I almost always miss last week's episode. I wish someone would tape it for me.

Do you have any theories about it?
I have a few theories, but the one I keep coming back to is that all we are is dust in the wind. Just like the song says.

Do you carry any crosses?
I like to dot my eyes with happy faces.

War, disease, global warming, poverty: do you ever feel like we're doomed? And does that make you want to laugh or cry?
Both. Now you're depressing me.

What's your favourite satire film, what was your favourite scene?
The Lord of the Rings. The scene where the two midgets realise that they're in love.

What's your favourite children's book?
The Night Kitchen by Maurice Sendak.

What would you say is definitely NOT your motto?
"Turn that frown upside down."

Do you have any addictions?
I am addicted to Jesus. Jesus Fernandez, a neighbourhood crackhead/funny man. I enjoy his daily witticisms.

Have you started reading self-help books yet?
It's too late for me.

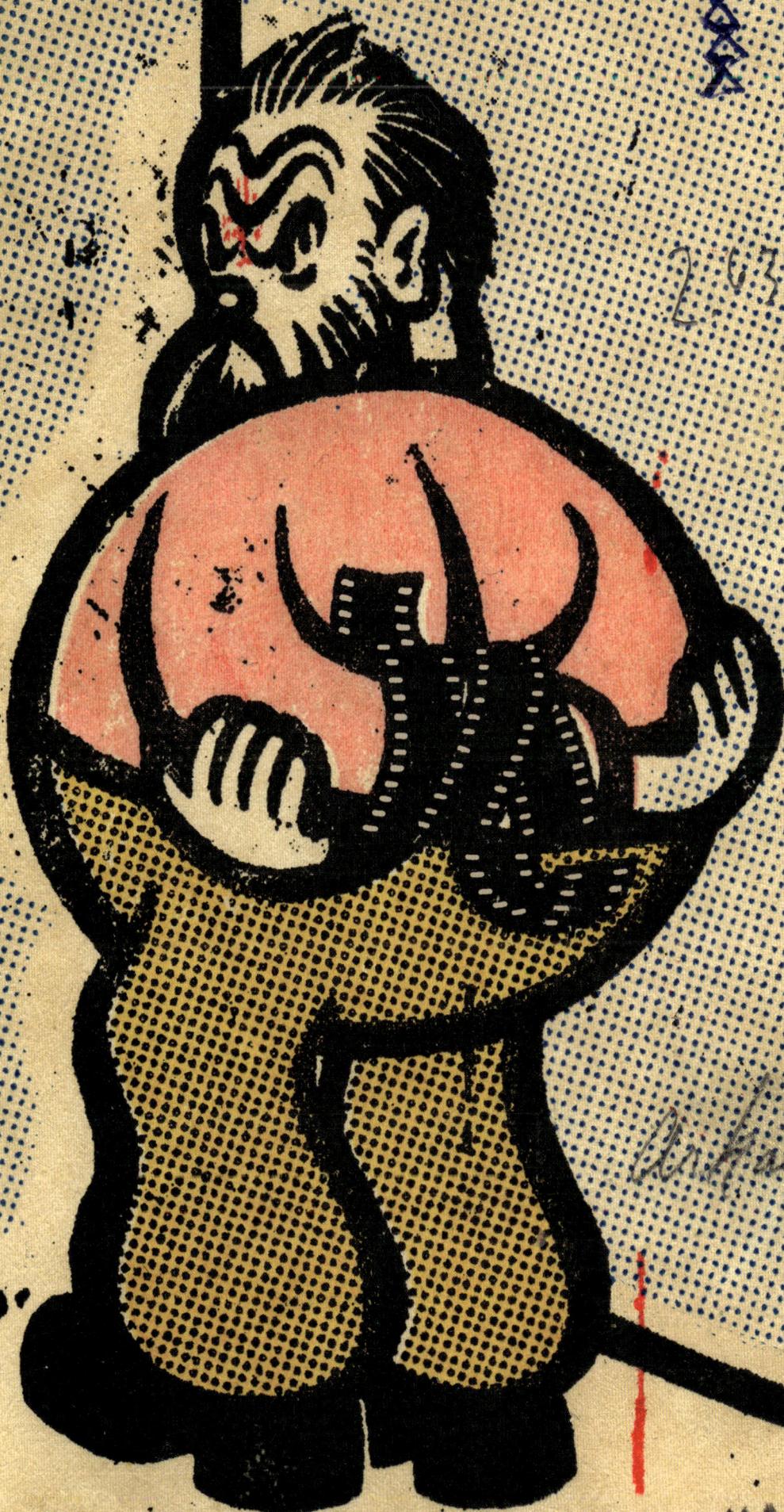

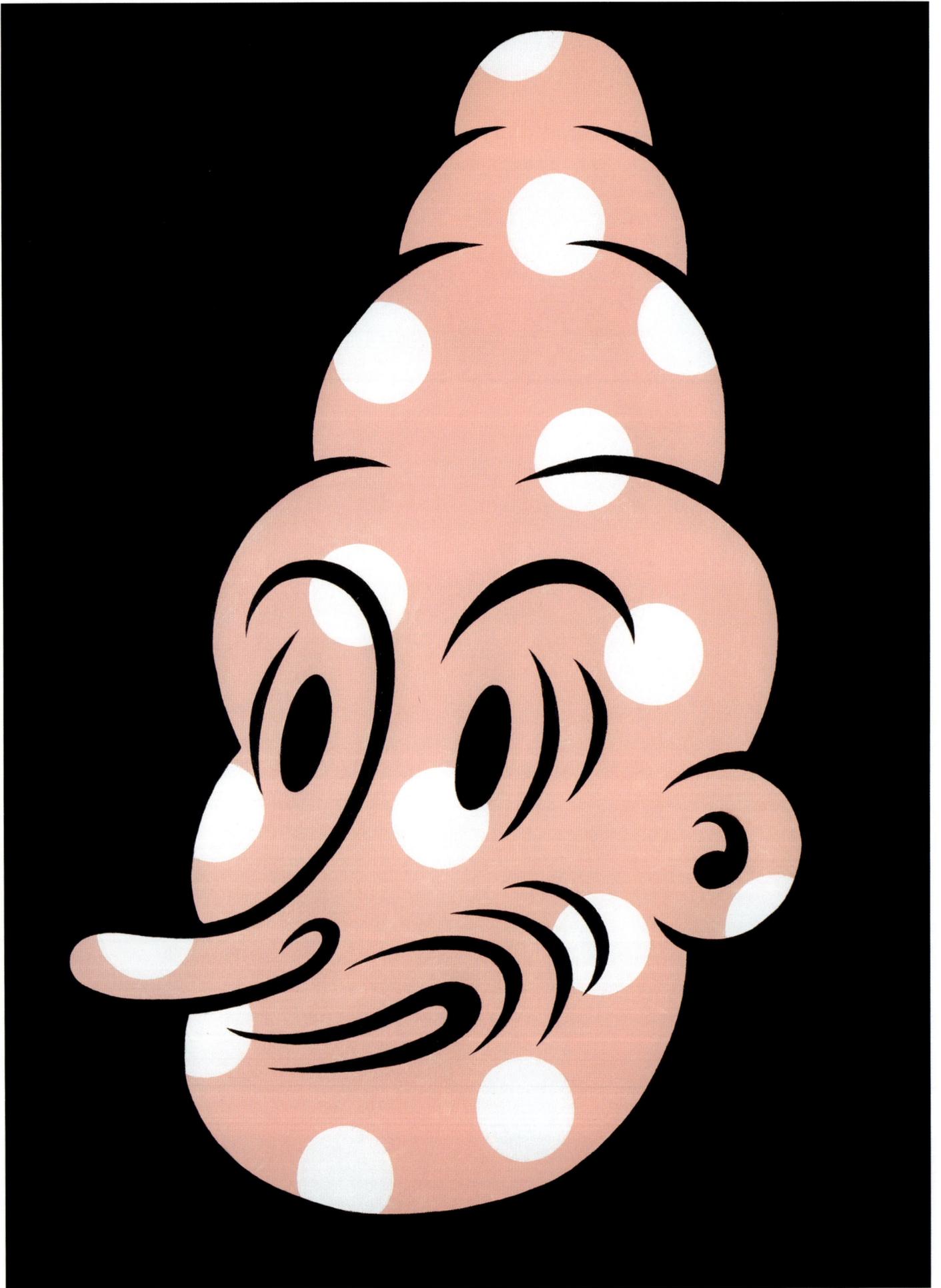

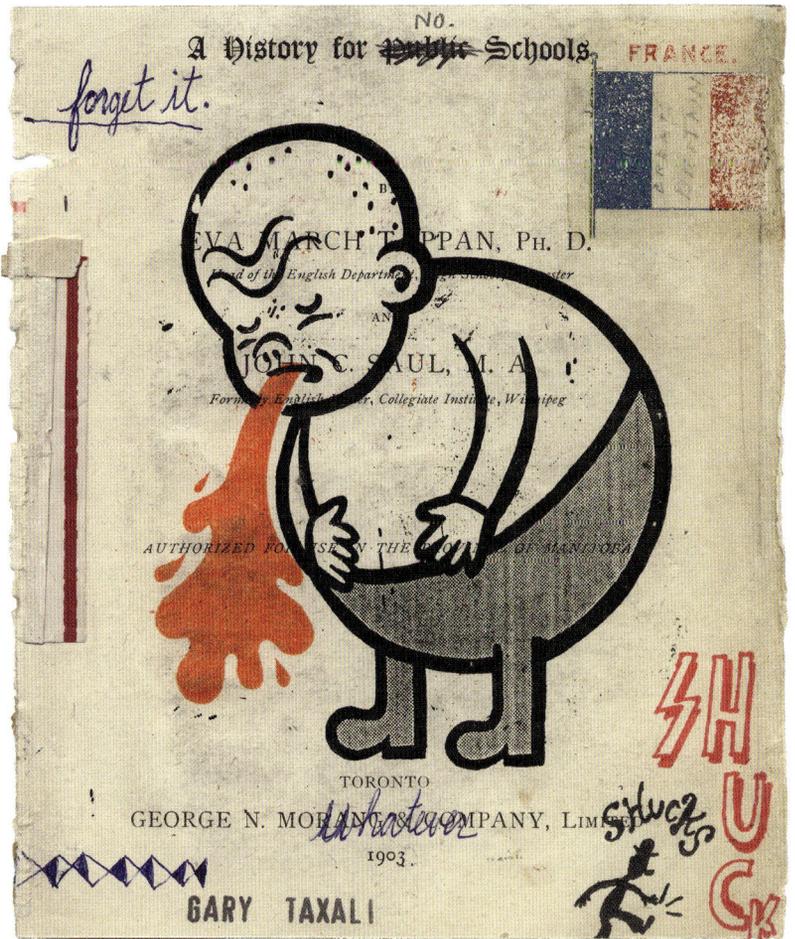

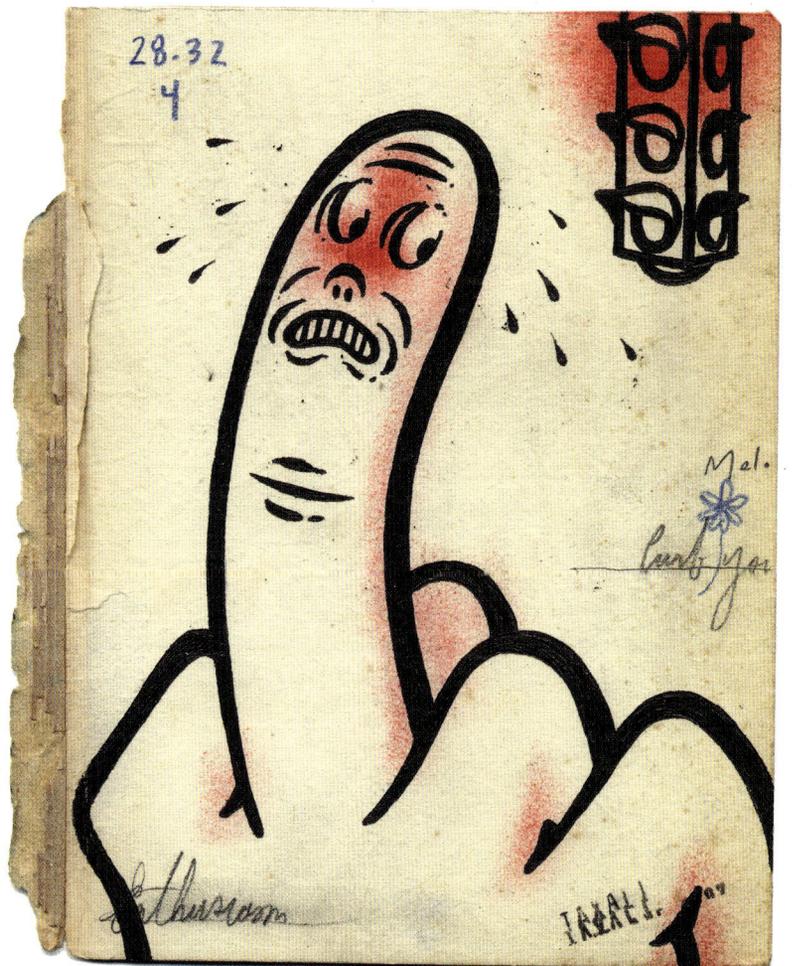

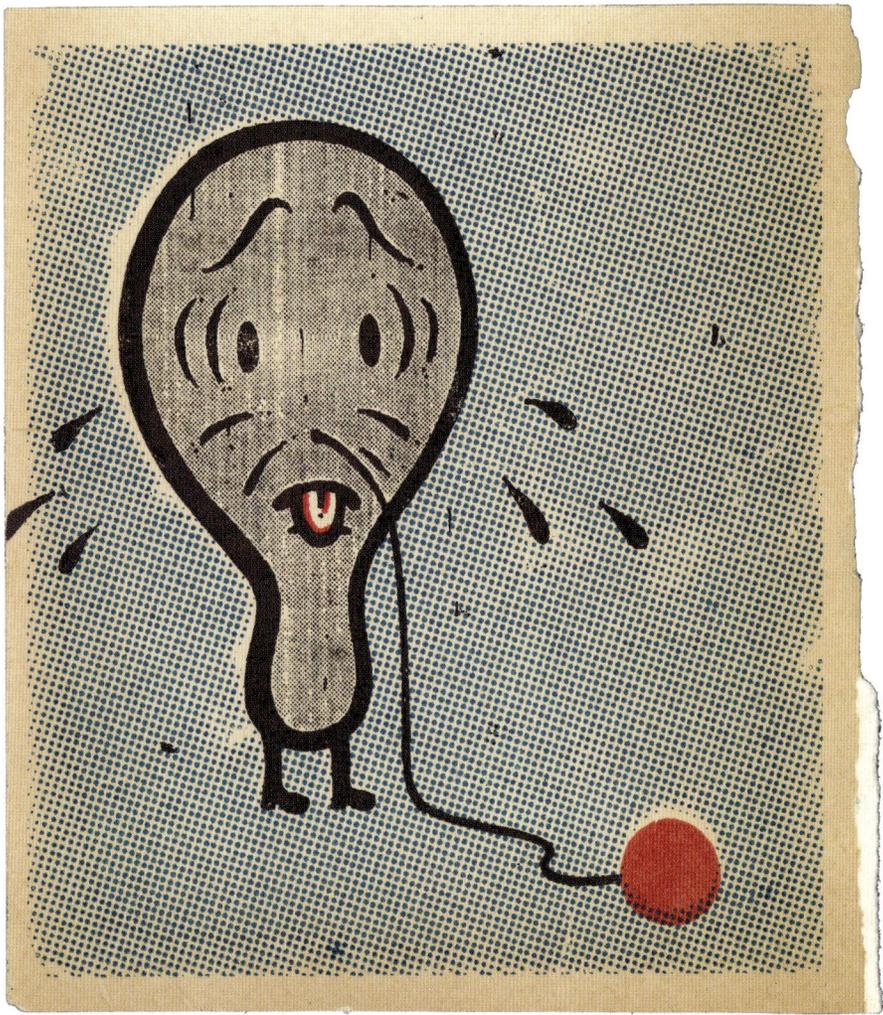

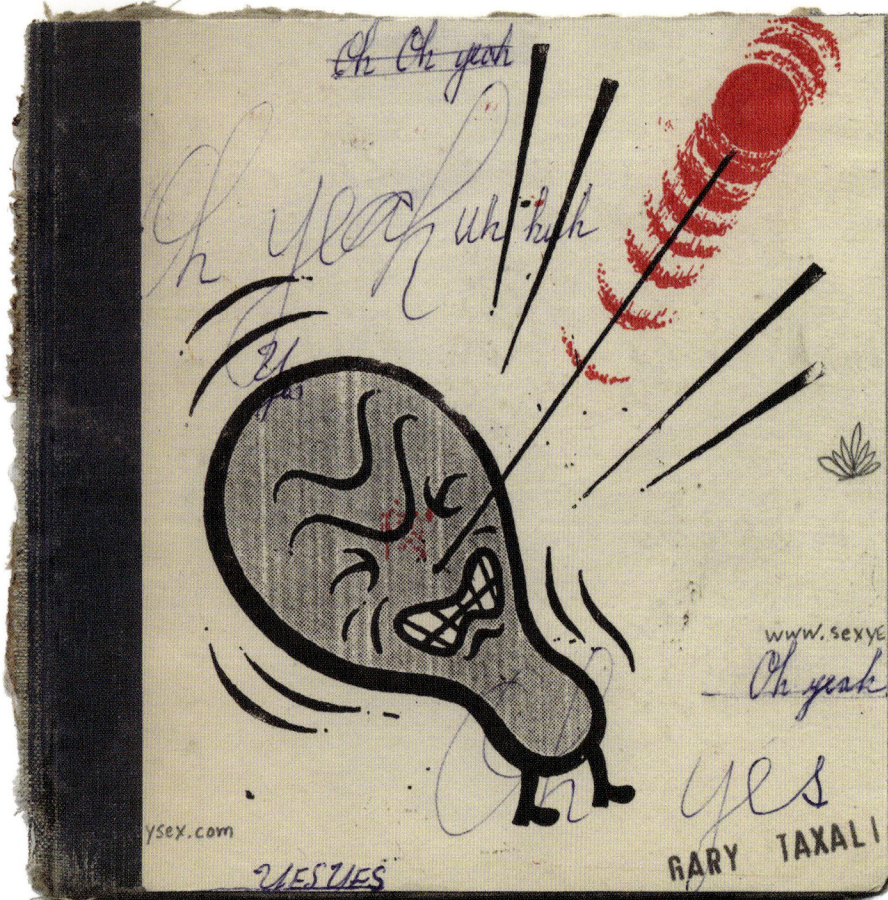

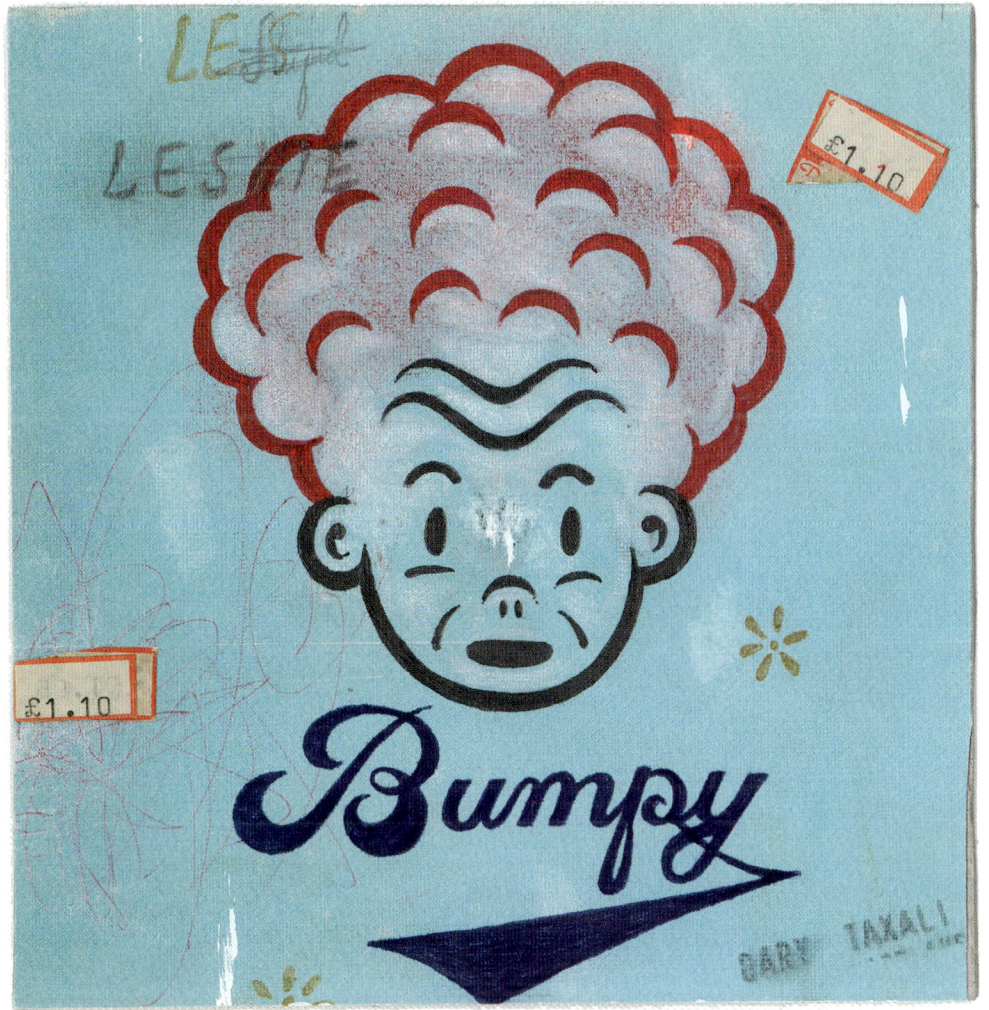

VÄNSKAP
ART SCHOOL DROP-OUTS

Vänskap are a design bureau located in the woods of the far north. Way too near the Russians, way too far from sunny California. The three founding members all met in a Helsinki art school in 2003. After flunking studies, they decided to get together to make a better world, at least for themselves.

Ever since, like the Vikings they have pillaged and explored new continents in pursuit of fine design. On the way they've managed to conquer clients such as *Music Television*, *Colette* and *Harper & Collins*.
www.vanskap.fi

How idyllic was your childhood?
Cajsa: I'm from Sweden, which equals everything happy.
Teemu: I'm from Finland, which equals the exact opposite.

Can you remember something that really made you laugh when you were a kid?
Teemu: I had this magnificent house made out of a cardboard box. We had a game with my dad (when he still was around) where he lifted the box up with me in it, walked around and placed it in random places throughout the flat. When I crawled out from the box it was always a surprise to see where I had landed.

What kind of teenager were you?
T: A late blooming comic geek fuelled with gallons of repressed anger.

What's the worst look you can remember sporting?
C: My home made futuristic graduation dress 1999 after a bottle of rum.
T: Yellow-ish jeans, so baggy and wide that a football once disappeared inside one of the legs.

When and where did it all start to go wrong?
C: When I started sewing my own futuristic graduation dresses.
T: When my dad stopped moving my cardboard box around and started moving his own cardboard boxes out of the house.

If you were to place yourself in a novel, how would you describe your character?
T: A wanna-be-jew on a never ending psychoanalysis trip.

Do you have a sense of humour? If so, what kind?
C: No, I'm Swedish.
T: Yes. Perverted.

What did you think when you first saw your therapist?
C: A Swede in therapy? Like that would ever happen.
T: Disgusted cause she was in a wheel chair. But I was kid then.

Do you laugh at yourself?
C: Yup. A lot. It feels like an encouraging pad on the shoulder.
T: Yeah, all the time. It doesn't help.

What are you good at, what are you bad at?
C: I can't drink from a glass without leaving filthy fingerprints all over it and I don't know left from right but I'm good at reading maps, remembering codes to people's homes, juggling and starting up dance floors.
T: I don't remember the names of the months without using the old nursery rhyme. I can't spell, due to my dyslexia. I'm good with all anal things like organizing, cleaning and being pennywise.

Are you the type to exaggerate things?
C: Hell yes. Over the top.
T: Yes, a little, like any good fisherman.

Do you ever feel like we're doomed? And does that make you want to laugh or cry?
T: Mankind has been doomed since Columbus's ship crashed into an iceberg and Leonardo DiCaprio drowned.

What/who do you discriminate against?
C: Danes (Nazis) and statistics visualized by charts.
T: Nazi-wankers in all forms. People who play card games. Retards ordering advanced c-listed cocktails from a crowded bar desk. Cigar smokers. Owners of pimped weird bikes where you're pedalling from a horizontal position.

Do you have a nickname?
C: The new chap at my part-time job started to call me "Nisse" referring to a character from a Swedish children's book with the same family name as me. Since this fictional dude is an animals-torturing midget, I'm very happy about my new nickname.
T: Mr Poop-a-lot. Well, it's well-deserved.

We're doing everything we can to help. Do you have any addictions?
C: Cigarettes, nasty smelling cheese and downloading blog-techno.
T: New-age literature, non-flavoured yoghurt with sliced banana. Sniffing my own fingers.

Have you started reading self-help books yet?
C: I'm young enough to still consider all fictional literature as self-help books.
T: If New-age literature is counted as self-help then I've read them all.

Polly wants a cracker!

NIRVANA

FREE THE TEENAGE CAVEMAN

DON'T SUPPORT YOUR LOCAL ART SCHOOL DROP-OUT

HAPPINESS IS AN OUNCE OF CRACK

HAPPINESS IS A TIGHT PUSSY

JUST CAN'T KICK THE HABIT

SUN GOES DOWN EARLIER FOR SHORT PEOPLE

170–173:
POROUS WALKER
THIS FEELS AWESOME

In 1974 on a flight from New York to Rome Porous Walker was born Jimmy DiMarcellis. In 1998 Porous moved from New York to California where he's lived ever since. In 2000 while living in a lifeboat in the famed Sausalito houseboat community Porous was visited by the ghost of Shel Silverstein. The ghost delivered an imaginary copy of the Koran and things haven't been the same since.
www.owltooth.com

How idyllic was your childhood?
I don't really know what idyllic means so it probably wasn't very.

Can you remember something that really made you laugh when you were a kid?
The words 'butthole' and 'penishole'.

Did you cherish any grandiose dreams?
Yes.

What kind of teenager were you?
First half very sober, second half very high.

What's the worst look you can remember sporting?
The look of having been on LSD for three straight days in the woods.

What's the most embarrassing situation you would admit to finding yourself in?
Running over a stop sign and smashing into a cop car while smoking a joint and than accusing that same cop of speeding.

When and where did it all start to go wrong?
Tomorrow.

How would you describe your character?
Very confused.

Do you have a sense of humour? If so, what kind?
Yes, a healthy one.

What did you think when you first saw your therapist?
Wow, she's half black and half Asian and she is not taking any shit from me.

Do you laugh at your own jokes? How loud?
I chuckle medium-loud at my own jokes.

What's the most inappropriate place/time you have ever laughed?
Laughing is always appropriate.

Did anyone ever take any of your jokes badly?
I think so.

What are you good at, what are you bad at?
Good at eating pasta, bad at singing and surgery.

Do you work with other people? How does that work? Does it work?
I guess it works but it can really piss me off and slow me down.

Are you the type to exaggerate things?
I think so. A whole shitload.

We noticed that some of the submissions we received seemed a little angry, possibly maladjusted. Would you say that creative people are unbalanced?
No way, you motherfuckers.

In your opinion, is there such a thing as intelligent or stupid humour?
What?

How do you see the world?
Available.

Do you have any theories about it?
My theory is that we live in a world.

Do you carry any crosses?
I think I have learned to bitch a lot.

What's your favourite children's book?
Anything by Fred Gwynne.

Do you have a nickname?
Asshole. My wife says that sometimes. I think it means 'great and powerful lover'.

Do you have any addictions?
Tobacco and pasta.

And finally, would you like to say a word about submitting to the magazine and replying to this questionnaire?
Thanks for being nice to me.

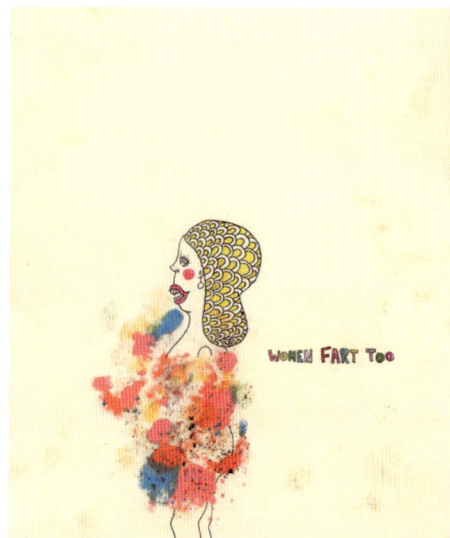

WOMEN FART TOO

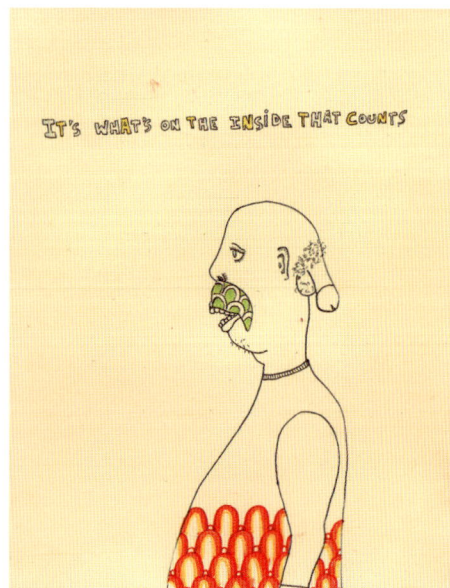

IT'S WHAT'S ON THE INSIDE THAT COUNTS

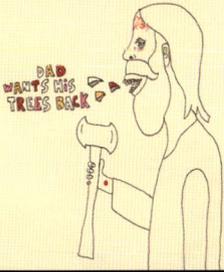

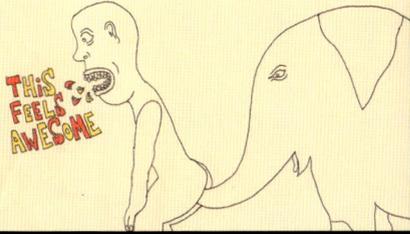

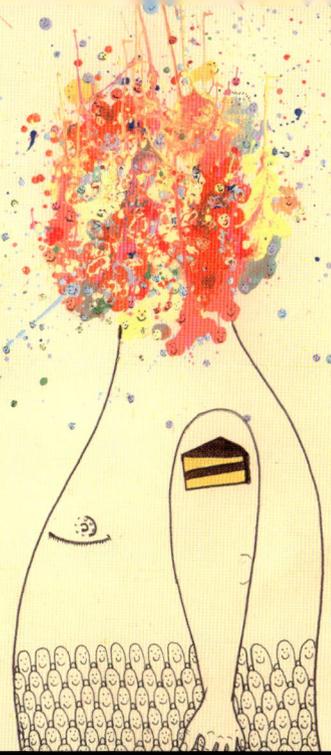

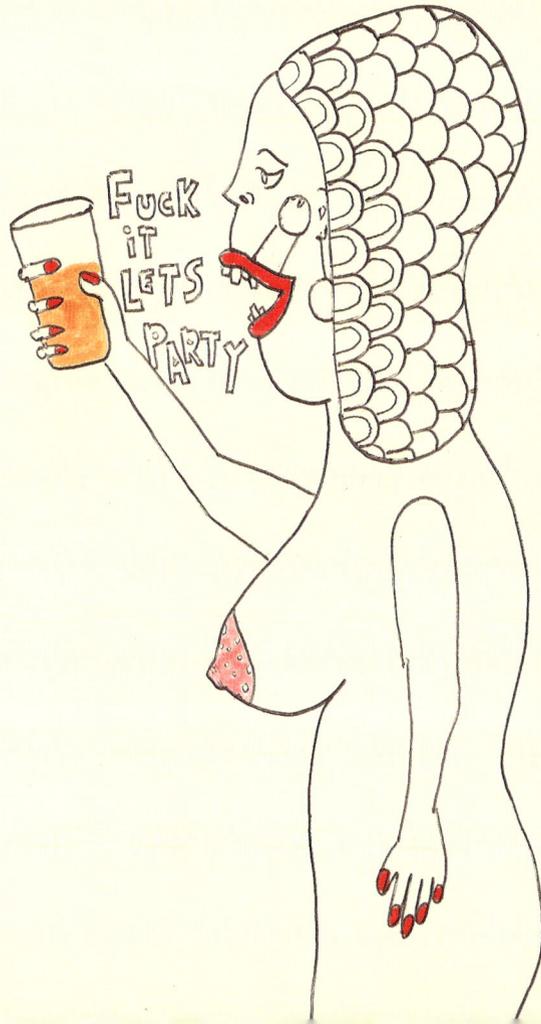

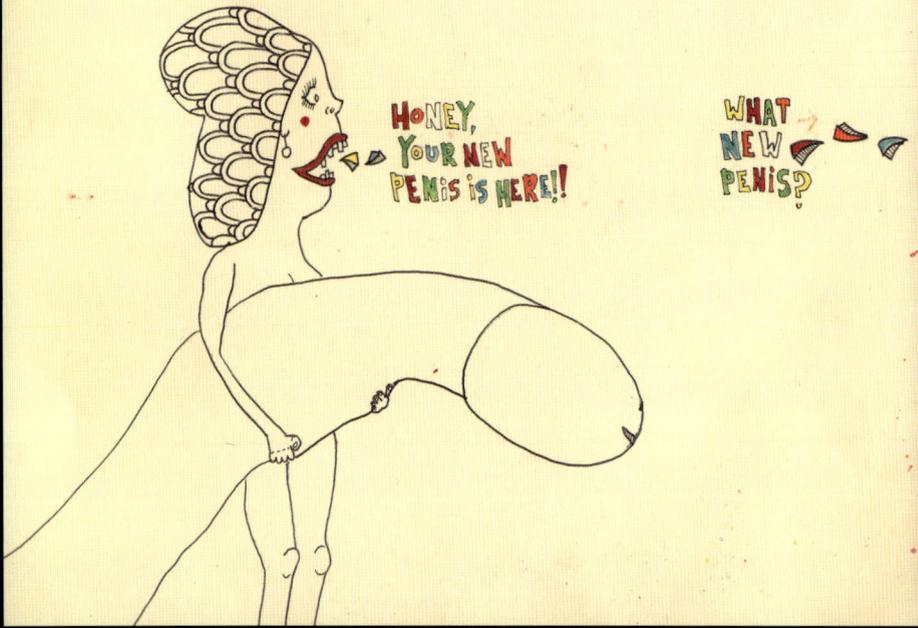

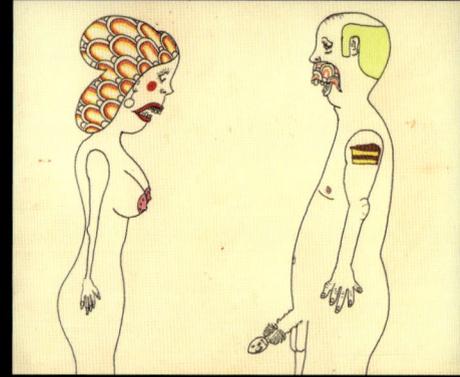

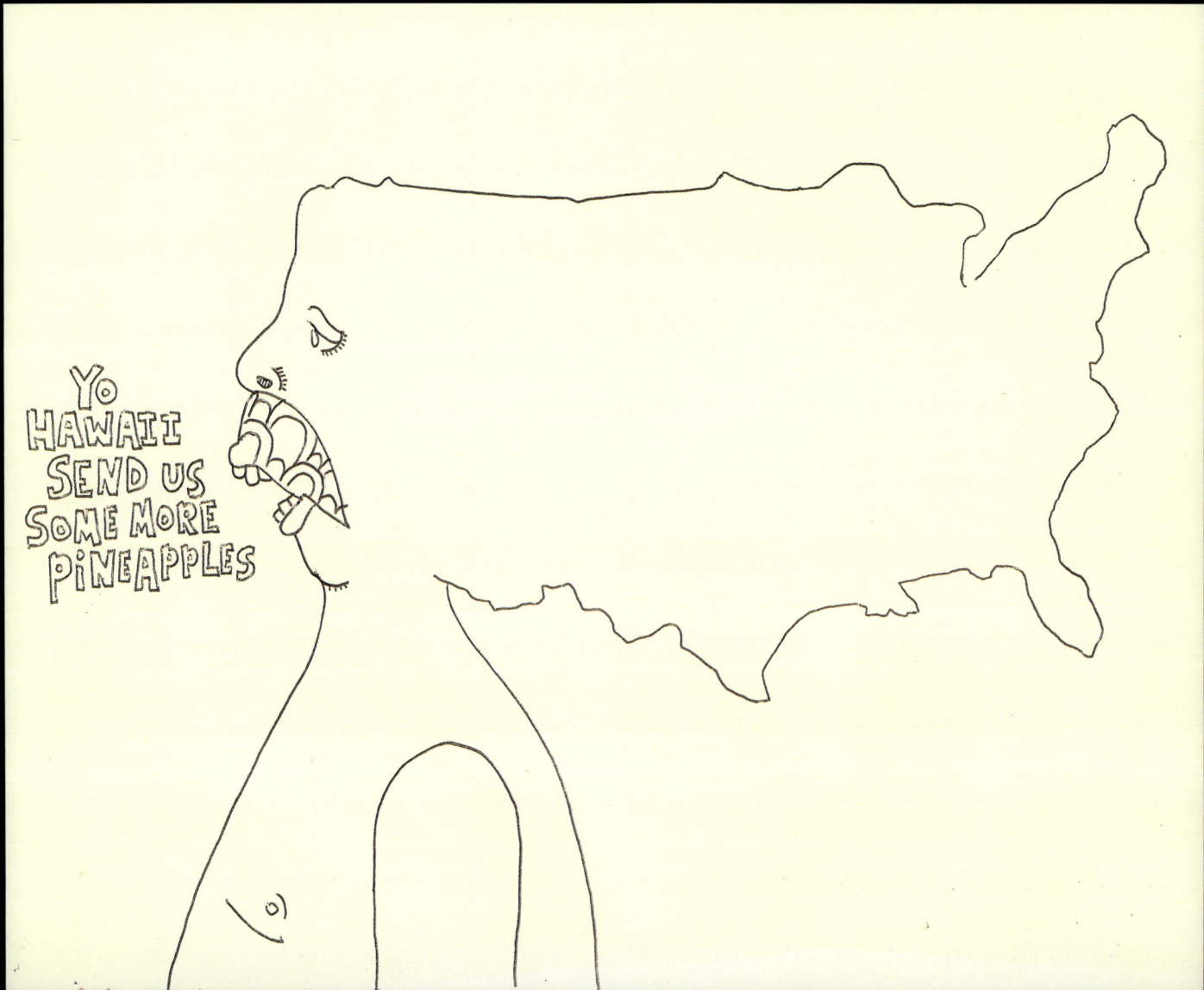

174–181:
BALINT ZSAKO
DEAD BIRD

Balint Zsako was born in Budapest, and now lives in Toronto. He received his BA in Fine Arts from Ryerson University. Zsako works with photography, mixed media, painting, drawing and sculpture, and has exhibited in Hungary, South Korea, Hong Kong and Canada.
www.balintzsako.com

How idyllic was your childhood?
Filled with adventure, but not always easy. Happy, but idyllic is not the term.

Can you remember something that really made you laugh when you were a kid?
My own bad jokes. And I really love telling them.

What's the worst look you can remember sporting?
MC Hammer pants in grade eight.

What's the most embarrassing situation you would admit finding yourself in?
I prefer not to fantasise about how I could embarrass myself.

When and where did it all start to go wrong?
It can go wrong?

How would you describe your character?
Like Batman crossed with Bill Cosby with the charm of Rhett Butler, as written by Kurt Vonnegut.

Do you have a sense of humour? If so, what kind?
Mostly elliptical, sometimes tetrahedral, mostly olive green, sometimes ultramarine blue.

Do you laugh at your own jokes? How loud?
Yes, medium loud.

What are you good at, what are you bad at?
I make a brilliant garlic salad dressing, but I am not so good at antique shopping.

Do you work with other people? How does that work? Does it work?
Mostly over the internet and phone. I wish I had a secretary.

Are you the type to exaggerate things? How much?
I tend to understate.

Would you say that creative people are unbalanced?
Creative people are only as fucked-up as the rest of the population, no more, no less.

In your opinion, is there such a thing as intelligent or stupid humour?
Crude humour can be genius, smart humour can be dull. There is no such thing as intelligent or stupid, there is only good or bad.

Some people seem to see the state of the world as 'serious, but not hopeless', others see the world as 'hopeless, but not serious'. How do you see it?
The world is only half serious, and not at all hopeless.

Do you have any theories about the world?
I leave theorising to the old Portuguese men on my street and the French academics of the world.

Do you carry any crosses?
Yes. A few big ones, a handful of medium-sized ones, half a dozen little ones, no huge ones though.

Do you ever feel like we're doomed? And does that make you want to laugh or cry?
The idea that people think we're doomed makes me laugh, then cry, because we're not.

What/who do you discriminate against?
Any soup based on fish or seafood, I am not allergic, just think the theory behind it is flawed.

What's your favourite satire film?
The Adventures of Picasso. The entire film is perfect.

What's your favourite children's book?
The Owl and the Pussycat (in the Hungarian translation)

Do you have a nickname?
I wish I had a nickname. A good old cowboy film one. But I don't.

Do you have any addictions?
Red wine, other people's cigarettes and the colour yellow.

Have you started reading self-help books yet?
No, I am not yet ready to become a better person.

And finally, would you like to say a word about submitting to the magazine and replying to this questionnaire?
Never trust an artist's words, trust his work.

Opposite
'Dead bird;'

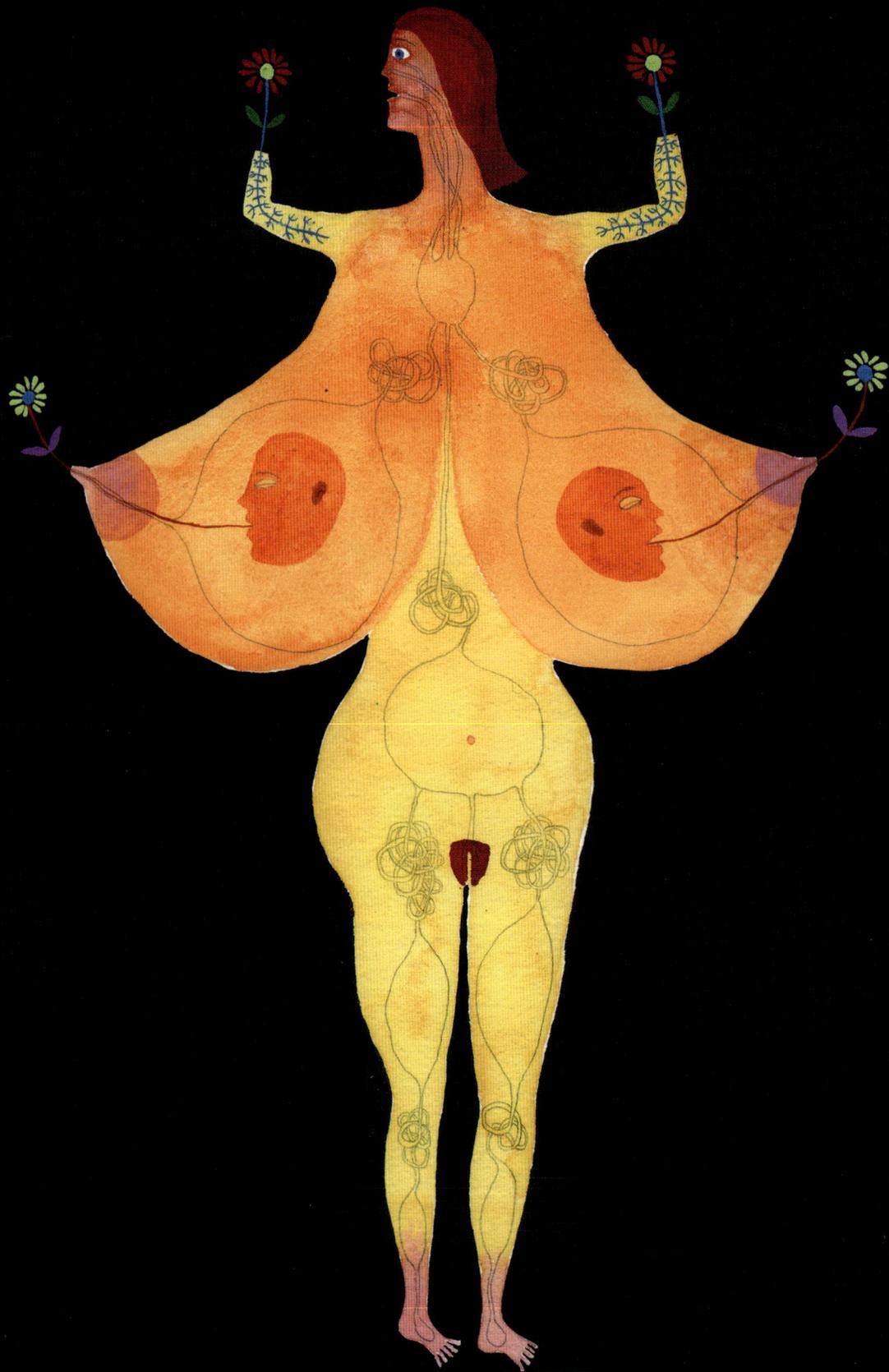

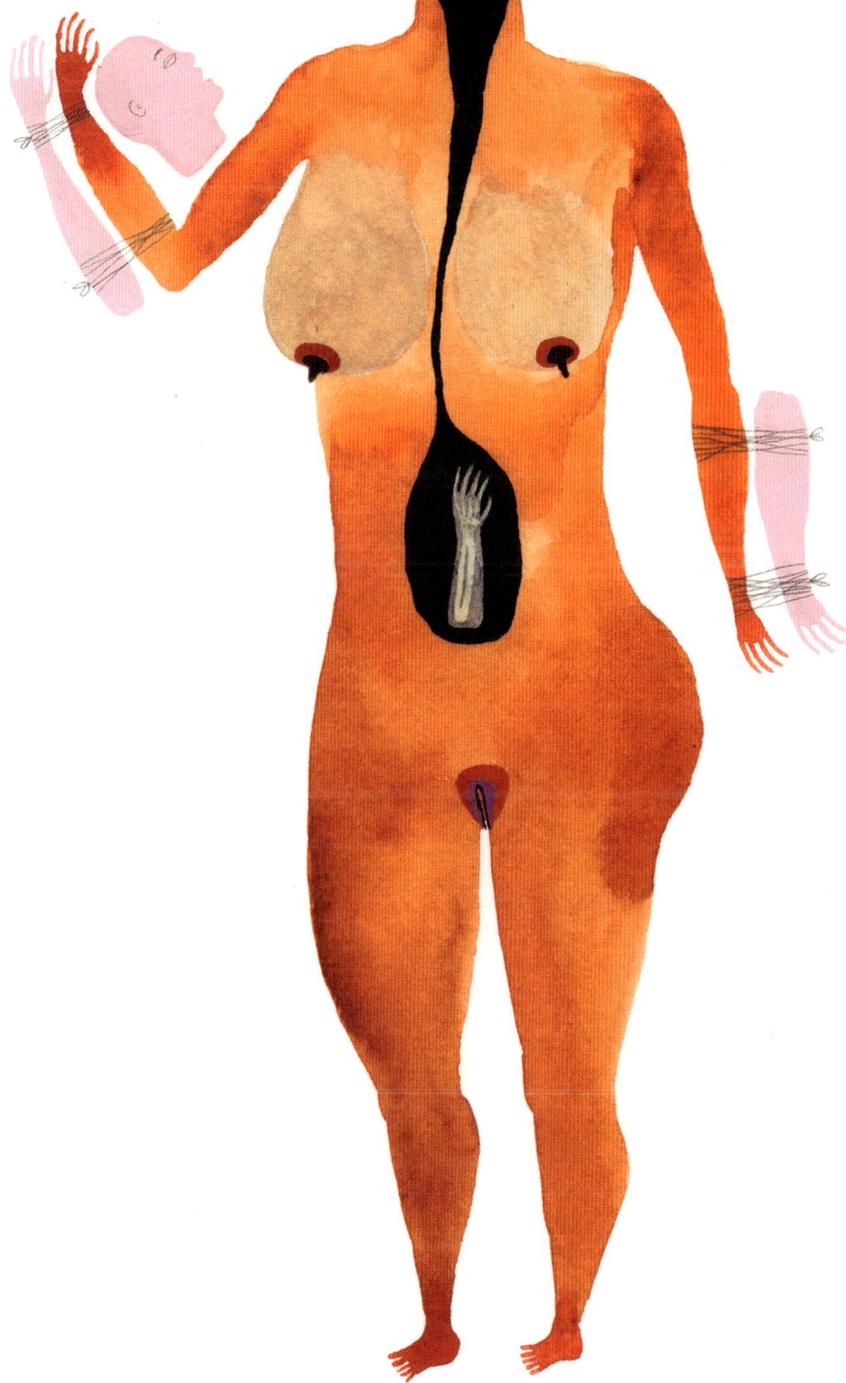

BALINT
ZSAKO
2005

YOUNG LADIES WHO MIGHT

young ladies who won't

NO.

YES

NO.

YES

WHAT I REALLY WANTED TO DO WAS CURATE!

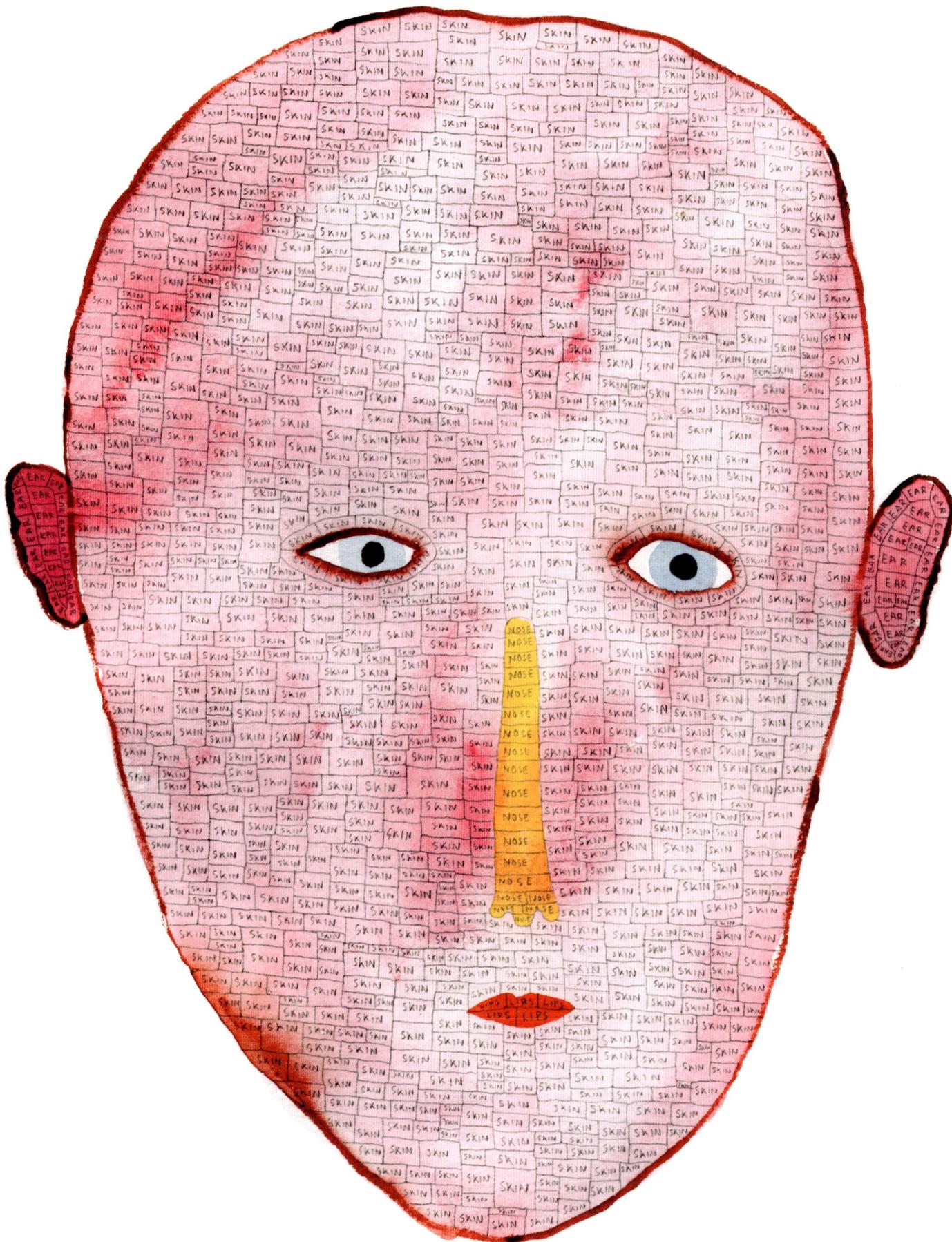

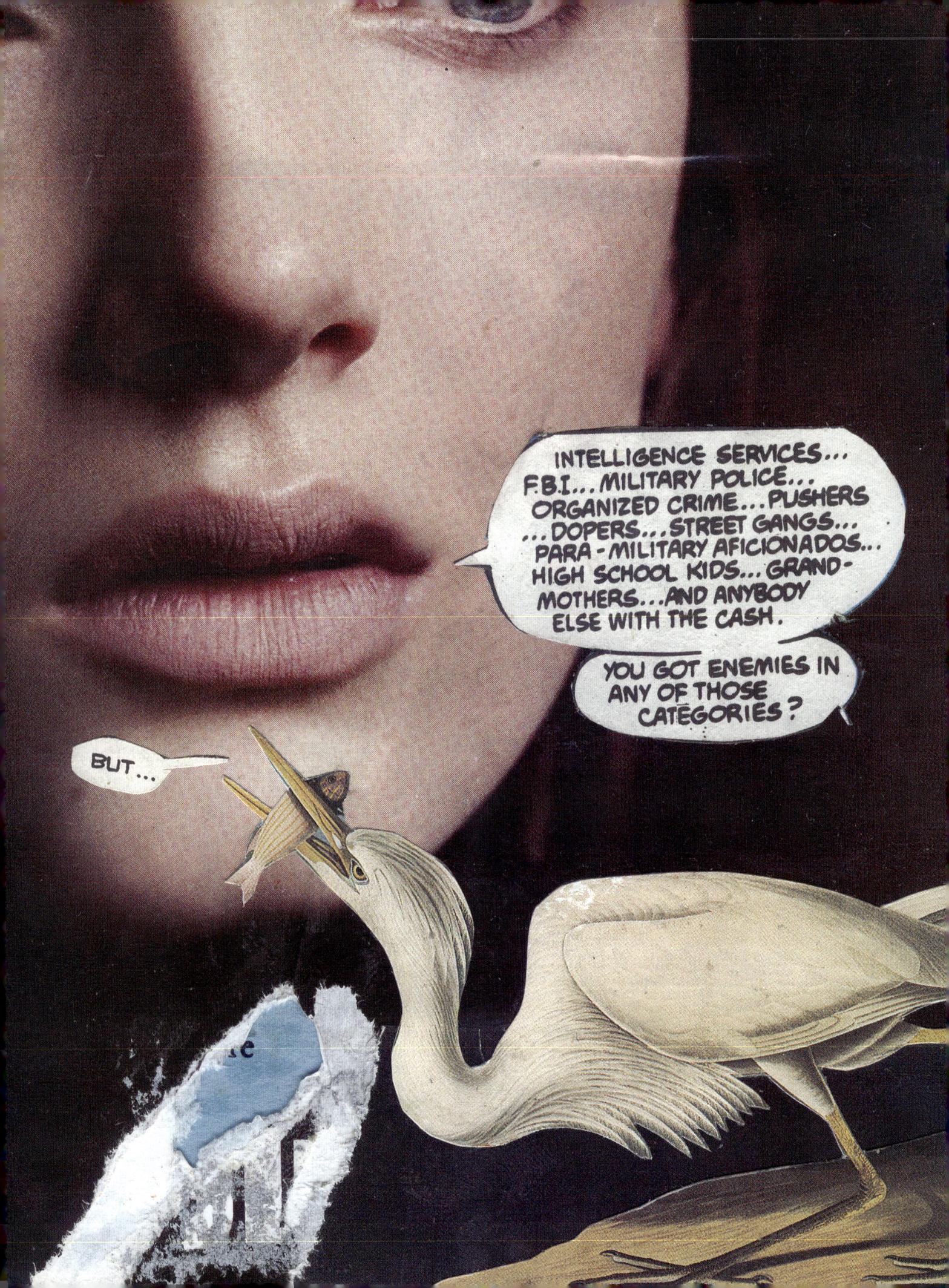

42 QUESTION MARKS BY MARC VALLI 128 FULL STOPS BY DAN EATOCK

Marc Valli exchanges emails with **Dan Eatock**

There are two ways of making a joke out of something. One is by not taking it very seriously. The other is by taking it far more seriously than you are supposed to.

Whether it be by compiling lists of things he has done (including lists he has compiled), or by collecting pictures of camera straps, or by organizing the world's largest signed & numbered limited edition, or even by trying to balance his chair on two legs in order to demonstrate the properties of balance – Dan Eatock's humour definitely fits in the second category.

BACKGROUND:

marc@magmabooks.com: *Did you have an idyllic childhood?*
daniel@eatock: Went to Disney World
Built dens in the backfield
Cut my thumb with a penknife given by my granddad
Played with Lego listening to Woodstock
Learned to cycle on canal towpaths
Built radio-controlled cars
Skateboarded and made a mini quarter pip on my driveway
BMXed
Walked every mountain in the Lakes and Wales including the 3 peaks
Raced karts
Mountain-biked
Weekend caravanning
Hay fever
Built a 1966 VW Beatle
Went to 24 hours Le Mans each year
Learned to drive in a rental car on a steep slope in Spain

Can you remember something that really made you laugh when you were a kid?
My sister asking for the dark to be switched off.

Did you cherish any grandiose dreams?
Living in New York.

What kind of teenager/student were you?
A teacher at high school compared me to a squirrel, she said I was always working hard for the future.

My best friend from high school, Dan Forster, is amazing at drawing, he can look at something and represent it perfectly on paper. When we were 16 we went on holiday to the South of France. At the beach he started to draw the view.

There is a very memorable scene in an Indiana Jones film: a skilled warrior yielding two huge gleaming swords elaborately swings them around in circles threatening to kill Indiana Jones. After this public display, Jones simply draws his gun, shoots him, and runs.

I could never compete with my friend at drawing, so I had to invent new rules. My solution (this is many years before I discovered Yoko Ono's work): I drew two straight lines across the page dividing it into thirds. I wrote sky in the top third, sea in the second and sand in the bottom third. I realised in that instance the craft and skill of drawing can be overcome with an idea.

This simple realisation has changed the way I approached almost everything I make. If something did not come naturally I would search out an alternative way to respond or solve the problem.

Did you go to art-school? What was that like?
At Ravensbourne I always arrived early for lectures and sat at the front. I tried hard to antagonize people with an unwavering commitment to my work.

It sounds like you were quite an intense student. Did you have a career plan? Did it work out?
Yes, I was a 100 per cent committed student. It felt rebellious and punk rock to be the hardest working, a reversal of the cliché slacker type. I enjoyed provoking by always being on time, having a clever solution to the brief that did not follow the statuesque, working when others where at parties, etc.

I had long hair, and remember Rupert asking the group: if it were required to shave your head to be part of the course, would you do it? I think some designers at the Bauhaus had done this, sat in circles and shaved each others heads. This really resonated. A few weeks later I shaved my head.

In real life, did you ever come across a lucky break? A happy-ending?
RCA> Walker Art Center> Flávia> Foundation 33> Channel 4.

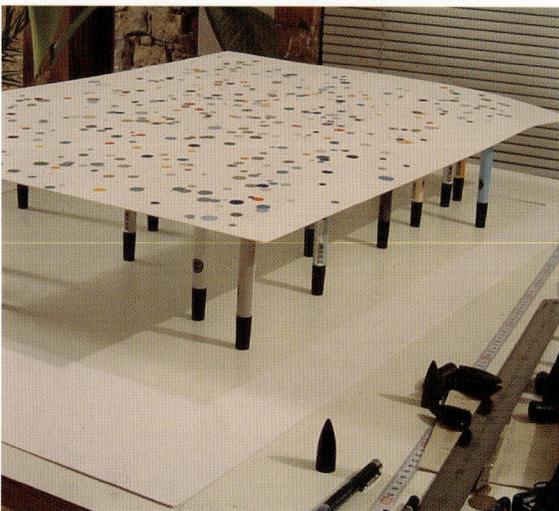

Far left and previous page
Felt-tip pen print
Left
Tape Coil
Opposite
Aerial Views

WORK:

You have done a lot of work for Channel 4 and Big Brother. How did that start? How would you describe this relationship?

It started by a chance introduction. I exhibited the 10.2 Multi-Ply Coffee Table at the Milan Furniture Fair. During the event I met a woman who was interested in helping find retail spaces and distributors for the furniture. Back in London she visited me in the studio and discovered I was a graphic designer. Previously, she presumed I was a furniture designer.

A few days later she introduced me to a friend of hers who worked in marketing at Channel 4. A few more days later I was invited to do my first pitch, designing an identity for Big Brother. I won the pitch, and formed a studio overnight employing friends, etc. and worked non-stop for two months creating everything for the show.

Big Brother's quite a controversial program. Do you have any special feelings about it?

When I first started making work for Big Brother in 2001 the program was perceived very differently than it is now. Each year it seems to generate more and more controversy. I have to distance myself from negative content and focus on some of the positive things that the programme does. It is one of the few TV programmes that crosses all demographics and starts public debate.

What is a normal day in the life of Daniel Eatock?

Wake up, make a fruit smoothy (5 fruits minimum)
Check emails
Coffee mid morning
Think
Read
Write
Walk
Work down my 'to do' list
Focused thinking on a specific problem/project
Invoice
Cycle
Cook
Swim
Stretch
Food Shop
Organise my desk
Sleep

Do you ever struggle to explain your design work or ideas to others, such as clients or friends or journalists?

I enjoy presenting work to others, both clients/friends.
I make work that is language-based, so the communication of it is very straightforward and direct.

What is the kind of job that excites you? How would a client go about getting the most out of Daniel Eatock creatively, speaking?

I like jobs (projects, works) where I can be involved from the very beginning. Where my ideas can really have a big impact on the final outcome, not just on the aesthetics.

Are you good at selling your own work?

I am good at framing the work, or explaining its relevance. I do not want to twist somebody's arm and persuade them to accept a work.

Do you come to work with certain ideas in mind?

I try to approach new projects without too much baggage, but inevitably my interests guide me to solutions that often connect to other works.

How do you approach a new subject?

Like a student: ask many questions, submerse myself in the research, etc.

Do life and work fit into each other neatly or do they clash? What about design and life?

My life and work are inseparable.

What would you put on top of your CV?

Name & date.

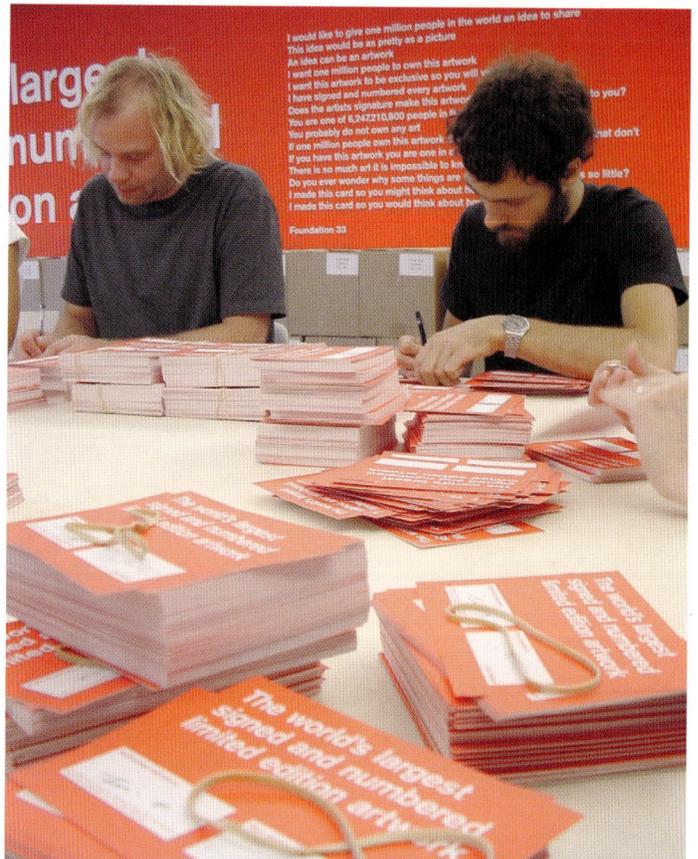

Right top
World's largest signed &
numbered limited edition
Right middle
Postcard

Right
Photograph
Opossite
Sun Light

This postcard is temporarily out of stock

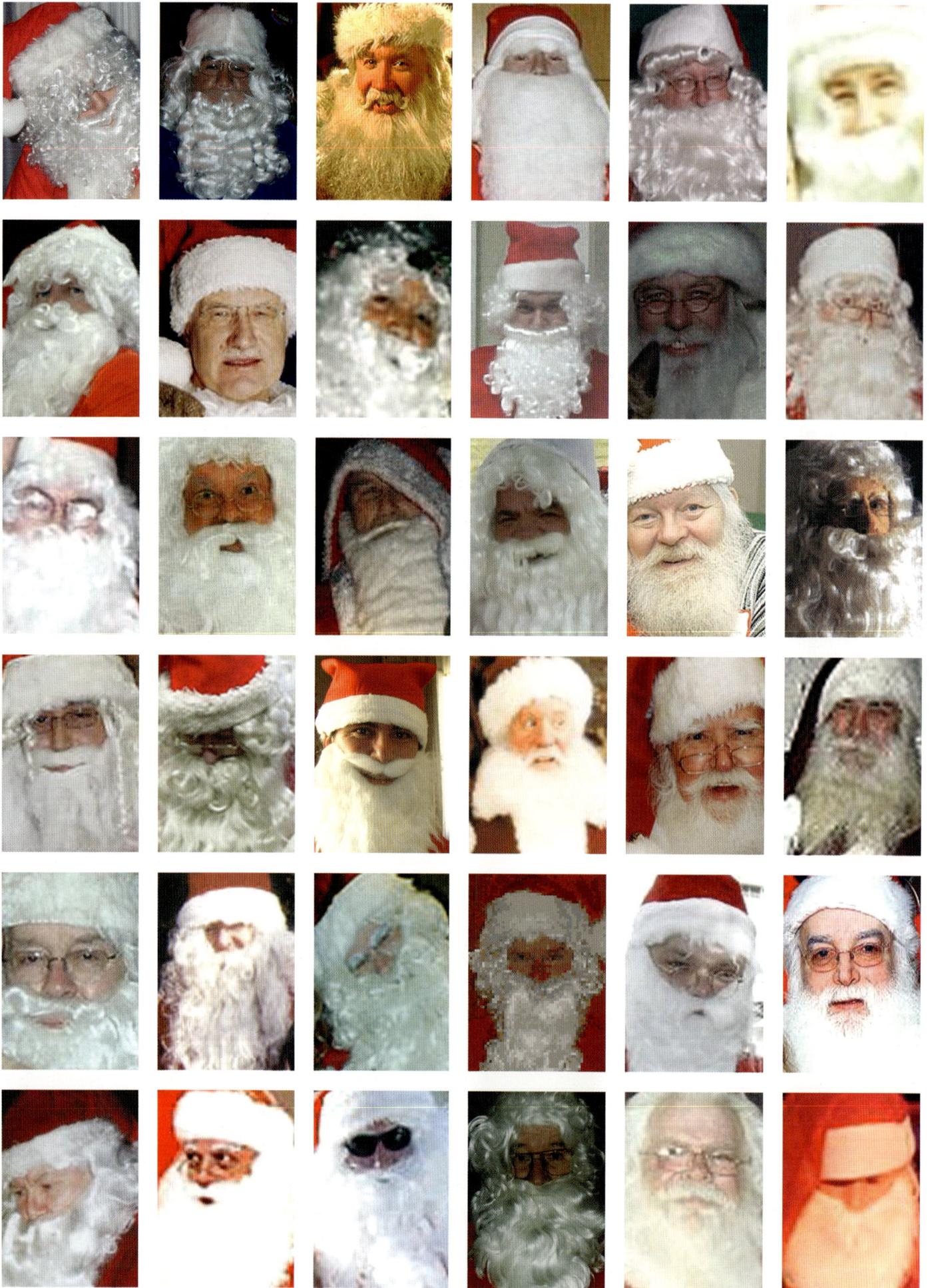

IDEAS, MANIFESTOS, HUMOUR:

Would you say that you have something like 'a design philosophy'?
I often heard the term 'non-design' used about your work.
Could you expand on that?
Manifesto:
Begins with ideas
Merges graphic design and art
Knows banal ideas cannot be rescued by beautiful execution
Eliminates superfluous elements
Subverts the expectation
Believes complex ideas can produce simple objects
Trusts the process
Allows material/research/concept to determine form
Reduces material and production to their essence
Sustains the integrity of an idea
Proposes honesty as a solution
Removes subjectivity
Ethos:
I would never use a female body in an objectified way to sell products.
I would not make work for a tobacco company, online casino, or anybody who is irresponsible.
I would love to be commissioned to think of ways that encourage people to not drop litter, or quit smoking.
I would enjoy promoting healthy food, or well-made sustainable products.
I enjoy being involved with art, museums, education, entertainment and culture.

Do you get excited by ideas (as in writings, concepts, theories)? Do you have any examples of that?
Ideas excite me more than pictures. I really connect with the 60s conceptual artists whose work was about the dematerialisation of

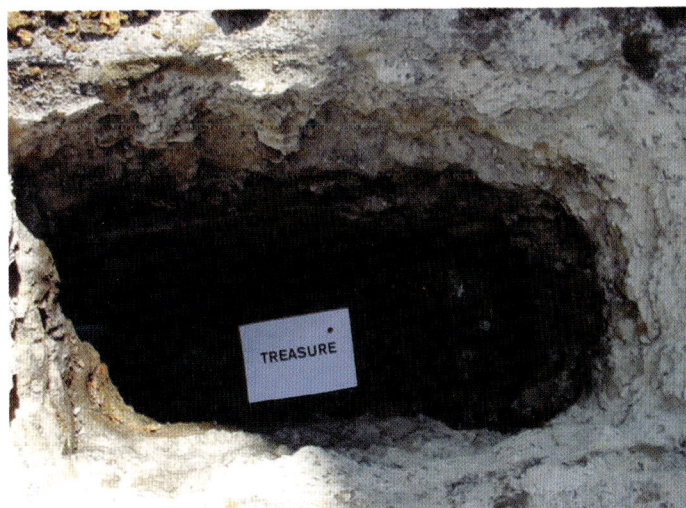

the art object. The idea was more important than the aesthetic.

People like Yoko Ono are very inspiring, they had avant-garde ideas that crossed into the mainstream.

I also like ideas for everyday life, theories of living well, learning, eating. Simple things such as eating fruit in the morning before eating anything else, as fruit only digests in your intestine. So if food is in your stomach it blocks the fruits path and the stomach acid destroys the vitamins.

Documentation seems to be an important part of your work.
Documentation is often the work. I find existing, often transient situations and record them. It is the photo that enables the work to exist. If a tree falls in a forest and nobody is around, does it make a sound?

What about titles? What would you say is a good title?
I like titles that complete the work, that are not captions or that reconfirm what the work is. For example, 'Neckclasp'. The title is the work, it is an integral and inseparable part of the object, same with 'One Stone, Rubber Stamp', and all the titles from 'Picture of the Week' series.

What would be a good title for this interview?
'63 Question Marks by Marc Valli 678 Full Stops by Daniel Eatock.' (When the text has been edited and finalised, you could count the number of question marks and full stops and title it accordingly).

Do you have a foolproof way of telling good ideas from bad ones?
No. Sometimes bad ideas become good. It might be a bad idea to cut all your t-shirts in half and then sew them back together. But once it's done, it becomes something great.

In your work the line between art and design seems to be growing thinner and thinner. Can you still tell the difference?
I have given up trying. For the first time since making works, I have become increasingly comfortable with occupying an in-between middle ground. I am not a graphic designer or an artist. I make works that uncomfortably fit in each discipline.

I suppose I could ask the same question about the difference between designer/product designer/graphic designer?
It's the differences that make the breaking of disciplines interesting. I enjoy seeing how an architect approaches the making of a book, or how a graphic designer goes about making a table, etc.

You seem particularly interested in objects and materials. Would you be able to list a few favourites?
Archetypal objects, T-shirts, cups, postcards. I like existing things that can be transformed with an idea.

As for materials: common, readily-available, non-exotic, again materials that can be re-appropriated and transformed with an idea.

What would you say is definitely NOT your motto?
Say NO to fun & function & YES to seductive imagery & colour!

Who do you look up to in the humour/wit department?
Andy Kaufman
Peter Kay
Johnny Vegas
Steven Wright
Eddy Murphy
Billy Connelly

Do you ever come across people who you think take themselves just a bit too seriously?
Comedians and clowns.

In your opinion, is there such a thing as intelligent or stupid humour?
Yes. Steven Wright is intelligent humour. Johnny Vegas is stupid humour. Both are brilliant.

What's your favourite children's book?
Jonathan Livingston Seagull by Richard Bach.

Some people seem to see the world as 'serious, but not hopeless', others see the world as 'hopeless, but not serious." How do you see it?
The world is an amazing place that is sometimes spoiled by people and sometimes improved by people.

Do you have any theories about the world we live in?
Be happy.

Opposite
Santa
Left
Burying Treasure

I would like to ask people what they are going to buy as they are walking into a supermarket and ask them what they bought on their way out.

I would like to make an archetypal steel ruler one kilometer long.

I would like to be asked to spell every word in the concise Oxford English Dictionary as a standard high school spelling test. I would form a list of all the words I spelt wrong a list of all the words I spelt correctly.

I would like to curate a show called 'Untitled' containing works that are all 'untitled'.

I would like to buy postcards in art museums of artwork on display then hold them in front of the actual artwork and take a photograph.

I would like to write non stop for 24 hours

I would like to know how many night light candels I can light before the first on burns out.

I would like to copy every single artist signature from every artwork displayed in the Tate Modern on a single page.

I would like to own a complete set of Edward Ruscha's artist books.

I would like to cut all my t-shirts in half and have them stiched back together.

I would like to read every book I own.

I would like to meet Yoko ono.

I would like to employ a professional proof reader to read through all my sketch books and proof corrections.

I would like to collaborate with 3m to make the Fly Post-it a mass produced artwork.

I would like to make the smalest ton.

I would like to see 1 ton of feathers.

I would like to open a can of Piero manzoni merda.

I would like to add more paint to a real Picasso.

I would like to commission sol lewit to make a wall drawing on the ceiling.

I would like to ask Tracy Emin to make a bed.

I would like to hear Paul McCartney sing only John Lennon songs.

I would like to exhibit Richard Prince joke paintings at a comedy club.

I would like to own a John & Yoko war is over poster.

I would like to design a Royal mail postage stamp with a drawing of an envelope on it.

I would like to make blank badges for people to wear over the logos and brand marks on clothing.

I would like to hang paintings from the Renaissance in a gallery with the smell of fresh oil paint.

I would like to put an Alkerseltzer in a pint of beer.

I would like to have seen Andy Kaufman read the great Gatsby.

Opposite
List

This page from top
Postcard Back compositions

Stone

Neckclasp

Chair balance

DAN EATOCK ON:

STANDARDS / ARCHETYPES
I have a fascination with producing something extraordinary from readily available (non exotic) materials. Common things: A6 postcards, A4 paper and reams, CMYK colours 100% yellow + 100% magenta = standard red, grey board, Courier, HTML websites, small budgets, single colour printing, embracing restrictions, making the most out of limited resources. etc. I aim to employ standards whenever possible, it helps me to reduce subjectivity, and gives me more time to concentrate on the conceptual part of making work. Eg. 'Postcard Back Compositions'

INSTRUCTIONS / TEMPLATES:
I like unfinished or incomplete works that rely upon the user/viewer to literally or conceptually finish the work. I like the aesthetic of forms, blank spaces awaiting their content. I am interested in interpretation and how others respond to instructions. Eg. 'Utilitarian Greeting Cards'

WIT / HUMOUR:
Absurdities, irony, sarcasm, pointlessness. I enjoy ideas that make you smile. Not a joke with a punchline, but a moment of realisation that makes you smile, even if it's only smiling to yourself. Eg. 'Stone'

QUICK OBSERVATIONS:
Being open and utilising simple observation as and when they occur. Going with your first idea, adlibbing, making things up on the spot, improvisation. Eg. 'Pair of Socks'

READYMADE / NON DESIGN:
Taking something generic and familiar from its expected context and applying it in another. The utilisation and embracement of existing things. Don't invent if something exists that can do the job. Eg. 'Neckclasp'

BREAKING RULES & BEING AWKWARD:
Standing out by being difficult to see. Challenging conventions, breaking rules, antagonising established notions of branding. Eg. Big Brother Identity 2000-06

BALANCE:
Designers, painters, photographers, etc. often refer to an image, page or form looking 'balanced'. In this instance balance is a subjective description suggesting that the image, page or form appears comfortable. Not too heavy, not lopsided, equally spaced, that the elements create a harmonious feeling or composition.

Everybody remembers being a kid and leaning back on the back two legs of a chair. There is a very special feeling when the body is suspended momentarily, neither falling forward or back. The moment the chair inches back, the body reacts by throwing legs and arms forward to counterbalance, creating a feeling of butterflies in your stomach.

Skateboarders, surfers, tightrope walkers, unicyclists and trials riders are constantly teetering on the edge of balance – movement and momentum keeps them from falling. Subtle movements and adjustments are required to maintain control – often twitchy and seemingly erratic – yet they are intuitive reactions to maintain control.

Balance is the striving for stillness created by the constant adjustment and movement that brackets the point of balance. The balance of form, colour, texture, composition, sound etc. becomes more tangible with the understanding of real un-subjective balance. Eg. 'Chair Balance' (Extracts from Dan Eatock's own intro)

Adam McEwen
Courtesy of the artist and
Nicole Klagsbrun Gallery

From top
Untitled (Dead) 2005,

Untitled (Sorry) 2002,

Untitled (Cunts) 2005